Brenda —
To help spur you
on and give you ideas!
Merry Christmas!
Love always
Deb

GLORIOUS AMERICAN QUILTS

THE QUILT COLLECTION OF
THE MUSEUM OF AMERICAN FOLK ART

Elizabeth V. Warren and Sharon L. Eisenstat

PENGUIN STUDIO
in association with
Museum of American Folk Art
New York

To Cyril Irwin Nelson, whose deep and abiding
interest in American quilts has immeasurably
enriched the collection of the Museum of American
Folk Art and made this book possible.

PENGUIN STUDIO
Published by the Penguin Group
Penguin Books USA Inc., 375 Hudson Street,
New York, New York, 10014, U.S.A.

Penguin Books Ltd, 27 Wrights Lane,
London W8 5TZ, England

Penguin Books Australia, Ltd, Ringwood,
Victoria, Australia

Penguin Books Canada Ltd, 2801 John Street,
Markham, Ontario, Canada L3R 1B4

Penguin Books (N.Z.) Ltd, 182-90 Wairau Road,
Auckland 10, New Zealand

Penguin Books Ltd, Registered Offices:
Harmondsworth, Middlesex, England

First published by Penguin Studio, an imprint of Penguin Books USA Inc.

First printing, June 1996
10 9 8 7 6 5 4 3 2 1

Library of Congress Catalog Card Number: 96-67093

Book designed by Nancy Danahy
Printed and bound by Dai Nippon Printing Co., Hong Kong, Ltd.

ISBN: 0-670-86913-9

TABLE OF CONTENTS

I t is difficult to imagine the field of American folk art without quilts. I suspect that for many curators and collectors, quilts immediately bring to mind the very qualities that have come to characterize the field, perhaps more than any other medium of creative expression. Utilitarian in origin, they often are *tours de force* of artful composition and exuberant decoration; striking examples of individual creativity, they nevertheless draw upon a traditional repertoire of design; celebrations of virtuosity, they frequently depend upon patterns and techniques that have been transmitted within families, small communities or other close-knit groups, or more broadly through classes or publications.

It is therefore surprising to note that quilts were not always perceived to be essential elements of the field. When the first collections and exhibitions of American folk art were assembled in the 1920s and 1930s, quilts were not generally included, for at that time a strict and limiting fine-arts model prevailed. Only works that could be contextualized as painting or sculpture, whatever the original intention of the maker, were admitted to the canon. The omission of quilts is somewhat ironic because they alone among the various objects of utility, household decoration, or personal fancy that were then understood to constitute the field of American folk art had a long-standing history of public exhibition dating to the early nineteenth century, if not at museums then, at least, at fairs and expositions.

Was this a bias against a form of creative expression traditionally associated with women? I do not think so. The field of American folk art has always been receptive to women's work, and other mediums in which women figured prominently—painting in watercolor, for example—were well represented in the early collections. Moreover, as Holger Cahill, the pioneering curator of American folk art, described the field in an essay published in *The American Mercury* in September 1931, many callings associated with men were also omitted. "Folk art . . . does not include the work of craftsmen—makers of furniture, pottery, textiles, glass, and silverware—but only that folk expression which comes under the head of the fine arts— painting and sculpture," he wrote. These words read

strangely today, now that the field has been enhanced by its receptivity to a broad range of objects from various crafts traditions.

This is not to imply, however, the art of quiltmaking did not have opposition from male critics. Writing in the *Portland* [Maine] *Pleasure Boat*, a weekly journal of opinion, on November 1, 1849, Jeremiah Hacker, its editor, railed against the practice of awarding prizes at state and county fairs to the makers of ornamental quilts. He was particularly incensed by a prize-winning quilt consisting of 9,800 pieces of silk, which he called a "splendid folly"; the practice of quiltmaking itself he dismissed as a "sinful waste of time." "If State or County Fairs are to offer premiums to those who will thus trifle away whole months of a short life when the time might be so much more usefully and profitably spent," Hacker scolded, "they will prove a great injury to the country instead of benefit." He also regretted that *any man* could be found in the whole country, willing to encourage such a waste of time." [Emphasis mine.] Fortunately, no one seems to have taken him very seriously.

The Museum of American Folk Art was established in 1961. Its founders subscribed to Cahill's fine-arts model for the field of American folk art, and the institution built its early reputation on the vigorous works of folk sculpture that it collected in the years immediately following its founding. It was not until the decade of the 1970s that the Museum would accession its first quilt and not until the explosion of interest in quilts that took place in the 1980s that quilts in significant numbers would enter the Museum's permanent collection.

The Museum's exhibition history reflects a similar emphasis. No quilts were included in the Museum's initial loan exhibition in 1962, and although quilts may have been seen at the Museum in such exhibitions as "American Needlework" in 1967, it was not until 1972 in "Fabric of the State" that quilts would be featured in an exhibition at the Museum and not until even later, in "A Child's Comfort: Baby and Doll Quilts in American Folk Art" presented in 1976–1977 that the Museum would devote an entire exhibition to the subject.

Outside the Museum, the art world also awakened to the importance of quilts. Jonathan Holstein and Gail

van der Hoof presented "Abstract Design in American Quilts" at the Whitney Museum of American Art in 1971. Not only were quilts included in "The Flowering of American Folk Art," the Whitney's seminal 1974 exhibition, but the cover of the exhibition catalogue is illustrated with details of a quilt, the "Bird of Paradise Quilt Top," which I am pleased to note is now one of the signature pieces of the Museum of American Folk Art. Indeed, it was the purchase of that quilt for the Museum by a group of the Museum's trustees in 1979 that signaled a new direction for the Museum, one in which quilts were moved to center stage.

The impetus for this new and sustained concentration on quilts may be traced in large part to the enthusiasm of my predecessor as director of the Museum, Dr. Robert Bishop (1938–1991), who began his association with the Museum in 1977. Although his interests were diverse, he held quiltmakers and their work in very high esteem. In part because of sentimental associations with his boyhood in rural Maine and memories of a beloved grandmother, but more importantly because of his appreciation of rich color and technically proficient design, he emphasized quilts in his research and writing and in the exhibitions and programs that he planned for the Museum. Even before he came to the Museum, he had published *America's Quilts and Coverlets* with Carleton L. Safford in 1972; *New Discoveries in American Quilts* with Patricia Coblentz in 1975; and *A Gallery of Amish Quilts* with Elizabeth Safanda in 1976.

Under Robert Bishop's stewardship the quilt collection of the Museum of American Folk Art grew to become a major institutional strength, as is obvious from the pages of this splendid book, and quilt-related exhibitions have been presented with great regularity ever since, not only in the Museum's own galleries in New York, but through its touring program in museums throughout the country and abroad. As I write these remarks, for example, "Victorian Vernacular: The American Show Quilt," organized by the authors of this volume, is on exhibit at the Museum. It is the most recent in a long series of distinguished quilt exhibitions presented by the Museum.

From time to time the Museum has purchased quilts for its permanent collection; a grant from the National Endowment for the Arts, for example, funded the purchase of an important collection of contemporary African-American quilts in 1991. By far the greater number of quilts that are documented in this book, however, came to the institution through the generosity of donors. As Assistant Director of the Museum, I had the pleasure of working closely with David Pottinger on his gift of about one hundred midwestern Amish quilts in 1980; he also thoughtfully donated to the Museum all royalties earned from his *Quilts from the Indiana Amish: A Regional Collection*, published by E.P. Dutton in association with the Museum in 1983. Large and significant groupings of quilts were also presented to the Museum by the Amicus Foundation, Robert Bishop, Margaret Cavigga, Cyril I. Nelson, Irene Reichert, Maude and James Wahlman, William and Dede Wigton and many others. To them and to all those friends and associates who have thoughtfully helped the Museum to build a major repository for the study and exhibition of quilts goes my deep and abiding appreciation.

This book is dedicated with esteem and affection to its editor, Cyril Irwin Nelson, who has been a good friend of the Museum of American Folk Art for over twenty years. During his association with the Museum, Cyril Nelson has documented many of the Museum's exhibitions in the outstanding volumes published under his editorship. A longtime advocate for the recognition of quilts as an art form, he has illustrated many great examples in his annual series, *The Quilt Engagement Calendar*, a popular favorite for over twenty years. I have always believed that one of the special qualities of the Museum of American Folk Art is the loyal support and caring of people like him. It is my privilege to thank Cyril I. Nelson warmly for the significant role that he has played in the history of the Museum.

It remains for me to express my heartfelt thanks to the authors of this book. Elizabeth V. Warren, the Museum's Consulting Curator, and her associate, Sharon L. Eisenstat, not only have painstakingly catalogued the Museum's extensive quilt collection but have presented it to the public in this highly informative, visually appealing volume. Their many discoveries are here to be studied and enjoyed for many generations to come. They have the warm appreciation of the entire Museum family.

GERARD C. WERTKIN
Director
Museum of American Folk Art

ACKNOWLEDGMENTS

This book was one of the last projects envisioned by Dr. Robert Bishop, the late director of the Museum of American Folk Art. Bob Bishop's enthusiasm for quilts was inspiring—and catching. He was the author or co-author of some of the seminal books of the 1970s quilt revival—*America's Quilts and Coverlets, New Discoveries in American Quilts, A Gallery of Amish Quilts*—and published his last book on the subject, *The Romance of Double Wedding Ring Quilts*, in 1989. His contributions to the field of American quilts are too numerous to mention here, but the authors would like to acknowledge his belief in this project and our abilities to accomplish the task.

It is with great thanks that we acknowledge the financial support of our good friends Dr. Nancy Kollisch and Dr. Jeffrey Pressman, and the American Folk Art Society, whose timely and generous grants made it possible to complete the new photography required for this book. Many photographers have contributed their time and talent over the years to documenting the Museum's quilt collection and their names can be found in the credit information. We especially would like to thank Matt and Kristin Hoebermann and Gavin Ashworth for their help in completing the new photography.

This book could not have been written if we could not have stood on the shoulders of other authors and quilt scholars. We would particularly like to recognize the works of: Barbara Brackman, on whose "bible"—*Clues in the Calico*—we depended for consistency of terms and usage; Eve Wheatcroft Granick; Penny McMorris; Cuesta Benberry; Maude Wahlman; Virginia Gunn; Merikay Waldvogel, and all the others whose published contributions on the many and varied aspects of American bedcovers and needlework are mentioned in the notes and bibliography.

We especially would like to acknowledge the help of Gillian Moss, Associate Curator of Textiles at the Cooper-Hewitt Museum in New York City, who was so gracious in sharing her time and expertise to identify the early fabrics in a number of the Museum's quilts.

Much of the research documented in this book was carried out by Stacy C. Hollander, Curator of the Museum of American Folk Art, Lee Kogan, Director of the Folk Art Institute, and the students and interns whose contributions are mentioned in the text and endnotes. The authors also would like to recognize the support and assistance of other Museum staff members, particularly Gerard C. Wertkin, Director; Ann-Marie Reilly, Registrar; Gina Bianco, Consulting Conservator; and Janey Fire, Photographic Services.

As always, thanks to Irwin Warren for his editorial eagle eye and to Ted Eisenstat for his many favors.

Finally, the authors would like to thank all the donors to the quilt collection of the Museum of American Folk Art. We sincerely appreciate the generosity of those who chose to give anonymously and those whose names—too numerous to mention here—can be found in the caption information and in the complete catalogue of quilts at the back of the book.

INTRODUCTION

The Museum of American Folk Art takes quilts seriously. In a permanent collection that includes approximately 2,500 objects, there are (as of this writing) almost 400 quilts, with more added at virtually every quarterly meeting of the Museum's accessions committee. But the collection is not just about numbers. Among the Museum's holdings are some of the masterpieces of American quiltmaking, both in terms of aesthetics and historic significance. The early wool "Harlequin Medallion Quilt"; the magnificent "Sunburst Quilt" that has been traced to the Savery family of Quakers in Philadelphia; and the beautiful "Bird of Paradise Quilt Top" are among the best-known of these stars. There are also areas of particular strength within the collection. Categories such as Amish quilts, Victorian show quilts, and twentieth-century revival quilts are so extensive that they can be studied in depth and presented to the public in a variety of exhibitions and publications.

In consequence, quilt exhibitions are an annual occurrence at the Museum's gallery in New York City, and exhibitions of quilts from the Museum's collection tour around the world. A special membership category—"The Quilt Connection"—with its own newsletter is available for members with a particular interest in textiles. Classes and lectures in the history of American quilts, and demonstrations and workshops that explore quiltmaking techniques are perennial favorites at the Museum's educational branch, the Folk Art Institute.

Until this publication, however, there has been no comprehensive reference guide to the quilts in the Museum's collection. Highlights from the collection have been published and exhibited many times, but the purpose of this book is to provide an opportunity for scholars, quiltmakers, collectors, and others who appreciate these bedcovers to explore the collection in depth, to review the significant research that has been done on the quilts, and to appreciate textiles that are unfortunately too delicate to exhibit frequently and are therefore not generally available to the public.

In examining this catalogue, it will immediately become clear that the majority of the quilts in the Museum's collection are "orphans"—they have entered the collection without any solid provenance.

Occasionally, there will be information relating where the quilt was found ("bought at a flea market in Connecticut"), and sometimes scraps of hearsay evidence or family folklore ("made for a wedding," or "made by an African-American woman") accompany the quilts into the collection. Over the years, many of these tales have been retold so often that they have become accepted as gospel. Where possible, it has been the authors' purpose to authenticate such stories or, as in most cases, to lay to rest the often romantic anecdotes that frequently become associated with works of folk art.

Where there have been enough clues to enable more historical or genealogical research, this work has been carried out either by the authors, by members of the Museum staff, or by students in the Folk Art Institute. When such information has not been available, the quilts themselves have been relied upon to provide some evidence as to when and where they were made. Clues such as overall design, fabrics, color, patterns, sewing techniques, and quilting motifs have been evaluated and relied upon to place the bedcovers within the overall framework of American quilt history.

It should be noted that this book is not intended either as a history of American quilts or as a guide to dating quilts. However, in order to set the Museum's quilts in context, a good deal of that history is told, and information regarding how the Museum's quilts were evaluated is provided. Where there are gaps in the story of American quiltmaking, it is because the Museum's collection includes no (or no significant) examples of that type of quilt. Where appropriate, the authors have attempted to set the quilts within the larger context of American decorative arts.

In general, the objects included in this book are either quilts or quilt tops, both finished and unfinished. Because the Museum's collection of quilts is so large, the authors chose not to include coverlets, woven candlewick spreads, bed rugs, and other types of bedcovers that are sometimes discussed in books on quilts. However, a few related objects, such as the "Crazy Trousseau Robe," are included here because they use the same technique or are part of the same tradition as the quilts of the period. Other categories, such as sten-

ciled bedcovers and hand-embroidered candlewick spreads are discussed because they have consistently been collected and studied with quilts for most of this century.

The Museum's collection has grown over the years primarily through the kindness of donors. Occasionally, funds have been raised or grants received to purchase a significant and rare example (such as the "Bird of Paradise Quilt Top") or fill a gap in the collection, but in general quilts enter the collection through gifts. As it is a national, not a regional institution, the Museum does not restrict its collection by location, nor is it restricted by time period: The quilts included here have been made all over the country and range in date from the late-eighteenth to the late-twentieth century. The only restrictions placed on gifts are condition and aesthetic and/or historical importance. Occasionally, a quilt in less desirable condition will be accepted if it has a significant family history or is of importance in understanding the development of the American quilt-making tradition.

Because the collection has grown mainly by gifts, its strengths have been determined largely by the interests of the Museum's donors. The collection is particularly strong in Amish quilts, for example, a result of major gifts of Midwestern Amish quilts from David Pottinger in 1980 and primarily Pennsylvania Amish quilts from William and Dede Wigton in 1984. Because of the interest in early textiles on the part of a friend of the Museum, it today has a fine representation of quilts from the late-eighteenth century and the first part of the nineteenth century, including whole-cloth, whitework, and early chintz examples. A recent Museum exhibition of Victorian show quilts was inspired in part by the Crazy and other late-nineteenth-century quilts that were given to the collection by Margaret Cavigga in honor of the first Museum-sponsored Great American

Quilt Festival in 1986. A traveling exhibition and publication was organized in 1989 to highlight Robert Bishop's extensive collection of quilts in the "Double Wedding Ring" pattern, now owned by the Museum.

In 1990, the Museum received a matching grant from the National Endowment for the Arts for the purchase of ten quilts made by African-Americans living in the South. This grant inspired a number of collectors to donate other contemporary African-American quilts to the Museum, and today this is a growing segment of the collection. Most of the other contemporary quilts in the collection represent the winners of the quiltmaking contests that the Museum has sponsored in recent years.

Some of the quilts included in this book came to the Museum directly as a response to needs that were identified during work on this project. In 1992 and 1993, Irene Reichert answered a "call for quilts" that was published in *Folk Art* magazine and donated five beautiful nineteenth-century floral-appliqué quilts. This gift filled what had been a major gap in the collection and enables the Museum to present now a more comprehensive history of quiltmaking in America.

All of the quilts in the Museum's permanent collection are included in this book in some form. Quilts that are of particular aesthetic or historical significance have been illustrated in color—and in black-and-white in the case of the whitework pieces where it is important to be able to see all the detail—and are discussed in the text. Others are pictured in black-and-white in the catalogue in the back of the book. This catalogue section includes basic information on every quilt, arranged according to the categories outlined in the individual chapters. It is hoped that this catalogue will be useful to quilt historians and others who need access to the Museum's extensive collection. Researchers should contact the Museum if further information is required from the object files.

ELIZABETH V. WARREN
SHARON L. EISENSTAT

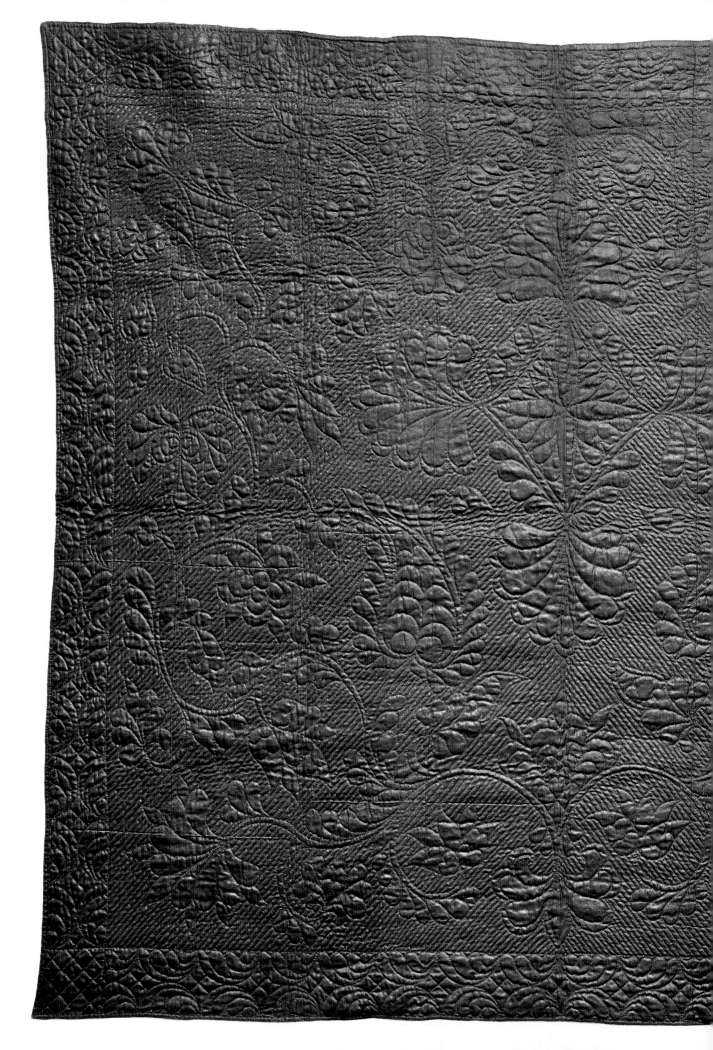

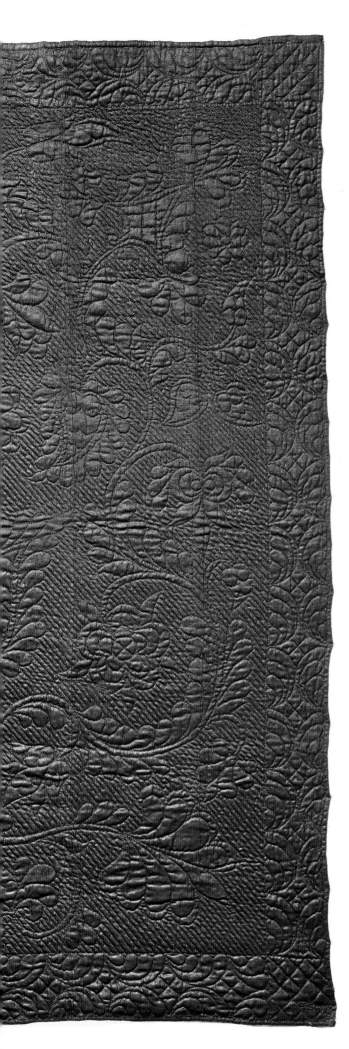

WHOLE-CLOTH QUILTS

||T|| he oldest quilts in the Museum's collection belong to what is called the "whole-cloth tradition." This is generally acknowledged among quilt historians to include bed coverings made of large pieces of either solid-colored wool or silk; printed chintz or copperplate-printed cotton or linen; stenciled cotton; or one of the various forms of embroidered cotton or linen known as "whitework."

Technically, the quilts that are called "whole cloth" are not made of one piece of fabric. Eighteenth- and early-nineteenth-century looms were too narrow to permit production of fabric that was large enough to cover the entire surface of the beds of the period, which often were piled high with feather mattresses or straw ticks. Consequently, a number of pieces of fabric, occasionally of different colors or patterns, would be seamed together to form the quilt top, which was then usually quilted with motifs that covered the entire surface. Whole-cloth quilts were made both in England and in America and sometimes they were made by professional quilters.[1]

WOOL WHOLE-CLOTH QUILTS

For many years, whole-cloth quilts made of wool were called "linsey-woolsey." Today, however, it is understood that these quilts were not made of a homespun combination of linen and wool as that term implies, but rather were usually sewn entirely of wool. Often, the wool that was selected for the quilts was a professionally manufactured "worsted . . . stuff with a fine glaze on it"[2] known as "calimanco," which probably was imported from England. The glazing, or "calendering," was produced by running the fabric between rollers or calenders with heat and pressure applied. Glazed effects also could be achieved by rubbing the fabric with a soft stone or applying gum arabic or some other

1. INDIGO CALIMANCO QUILT

Quiltmaker unidentified; probably New England; 1800–1820; wool; 86" x 95". Promised gift of a Museum friend in honor of Joel and Kate Kopp; P1.1995.4

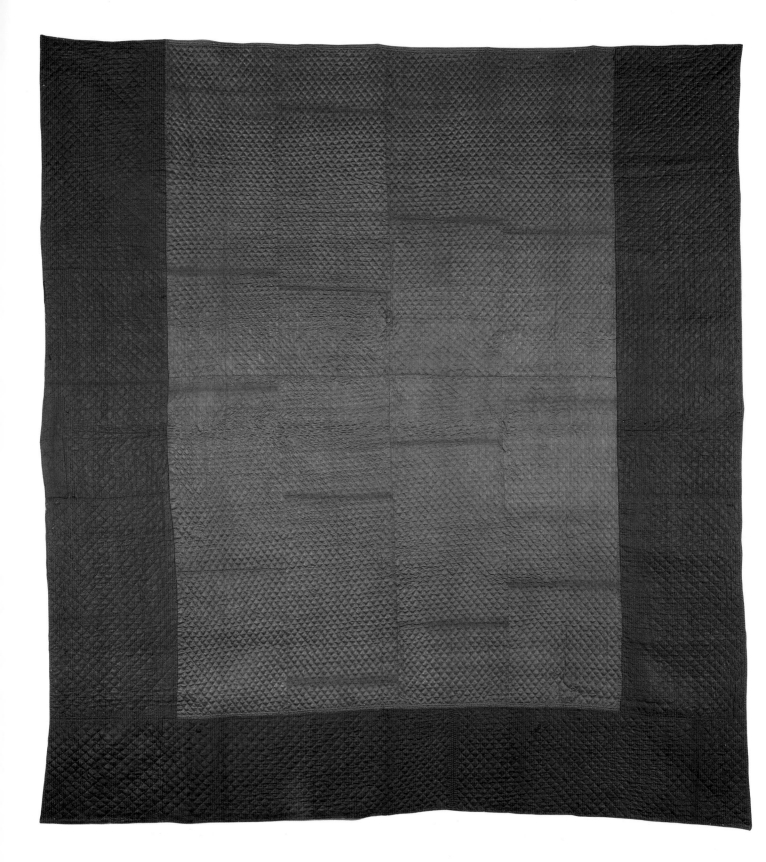

2. CALIMANCO QUILT WITH BORDER

Quiltmaker unidentified; United States; 1810–1820; wool;
96" x 91". Gift of Cyril Irwin Nelson in devoted memory of his grandmother,
Elinor Irwin (Chase) Holden; 1993.6.5

resinous substance to the surface. In the eighteenth century this type of fabric was more common for clothing, especially quilted petticoats, and sometimes the fabric used for the bedcovers was salvaged from worn petticoats. Although these quilts were also made in England, all the Museum's wool, whole-cloth quilts entered the collection with a Northeastern United States provenance.

Typically, wool whole-cloth quilts were made in a solid color, such as the rich blue used for the "Indigo Calimanco Quilt" (fig. 1). As was also common for this style of bedcover, the quilt has been made in a central medallion format, with a feathered diamond design used for the center motif. This is surrounded by a rich panoply of fruit and floral designs that may be derived from Jacobean crewel embroidery. Such elaborate quilting may indicate that this bedcover was sewn by a professional. It was certainly a valuable possession that would have been owned by a family of means.

In contrast to the solid-color "Indigo Calimanco Quilt" (fig. 1), the "Calimanco Quilt with Border" (fig. 2) is not distinguished by intricate quilting patterns (an overall grid design has been used), but by the two shades of blue wool that the maker selected. A rich bright fabric forms the center section while a deeper indigo has been used as a border on three sides. The unbordered side indicates the top and would presumably have been covered by pillows.

Both the "Center Star Quilt" (fig. 3) and the "Harlequin Medallion Quilt" (fig. 4) are also made of calimanco, although the fabrics used for the "Harlequin Medallion" have retained more of their original glazing. Both of these quilts also have been pieced with contrasting fabrics. They are considered part of the whole-cloth tradition, however, because of their large size, early date, and the fact that they have been made of sizable pieces of wool in a center-medallion format. These factors all indicate a closer affinity to eighteenth- and early-nineteenth-century whole-cloth quilts than to the pieced-block tradition that developed later in the nineteenth century (see Chapter 5).

The "Center Star Quilt" (fig. 3) also exhibits elaborate quilting motifs that are typical of late-eighteenth and early-nineteenth-century calimanco (as well as silk) quilts. The quilting design is essentially a center-medallion format, with a large pomegranate placed in the center and in the four corners of the central square. A meandering feather vine, a favorite Federal period motif, surrounds the center. As on the "Indigo Calimanco Quilt" (fig. 1), these fruit and floral motifs are similar to Jacobean crewel embroidery designs and may have been adapted from the crewel-work bed hangings that were popular in eighteenth-century America.

The "Harlequin Medallion Quilt" (fig. 4) has been similarly made in the center-medallion format that was most favored for American quilts before about 1840. The large center section, however, can be viewed as sixteen "four-patch" blocks, an arrangement that fore-

shadows the development of later pieced quilts that were composed of equal-sized blocks. The bright pieces of calimanco—hot pink, red, yellow, green, light blue, and black—that were chosen for this quilt may appear modern but were also popular during the period.[3]

CHINTZ AND COPPERPLATE-PRINTED WHOLE-CLOTH QUILTS

Cotton and linen whole-cloth quilts from the late eighteenth and early nineteenth centuries are among the rarest American bedcovers. The Museum's "Chintz Whole-Cloth Quilt" (fig. 5) is a particularly well-preserved example that was made of high-quality block-printed English fabric, probably between 1810 and 1820. The "Whole-Cloth Quilt with Pieced Border" (fig. 6), probably made during the same time period, combines a center field of a single fabric with a border composed of a variety of early block- and copperplate-printed fabrics. A much later quilt in the Museum's collection (Catalogue #11) is believed to have been made after 1850 out of comparatively inexpensive roller-printed fabrics that were produced about 1830 (front) and 1840 (back).

Although quilts made of pieced and cut-out chintz are more numerous and therefore better known (see Chapter 2), chintz whole-cloth quilts provide a wonderful opportunity for textile historians to study large lengths of fabric. The term "chintz" is derived from the Hindu language *chitta*, meaning "spotted cloth,"[4] and the first examples of this cloth were brought to England from India by sixteenth-century traders. Over the years, the word has come to refer to a "large-scale print, suitable for furnishings like drapery and upholstery, with a glaze (which is liable to wash out with use)."[5]

Chintzes brought from India often were finished in that country as bedcovers known as palampores, which sometimes were stuffed with cotton and quilted. Both the whole-cloth and the cut-out chintz bedcovers made of English (and later American) printed fabrics are often seen as continuations of the palampore tradition. This is particularly true for quilts that maintain the Indian motifs, such as the "Tree of Life" and other floral patterns.

The "Chintz Whole-Cloth Quilt" (fig. 5) was made of a block-printed floral pattern in the colors and designs that were popular at the beginning of the nineteenth century.[6] Two shades of red, brown, black, green and penciled blue (indigo) have been set against a bright yellow background. According to textile historian Florence Montgomery, "About 1810 . . . arborescent patterns in short repeats were printed on brilliant yellow grounds, and blue and green grounds also appeared. Thus the present-day custom of offering a print in several different color combinations was begun."[7] This bedcover was quilted in a simple diamond grid. Neither the style of quilting nor the fabric reveal any clues as to the origins of the quilt; it could

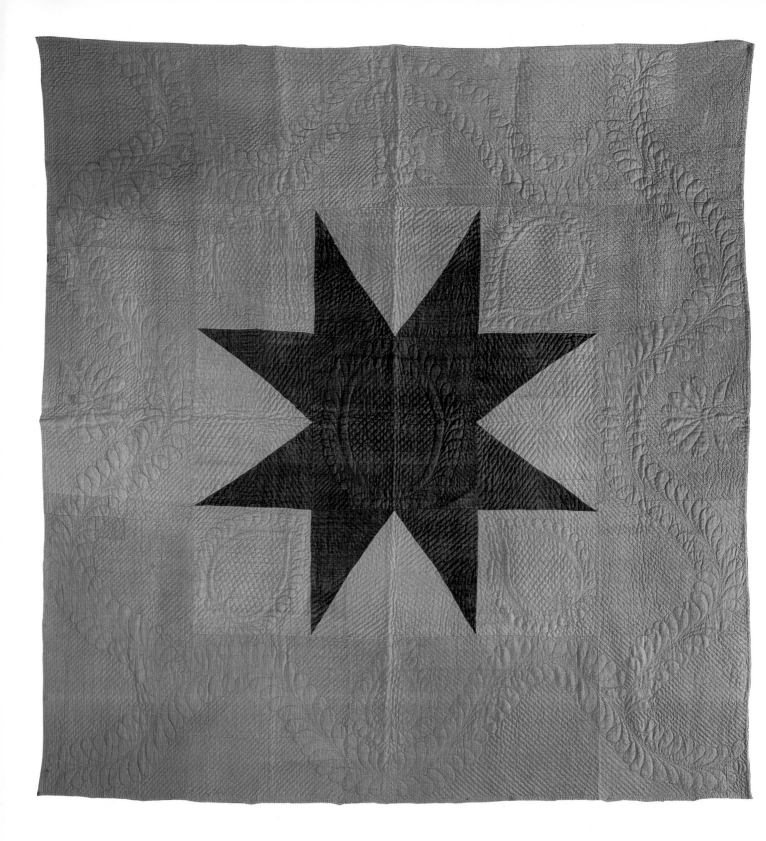

3. CENTER STAR QUILT
*Quiltmaker unidentified; New England; 1815–1825; wool; 100¹/₂"
x 98". Gift of Cyril Irwin Nelson in honor of Robert Bishop,
Director of the Museum of American Folk Art; 1986.13.1*

4. HARLEQUIN MEDALLION QUILT
*Quiltmaker unidentified; New England; 1800–1820; wool; 87" x
96". Gift of Cyril Irwin Nelson in loving memory of his grand-
parents, John Williams and Sophie Anna Macy; 1984.33.1*

have been made in either the United States or England.

The Museum's "Copperplate-Printed Whole-Cloth Quilt" (fig. 7), another rare bedcover, could also have been made in either the United States or England. The blue-and-white linen-and-cotton fabric that was used for the top of the quilt (the back is a cream-colored wool) may have been made by the English firm, Bromley Hall, between 1775 and 1785. A black-on-white version of the exotic floral pattern, identified as "Bamboo Trails" by Florence Montgomery, was used for a set of bed hangings that came from East Hartford, Connecticut, and is now in the collection of the Winterthur Museum.[8]

STENCILED SPREADS

Although they are also quite rare, the Museum's collection includes two stenciled bedcovers from the first half of the nineteenth century: the "Pots of Flowers Stenciled Spread" (fig. 8) and the "Block-Work Stenciled Spread" (black-and-white fig. 1). Like the majority of this type of bedcover, these spreads were neither backed nor quilted and are composed of a single layer of cotton decorated with paint. Also like most of the approximately thirty known stenciled bed coverings, the Museum's examples are believed to have been made in the Northeastern United States.

Stencil decoration on fabric is closely related to

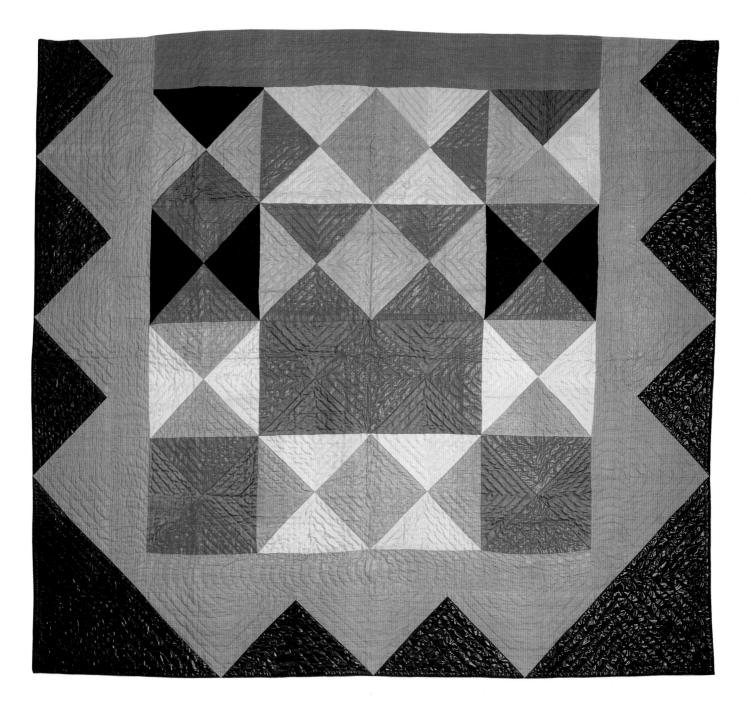

5. CHINTZ WHOLE-CLOTH QUILT

Quiltmaker unidentified; United States; 1810–1820; cotton; 91¼" x 87". Gift of a Museum friend in honor of Joel and Kate Kopp; 1993.6.7

the early-nineteenth-century vogue for paint-decorated walls and furniture, as well as the "theorems," or stenciled still-life and landscape paintings executed by young ladies on velvet, silk, or paper.

To produce a stenciled spread, the patterns were first cut from oiled paper, stiffened fabric, or tin with a different stencil needed for each color. The makers may have made their own stencils—*Hints to Young*

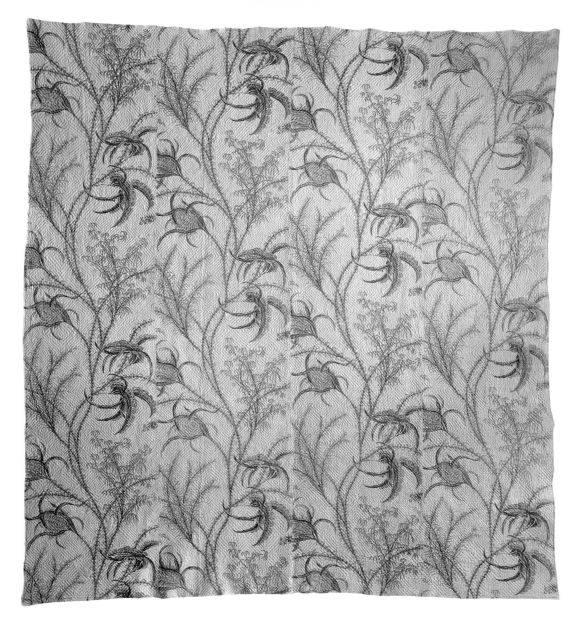

6. WHOLE-CLOTH QUILT WITH PIECED BORDER

Quiltmaker unidentified; probably New England; 1810–1820; cotton; 88" x 76". Promised gift of a Museum friend; P1.1995.1

7. COPPERPLATE-PRINTED WHOLE-CLOTH QUILT

Quiltmaker unidentified; New England or England; 1800–1815; linen and cotton; 96" x 93". Gift of a Museum friend in honor of Laura Fisher; 1995.13.3

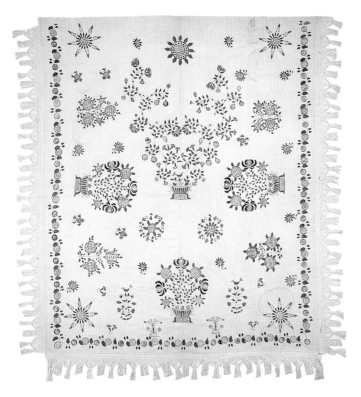

**8. POTS OF FLOWERS
STENCILED SPREAD**

*Maker unidentified; New England; 1825–1835; cotton and paint
with cotton fringe; 92" x 85" framed. Gift of George E.
Schoellkopf; 1978.12.1*

Practitioners in the Study of Landscape Painting by J.
William Alston, the earliest book on theorem painting,
was published in Edinburgh in 1804 and reprinted in
London in 1820—but by the mid-1830s it was possible
to buy professionally designed and cut stencils. The col-
ors were produced by mixing concentrated vegetable
dyes with gum arabic, corn starch or cream of tartar, or
commercially prepared ground pigments could be sus-
pended in an oil medium and mixed with "stencil mor-
dant" for a dye that was more durable. The foundation
fabric was placed over a padded work table and pulled
taut. Finally, the coloring was applied with a brush or
cloth-wrapped balls of cotton. Because the dyes were
not boiled into the fabric and were therefore not color-
fast, the spreads were generally not laundered.

The Museum's two stenciled spreads exemplify the
two formats that were used for this type of bedcover:
center-medallion and block. The "Pots of Flowers"
spread (fig. 8), made in the center-medallion format
that was popular in the eighteenth and early nineteenth
centuries, is probably the earlier example. It was also
made in a much more intricate design, with a great
number of stencils needed for the many different floral,
star, and bird motifs. The equal-size block design and
the comparatively simple motifs of the "Block-Work

Stenciled Spread" (black-and-white fig. 1) indicate a
date later in the nineteenth century, probably closer to
the 1840s, when block-style quilts became popular.

WHITEWORK BEDCOVERS

There are three major types of whitework (sometimes
referred to as "muslin work"[9]) bedcovers: embroidered;
quilted and stuffed (sometimes incorrectly called "Mar-
seilles quilting"[10]); and those decorated by an embroi-
dery technique known as candlewicking. The
Museum's collection does not include any plain embroi-
dered whitework bedcovers, although it does feature a
number of examples that have been either quilted and
stuffed or decorated with candlewick embroidery.

Many of these whitework bedcovers were made at
the end of the eighteenth century and the first half of the
nineteenth century. The vogue for all-white textiles has
been related to the popularity of Neoclassicism in both
furnishing and clothing styles, as well as to the increased
availability of both cotton fabric and the cotton thread
necessary for the complex quilting and embroidery that
is generally a hallmark of whitework bedcovers.[11]

Two of the quilted and stuffed whitework bedcov-
ers in the Museum's collection, the "Tree of Life
Whitework Quilt" (fig. 9) and the "Basket of Flowers
Whitework Quilt" (fig. 10) reveal the elaborate stuffing
and cording that are characteristic of the best examples
of this style. As was also seen on the wool, whole-cloth
quilts, the designs on these whitework bedcovers are
usually based on a central medallion format and
include motifs, such as the "Tree of Life" and other fruit
and floral designs, that may be derived from Indian
palampores and/or Jacobean embroidery. In addition,
the "Tree of Life Whitework Quilt" (fig. 9) includes the
date, 1796, written in cording at the bottom center of
the quilt. This early date makes it the only positively
dated eighteenth-century bedcover in the collection.

Stuffing and cording (a technique that is sometimes
called "trapunto" work in reference to a possible Italian
origin for the tradition) adds an extra dimension to a
quilt, but also adds extra time to the quiltmaker's task.
In order to create the elaborate motifs seen here, the
seamstress could add the extra padding either before or
after her regular quilting. Quilt historian Barbara
Brackman has described the laborious process:

> . . . the seamstress bastes a piece of coarsely woven
> cotton, linen or combination fabric directly to the
> back of her top. She quilts these two layers together
> in a technique called flat quilting that allows her to
> take minute stitches. Floral motifs, leaves and other
> enclosed shapes are contained on all sides by quilt-
> ing; she then pads them by working small bits of
> cotton through the coarse backing fabric. To cord the
> linear elements she threads a large needle with cot-
> ton yarn or cord and runs it through the tunnel cre-
> ated by quilting either side of the line.[12]

Finally, the two quilts shown here were surrounded by a white cotton fringe, a common finishing touch for whitework bedcovers.

Embroidered candlewick bedcovers in the Museum's collection include the five shown here—the "Sarah Stoddard Candlewick Spread" (fig. 11), the "Maria Clark Candlewick Spread" (fig. 12), the "Susan

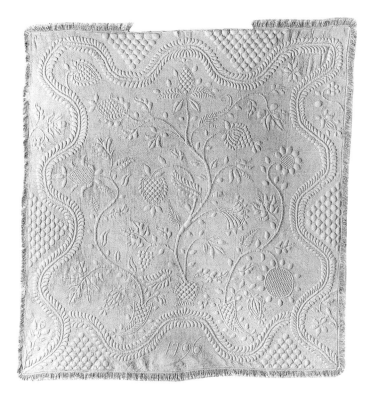

9. TREE OF LIFE WHITEWORK QUILT

Quiltmaker unidentified; United States; dated 1796; cotton with cotton fringe; 92$\frac{1}{4}$" x 87$\frac{3}{4}$". Promised gift of a Museum friend; P1.1995.7

10. BASKET OF FLOWERS WHITEWORK QUILT

Quiltmaker unidentified; possibly Pennsylvania; 1810–1820; cotton with cotton fringe; 97$\frac{1}{2}$" x 90". Promised gift of a Museum friend; P1.1992.2

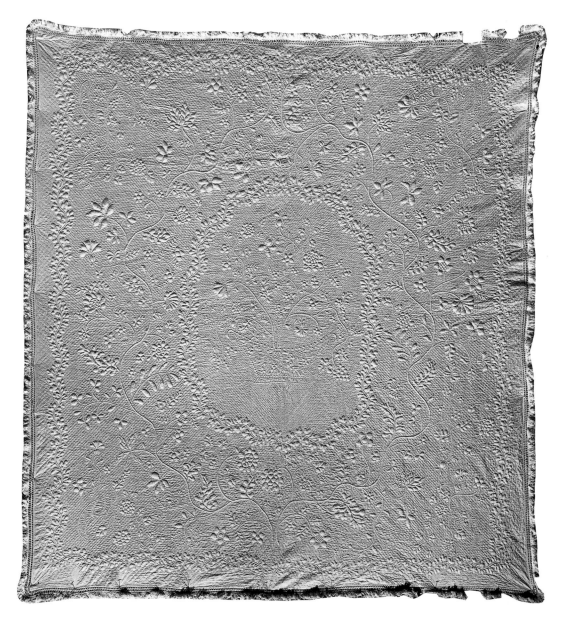

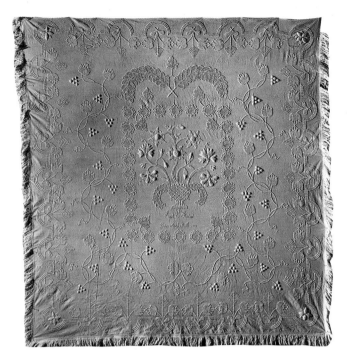

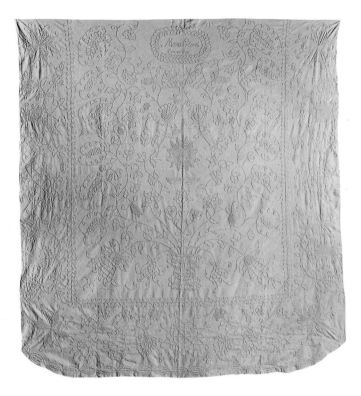

11. SARAH STODDARD CANDLEWICK SPREAD

Sarah Elmira Stoddard (1813–1887); Groton, Connecticut; dated April 5, 1832; cotton with clipped cotton roving and cotton fringe; 96³/₄" x 92" without fringe. Gift of a Museum friend; 1985.36.2

12. MARIA CLARK CANDLEWICK SPREAD

Maria Clark; Coventry, Connecticut; 1825–1840; cotton with cotton roving; 102" x 94". Promised gift of a Museum friend; P1.1995.2

Tibbets Candlewick Spread" (fig. 13), the "Flowering Vines Candlewick Spread" (fig. 14), the "Eagle Candlewick Spread" (fig. 15)—as well as the "Candlewick Spread with Eagles" (black-and-white fig. 2), the "Double Wedding Ring Candlewick Spread" (black-and-white fig. 3), and the "Concentric Circles Candlewick Spread" (Catalogue #22).

The term "candlewicking" refers to embroidery with thick cotton embroidery threads that were pulled through a white cotton or linen backing to form a three-dimensional looped or fringed pile design. These threads are sometimes called roving or wicking, for the name derives from the loosely twisted yarn used as the wick in eighteenth-century candlemaking. The candlewick bedcovers easiest to identify are those that have been "tufted," meaning that the stitches are raised on the surface by passing the loop over a small twig. When the twig is removed, the wicking is cut where the twig was, leaving strands in the air. After the spread is washed and the material shrinks, the strands tighten and fluff to form a puff. Other popular embroidery stitches that were used for candlewicking include knotting and couching, as well as the stem stitch, backstitch,

satin stitch and outline stitch. Sometimes a number of different weights of roving would be employed for embroidery on the same spread.[13]

Hand-embroidered candlewick spreads are sometimes confused with woven examples. The woven bedcovers were made on large looms, and they were often made without seams. The raised loops or bumps in the design are the result of the weaving technique, not embroidery, and woven candlewick spreads are generally considered closer to the woven coverlet tradition than to the handmade quilt tradition.

Three of the candlewick spreads in the Museum's collection were signed by the makers, and two have also been dated. Sarah Stoddard signed and dated her spread (fig. 11): "Sarah E. Stoddard, Groton, AD April 5th, 1832." When this bedcover entered the Museum's collection, it was not known if "Groton" referred to the town in Massachusetts or the one in Connecticut. Subsequent genealogical research, however, proved that it was indeed made in Connecticut by Sarah Elmira (also recorded as "Elmina") Stoddard, seven months before her wedding to Franklin Brewster of Ledyard, Connecticut. Brewster was a carpenter, deacon of the

**13. SUSAN TIBBETS
CANDLEWICK SPREAD**

*Susan Tibbets; possibly Connecticut; dated
1847; cotton with clipped cotton roving;
100½" x 91". Gift of a Museum friend;
1991.18.1*

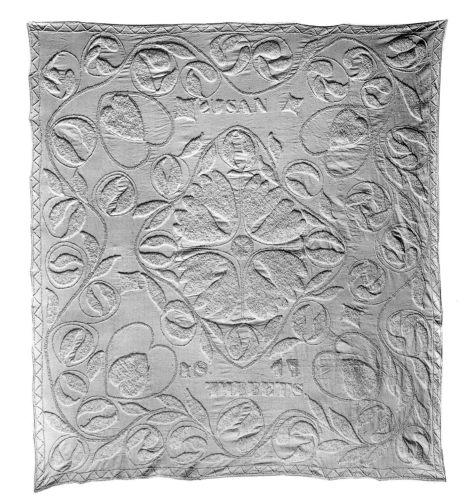

church, and a representative in the state assembly. The couple had two children and Sarah Stoddard Brewster died in Ledyard in 1887 at the age of 73.[14]

Maria Clark included both her name and town, Coventry, in a cartouche located at the top center of her candlewick spread (fig. 12). Although she did not include the date, the bedcover is similar (especially as regards its rounded shape and the place of the signature) to a whitework spread in the collection of The Metropolitan Museum of Art that is signed and dated: "Prudence Clark, 1817."[15] Unfortunately, the Metropolitan Museum has no information regarding where Prudence Clark was living when she stitched her bedcover. Further genealogical research is needed to determine whether the two Clarks were related and if they were living in the same town (presumably Coventry, Connecticut) at the same time, or if one seamstress is descended from the other.

Susan Tibbets signed and dated her candlewick spread (fig. 13) in 1847, and although she did not include her town, the bedcover probably was made in New England, possibly Connecticut. This much later example of the candlewicking tradition also was made in a center medallion format, but the motifs used here are much larger and less delicate than on the earlier spreads. The major design component is an oversized

trailing vine that features large leaves that have been tufted and that give the spread an overall "sheared" appearance. A heart-within-a-heart in each corner has led to speculation that this bedcover was probably made, as Sarah Stoddard's is believed to have been, in anticipation of a wedding.

Two of the oldest candlewick spreads in the collection exhibit the design motifs that were popular in early-nineteenth-century decoration. The "Flowering Vines Candlewick Spread" (fig. 14), probably made in New England between 1810 and 1820, features the trailing vines, urns, and garlands of flowers that were popular during the Classical Revival. In contrast, the "Eagle Candlewick Spread" (fig. 15), while still including a trailing vine of grapes, uses that vine to enclose a single central motif—an eagle and stars—that was probably adapted from the shield of the United States and was a favorite Federal period motif.

Two other candlewick bedcovers in the Museum's collection, "Candlewick Spread with Eagles" (black-and-white fig. 2) dated 1871, and "Double Wedding Ring Candlewick Spread" (black-and-white fig. 3) dated 1897, are evidence of the enduring popularity of this type of work. Both also share motifs with quilt designs. The "Candlewick Spread with Eagles," which combines decorative cut work with candlewick

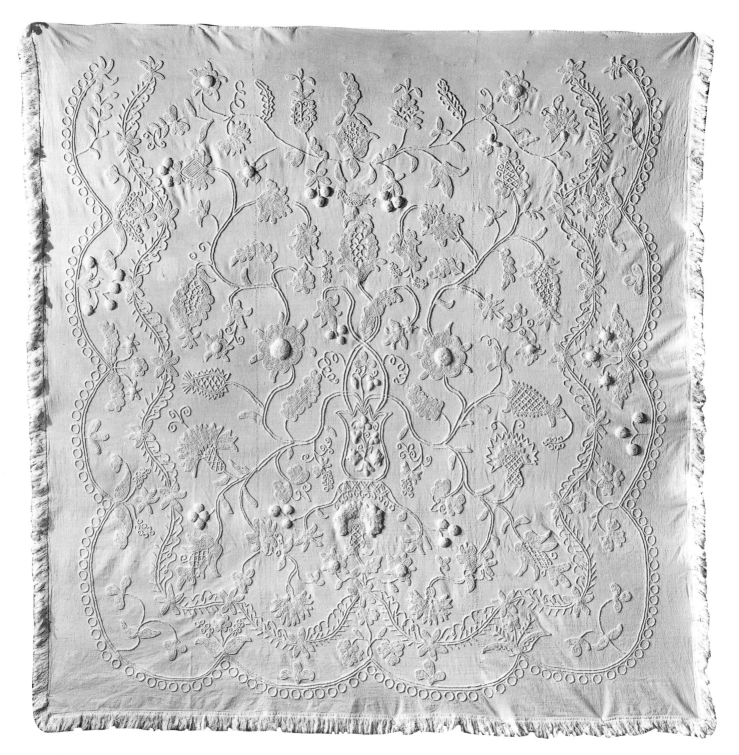

14. FLOWERING VINES CANDLEWICK SPREAD

Maker unidentified; New England; 1810–1820; cotton with clipped cotton roving
and cotton fringe; 96" x 95" including fringe. Gift of a Museum friend in honor
of Cora Ginsburg; 1993.6.8

embroidery, resembles the four-eagle quilts that were most common in Pennsylvania, probably beginning at the time of the 1876 Centennial Exposition. The "Double Wedding Ring Candlewick Spread" has been related to the quilt pattern of that name,[16] although the interlocking rings design also resembles some earlier pieced and appliquéd quilts (see Chapter 8).

15. EAGLE CANDLEWICK SPREAD

Maker unidentified; United States; 1810–1820; cotton with cotton fringe; 96" x 78".

Gift of a Museum friend; 1995.13.2

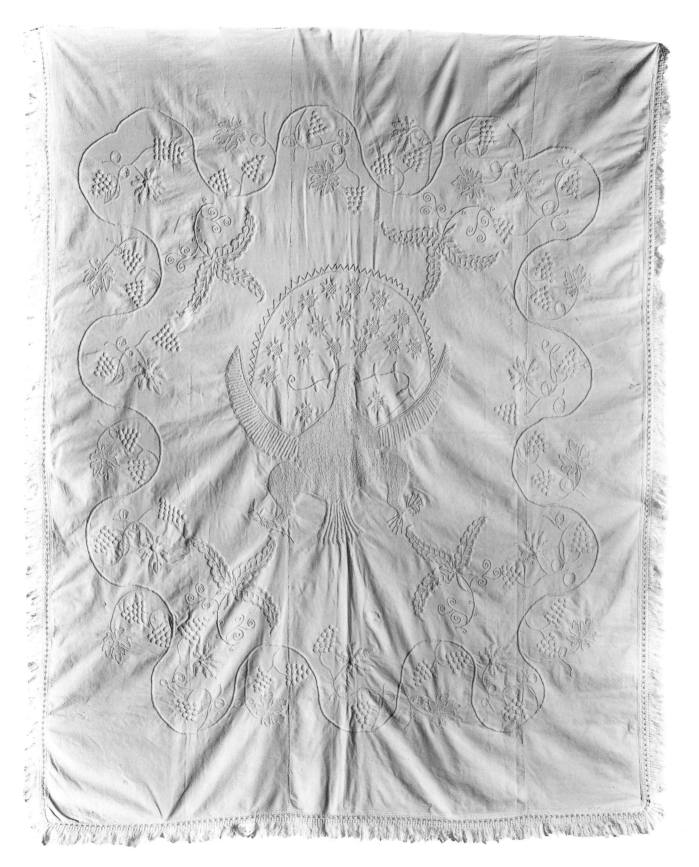

CHINTZ QUILTS

There are two major chintz quilt styles: appliquéd cut-out chintz quilts and pieced scrap quilts. (Whole-cloth chintz quilts are considered part of the "whole-cloth tradition" and are discussed in Chapter 1.) Both styles were popular in America from the late eighteenth century to the middle of the nineteenth century and are considered among the earliest varieties of patchwork quilts. The Museum's collection includes both types of quilts, as well as examples that combine the two techniques.

CUT-OUT CHINTZ QUILTS

Appliquéd quilts made of cut-out elements (such as birds, flowers, and trees) of printed chintz that have been sewn down on a plain, usually white, background, have long been considered among the most elegant American bedcovers. In the late nineteenth century, this type of needlework was given the French name "Broderie Perse," meaning "Persian Embroidery." Today, however, many quilt historians believe that since "Broderie Perse" was not a term in use when the quilts were made, it is more appropriate to refer to them as "cut-out chintz" or "appliquéd chintz" quilts.

Three cut-out chintz quilts in the Museum's collection, the "Martha Micou Cut-Out Chintz Quilt" (black-and-white fig. 4), the "Cut-Out Chintz Quilt with Sawtooth Border" (fig. 16), and the "Cut-Out Chintz Quilt with Chintz Border" (fig. 17), were constructed in the center-medallion format that was most favored for American quilts made prior to 1840. As discussed in Chapter 1, chintz quilts often recalled—if not actually imitated—the Indian palampores that first were brought to England in the sixteenth century and were then later carried to America.

Cut-out chintz quilts represented a great expenditure of both time and money, and therefore usually are presumed to have been made by quiltmakers of some means. Although the chintz fabric could be salvaged from previous use or purchased specifically for the quilt, the large lengths of background fabric that were needed implied a significant investment, and quiltmakers often reserved their most intricate, delicate stitches for this type of work. It is believed that most were reserved for "best" and were not subjected to the harsh treatment of daily use or the wash tub.

Martha Chatfield Micou's quilt (black-and-white fig. 4), however, has been subject to the ravages of time—the chintz fabrics have discolored due to the migration of the original dyes and the white background exhibits significant staining. The quilt is impor-

16. CUT-OUT CHINTZ QUILT WITH SAWTOOTH BORDER

Quiltmaker unidentified; Pennsylvania; 1835–1850; cotton; 100" x 104". Gift of a Museum friend in honor of Cora Ginsburg; 1992.28.1

17. CUT-OUT CHINTZ QUILT WITH CHINTZ BORDER

Quiltmaker unidentified; possibly New England; 1835–1850; cotton; 100" x 91". Promised gift of a Museum friend in honor of Judith and James Milne; P1.1995.5

tant to the Museum's collection, however, because of its family history and because of the fabrics employed in its construction.

According to family tradition, Martha Micou made the quilt for the impending marriage of her daughter, Kitty, in 1835. Thereafter, the quilt descended in the family as a gift to the first daughter upon her marriage. It was last acquired by Mary Catherine Wing Carter in 1943, and Mrs. Carter gave the quilt to the Museum. The family believed that Martha Micou lived in South Carolina when the quilt was made, but genealogical research has revealed no Micous in that state at the appropriate time. Micou was, however, a well-known

name in Virginia, and the bedcover has been noted to bear a stylistic resemblance to other cut-out chintz quilts made in that state.[1] As many other well-documented quilts in this style indicate, however, it was a tradition that was especially popular in the Southern states.

The most interesting cut-out chintz motifs on this quilt are the eagles on tree trunks that decorate three sides of the bedcover (the fourth side was presumably the top of the quilt, meant to be covered by pillows). These eagles were taken from a fabric that was roller printed in England between 1830 and 1840. At least four different colorways of this design, which must have been very popular in the American market, are known.[2]

As was often expected for "best" quilts, the quilting on this bedcover is particularly precise. Tiny stitch-

es in a variety of patterns, including clamshells, diamonds, and swirls, cover the entire quilt and are indicative of the amount of work that was lavished on this once-elegant textile.

In the first half of the nineteenth century, particularly between 1820 and 1840, a number of fabrics were printed specifically for use in quilts. Bold central motifs, borders, and smaller designs would be combined in a single fabric that then could be cut out and appliquéd onto a quilt top of the maker's own planning. The "Cut-Out Chintz Quilt with Sawtooth

18. CENTER MEDALLION AND FLYING GEESE QUILT

Quiltmaker unidentified; New England; 1825–1835; cotton; 80" x 80". Gift of a Museum friend in honor of Thos. K. Woodard and Blanche Greenstein; 1995.13.5

Border" (fig. 16) may have been made using this type of fabric, as it employs a central motif, circular design, and a variety of small branches and bouquets that appear to have been cut from a single roller-printed chintz that probably was manufactured in the 1830s. The only mismatched chintz appliqué on this quilt is the single bird perched in the central flowering tree. This motif is cut from a fabric that dates between 1850 and 1870 and was probably a later addition to the quilt, possibly a repair.[3] The appliquéd sawtooth border is original to the quilt and, according to quilt historian Barbara Brackman, is "a distinctive early border technique, rarely seen after 1850."[4]

The chintz fabric used for the "Cut-Out Chintz Quilt with Sawtooth Border" (fig. 16) must have been a popular design as the unidentified maker of the "Cut-Out Chintz Quilt with Chintz Border" (fig. 17) employed the same pattern for the central wreath of her bedcover. This does not indicate, however, that the quilts were made at the same time or place as favorite fabrics were often reprinted and available over a period of many years.

19. VARIABLE STARS QUILT

Quiltmaker unidentified; New England; 1825–1840; cotton with linen backing; 95" x 87". Museum of American Folk Art purchase made possible by a grant from the George and Frances Armour Foundation; 1985.33.1

20. CARPENTER'S WHEEL QUILT

Quiltmaker unidentified; Pennsylvania; 1835–1845; cotton; 102¼" x 101¼". Gift of a Museum friend; 1992.28.2

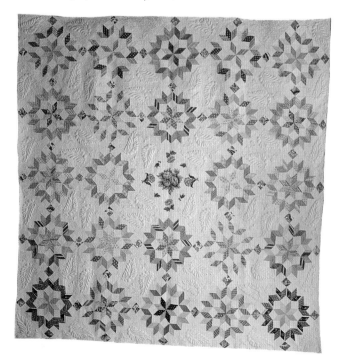

PIECED CHINTZ QUILTS

Three of the pieced chintz quilts in the Museum's collection, the "Center Medallion and Flying Geese Quilt" (fig. 18), the "Variable Stars Quilt" (fig. 19), and the "Carpenter's Wheel Quilt" (fig. 20), combine appliquéd cut-out centers with pieced patterns. The combination of two traditions in this manner is often indicative of a transition in quiltmaking styles and in this case is a clue that the quilts were probably made in the second quarter of the nineteenth century.

While the "Center Medallion and Flying Geese Quilt" (fig. 18) does have an outer border made of chintz, the appliqués in the center of the quilt have been cut from a copperplate-printed fabric of a type that is often referred to as "toile" or "Toiles de Jouy." These terms originally applied to fabric printed in the French town of Jouy, a place renowned for its printworks, although the technique was invented by an Irishman in the mid-eighteenth century and used in England, Switzerland, Holland, and, eventually, America as well. Copperplate-printed fabrics are usually characterized by the great detail that was made possible by the process and by the monochromatic

21. LADY OF THE LAKE QUILT

Quiltmaker unidentified, initialed E.M.; United States; dated
1837; cotton; 92¼" x 91". Gift of a Museum friend in honor of
Joel and Kate Kopp; 1991.18.3

color schemes that such detail required for accurate registration. The blue-and-white design seen here was a typical combination.

A study of Maryland quilts found that "By the 1820s, Maryland quiltmakers combined appliquéd motifs with larger areas of piecing, frequently in the form of large or small eight-pointed stars."[5] This statement may no doubt be applied to quilts made in other parts of the Eastern seaboard as well, and clearly describes the Museum's "Variable Stars Quilt" (fig. 19).

This quilt combines a variety of chintz fabrics, both roller and block prints, that probably were saved by the maker over a period of years. The cut-out chintz center motif was appliquéd using the buttonhole stitch, which, along with the appliqué stitch, was the most common method for this type of needlework.[6] The striking dark floral fabric that has been used throughout, including for the center star, inner border, and sawtooth border, may have been printed as a stripe that was intended be cut out and re-used either for quiltmaking or some other home-furnishing project. According to Florence Montgomery, dark-ground prints such as this became popular beginning about 1790[7] and were sometimes printed in stripes that could be cut into strips for use as borders.[8] As was mentioned above in the discussion of the "Cut-Out Chintz Quilt with Sawtooth Border" (fig. 16), the type of appliquéd border used here is often indicative of a date prior to 1850.

The cut-out chintz center motifs of the "Carpenter's Wheel Quilt" (fig. 20) also were secured with the buttonhole stitch, although on this quilt the delicate flowers and leaves were also padded employing a technique known as "raised appliqué." While a variety of cotton fabrics was used to piece the "carpenter's wheels," most of the diamonds that separate the wheels appear to have been cut from the same blue-and-rose chintz that was used for the central design. The unidentified maker of this bedcover was evidently an accomplished seamstress as she further embellished the white blocks of the quilt with stuffed and corded leaf motifs.

The leaf motif is also seen in the white triangles of the "Lady of the Lake Quilt" (fig. 21), although in this example the leaves were simply quilted, not stuffed or corded. The workmanship on this quilt is equally proficient, however, as the quilting stitches measure sixteen to the inch. The maker of the quilt has not been identified, but the initials "E.M." and the date 1837 have been quilted into the lower right-hand corner. The initial "A" was embroidered on the back of the quilt.

A number of cotton fabrics, including chintzes, have been used to piece this quilt. The large-scale chintz used for the border is an example of one of the numerous versions of the "Pheasant and Tree" pattern that was popular in block-printed fabrics beginning about 1812 and that continued as a roller print for many years thereafter.[9]

In one of the first histories of American quilts, Hall and Kretsinger's *The Romance of the Patchwork Quilt in America*, the authors noted that the "Lady of the Lake" design "is one of the few patterns which has never been known by any other name."[10] While quilt historians today may question Hall and Kretsinger's statement that the pattern developed in 1810 in Vermont, it is widely believed that designs that utilize small pieces of fabric are typical of the first half of the nineteenth century.[11] The maker of the Museum's quilt added her twist to the popular pattern, however, by turning the top row of blocks in the opposite direction from the rest of the quilt. Perhaps this was an easy way for her to distinguish the top of the almost square bedcover.

The "Chintz Bars and Pinwheels Quilt" (black-and-white fig. 5) is another example of an early nineteenth-century pattern that combines small scraps of fabric with large strips of furnishing chintz. In this case, the bars are made of a floral stripe, a style of printed fabric that was popular through much of the first half of the nineteenth century.

All of the quilts discussed in this section have been constructed using the traditional "running stitch" method of piecing, which is sometimes also called the "American" method. This is the most common means of piecing a quilt in the United States. The technique is straightforward: "two pieces of fabric are placed face to face and a seam is stitched about 1/4 inch from the edges on the back sides. The joined pieces are then pressed open, with the seams usually pressed to one side or the other."[12]

Two of the Museum's chintz quilts, however, the "Honeycomb Quilt Top" (fig. 22) and the "Sunburst Quilt" (fig. 23) were pieced using what is known as the "whipstitch," "paper template," or "English patchwork" technique (as well as a variety of combinations of these words). In this more time-consuming method, "The seamstress cuts paper templates to line each piece in the quilts and bastes the fabric patches over the templates. She whipstitches or overstitches the pieces together by hand and removes the papers."[13] This method was most often used for quilts made in all-over mosaic-type patterns, such as the Museum's two examples, rather than for those constructed in blocks.

In January 1835, *Godey's Lady's Book* published instructions for one of the most popular patterns to employ the template method, what was called "hexagon," "six-sided," or "honeycomb patch-work." This type of piecing was commonly known by these terms in the nineteenth century, although it is more often referred to in the twentieth century by the name "Grandmother's Flower Garden."

The Museum's "Honeycomb Quilt Top" (fig. 22) is constructed in a center-medallion set, indicating that it was most likely made in the first half of the nineteenth century. The fabrics, which remain remarkably bright, include both block- and roller-printed cottons (including a number of glazed chintzes) with some dating

22. HONEYCOMB QUILT TOP

Quiltmaker unidentified; United States or England; 1835–1845; cotton; 98³/₄" x 75". Gift of Mr. and Mrs. Edwin C. Braman; 1978.27.1

from the late-eighteenth century and none later than 1835.[14] Both French and English fabrics have been used to make this quilt top, and its provenance is difficult to determine. As the term implies, "English-style template piecing" originated in England in the early eighteenth century, and although English quilts also were made using the running-stitch method, template patchwork continued in popularity there (as well as in former British colonies) long after it went out of style in the United States. Some of the papers that were used to make the templates remained in place in this quilt top but, unfortunately, none was dated nor gave any clue to the quilt's origins. It cannot be determined, therefore, whether the quilt top was made in the United States or England.

Diamond patchwork, employed for the Museum's "Sunburst Quilt" (fig. 23), was also commonly execut-

ed using the English template method. Although the pattern certainly could be done more quickly by the running stitch method, template piecing produces a flatter and often more precise result. Approximately 2,900 diamonds made of roller-printed cottons (including some glazed chintz) were joined to form this large, magnificent, and historically important quilt.

To date, six quilts are known to be associated with Rebecca Scattergood Savery, a member of a well-known Quaker family who lived in and near Philadelphia from 1770 to 1855. Two of the quilts, the "Sunburst Quilt" (fig. 23) and the "Savery Friendship Star Quilt" (fig. 24), are in the Museum's collection and these, as well as the other four quilts, have been fully documented by Museum researcher Mimi Sherman.[15]

The Museum's "Sunburst" is remarkably similar to both a "Sunburst" quilt in the collection of the Philadel-

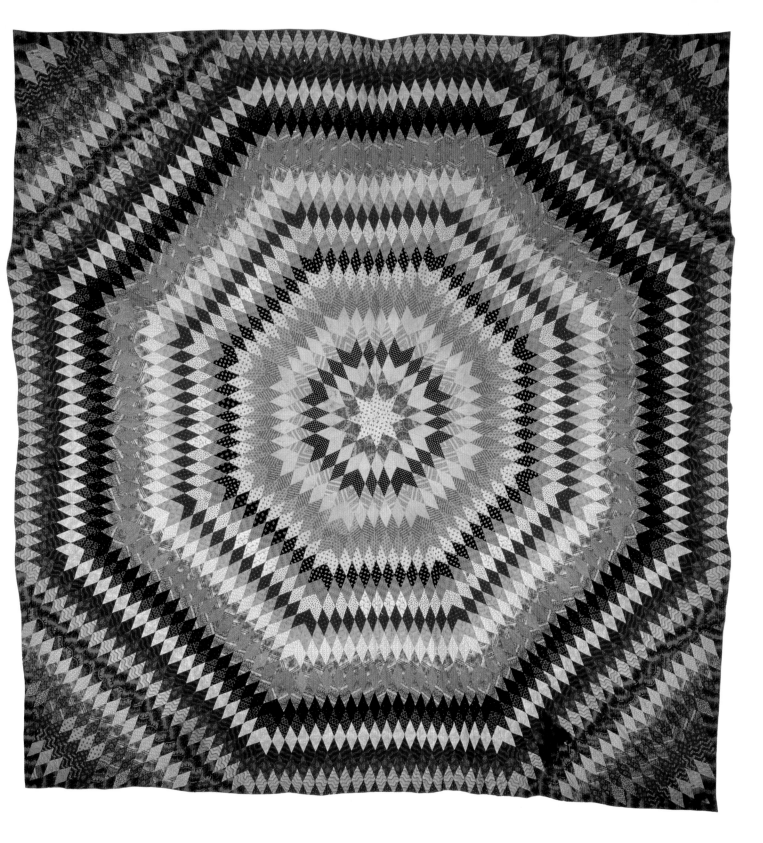

23. SUNBURST QUILT

Probably Rebecca Scattergood Savery (1770–1855); Philadelphia,
Pennsylvania; 1835–1845; cotton; 118¹/₂" x 125¹/₈". Gift of Marie
D. and Charles A.T. O'Neill; 1979.26.2

phia Museum of Art as well as a "Sunburst" that is still owned by a descendant of Rebecca Scattergood Savery. The Philadelphia Museum's quilt was donated by descendants of Rebecca Scattergood Savery and was accompanied by a message on a piece of white cotton that was sewn onto the back of the quilt. The note was written around 1890 or 1900 by Hannah Savery Mellor and reads: "This quilt was made for Mother by my Great-grandmother, Rebecca Scattergood Savery." The quilt that is still owned by the family is also accompanied by two handwritten tags, one on cotton that reads: "Patch't by my Great Grandmother, Rebecca Scattergood Savery—Mrs. Edward H. Jacob," and a second one on paper signed by Elizabeth L. Savery, another granddaughter of Rebecca, that states that "This Bed quilt is made of 6,708 patches."

Both of the Museum's Savery-associated quilts were found by the donors in a barn near Philadelphia that had originally belonged to Mrs. Elizabeth Biddle Yarnall, who was descended from a long line of Quakers and was herself a practicing Quaker. The quilts are believed to have been handed down in the family of Rebecca Walter Savery, only daughter of William (Rebecca Savery's elder son) and his wife Elizabeth (Cresson) Savery. Mrs. Yarnall was in the direct line of descent from Rebecca Walter Savery, and therefore from Rebecca Scattergood Savery.

SIGNATURE QUILTS

Quiltmaking, like other aspects of American culture, is subject to fads, fashions, and variations in popular taste. The bedcovers discussed in this chapter represent a fad for signed quilt blocks that started in the early 1840s, reached its peak by mid-century, then began to fade in the late 1850s. Rather than dying out, however, the tradition experienced a revival (albeit with some changes) at the end of the nineteenth century.

Most of the quilts shown here belong to a tradition of group projects: The blocks were made by, paid for, and/or signed by different people. The squares then were assembled either by a single quiltmaker or by a group working together. All of these quilts also can be related to the nineteenth-century fondness for autograph albums, a fad that is believed to predate the fabric examples by approximately twenty years.[1]

A number of terms have been used over the years to refer to these kinds of quilts. In this catalogue, "signature quilt" will be used to describe any quilt composed of signed blocks. It is, therefore, a large category that includes "friendship," "album," and "fund-raising" quilts. These more specific categories will be defined in the appropriate sections.

FRIENDSHIP QUILTS

Friendship quilts also are known as "single-pattern albums," or sometimes "single-pattern friendship quilts," terms that indicate that all (or most) of the blocks are made of the same design. The "Savery Friendship Star Quilt" (fig. 24), for example, is composed of forty-nine pieced six-pointed stars, each with either a cursive or printed signature and a drawn or stamped design in the hexagon that forms the center of the star.

As discussed in Chapter 2, this quilt was discovered with the "Sunburst Quilt" (fig. 23) in a barn near Philadelphia that had once belonged to a descendant of Rebecca Scattergood Savery. The names on this friendship quilt clearly link it to the extended Scattergood-Savery families of Quakers (see chart). Two similar friendship quilts, also composed of pieced six-pointed stars and bearing many of the same signatures, have

been identified, including one that still remains in the family.[2]

The Museum's "Savery Friendship Star Quilt" (fig. 24), dated 1844, is part of a well-documented group of Delaware Valley Quaker-made signature quilts from the 1840–1860 period. Quilt historian Jessica Nicoll has examined many of these bedcovers and identified their characteristics.[3] Her study indicates a preference among Quakers for the relatively subdued single-pattern friendship quilts, as opposed to the more exuberant sampler album quilts. This "unity of design" is in keeping with Quaker beliefs in equality and presents an image of a cohesive community. Unlike non-Quaker quilts, which are more likely to represent groups of women, Quaker examples often record large numbers of people, usually extended family networks including men, women, and children, exemplifying the importance of community in Quaker life.

Most of the signers of the Museum's friendship quilt have been traced to central Philadelphia and Chester County, Pennsylvania. The two main groups represented are the Saverys and the Cressons, members of a large extended family. (The Saverys on this quilt are direct descendants of William Savery, the well-known furniture maker in Philadelphia in the second half of the eighteenth century.) Research by Mimi Sherman proved that E.H. Savery, whose signature (and the date, 1844) is on the center of the quilt, was Elizabeth Hooten (Cresson) Savery, wife of William Savery (the original William's grandson), who was Rebecca Scattergood Savery's elder son. Rebecca herself is represented on the quilt, just diagonally above and to the right of Elizabeth Savery. Diagonally above and to the left of Elizabeth is her mother, Rachel Cresson. The ages of these mothers-in-law (Rebecca, 74; Rachel, 65) have been included with their names as a way of honoring and giving status to the older members of the community.[4]

The development in the 1830s of a permanent ink that would not damage fabric probably contributed to the signature-quilt fad. Writing in ink on fabric was not, however, a technique that was easily mastered. Generally, one or two especially skilled writers would provide the inked names. (Sometimes, the names were

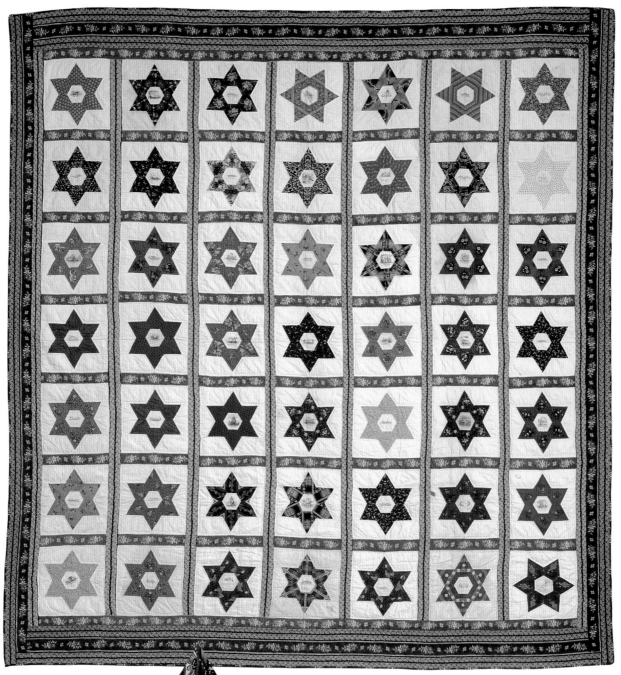

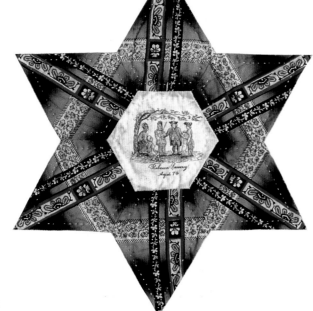

24. SAVERY FRIENDSHIP STAR QUILT
Elizabeth Hooten (Cresson) Savery and others; Philadelphia, Pennsylvania; 1844; Cotton and linen with inked signatures and drawings; 80" x 83¼". Gift of Maire D. and Charles A.T. O'Neill; 1979.26.1

24A. *Detail showing Penn's Treaty with the Indians.*

Margaretta Woodward	Margaretta P. Webb	Mary Ann Webb	Caroline Baldwin	Mary L. Betts	Deborah J. Baldwin	Rebecca Savery Betts
Louisa E. Wright	Rebecca Savery Barr	Ann C. Hooton	William S.T. Neal	Susan Morton	Sarah Wynn	Annie N. Collins
Mary Ann Rowen	Phebe De PreFontaine	Rachel Cresson Ages 65 yrs.	John H. Cresson	Rebecca Savery Aged 74 yrs.	Thomas Savery	Hannah H. Savery
William C. Dixon	Mary W. Dixon	Sarah H. Cresson	E.H. Savery 1844	William Savery	Elizabeth Savery	Sarah Savery
John W. Dixon	I.H. Cresson Dixon	Thomas Savery	John C. Savery	Rebecca W. Savery	William Savery	Thomas F. Scattergood
Jonathan L. Cresson	William Cresson	Walter Cresson	Alice H. Cresson	Sarah S. Scattergood	Thomas F. Scattergood	Mary Scattergood
Alice J. Cresson	John Cresson	Mary H. Cope	Mary F. Hannum	Debby E. Cope	Mary Ann Cope	Jane M. Cope

written in cross-stitch and, later in the century, in outline embroidery or chain stitching.) As mentioned, the signatures on the Savery quilt were written in either printed or cursive letters, and although the number of hands involved has not been determined, it is believed to be no more than three or four for the fifty different names (one square includes two names). Each of the signatures is accompanied by a garland or small vine. These were either hand drawn or stamped with one of the metal linen markers that were widely used for this purpose. Twenty-seven of the stars also include pen-and-ink motifs, ranging from a small stack of books to a detailed depiction of William Penn's Treaty with the Indians (see detail illustration), probably adapted from Benjamin West's well-known painting. Again, these were not necessarily applied by the person in whose star they appear, but by someone who was deemed well-skilled in the technique. Some also may have been done with stamps or tin stencils.

Like the "Sunburst Quilt" (fig. 23) the "Savery Friendship Star Quilt" (fig. 24) has been carefully pieced using the English template method. Three stars, however, have been set differently than the others: they have been pieced with two points, rather than one, facing up. Possibly the makers misunderstood the organizer's directions—a hazard in all group projects! The stitching on the quilt suggests, however, that it was quilted by only one hand, perhaps the Elizabeth Savery whose name appears at the center.

A number of roller-printed cottons were selected for the stars and a single chintz has been used for both the sashing and borders of this quilt. This may have been a fabric that was printed for just such a purpose. By the time this quilt was made, the fabrics could have been printed in either England or the United States. It is Mimi Sherman's theory, however, that the fabrics were of English manufacture. The Scattergoods and the Copes, families whose names appear on the quilt, were seafarers with direct access to English fashions and products. Furthermore, many Quakers made it a practice to avoid purchasing items produced by slave labor, including American cottons. The selection of English fabrics would have been seen by their community as a protest against slavery.[5]

While many friendship and album quilts were made to celebrate a particular event, to honor a distinguished member of the community, or as a gift for a departing family member or friend, others were made simply as an expression of community, as a way of "reinforcing familial and communal ties that were threatened as people uprooted themselves in search of employment and personal opportunity."[6] The Museum's "Savery Friendship Star Quilt" (fig. 24) would seem to have fulfilled such a purpose. Until its discovery in a barn in 1979, it remained in the Delaware Valley in which it was made, symbolically uniting throughout the generations the people whose names appear on the quilt.

ALBUM QUILTS

The quilts discussed in this section are commonly called "sampler albums," meaning that, unlike the "single-pattern" friendship quilts discussed above, the blocks are composed of a number of different patterns. Often the blocks have been sewn using a variety of techniques, including cut-out chintz appliqué, conventional appliqué, piecing, and embroidery.

The earliest sampler album in the collection of the Museum of American Folk Art, the "Sarah Morrell Album Quilt" (fig. 25), includes blocks dated 1842 and 1843, and was signed by fifty-eight people who lived either in Philadelphia or across the Delaware River in New Jersey. Most of the inscriptions are in ink, although some are in embroidery and some have been enhanced by designs made by a linen marker or stamp (see chart).

The "Sarah Morrell Album Quilt" (fig. 25) (Sarah Morrell's name is in the large center block) also may have ties to the Pennsylvania-New Jersey Quaker community. A number of the surnames on the quilt, including Morrell and Biddle, have been located in Quaker records of the time.[7] Some of the same people—all members of the extended Miller, Biddle, and Shinn families—whose names appear on the Museum's quilt

Anna Chaloner Philadelphia		George W. Shinn Pleasant Hill New Jersey		Adelaide H Jobes Bordentown New Jersey	M L Ogilby	Bun.	Ellen (G)ree(n) Philadelphia
Joseph—1842	E. Gardiner	M. Gardiner	Matilda Neff Philadelphia	Charles H. Morrell Philadelphia	Henry Emley Esq. Cooks Town New Jersey	Mr. F? Darrieux	Rebecca Miller Bordentown
Catharine A. Strahan	Susana B. Grover	Richard H. Morrell Philadelphia	A. Grover	Mrs. Elizabeth Darrieux Philadelphia	Eliza B. Plummer Philadelphia	A.J. Allen	Maria Grover Philadelphia
James L. Gardiner	James M. Shinn Pleasant Hill (New Jersey)	April 3rd 1843 Charles M. Harker Mount Holly	August 1842 Sarah E. Morrell Philadelphia		Augustus W. Harker 1842	C.H. Plummer	Anne M. Biddle 1843 Philadelphia
R.H. Allen	Mary H. Harker Mount Holly	A. Williamson April 18, 1842 Philadelphia			(P) Miller Shinn New Egypt	Caroline C. Shinn Pleasant Hill New Jersey	Mrs. H. Ridgway Mount Holly
Henry B. Gardiner Philadelphia	Robert Biddle Philadelphia— 184-	Edith Harker	Mrs. E. Lowery Philadelphia	James Shinn New Jersey	Abilena P. Harker	Charles Grover Jr. Philadelphia	E.B. Caldwell Philadelphia
Sarah Miller Bordentown	Sarah L. ???win 1842	John Grover Philadelphia	Charles Grover Philadelphia 1842	Miss Mary Watts Philadelphia	Thomas B. Jobes Bordentown New Jersey	Mary M. Shinn Pleasant Hill New Jersey	
Sarah J. Thomson	S.A. Gardiner	M.C. Plummer	Wallace Morrell 1842	Elizabeth Thomson	Onesiphorus Paul Blackburne	William Strahan	Josephine D. Williamson Philadelphia

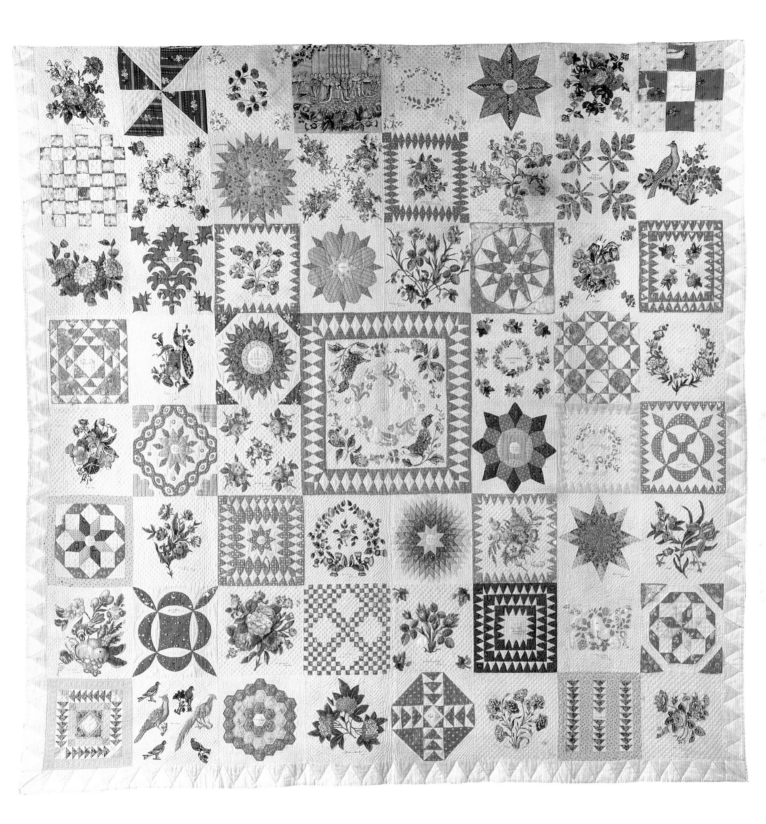

25. SARAH MORRELL ALBUM QUILT
Possibly Sarah Morrell and others; Pennsylvania and New Jersey;
1843; Cotton and ink with cotton embroidery; 93¹/₄″ x 95¹/₄″.
Gift of Jeremy L. Banta; 1986.16.1

also appear on a sampler album that was known to have been made by and for Quakers and is now in the collection of the Smithsonian Institution.[8] However, research has shown that at least one man whose name is on the Morrell quilt—Henry Emley of Cookstown, New Jersey—was an officer of the Methodist Episcopal church, and the name Morrell also has been found to have ties to the Presbyterian church.[9]

Since the signers of the Morrell quilt did not necessarily belong to the same church, town, or family, research must continue to uncover the ties that brought them together. A number of the male signers have been located in the city directories for Philadelphia during the 1840s and 1850s, and many gave their occupation as "merchant." It therefore is possible that an economic or fraternal bond existed among the participants of this quilt.

Even though the people represented on this quilt were from the vicinity of Philadelphia, it cannot be assumed that the bedcover remained in that area. Genealogical research on the Smithsonian's quilt proved that many of the signers were from the Philadelphia Quaker community, but that the quilt actually was made for Hannah Nicholson of Indiana. Hannah's father was from New Jersey and it is the names of paternal aunts, uncles, and cousins that appear on the quilt.[10] Unfortunately, the Museum of American Folk Art's quilt entered the collection without any provenance or any means to trace previous ownership. Since the name Morrell appears in many state records, including Indiana, it is possible that is was made in the Philadelphia area and then carried elsewhere. As Jessica Nicoll has written, "Signature quilts were made to commemorate events, and at the same time to preserve for the recipient the memory of a community of which they had once been a part."[11]

The composition of the Sarah Morrell quilt—equal-size blocks except for a large square in the center—is typical of its early date and indicative of the transition from center-medallion to block-style set in quiltmaking during the 1840s. A wide range of patterns and techniques have been employed, and no two blocks are exactly alike. In general, the quilt has been constructed so that every other block is made of cut-out chintz appliqué. This rhythm is broken in only one place—at the center top a printed cotton commemorating the coronation of Queen Victoria takes the place of a pieced pattern. Originally, the quilt had a red sawtooth border, much like the one that still exists on the cut-out chintz quilt discussed in Chapter 2 (fig. 16).

The extensive use of many different fabrics and vibrant patterns separates this quilt from the more subdued Quaker friendship quilts, such as the "Savery Friendship Star Quilt" (fig. 24). If it is a Quaker bedcover, it falls in the group of Philadelphia quilts identified by Jessica Nicoll as "made by or for people living in an urban area where ostentatious display was a way of signifying social position."[12]

It has been theorized that the fashion for signing quilt blocks was first popular in the Philadelphia area and then spread to Maryland, New Jersey, New York, and other Eastern Seaboard states.[13] It was in and around Baltimore that what many regard as the "acknowledged heights of the fashion"[14] was reached between about 1845 and 1855. These bedcovers, such as the Museum's "Baltimore-Style Album Quilt Top" (fig. 26), are renowned for their combination of elaborate appliqué work, exotic fabrics, intriguing geometric and pictorial designs, and elegant compositions.

The magnificent Baltimore bedcovers have been the subject of intense interest and research in recent years. While only about fifty quilts were known when quilt historian Dena Katzenberg first published and exhibited on the subject in 1980,[15] the most recent study recorded almost three hundred Baltimore album quilts.[16] As a result of this continuing focus, a great deal of information has been discovered about the quilts and their possible makers and design sources.

The Museum's quilt top falls into a group identified by Jennifer Goldsborough and a team of researchers at the Maryland Historical Society as the work of "Designer I," a hand attributed to a woman named Mary Simon. This is the elegant style that is most often associated with Baltimore album quilts and that was previously inaccurately attributed in the literature to Mary Evans. Among the hallmarks of the style that can be seen in this quilt top are triple bowknots, white roses, and the use of rainbow fabrics to indicate contours, as well as "a sure sense of formal design, and compositional skill."[17] But while the attribution to Mary Evans was circumstantial and based on a single quilt block that was part of a group seen first in 1938 and then not again until 1990,[18] there is compelling written documentation to indicate that Mary Simon was indeed the designer of some of the most artistic and elaborate quilts, including the Museum's.

Hannah Mary Trimble, a young Quaker woman from Baltimore, noted in her diary on February 1, 1850, that she had been to Mrs. Williams in Exeter St. "to see

26. BALTIMORE-STYLE ALBUM QUILT TOP

Possibly Mary Heidenroder Simon (b. 1810); probably Baltimore, Maryland; 1849–1852; cotton and ink; 109" x 105". Gift of Mr. and Mrs. James O. Keene; 1984.41.1

26 A. *Detail from quilt.* **26 B.** *Detail from quilt.*

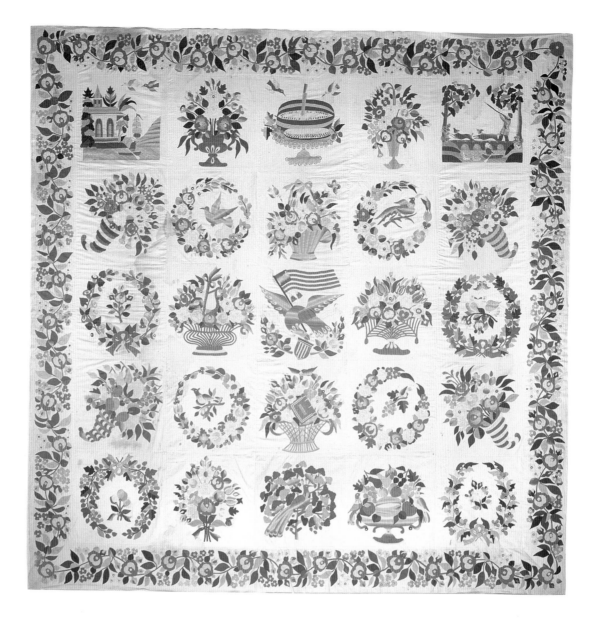

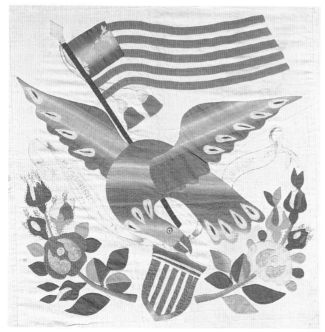

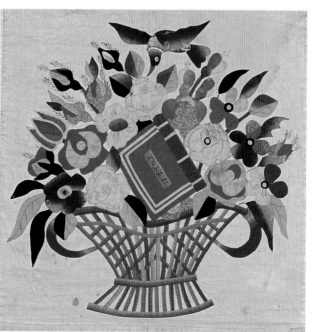

a quilt which was being exhibited and intended for Dr. Mackenzie as a tribute of gratitude for his father's services." She describes the quilt, including the style of cornucopias, wreaths, and eagle found on the Museum's quilt, and continues ". . . then out to Mrs. Simon's in Chesnut [sic] St. The lady who cut & basted these handsome quilts—saw some pretty squares."[19] As Jennifer Goldsborough concludes, "Thanks to this diary entry, we know that a Mrs. Simon drafted, basted, and distributed squares to be finished by others."[20] "Mrs. Simon" is believed to be the Mary (Mrs. Philip) Simon, born Maria Anna Heidenroder in Bavaria in 1810, who arrived in Baltimore in 1844. Census records show that she was living on Chestnut Street in Baltimore in 1850. Goldsborough further concludes that Mary Simon most likely sold her squares and did not give them away, as the imported fabrics would have been too expensive for her to provide. Also, since Simon was a Roman Catholic, she was not part of the network of Protestant churchwomen who are believed to have made most of the quilts containing her squares.[21]

A number of the squares on the Museum's quilt top are nearly identical to those on other quilts with firm Baltimore provenances. (Because the Museum's quilt is unsigned and was received with no history, it is designated a "Baltimore-style" album quilt.) Among these are the eagle with flag in the center of the quilt, a motif that is found on several examples, including a presentation quilt given to Captain George W. Russell by his family and friends in 1852.[22] This latter quilt also contains cornucopias that appear to have been made by the same hand as those on the Museum's quilt top.

The hunting scene that can be found on the top right of the Museum's quilt is exactly the same as a square in a quilt in a private collection.[23] Dena Katzenberg believes that the motif was derived from printed fabric. According to her research, "A set of eighteenth-century cotton drapery panels printed by the Robinson factory in Balls Bridge, Ireland, exhibits almost identical landscape scenes of hunters with dogs and smoking guns. . . ."[24] The unusual waterfront scene on the top left of the quilt top, however, has yet to be identified or found on any other quilt. It is possible that this motif, like other designs found on the Baltimore quilts, were adapted from English transfer-printed dishes made for the American market and imported through Baltimore.[25]

Most of the Baltimore album quilts also include beautifully inked inscriptions, including names and verses, on the individual blocks. The Museum's quilt top, however, displays no names and only the words "E Pluribus Unum" on the block with the eagle and "Token" on the book in the basket underneath the eagle. Similar quilts in the collection of The Metropolitan Museum of Art[26] and the Baltimore Museum of Art[27] were made with an inscription (removed, in the Metropolitan's example) underneath

the central motif and no other names. The Baltimore Museum's quilt was made as a gift for Miss Elizabeth Sliver and presented to her by her parents on the occasion of her marriage in 1849, and it is believed that the Metropolitan's quilt was intended to serve a similar function. Quite possibly, the Museum of American Folk Art's quilt top also was never intended to have signatures on the individual squares. However, it is clear that the quilt top was left unfinished by its maker as the rose in one of the corners was not completed and the top was never bound as it would have been were it to be used as an unquilted spread.

When the most recent research began on the Baltimore album quilts, it was believed that the makers were united by a common membership in the local Methodist Church. One Methodist woman, Achsah Wilkins, was suggested by Dena Katzenberg as the "patroness" of a group of quilters who encouraged the making of a new style of quilt as well as supplied money or materials and the use of her home as a meeting place.[28] Further genealogical research by the Maryland Historical Society team confirmed the Methodist affiliation of many of the Baltimore quilters, but also revealed a number of other religious affiliations, including German Reformed (Lutheran), Presbyterian, Baptist, and other Protestant denominations.[29]

Research on the "Dunn Album Quilt" (fig. 27) in the Museum's collection also showed that while the makers of this particular quilt belonged to a Methodist congregation, it is just one of a trio of related bedcovers made by members of three different Protestant churches in Elizabeth, New Jersey,[30] in the 1850s.[31]

According to an inscription on the Dunn quilt, it was presented in 1852 to Mr. (probably Reverend) and Mrs. Dunn, by the members of the Sewing Society of the Methodist Episcopal Church of Elizabeth Port. Information supplied to the Museum when the quilt was donated stated that the Dunns were missionaries to the South Pacific. Research by Lee Kogan of the Museum's staff, however, revealed that there was no proof that the Dunns had ever left the United States.

27 . DUNN ALBUM QUILT

Sewing Society of the Fulton Street United Methodist Episcopal Church; Elizabethport, New Jersey; 1852; Cotton and ink with cotton embroidery; 99¹/₄" x 100". Gift of Phyllis Haders; 1980.1.1

27 A . *Detail from quilt.* **27 B .** *Detail from quilt.*

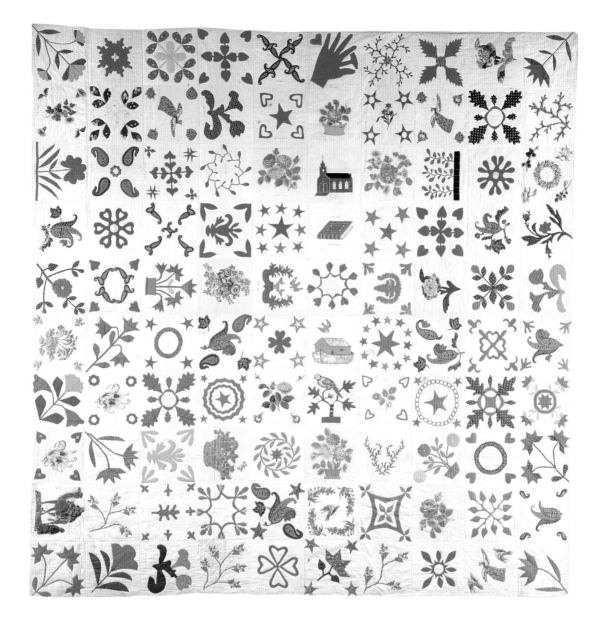

The misconception probably arose because the Methodist church was organized on a circuit system with an itinerant ministry. The itinerant pastor was thought of as a missionary, but he did not necessarily leave the local area.

Rather than as a gift for leaving the country, the Dunn quilt probably was made to commemorate the Reverend's role in the establishment of a new Methodist congregation in Elizabeth. As Lee Kogan discovered in newspaper accounts of the time, "On October 23, 1851, at 3 p.m., a cornerstone was laid for a new church, the Fulton Street M.E. Church of Elizabethport," and "Rev. Lewis Dunn, pastor of the parent Water Street M.E. Church in the center of Elizabethtown, came to speak July, 4, 1852, the first Sunday service after the new church dedication; at that time, Rev. Dunn baptized ten to twelve children."[32] The quilt may have been presented to Reverend Dunn at the time of the church's dedication to thank him and his wife for their help in erecting the building. It is believed that the quilt block that contains the image of a church may be the only existing visual reference to the original 1852 building of the Fulton Street congregation, as it was rebuilt in 1859. Reverend Dunn was asked to lay the cornerstone of this newly-enlarged Fulton Street Church and in the 1880s, at the end of his career, he became the Fulton Street Church pastor.

In January 1852, probably shortly before the Dunns received their quilt, the members of the First Presbyterian church and congregation of Elizabethport, located only a few blocks from the Methodist church, presented a strikingly similar quilt to Hannah Reinhart, the wife of their minister, Reverend Edwin Reinhart. This quilt is now in the collection of the Newark Museum, Newark, New Jersey. A third quilt in the same style is believed to have been created by members of the First Baptist Church, situated about one mile from the other two congregations. Currently owned by The American Museum in Britain, this third bedcover was presented to Mrs. Waterbury, wife of the Baptist minister, Reverend John H. Waterbury, on April 1, 1853.

All three Elizabeth quilts share common fabrics, colors, layout, and design characteristics. They are composed of a large number of blocks, have no borders or sashing, and appear to be arranged haphazardly. Evidence suggests that the construction of all three quilts may have been directed by the Sarah J. Davis who signed a centrally positioned and skillfully executed book square in each of the three quilts. Mrs. Davis also signed a second square in the Dunn quilt, and four squares in the Reinhart quilt are associated with her and her family. Lee Kogan surmises that Mrs. Davis "created the squares in which her name appears; her blocks are among the more intricate and almost all are marked by carefully embroidered cross-stitched lettering."[33] She also suggests that Sarah Davis may have designed some of the more elaborate blocks that were mixed with homemade squares in all three quilts, "explaining the identical pattern, design, and fabric of some of the blocks in all three quilts."[34]

Sarah Jane Davis and her husband, George, a machinist, were admitted to the Presbyterian Church on October 2, 1854, one and one-half years after all three Elizabeth quilts were completed. Names from all three quilts can be found in the earliest Elizabethport Presbyterian Church Register, and a number of names are found on more than one quilt. As Lee Kogan concludes, "Some of the congregants may have moved from church to church, or may have belonged to or lent their support to more than one church. The similar motivation, concept, fabric and design of these three quilts suggests that the quilt creators and signators knew each other or shared ideas."[35] Possibly the sewing societies of the different churches were open to members of a number of congregations, revealing the important role that such groups played in the lives of mid-nineteenth-century women.

While Mrs. Davis may have organized the construction of the Museum's quilt, it was clearly the work of many hands. The skillfulness of the maker varies from square to square, ranging from simple to masterful, but the uniformity of the quilting stitches suggests that one hand assembled and quilted the entire bedcover. Careful examination also reveals that while the organization of the quilt may appear haphazard, the more skillfully made and symbolically significant squares are clustered near the center of the quilt.

Many of the squares have a religious theme that would surely have been appreciated by the quilt's recipients. "God is Love" from the First Epistle of John 4:8 has been written on the block that bears a representation of a church, most likely the original edifice of the Methodist church attended by those who made the quilt. Other Christian symbols include the red Bible, Noah's ark, a baptismal font, and a wreath of rosebuds which may be interpreted here as the crown of thorns, "symbolically the mockery and humiliation that Jesus endured before his crucifixion."[36] One of the more interesting squares, a narrative print cut whole from a piece of fabric and showing a turbaned man on a camel speaking to another man, can be found on both the Dunn and Waterbury quilts. The maker also wrote on the square "Hossiath Winding His Way Though Turkey," which is perhaps a reference to Hoshaiah, an obscure biblical character who assisted Nehemiah in rebuilding the walls of Jerusalem. If this is indeed the correct interpretation of this square, it would be a fitting reference to the Reverend who helped to build the Fulton Street church.[37]

As the wide range of appliqué motifs in both the "Dunn Album Quilt" (fig. 27) and the final quilt in this section, the "Cross River Album Quilt" (fig. 28), suggest, by the middle of the nineteenth century quiltmakers were using the album quilt format to "explore the

28. CROSS RIVER ALBUM QUILT

Mrs. Eldad Miller (1805–1874) and others; Cross River, New York; 1861; cotton and silk with wool embroidery; 90" x 75". Gift of Dr. Stanley and Jacqueline Schneider; 1980.8.1

28 A. *Detail from quilt.*

28 B. *Detail from quilt.*

design possibilities of a new technique."[38] Quilts such as these two examples can be looked at as "design workbooks as well as expressions of friendship."[39]

Indeed, no other purpose than to acknowledge a relationship between the signers of the "Cross River Album Quilt" (fig. 28) has been uncovered. The quilt had been given to the Museum without a provenance, but a visitor who saw the quilt on exhibition left a note stating that at least two of the signatures were surnames common in the town of Katonah, New York. Museum researcher Paula Laverty located all the eleven women who signed the quilt and placed it firmly within the Westchester County, New York, community of Cross River, a hamlet in the town of Lewisboro and very near to Katonah. She also found that the women who made

the quilt were probably related and lived within a mile or two of each other. They were of average means and ranged in age from fifteen to fifty-five.[40]

Unlike the other signed quilts in the collection, each signature on the "Cross River Album Quilt" (fig. 28) was individually executed. Some were stenciled (see detail), some embroidered, and some written directly onto the cloth in ink. The block designs include many of the popular patterns of the day, but some appear to be either original adaptations or especially well-executed examples. The red socks and green button shoes at the lower right (see detail) make a charming, unsigned square. Almira Rusco's block at the lower left contains an intricately embroidered design in green cotton thread. Mrs. Eldad (Nancy) Miller was

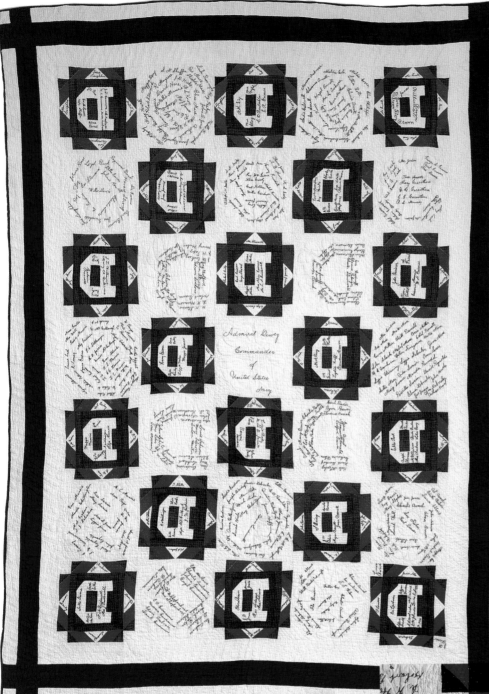

29. ADMIRAL DEWEY COMMEMORATIVE QUILT

*Possibly The Mite Society (Ladies' Aid), United Brethren Church;
Center Point, Indiana; 1900–1910; cotton with Turkey red cotton
embroidery; 88" x 65". Gift donated by Janet Gilbert for Marie
Griffin; 1993.3.1*

29A. *Detail from quilt.*

also handy with embroidery, as her block includes a beautiful basket of fruit as well as an appliquéd and embroidered butterfly and a delicate depiction of two clasped hands rendered in outline stitch (see detail). The grapes in the basket have been executed in raised appliqué, as have the grapes in the vines along the top and bottom of the quilt.

Mrs. Miller's square was signed in embroidery and dated "November 1st 1861." However, this date has not been shown to have had any obvious significance in the lives of the signers—no weddings, births, deaths, or moves to other communities have been found.

One possibility is that it was made to honor a departing minister as a strikingly similar quilt, made in 1861 in the nearby community of Bedford, New York, and in the collection of the Bedford Historical Society, was sewn by the ladies of the Baptist Church on the departure of their pastor. However, there is no mention of any of the names on the Museum's quilt in the Baptist Church records of Cross River and, unfortunately, the Methodist Church records from this time were destroyed by fire. And unlike the "Dunn Album Quilt" (fig. 27) and its related bedcovers, there are no names that are common to the two New York State album quilts.[41]

There may have been a patriotic reason for making this quilt, for 1861 marked the start of the Civil War and the Soldiers Aid Society was active in the area raising funds through private contributions, fairs, and entertainments. And at the bottom center of the quilt is a block in a flag design[42] that has been enhanced with the embroidered word "UNION" and appliquéd stars. In June 1861, shortly before this quilt was dated, *Peterson's Magazine* printed a colored illustration for a red, white, and blue quilt in a very similar design under the caption "A Patriotic Quilt."[43] The magazine was trying to inspire readers to quilt their Union sympathies, and this block points to at least patriotic feelings among the makers if not a war-related purpose behind the construction of the quilt.

FUND-RAISING QUILTS

In the middle of the nineteenth century, it was common for women to make signature quilts for charitable purposes. For a specified payment, often a dime, quiltmakers would ink or embroider the names of donors onto the top of a quilt. The finished quilt might be given to a distinguished person in the community or the quilt could be auctioned or raffled to raise more funds. These quilts often were indistinguishable from other album or friendship quilts, and it is possible that some of the quilts in the Museum's collection were made for this purpose. By the 1880s, however, a distinctive style of fund-raising signature quilt developed. These examples, such as the "Admiral Dewey

Commemorative Quilt" (fig. 29) and the "Schoolhouse Quilt Top" (black-and-white fig. 6), employed simple patterns, often in only two colors (red-and-white and blue-and-white were popular combinations) and were literally covered with names. For many quiltmakers, the fund-raising aspects of making a signature quilt evidently had become more important than the aesthetic considerations.

Sometimes, as in the "Admiral Dewey Commemorative Quilt" (fig. 29), the signatures are used to form part of the pattern. In this patriotic red, white, and blue example, four "D's" in the center of the quilt are composed entirely of embroidered names. Other names (all of which were embroidered after the bedcover was quilted) fill the plain blocks and the white spaces around the pieced "D's." In the center of the quilt is the embroidered inscription, "Admiral Dewey Commander of the United States Navy." The inscription can only be read, however, when the quilt is turned so that the "D's" are facing backwards.

Information supplied by the donor of the "Dewey" quilt indicated that it had been made in Indiana. By examining the names on the quilt, it was determined that many of the signers were members of the United Brethren Church of Center Point, Indiana, and that it is probable that the quilt was made by members of the Mite Society, the woman's group associated with the church.[44] It is likely that the quilt was used as a fund raiser during the Spanish American War, but Admiral Dewey remained a popular hero in America for a number of years and other quilts made in his honor were completed well after the war ended. There were even a number of quilt patterns named for him and published by various sources beginning in 1899 and continuing through the 1920s.[45] Since other quilts using the same "D" block pattern as the Museum's quilt have been identified, it is possible that the design was available for sale from a mail-order company or was published in a newspaper or magazine.

There can be little doubt about the makers of the "Schoolhouse Quilt Top" (black-and-white fig. 6) for it is clearly signed: "Pieced by the Presbyterian Ladies of Oak Ridge Mo. in 1897 & 1898." The signatures on the quilt top include individuals, organizations such as the "Modern Woodmen of America," and a number of local businesses. Family history states that seventeen-year-old Vest Walker, the uncle of the woman who gave the quilt to the Museum, wrote all the names onto the top before they were embroidered. The young man then purchased the quilt at auction and it remained in the family until it was given to the Museum. As this top was never made into a finished quilt and, according to the donor, was kept in a trunk until it was given to the Museum, it is clear that it was made solely as a fundraising tool and not as a functional bedcover.

APPLIQUÉ QUILTS

Bedcovers decorated primarily by the conventional appliqué technique (as opposed to the cut-out chintz method) became popular among American quiltmakers in the early 1840s. Such bedcovers remained stylish through most of the nineteenth century, although some quilt historians note a decline in both the number of quilts made and their quality in the last quarter of the century.[1]

The rise in popularity of appliqué quilts has been related to a number of factors, among them the fashion for album quilts and the widespread availability of relatively inexpensive cottons. As was seen in Chapter 3, some of the earlier signature album quilts in the Museum's collection, such as the "Dunn Album Quilt" (fig. 27) and the "Sarah Morrell Album Quilt" (fig. 25) combined both conventional and cut-out chintz appliqué techniques. As the preference for block-style quilts over the center-medallion format increased, however, quiltmakers found that traditional chintz prints, which had a limited number of repeats that could be cut out, were less suited to individualized quilt blocks than the calicos and plain fabrics required for conventional appliqué.[2]

Furthermore, according to quilt historian Barbara Brackman, the "new, lower price of calicos consequently democratized quiltmaking, enabling more American girls and women to take up the craft that had been the domain of the well-to-do for centuries. As cheaper calicos replaced the more expensive chintzes, conventional applique replaced chintz applique."[3] Brackman also cites the mechanization of the pin-making industry, resulting in lower prices and greater availability of the pins that are needed for conventional appliqué work, and the freedom from home-textile production that more affordable cloth gave women as factors that aided in the popularity of the appliqué tradition.[4]

Another important influence that is often mentioned for the "new look" of appliqué quilts was the adoption of the quiltmaking tradition by Pennsylvania Germans. This conservative group of immigrants had long made their beds in the German style, sleeping under heavy home-woven ticks filled with straw and feathers. Beginning about 1830, however, they copied their English-American neighbors and began making pieced quilts. Instead of making cut-out chintz bedcovers, however, they preferred appliqué designs based on traditional German motifs. As Germanic settlers migrated west and as the appliqué patterns spread from quiltmaker to quiltmaker, theirs were the motifs—especially the eight-lobed rosettes and the three geometric flowers in a pot—that came to dominate American appliquéd quilts for the rest of the century.[5]

There has been much discussion and confusion over the years regarding the names of quilt patterns, particularly the appliqué designs. The motif called "Whig Rose" here, for example, is sometimes also identified as "Rose of Sharon"; "Princess Feather" is also known as "Prince's Feather"; and many designs have no known historical names and are identified here simply in a descriptive fashion. In part, the confusion arises because a study of historical documents reveals that "names for specific patterns, whether pieced or applique, were unimportant if they were used at all."[6] Pattern names changed according to region and individual whims. Unless a quilt has been handed down with evidence linking it to a specific name given to it by its maker, there is no way of knowing exactly what pattern name, if any, was intended originally. Many of the names that now are used to describe nineteenth-century quilts were developed by early twentieth-century writers and pattern manufacturers and have little historical basis.

FLORAL APPLIQUÉS

A variety of floral designs, usually rendered in red and green on a white background, are probably the best-known examples of conventional appliqué quilts. The floral patterns can be traced to a number of design sources, including Jacobean embroidery, cross stitch samplers, and theorem painting, as well as other decorative arts of the period. The red-and-green color scheme was found in palampores,[7] but was also a traditional color scheme in many forms of Pennsylvania German folk art. Sometimes, blue was substituted for the green, as in the Museum's "Tulip Bouquet Quilt" (black-and-white fig. 7), but sometimes the blue that is

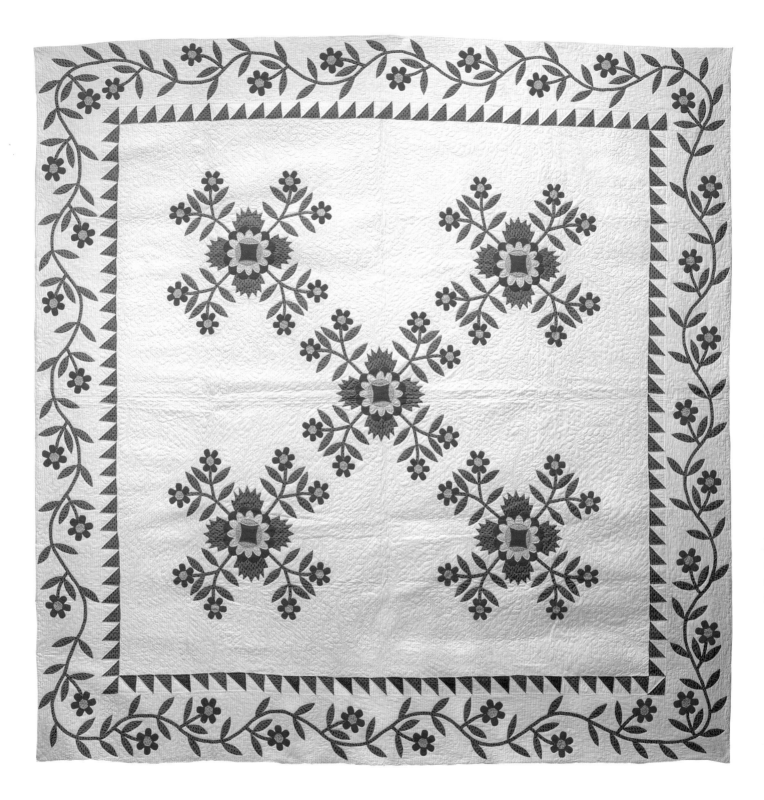

30. WHIG ROSE QUILT
Quiltmaker unidentified; possibly Pennsylvania; 1860–1880; cotton; 96¼" x 94¼". Gift of Karen and Warren Gundersheimer; 1980.20.1

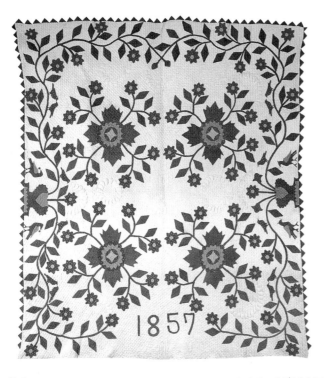

31. ABIGAIL HILL WHIG ROSE QUILT

Abigail Hill; probably Indiana; dated 1857–1858; cotton; 79³/₄" x 70". Gift of Irene Reichert in honor of her daughter, Susan Reichert Sink, and granddaughter, Heather Sink; 1992.13.1

32. WHIG ROSE QUILT WITH SWAG AND TASSEL BORDER

Quiltmaker unidentified; United States; 1850–1860; cotton; 100" x 82". Gift of Irene Reichert in honor of Nathan Druet; 1993.1.2

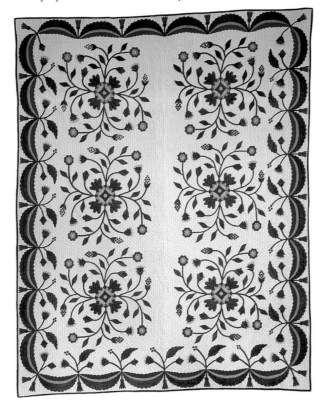

seen today is actually a faded green that was dyed with a two-step process of yellow and blue.

Quilt historian Barbara Brackman believes that the choice of red and green on white was a combination of "function and fashion."[8] The selection of white for the background was a practical matter, as undyed cotton was less expensive than calico and a large amount of material was needed. Most of the red fabrics found in quilts made between 1840 and the Civil War were colored with Turkey red, an expensive but unusually stable dye in a time when many dyes did not last. The green of the period was subject to fading, but the resulting yellow-green or blue-green leaves were deemed acceptable to the quiltmakers. As is seen in the Museum's quilts, double-pink prints, chrome yellow, and chrome orange were the favored accent colors.[9]

One of the most popular floral appliqué patterns rendered in the red, green, and white color scheme was the "Whig Rose," which is represented by three bed-covers in the Museum's collection; "Whig Rose Quilt" (fig. 30); "Abigail Hill Whig Rose Quilt" (fig. 31), and "Whig Rose Quilt with Swag and Tassel Border" (fig. 32). Each of these quilts is based on a floral block composed of a diamond (or square, depending on how the block is placed) in a circle, two many-lobed circles, four coxcomb or leaf elements radiating from the center circle, and four branches of roses emanating from the spaces between the coxcombs. Each of the quilts, however, has been individualized by its maker.

The "Whig Rose Quilt" (fig. 30) contains five floral motifs arranged to form an "X." The inner field is surrounded by a sawtooth border and the outer border is an undulating floral vine that continues unbroken around the quilt. Continuing the botanical theme, leaves and ferns have been stitched into the quilting. Anecdotal information received with the quilt suggests that it may have been made in Pennsylvania, probably between 1860 and 1880. However, a virtually identical quilt was recently published as part of a Maryland state quilt survey. This bedcover, called "Flower of Paradise Quilt," is believed to have been made in Frederick County, Maryland, as part of a dowry for a young woman who married in 1858.[10]

Although the year 1857 is clearly sewn onto the "Abigail Hill Whig Rose Quilt" (fig. 31), she most likely did not finish her bedcover until 1858 as the quilted inscription found just below the appliquéd date reads "Abigail Hill 1858." This "Whig Rose" is composed of a large floral motif in each of the four quadrants of the field. A pot of flowers, flanked by a pair of birds, can be found on two sides of the quilt and the vines that grow from these pots form the border. The vines are further enhanced by perching birds and careful examination shows that the vines are not symmetrical: one end is a strawberry and one is a flower. Both the facing pairs of birds and the undulating vine with leaves and birds were popular decorative devices on many forms of Pennsylvania German folk art, including textiles, frak-

tur, pottery, and furniture. Abigail Hill further embellished her quilt by stuffing the feathered wreaths that can be found in the white field and surrounding the bedcover with prairie points on three sides.

This quilt was given to the Museum with the information that it was made in Indiana. An Abigail Hill who was head of a household in Ohio County was located in the 1850 Indiana census. If this is the Abigail Hill who made the Museum's quilt, she would have been 65 years old in 1858.

The third "Whig Rose" quilt (fig. 32) in the Museum's collection is constructed of six equal-size floral blocks. These "roses" are more elaborate than the other two examples, as they include a number of branches with a variety of flowers, buds, and what appear to be cherries. The most interesting aspect of this quilt, however, is the "swag and tassel" border, evidence of the enduring popularity of the Greek Revival style in nineteenth-century America. Such classical devices as swags and tassels, rosettes, floral stars, anthemion ornaments and S-shaped curves flanking a central motif were often found on architecture and furnishings of the middle- and upper-middle class homes in which these quilts were made. Sometimes the same design vocabulary was incorporated into the bedcovers.[11]

The "Princess Feather Quilt" (black-and-white fig. 8) is an example of another pattern that was very popular for red-and-green appliqué work. The roots of this design possibly can be traced to English decorative arts, as the "Prince of Wales feather" is a traditional English decorative motif adapted in America by both English and Germanic quiltmakers.[12] However, it has also been interpreted by some quilt historians as an adaptation of the German whirling swastika design.[13] Nature also may have been an inspiration, as the leaves of the prince's feather plant (*Amaranthus hypochondrialcus*) actually are red and green.[14]

The Museum's "Princess Feather Quilt" was part of a gift that included a number of quilts that were made in the Walker household located near Oak Ridge, Missouri, in the late nineteenth century and handed down in the family. By 1897, the Ladies Art Company of Saint Louis was publishing a very similar pattern that would have been widely available by mail order.[15] Whether the maker of this quilt was aware of the commercially available pattern cannot, however, be determined.

The "Strawberries in Pots Quilt" (fig. 33) also entered the Museum's collection with an oral history that it was made in Missouri, but this information cannot be verified. In this example of the floral appliqué style, the maker has substituted oversized strawberries for flowers at the ends of her branches, although there is one floral motif at the exact center of the quilt. The maker also selected two "double pink" fabrics, a term used to describe cottons that are composed of two different intensities of pink printed on a white ground, instead of red for her strawberries. The sewing on the white field is quite intricate and includes both stipple quilting, stitches placed so closely together that the background puckers, and stuffed work for the quilted strawberries.

Similar intricate quilting can be found on the "Turkey Tracks Quilt" (fig. 34), believed to have been made in Ohio at about the same mid-century period as the "Strawberries in Pots Quilt." On this example, however, it is the undulating vines in the border and the wreaths and fronds in the center field that have been stuffed, rather than the appliquéd motifs.

The maker of the "Sunflowers and Hearts Quilt" (fig. 35) varied from the typical red-and-green or pink-and-green color scheme, choosing two orange fabrics in an effort to make her sunflowers more naturalistic. Unlike the other floral appliqué quilts in the Museum's collection, the blocks containing the sunflowers and accompanying hearts have been placed on point and separated by bright red diagonal sashing.

Sunflowers became a popular motif in the United States during the Aesthetic period of the 1870s and 1880s. Oscar Wilde in particular was associated with the design (he usually sported a sunflower in his lapel), and his well-received American lecture tour in 1882–1883 is said to have inspired a number of sunflower-filled "Oscar" quilts. It is impossible to determine, however, whether the maker of the Museum's quilt was inspired by the Aesthetic Movement motif or nature.

33. STRAWBERRIES IN POTS QUILT

Quiltmaker unidentified; possibly Missouri; 1850–1860; cotton; 91" x 89". Gift of Phyllis Haders; 1981.18.1

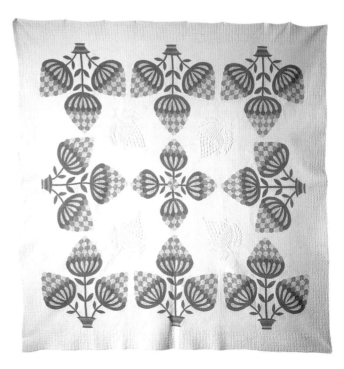

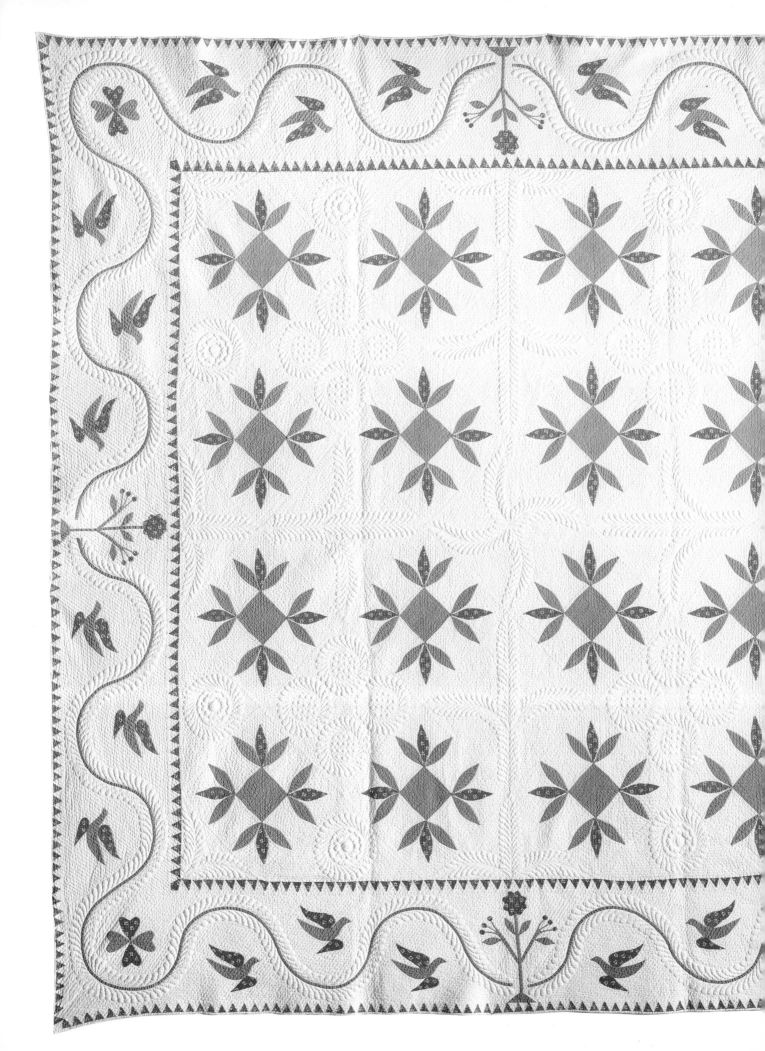

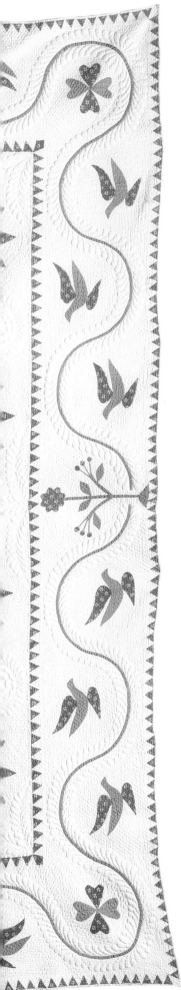

34. TURKEY TRACKS QUILT

Quiltmaker unidentified; possibly Ohio; 1840–1860; cotton; 90" x 86". Promised gift of a Museum friend in honor of Laura Fisher; P1.1995.9

Although the block format was the more popular style for floral appliqué quilts, some makers chose the center-medallion set. Three of the floral appliqués in the Museum's collection were constructed in this manner: the "MTD Quilt Top" (fig. 36), the "Floral Medallion Quilt" (fig. 37) and the "Oak Leaves with Cherries Quilt" (fig. 38).

The "MTD Quilt Top" (fig. 36), dated 1842, is the earliest dated example of appliqué work in the Museum's collection and may be seen as a transitional bedcover, bridging the cut-out chintz and traditional appliqué techniques. Although the unidentified maker chose a stylish red-and-green color scheme for her top, she maintained both the center-medallion set and the dense, overall use of motifs that were common for cut-out chintz bedcovers (see Chapter 2).

The "Floral Medallion Quilt" (fig. 37) contains a bold central wreath composed of a variety of flowers including open tulips and roses, and an unidentified flower that may represent a closed tulip. The maker of this quilt was skilled in the technique of layered appliqué in which the designs are built up through the placement of one piece of fabric onto another. Many of the flowers on the quilt have been formed in this manner. The central medallion is framed by an undulating vine border of alternating roses and "closed tulips."

The "Oak Leaves with Cherries Quilt" (fig. 38) also contains a bold central eight-lobed design, pointing to a possible Germanic source for the motif. The central element is surrounded by a wreath of leaves and cherries. Both the cherries and the tulips on the quilt have stems sewn of chain-stitched embroidery. Instead of a border, however, this quilt contains identical leaf-and-cherry motifs in each of the four corners.

There is little doubt about the Germanic origins of the motifs on the "Centennial Quilt" (fig. 39), which also was constructed in a center medallion format. The facing birds, tulips, lilies, hearts, baskets, leaves, stars, and rosettes are all designs that are found on a wide array of Pennsylvania German folk art. Many of these images have been interpreted to have symbolic meaning. The lily and the tulip, for example, have been called symbols of purity and the Virgin, as well as an attribute of the Archangel Gabriel.[16] Baskets, like cornucopias, "spelled out domestic and spiritual abundance and sometimes recalled the 'ample basket full of hay at Jesus' nativity scene' which was introduced in the first Protestant era."[17]

Whether or not this quilt had religious meaning to its maker (presumably the "G. Knappenberger" whose name is boldly placed twice along the border), she made it clear that it was created in honor of the nation's Centennial Celebration in 1876. Recent information received by the Museum may confirm the conclusion, previously based solely on visual evidence, that the quilt was made in Pennsylvania. A descendant of a woman named Gertrude Knappenberger saw a photograph of the quilt and notified the Museum that her

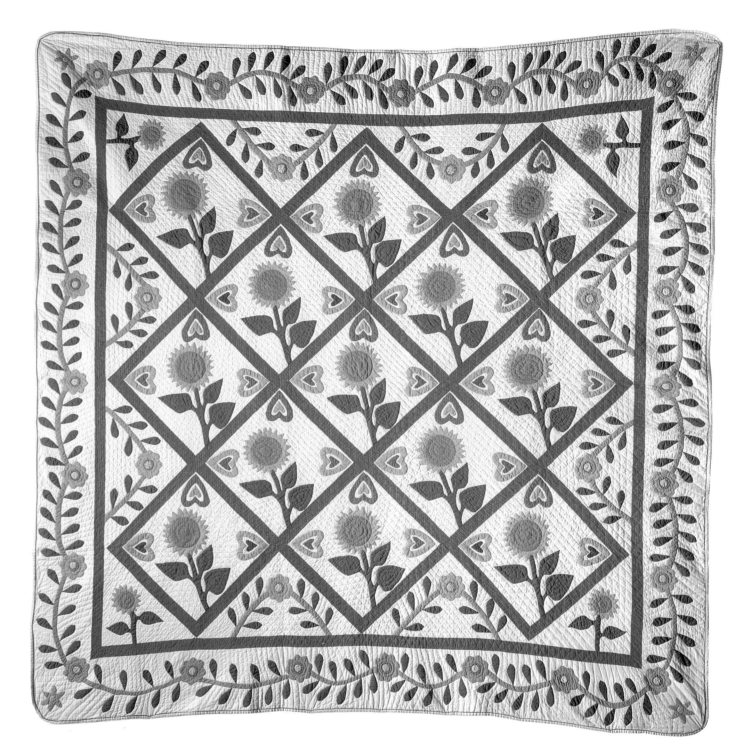

3 5 . SUNFLOWERS AND HEARTS QUILT

Quiltmaker unidentified; possibly New England; 1860–1880;
cotton; 85" x 91". Gift of Frances and Paul Martinson; 1994.2.1

great-great-grandmother was remembered in the family as an excellent quiltmaker. According to family information, Gertrude Knappenberger lived in Emmaus, Pennsylvania, and would have been between sixty and seventy years old in 1876.

There is also no doubt that the G. Knappenberger who made the "Centennial Quilt" (fig. 39) was experienced in appliqué work. Besides all the many designs that have been cut out and sewn onto the quilt using the conventional appliqué method, the maker also employed a technique known as "reverse appliqué." In

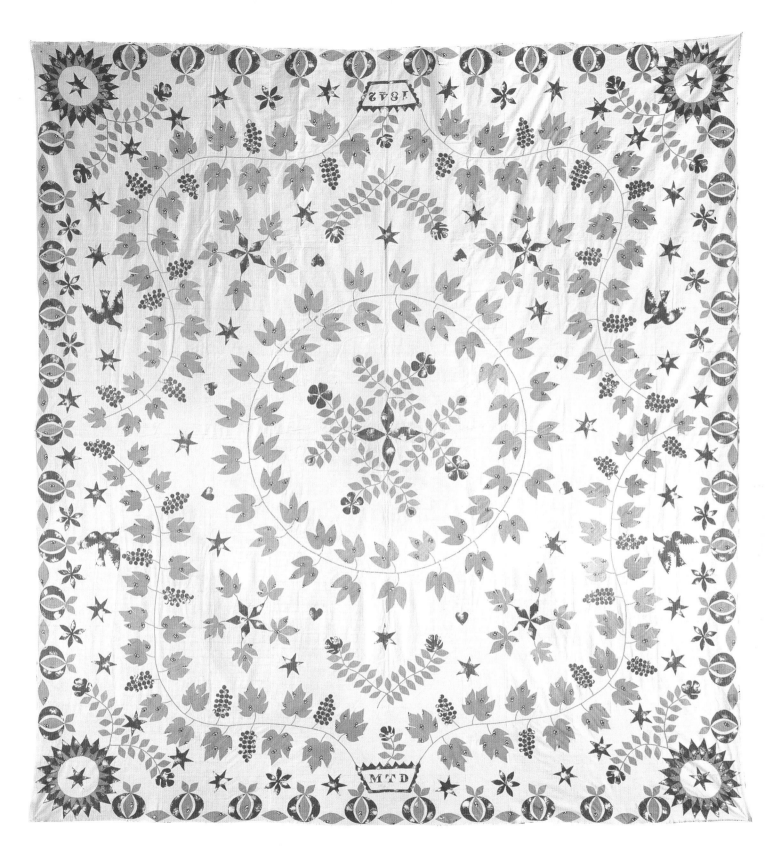

36. MTD QUILT TOP

*Quiltmaker unidentified, initialed M.T.D.; United States; dated
1842; cotton; 99" x 94". Promised gift of a Museum friend;
P1.1995.8*

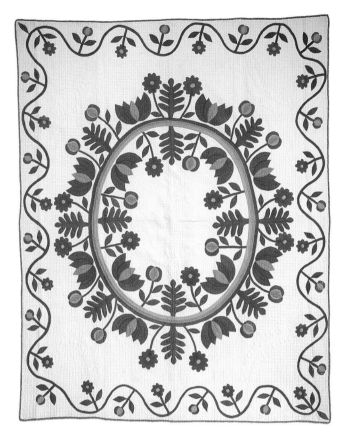

37. FLORAL MEDALLION QUILT

Quiltmaker unidentified; possibly Vincennes, Indiana; 1870–1880; cotton; 86 x 70". Gift of Irene Reichert; 1993.1.3

38. OAK LEAVES WITH CHERRIES QUILT

Quiltmaker unidentified; United States; 1870–1880; cotton with wool embroiderey; 80" x 78". Gift of Irene Reichert; 1993.1.1

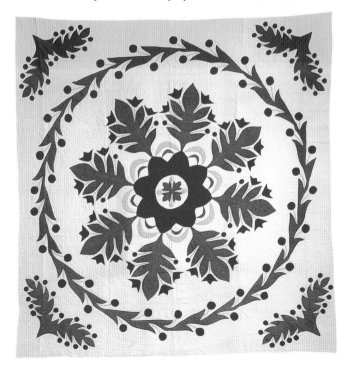

reverse appliqué, two or more layers of fabric are basted together, and then the top layer is cut away to reveal the fabric underneath. This technique was used here for the eyes of the birds.

SAMPLER APPLIQUÉS

Although they may resemble the album quilts shown in Chapter 3, the two appliqué quilts discussed in this section are believed to have been made by individual quiltmakers and do not belong to a tradition of group projects. As each block of these bedcovers is composed of a different pattern, they are often called "sampler" quilts.

The "Bird of Paradise Quilt Top" (fig. 40), named for the brightly plumed bird in the center, is arranged as a series of blocks containing floral and pictorial elements surrounded by a border, with the two center rows of blocks obviously the most important. The figures on the quilt top were made using templates that were cut from newsprint and other papers dated from 1858 to 1863 and handed down with the bedcover (see fig. 40a). Because this collection of patterns included the figure of a man who does not appear on the appropriate spot next to the woman on the quilt top, this bedcover may have been made in anticipation of a wedding that did not take place, and for that reason was never quilted and completed. The many symbols of life and fertility on the quilt top—the pairs of animals, the nesting birds, the fruits and flowers—add weight to the supposition that it was made either by or for a bride-to-be.

Besides domestic animals, the "Bird of Paradise Quilt Top" contains a number of unusual representations, including several well-known nineteenth-century racehorses—Eclipse, Flying Cloud, Ivory Black, and Black Hawk—that are identified by name; "Hanible" the elephant, with a trainer; and ostriches and peacocks, as well as the bird of paradise. Contemporary periodicals with pictures of these creatures may have been the source of these designs. The urns of overflowing flowers and vines on this quilt top are similar to some of those used on the Baltimore-style album quilts (see Chapter 3) made in Maryland only a few years before this New York State bedcover.

While the maker of this quilt top remains tantalizingly unidentified, an ambrotype bearing her likeness also was handed down with the bedcover and templates (see fig. 40b). This unknown woman was clearly a clever seamstress. Each block of the quilt top is different, yet consistent with the others in terms of style and motifs. The border is also purposefully irregular in its design, providing something new to look at in every section. The choice of fabrics is in keeping with the motifs: the patterned calicos of the leaves and branches, for example, provide the illusion of texture, while the bird of paradise is decked out in an appropriate array of colorful period cottons.

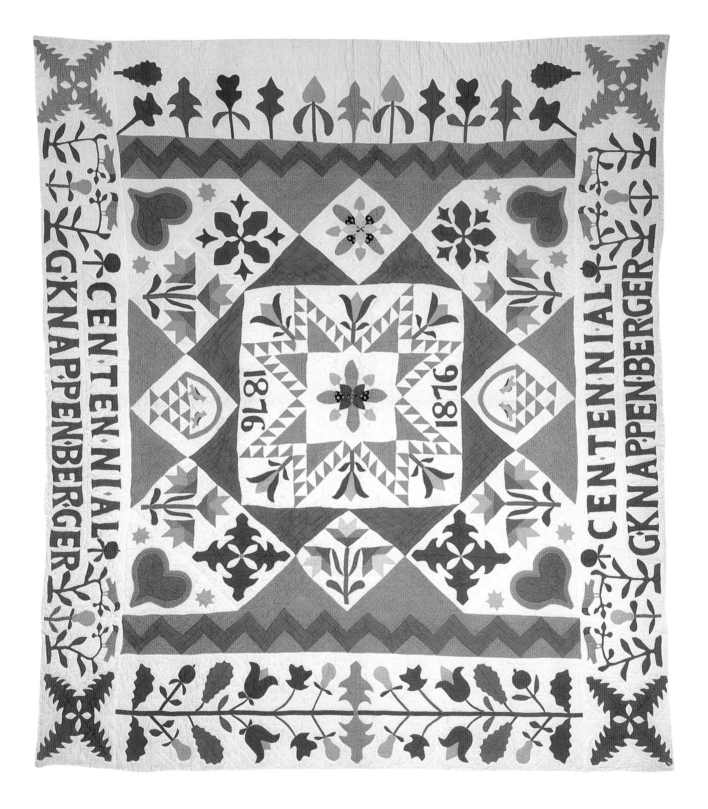

39. CENTENNIAL QUILT

Possibly Gertrude Knappenberger; possibly Emmaus,
Pennsylvania; dated 1876; cotton with cotton embroidery;
84" x 74" framed. Gift of Rhea Goodman; 1979.9.1

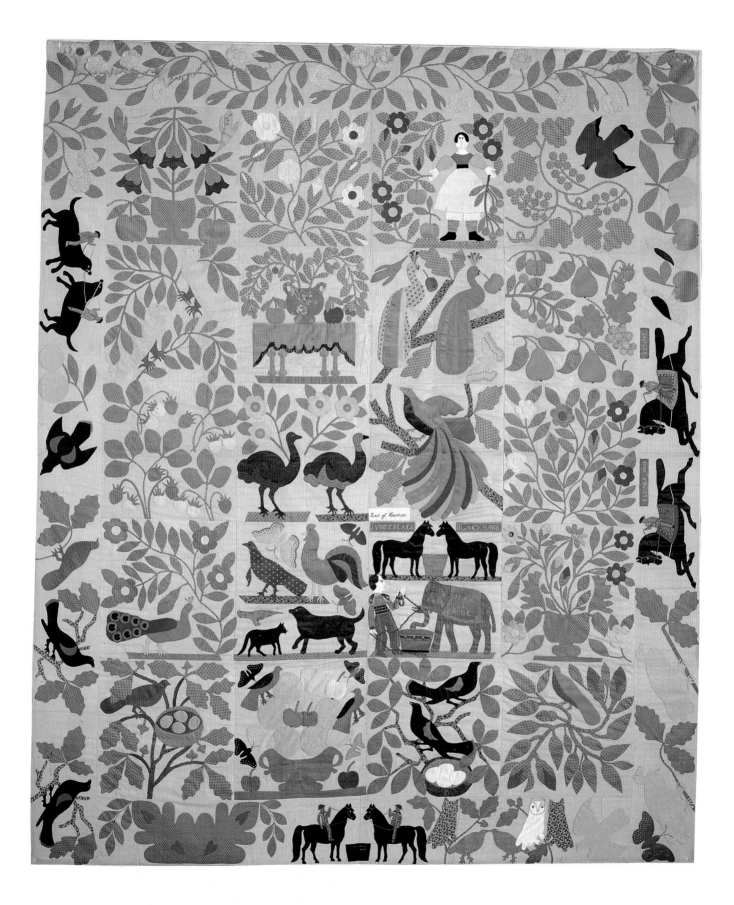

40. BIRD OF PARADISE QUILT TOP

Quiltmaker unidentified; vicinity of Albany, New York; 1858–1863; cotton, wool, silk, and ink, with silk embroidery; 84½" x 69⅝". Gift of the Trustees of the Museum of American Folk Art; 1979.7.1

46

Unfortunately, the "Bird of Paradise Quilt Top" (fig. 40) today is a still-beautiful but faded reminder of the original brilliantly-colored bedcover it once was. At some time in the past, before it entered the Museum's collection, it was either laundered or subjected to harsh lighting conditions that dulled the fabrics.

Unlike the elaborate and sophisticated designs on the "Bird of Paradise Quilt Top," the charmingly naive motifs of the "Cookie Cutter Quilt" (fig. 41) remain bright and unfaded. Each block of this quilt contains eight small shapes, such as hearts, crosses, clubs, and arrows, arrayed around one larger appliqué. Only one corner block differs from this arrangement. The simplicity of these designs has led to the possibly apocryphal suggestion that the shapes were created using cookie cutters. Whether this is true or not, it is likely that the quilt was made either in the fourth quarter of the nineteenth century or the beginning of the twentieth century, when there was a general decline in both the elegance and intricacy of appliqué quilts.

The fabrics used for some of the appliqués and the triple borders of this quilt—double pink, pale blue, yellow, and green prints—indicate that it may have been made in Pennsylvania. As was also seen in the "Centennial Quilt" (fig. 39), pink and green were commonly used in Pennsylvania quilts[18] and during the last decades of the nineteenth century, even the floral appliqué quilts in the Germanic areas of Pennsylvania were often made with a figured blue or yellow ground instead of the traditional white.[19]

PICTORIAL APPLIQUÉS

The two quilt tops discussed in this section belong to a tradition of storytelling in fabric. This tradition has Old World roots, traceable to both Europe and Africa, where it has been observed that most of the appliqué designs on bedcovers and hangings are pictorial narratives.[20] Both of the Museum's quilt tops are believed to have been made in Pennsylvania, although they probably derive from two very different cultures.

According to family tradition, the "Sarah Ann Garges Appliqué Quilt" (fig. 42) was made in celebration of the 1853 engagement of Sarah Ann Garges and Oliver Perry Shutt (1820-1907). They subsequently married on November 2, 1854. The Garges family owned a farm in Doylestown, Pennsylvania, where Abraham, Sarah's father, was a blacksmith, farmer, school director, and member of the old Mennonite church.[21] It is believed that Sarah died on January 1, 1887, at the age of 53.[22]

The quilt top is decorated with scenes of traditional farm life arranged within and around a central diamond. Along with the house, barn, farm animals and implements are depictions of such activities as hunting, plowing, and chopping down a tree, all performed by men. Originally, there was a fourth figure of a man visible on this bedcover (see detail, fig. 42b). This gentle-

40A. PATTERNS FOR BIRD OF PARADISE QUILT TOP

Maker unidentified; vicinity of Albany, New York; 1858–1863; pencil on newspaper; 10¹/₈" x 7". Gift of the Trustees of the Museum of American Folk Art; 1979.7.2 a.-k.

40B. AMBROTYPE: PORTRAIT OF A WOMAN

Gift of the Trustees of the Museum of American Folk Art; 1979.7.3

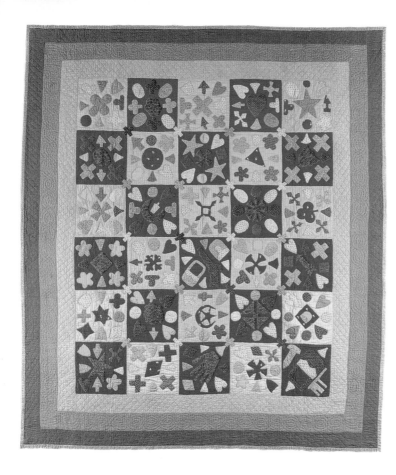

41. COOKIE CUTTER QUILT
Quiltmaker unidentified; probably Pennsylvania; 1875–1925; cotton; 71½" x 79½". Gift of Jackie and Stanley Schneider; 1979.21.1

42. SARAH ANN GARGES APPLIQUÉ QUILT
Sarah Ann Garges (c.1834–c.1887); Doylestown, Pennsylvania; 1853; Cotton, silk, wool, and wool embroidery; 96" x 98". Gift of Warner Communications Inc.; 1988.21.1

42A. *Detail from the Garges quilt.*

42B. *Detail showing the uncovered figure.*

man, who was probably tending to the two white animals that are located to the right of the center triangle, was completely covered over with yellow fabric, shaped to blend in with the rest of the motifs on the quilt top. As the yellow fabric is the same as that used on the rest of the bedcover, the "cover-up" was probably done shortly after the quilt was completed. It has yet to be determined who this figure represented or why he was obscured from view, although it is known that the oldest of Sarah Ann's three brothers, also a farmer, predeceased her.[23]

While the appliquéd floral and animal motifs on this quilt top may seem less sophisticated than some of the others in the Museum's collection, they nevertheless display an individuality that is today regarded as an integral quality of folk art. Some of the motifs, including the tulips and birds, are consistent with the maker's Pennsylvania German heritage, as is the choice of colors. Other designs, such as the bee hive, the squirrels in the tree, and the bugs probably were created by Sarah Ann to record the specific details of her everyday life. She was also an ambitious seamstress, as some of the motifs have been rendered in reverse appliqué and some have been stuffed. Although never backed and quilted, this bedcover was finished and was probably meant to be used, either for "show" or as a lightweight spread.

Information handed down with the "Sacret Bibel Quilt"[24] (fig. 43) stated that it, too, was made in Pennsylvania, although it is clearly not of Germanic heritage. The Susan Arrowood who signed this unusual bedcover is believed to have lived in West Chester, Pennsylvania, at the end of the nineteenth century, but she has proved difficult to locate in either census or church records of the period.

The "Sacret Bibel Quilt" (fig. 43) is composed of a number of patches, both squares and rectangles, that each contain from one to thirteen appliquéd figures. Probably, the patches were completed first and then sewn down onto a light, printed background cloth. The sewing techniques displayed here appear relatively inelegant with little attention paid to the quality of the stitching or the exact placement of the patches. However, the maker's narrative skills are strong and more than compensate for any coarseness in her sewing technique.

The scenes on this quilt top appear to have their origins in the Bible, although some may also represent activities at a church that was attended by the maker. Crudely written and misspelled legends identify many of the activities. At the top center, under a representation of a blue sky, is a box containing thirteen men. The caption reads: "Jesus on the monn/tain sending his de/siples threw the/world to preach." Each of these

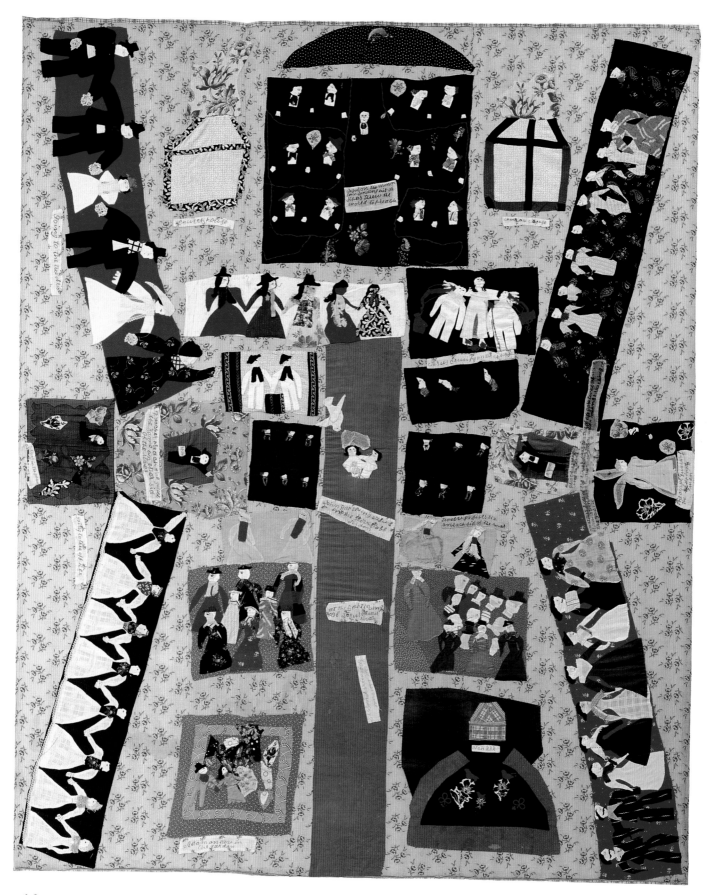

43. SACRET BIBEL QUILT

Susan Arrowood; possibly West Chester, Pennsylvania; 1875–1895; Cotton, silk, wool, and ink, with cotton embroidery; 88½" x 72" framed. Gift of the Amicus Foundation, Inc., and Evelyn and Leonard Lauder; 1986.20.1

men is wearing late nineteenth-century formal dress, complete with starched white fronts and cravats. The figures in the left-hand corner, identified as "going to the tree of life," may be interpreted to represent a bridal couple, as the young woman is garbed in white and wears a veil.[25] This procession moves toward a floral block that bears the figure of another man in black, identified as "Preacher preach the gospel/the same on either sid/of the river." The eight women alongside him, also on their way to the "tree off life," appear to have been cut out like identical paper-dolls, but although they all wear white dresses, each has been individualized with different bodice treatments and hairstyles. Bits of lace have been used here and at other places on the quilt to depict hands.

Other biblical references on the quilt include "John baptizing Jesus/in the river off/Jordan" with the river represented by a long tan rectangle running down the center of the textile, "Adam an eav in/the Garden" at the bottom, to the left of the "river," and "Noh Ark" to the right of the river. "Jesus crucify on the cross" can be seen directly below and to the right of the center top compartment that contains Jesus and his disciples. A particularly lovely square on the right edge of the bedcover depicts "The angel guarding/the sleeping/man."

The "Sacret Bibel Quilt" (fig. 43) has been compared with the two quilts created by the masterful late-nineteenth-century African-American quiltmaker, Harriet Powers.[26] Indeed, all rely on the Bible for inspiration and include appliquéd scenes as well as figures that are more symbolic than individualized. As discussed in Chapter 10, there was a strong appliqué tradition among many African groups, and these quilts may, even if indirectly, have been influenced by that cultural history. However, it must be stressed that even though there has been anecdotal information linking Susan Arrowood to the African-American community, there is no direct evidence for any such conclusion.

PIECED QUILTS

||T|| he historic quilts discussed in this chapter were all created using the technique of piecing, or "piecework."[1] In this method of quiltmaking, designs are created out of fabrics that are seamed together side by side, rather than layered on top of one another as they are in the various types of appliqué work. In general, piecing was favored for geometric patterns, although, as is seen here, the technique could be adapted for pictorial designs as well. Some of the quilts illustrated in this chapter combine both piecing and appliqué, but they are included here because piecework was the primary method of construction.

44. FEATHERED TOUCHING STARS QUILT

Quiltmaker unidentified; Ohio; dated 1846; cotton; 85¹/₂" x 84³/₄".
Gift of a Museum friend; 1989.17.6

GEOMETRIC QUILTS

One of the earliest pieced bedcovers in the Museum's collection, the "Nine Patch Quilt" (black-and-white fig. 14) was made using one of the simplest patterns. According to Barbara Brackman's statistical studies, this basic arrangement of nine squares in a block is found in early-nineteenth-century date-inscribed examples and it is still a popular pattern today.[2] Because of the simplicity of the pattern, "nine patch" often was used to teach the technique of piecing to children and, because it could be done relatively quickly, it was a favorite design for utility quilts.

The dark blue material used for the large and small squares on this quilt may be a cotton that was home-dyed with indigo, and it was once believed that the light-colored fabric was homespun. However, quilt historians now understand that although some wool and linen produced at home may have been used for making quilts, most of the fabrics used by quiltmakers were purchased. The "unbleached and undyed homespun linen and cotton"[3] that was originally described for this quilt is probably a factory-produced, natural-colored coarsely woven cotton cloth that was made to lower standards than the fine fabrics that were commonly used for the tops of quilts. This coarse cloth often was purchased for the back of a quilt, but may have been used here for the top of an everyday, utility bedcover.

While the "nine patch" may have been a pattern for learning piecework, other pieced geometric quilts in the Museum's collection represent the work of experienced needlewomen. Many star and "feathered" designs, for example, require a great deal of skill to ensure that the pieces do not pucker and these patterns often were reserved for special quilts. The "Feathered Touching Stars Quilt" (fig. 44), the "Pieties Quilt" (fig. 45), and the "ECB Feathered Stars Quilt" (fig. 46) have all been expertly pieced and enhanced with delicate quilting stitches, and may be examples of their makers' "best" work.

The maker of the "Feathered Touching Stars Quilt" (fig. 44) has not been identified, but she did include the date "1846" in the intricate designs she used to connect the three layers of her quilt. Like the red, white, and

45. PIETIES QUILT

Maria Cadman Hubbard (b.1769); probably Austerlitz, Columbia County, New York; 1848; cotton; 88½" x 81". Gift of Cyril Irwin Nelson in loving memory of his parents, Cyril Arthur and Elise Macy Nelson; 1984.27.1

46. ECB FEATHERED STARS QUILT

Quiltmaker unidentified, pieced initials ECB; possibly New York State; 1850–1860; cotton; 95½" x 76½". Gift of a Museum friend; 1985.36.1

green appliqué quilts discussed in Chapter 4, the red-and-white color scheme used for this quilt also became popular in the 1840s and probably for the same reasons: taste, availability of fabrics, and the color fastness of Turkey red cotton.[4] Both plain and printed fabrics dyed with Turkey red "became a staple in clothing and quilts during the second quarter of the nineteenth century and lasted until the end."[5]

The "Pieties Quilt" (fig. 45) is another example of a Turkey red-and-white quilt from the same period as the "Feathered Touching Stars Quilt." What distinguishes

this bedcover, however, are the many homilies that have been pieced into the white squares and rectangles that are part of the geometric pattern of the quilt. The maker, Maria Cadman Hubbard, included her name, her age (79), and the date (1848) among the biblical and secular sayings on the quilt, and thereby provided clues that made it possible for members of the Museum's staff and students at the Folk Art Institute to locate her almost one hundred fifty years after she stitched her bedcover. Although the quilt had been formerly attributed to New England, it now is believed that Maria Cadman Hubbard was a member of the Cadman family who lived in Austerlitz, Columbia County, New York, in the eighteenth and nineteenth centuries.[6]

A number of other mid-nineteenth-century quilts featuring a similar style of pieced lettering also have New York State provenances and may represent a regional tradition.[7] The "Pieties Quilt" (fig. 45), however, is the only example identified to date that displays this combination of verses with an intricate geometric pieced-work "feathered" design.

Blue and white also became a popular color scheme for both pieced and appliquéd quilts around 1840. It was an especially favored choice for the feathered star pattern, many of which, like the Museum's "ECB Feathered Stars Quilt" (fig. 46), were made with elaborate borders. This combination of the blue-and-white color scheme, a pieced geometric center, and a pictorial border has been related by some quilt historians to the influence of woven coverlets on quiltmakers.[8] Coverlets, which became popular only a few years before the blue-and-white quilt style, were often woven of indigo blue wool and white linen or cotton. This color combination was both inexpensive and practical, as indigo blue was a widely available and colorfast dye that would not run into the white.[9] Women of the period knew that the indigo would be equally reliable on cotton prints and may have been inspired to adapt the color combination for their quilts. Many of the woven Jacquard coverlets also were bordered by a floral or tree-like border, including some that are very similar to the trees that surround the Museum's quilt.

Blue-and-white quilts that bear strong resemblances to the Museum's "ECB Feathered Stars Quilt" (fig. 46) have been found with Pennsylvania, New York, and New England provenances. A somewhat simpler version of the "Feathered Star" pattern (the Museum's example is actually a "Feathered Star within Feathered Star") that has a border of willow trees alternating with almost exactly the same trefoil designs seen on the Museum's quilt, was made by Mary Elizabeth Togers Harvey of Lewisburg, Pennsylvania, probably between 1855 and 1875.[10] The simplified pattern of the Harvey quilt may be due to the fact that it is smaller than the Museum's "ECB Feathered Stars Quilt." A blue-and-white "Double Irish Chain" quilt with a border that contains the "oak" trees seen on the

Museum's quilt was made by Harriet Spicer of Amboy, New York, in 1854.[11] Finally, a number of quilts in the collection of the Shelburne Museum in Vermont, including an appliquéd "Willow Oak" made in Boston, probably about 1840, contain similar borders decorated with trees.[12] Possibly all these quilts were inspired by the woven coverlet designs that were popular during this period.

The "Star of Bethlehem with Star Border Quilt" (fig. 47) is another example of a pattern that required advanced needleworking skills and that often was chosen for special quilts. A "Star of Bethlehem" (sometimes also known as "Lone Star") is composed of a great many diamonds that must be sewn together with great care since "just one mistake in the early stages of construction can cause the star to pucker. Unfortunately, the flaw does not appear until the last diamond is fitted into place, and at that point no amount of pressing or pulling can fix it."[13] The unidentified maker of this quilt also chose a blue-and-white color combination, including a deep blue print enhanced with tiny white dots that help reinforce the imagery of a "starry night."

"Mariner's Compass," a design composed of radiating points in a circle, is another pattern that has long been popular for pieced quilts, with known examples dating to the eighteenth century.[14] The Museum's collection includes two bedcovers based on this design: the "Mariner's Compass Quilt," (black-and-white fig. 15), composed of blocks of the traditional form of the pattern and probably made between 1840 and 1860, and an unusual "Mariner's Compass Variation Quilt" (fig. 48), dating from the last quarter of the nineteenth century.

The "Mariner's Compass Variation Quilt" (fig. 48) has been made in the center-medallion format, with an open center field containing three concentric rings of triangles encircling a motif of six swirling arms and a central hexagon. "Hexagon," or "honeycomb" piecing, a technique that first became popular in the United States in the second quarter of the nineteenth century (see Chapter 2), was used to construct this center motif.

Nautical references abound on this quilt. Besides adapting the "Mariner's Compass" pattern, which has been related to compass designs on sea charts,[15] the maker chose a dark blue fabric that is printed with small white anchors. She also quilted stars into the blue diamonds along the border, as well as into the corner blocks of the inner border. This inner border and the top of the outer border, which today appear tan, originally may have been green. Synthetically dyed green fabrics, popular in the last quarter of the nineteenth century, often faded to brown, tan, or white, and many of the distinctive red, white, and tan quilts of the period were once red, white, and green.[16] It seems more likely that the maker of this quilt, perhaps the "BB" whose initials are embroidered on two corners, would have selected a bright green rather than a dull tan to enhance her otherwise lively bedcover.

47. STAR OF BETHLEHEM WITH STAR BORDER QUILT

Quiltmaker unidentified; United States; 1840–1860; cotton; 90¾"
x 90½" framed. Gift of Cyril Irwin Nelson in honor of Robert
Bishop, Director of the Museum of American Folk Art; 1990.17.3

By the second half of the nineteenth century, quilt-making in America was in full bloom. It has been said that the "quilts made in the years between 1850 and 1875 are characterized by an experimental spirit,"[17] and for the clever needleworker, there was an almost infinite variety of pieced quilt patterns that could be devised based on geometric designs. Squares, rectangles, diamonds, triangles, and circles could be combined and recombined in original ways or in new variations on old patterns, and the names that they are

48. MARINER'S COMPASS VARIATION QUILT

Quiltmaker unidentified, embroidered initials BB; Maine; 1880–1890; cotton, with cotton embroidery; 86" x 82". Gift of Cyril Irwin Nelson in memory of his grandparents, Guerdon Stearns and Elinor Irwin (Chase) Holden, and in honor of his parents, Cyril Arthur and Elise Macy Nelson; 1982.22.1

called today are often no more than descriptive titles or romantic, if unreliable, names that were created by late-nineteenth- or early-twentieth-century needlework editors and designers. The "Pieced Block-Work Quilt with Printed Border" (fig. 49) is an example of one of the many inventive ways mid-century needleworkers found to join geometric designs in the relatively new block style of quiltmaking. In this bedcover, pieces of salvaged early-nineteenth-century fabrics have been used for the diamonds and triangles that form the

49. PIECED BLOCK-WORK QUILT
WITH PRINTED BORDER

Quiltmaker unidentified; Pennsylvania; 1840–1860; cotton; 91¼"
x 85¾". Gift of a Museum friend; 1995.13.4

pieced squares. These squares alternate with solid blocks of a mid-century calico. The inner field is surrounded by what appears to be a number of borders sewn together, but is actually a single fabric printed to look like many borders. This may be another example of a fabric that was printed specifically for quiltmaking or other home furnishings project (see Chapter 2).

Among the other mid- to late-nineteenth-century geometric bedcovers in the Museum's collection are the "Diamond in the Square Variation Quilt top" (fig. 50), an eye-dazzling combination of triangles, squares, and rectangles cut from a variety of cotton prints and solids; the "Blazing Star Crib Quilt" (black-and-white fig. 16), a scaled-down version of the type of diamond piecing seen in the "Star of Bethlehem with Star Border Quilt" (fig. 47); and the "Georgetown Circle Quilt" (Catalogue #90), a spinning-wheels design that is almost identical to one that was distributed through mail order by the Ladies Art Company beginning in the last decade of the nineteenth century.[18]

COMMEMORATIVE AND PICTORIAL QUILTS

Patriotic themes have been common in American quilts since the early years of the nation. Quiltmakers have expressed their nationalistic pride through the use of specific motifs such as eagles, flags, and shields, as well as various combinations of the stars and stripes, and by incorporating printed commemorative fabrics into their bedcovers.

Two quilts in the Museum's collection, the "Baby Crib Quilt" (fig. 51) and the "Flag Quilt" (fig. 52), clearly were inspired by the design of the American flag. The "Baby Crib Quilt" (fig. 51) is an adaptation of an illustration that was published in *Peterson's Magazine* in June 1861 under the caption "A Patriotic Quilt."[19] The unidentified maker of the Museum's quilt chose to make a crib, rather than a full-size bedcover, however, and she used a star, rather than a diamond, with thirty-four smaller embroidered stars in the center of her quilt. She also added the embroidered word "Baby" in a decorative script.

The thirty-four stars in the center of this quilt had a political meaning during the Civil War: The stars represented all the states, both North and South, and undoubtedly implied that the maker held Union sentiments. The original design also had thirty-four appliquéd stars around the border to enhance the symbolism, but this quilt has fifty-two smaller embroidered stars.

According to oral tradition, the "Flag Quilt" (fig. 52) was made at the time of the Spanish-American War in 1898. Information provided to the Museum when the quilt was acquired stated that it was made by Mary C. Baxter of Kearny, New Jersey. Kearny was a town that was flourishing at the end of the nineteenth century,

50. DIAMOND IN A SQUARE VARIATION QUILT TOP

Quiltmaker unidentified; Massachusetts; 1870–1880; cotton; 88" x 84". Gift of a Museum friend in honor of Jolie Kelter and Michael Malcé; 1982.22.2

and the textile industry was preeminent. Both the Clark Thread Company and the Marshall Flax Spinning Company were major employers and many of the laborers in these factories were immigrants from the British Isles. In 1898, Captain George Buttle of Kearny led a regiment of volunteers to fight in Puerto Rico. Local histories report that when the regiment returned to Kearny on October 13, 1898, a celebration was held at Freeman Hall.[20] Although it cannot be proved that the "Flag Quilt" was made in commemoration of the war, it was certainly a time of great patriotic feelings among the townspeople of Kearny.

Patriotic and commemorative quilts often can be dated by the number of stars used by the quiltmaker, but that is not possible in this example. All of the flags and the shield in the center of the quilt have thirteen stars, a reference to the thirteen original colonies. The stars and flags have been appliquéd onto the top of the quilt and the flag poles have been embroidered in chain stitch.

It was not a war, but a political campaign that was the most likely inspiration of the "Grover Cleveland Quilt" (fig. 53). The portrait of Cleveland that has been

51. BABY CRIB QUILT

Quiltmaker unidentified; possibly Kansas; 1861–1875; Cotton, with cotton embroidery; 36³/₄" x 36". Gift of Phyllis Haders; 1978.42.1

52. FLAG QUILT

Mary C. Baxter; Kearny, New Jersey; 1898–1910; Cotton, with cotton embroidery; 77¹/₄" x 78³/₄" framed. Gift of the Amicus Foundation, Inc., Anne Baxter Klee, and Museum Trustees; 1985.15.1

53. GROVER CLEVELAND QUILT

Quiltmaker unidentified; New York State; 1884–1890; cotton;
85¹/₂" x 85¹/₂". Gift of Made in America–Margy Dyer; 1982.17.1

placed in the center of this quilt may have been taken from a flag banner that was used in Cleveland's 1884 Presidential campaign.[21] The same portrait, however, was part of a red pocket handkerchief or bandanna, one of the symbols of Cleveland's 1888 reelection campaign. Cleveland's running mate, Allen G. Thurman, had a habit of using a red bandanna after taking a pinch of snuff. The Democratic Party campaign managers made the most of this picturesque practice, publishing a campaign booklet entitled "Our Bandanna" and using "Wave High the Red Bandanna" as their campaign song.[22]

The portrait of Cleveland forms the center of a quilt that has been pieced in a light-and-dark pattern that resembles the "Barn Raising" set of some Log Cabin quilts (see Chapter 6). Unlike the Log Cabin quilts, however, this bedcover has not been foundation-pieced and it has not been constructed in blocks or "cabins." Instead, many small squares, sometimes called "postage stamps," have been arranged to create the "light" and "dark" sections. A number of very similar quilts in the same "Barn Raising" set have been identified, including one with a souvenir handkerchief of the 1876 Philadelphia Centennial in the center[23] and one featuring portraits of George Washington and Benjamin Harrison.[24] A quilt with a slightly different arrangement of pieced triangles includes a commemorative handkerchief with pictures of James A. Garfield and Chester A. Arthur, Republican candidates in 1880, in the center.[25]

Careful planning and ingenious piecing were required to create the "Saddlebred Horse Quilt," (black-and-white fig. 18), a pictorial pieced quilt that may have been made in the late-nineteenth or early-twentieth century. Appliquéd figures have been perennially popular on quilts and pieced designs featuring animals such as donkeys and elephants often were used during the quilt revival of the 1930s, but pieced figures from before that period appear to be scarce.

The entire central field of the "Saddlebred Horse Quilt" is another example of "postage stamp" piecing. Color distinguishes the design of the horse—black for most of the body, tan for the lower portion—ensuring that the prancing steed stands out against a white background. The black fabrics that have been chosen for the horse's body indicate that the quilt was probably made after 1890 when a reliable black dye was developed.

CHAPTER SIX

LOG CABIN QUILTS

J ust as the log dwelling has long been considered a symbol of American spirit and courage—the house that tamed the wilderness—so, too, has the Log Cabin quilt often been seen as the archetypal American bedcover. There is even some evidence to support a North American origin for the pattern. In England, where the American quiltmaking tradition originally developed, this type of piecing is generally known as "American" (or sometimes "Canadian") patchwork.[1] Barbara Brackman's statistical studies have shown that the pieced Log Cabin quilt dates from Abraham Lincoln's 1860 "log cabin" campaign.[2] Brackman also states that the pattern may have originated as a symbolic representation of the Union or republican sentiment, but adds that there is little corroborating evidence in the writings of the times to support such symbolism.[3]

The prevalence of the Log Cabin pattern for more than one hundred thirty years, however, is certainly attributable more to its versatility than to any patriotic or symbolic meanings. Regional quilt surveys consistently have confirmed the immense popularity of the many Log Cabin varieties, usually second only to the Crazy quilt tradition.[4] In the early 1870s, county fairs in Ohio offered prizes specifically for Log Cabin quilts, and other states soon followed suit, reflecting the growing fashionableness of the design.[5]

The Log Cabin tradition is important in American textile history not only because of the great numbers of quilts made in the many variations of the pattern, but also because it introduced a new method of construction that was different from both the American and English piecing techniques that were popular previously. Known as foundation patchwork or foundation piecing, or sometimes pressed piecing, the method calls for the individual pieces of fabric, in this case the logs of the cabin, to be sewn to an underlying piece of fabric, or foundation, as well as to each other. The foundation fabric can be either the size of an individual block, as is common for Log Cabin quilts, or the size of the entire finished quilt. After blocks constructed on foundation fabrics are joined and a backing is put on the quilt, the foundations are no longer visible but can frequently be discovered when handling the quilt. This foundation method of piecing is also used for the Crazy quilts and Fan and String quilts that became popular after the Log Cabin quilts were developed and built on the same construction technique.

As already mentioned, there are many varieties of Log Cabin quilts, almost all of which are based on the principle of individual blocks composed one-half of light strips of fabric and one-half of dark strips. The "Barn Raising" variation, for example, includes blocks that have been divided by color diagonally, while the "Courthouse Steps" pattern contains blocks that have colors arranged horizontally and vertically. The overall pattern of the quilt is determined by the way in which the separate blocks are sewn together. Often, the fabrics chosen for Log Cabin quilts are mismatched scraps that have been chosen for their color.

Log Cabin quilts, as well as Crazies, Fans, and the other varieties of "show" quilts that became popular in the second half of the nineteenth century, often are not quilted. Since the quilt top is made up of a double layer of fabric (the individual pieces and the foundation fabric), filling is not necessary for extra warmth. Although these quilts often have a border that has been quilted, it is most common to find that Log Cabins and their show-quilt relatives have been "tied" with a decorative thread connecting the front and the back instead of with quilting stitches.

The oldest Log Cabin bedcover in the Museum's collection, the "Mary Jane Smith Log Cabin Quilt" (fig. 54), is also the best documented. The quilt, constructed in the "Barn Raising" set in which light and dark fabrics are arranged to form concentric diamonds, was made by Mary Jane Smith (1833–1869) and her mother, Mary Morrell Smith (1798–1869) between 1860 and 1865.

Mary Jane Smith was born in Clintonville (now Whitestone) in Queens County, New York. Her father, John Smith, was a prosperous farmer, and the quilt originally was planned as part of Mary Jane's wedding trousseau, which also included a number of beautifully stitched garments now in the collection of the Queens Historical Society, Flushing, New York (see fig. 54a). Mary Jane's fiancé, Ephraim Gladfelter, was a young man from Philadelphia who served in the Union Army

54. MARY JANE SMITH LOG CABIN QUILT, BARN RAISING VARIATION

Mary Jane Smith (1833–1869) and her mother, Mary Morrell Smith (1798–1869); Whitestone, Queens County, New York: 1861–1865; Cotton, wool, and silk; 81" x 74". Gift of Mary D. Bromham, grandniece of Mary Jane Smith; 1987.09.

54A. *Nightgown and chemise made by Mary Jane Smith for her trousseau (Queens Historical Society, Flushing, New York)*

throughout the Civil War and who Mary Jane met at Fort Totten in New York during the war. Gladfelter intended to bring his bride back to Philadelphia where he had established a home. The day before the wedding, Mary Jane and her mother met Gladfelter at his Manhattan hotel and then journeyed back to Queens. Shortly after their arrival home, however, a messenger arrived to inform them that Gladfelter had died of pneumonia. Three years later, Mary Jane also died, unmarried, and the quilt—like the rest of the trousseau—was never used. The quilt and its history were given to the Museum by Mary D. Bromham, Mary Jane Smith's grandniece.[6]

As is typical of the early Log Cabins, Mary Jane Smith's quilt was made mostly of cotton and wool, with some silk pieces, including velvet. It probably was intended to be a functional bedcover, as was the "Log Cabin Quilt, Court House Steps Variation" (fig. 55), that was sewn entirely in cotton. This quilt is somewhat unusual in that it lacks a separate backing fabric—the back of the quilt is simply the cotton foundation blocks sewn together. The variety of madder-dyed brown prints on the front of the quilt were especially popular for scrapbag quilts, including Log Cabins, in the 1870s and 1880s.

Most of the Log Cabin quilts in the Museum's collection were not made as functional bedcovers, and so also fall into the "Show Quilt" tradition of the late nineteenth century (see Chapter 7). These quilts were made of luxurious fabrics, primarily silks, including velvet and satin, and were intended as parlor throws, spreads, or for other decorative uses. A typical example is the "Log Cabin Throw, Light and Dark Variation" (fig. 56), a small piece made of strips of silk ties and velvet that was never backed and finished. It was begun by Harriet Rutter Eagleson of New York City in 1874, the year she married William A. Eagleson.

According to New York State census records, Harriet was born in New York City in January, 1855. Her mother was also from New York and her father was from Fredericktown, New Brunswick, Canada. Harriet, her husband William and their two children were living with William's parents in Manhattan in 1880. Over the years, the family moved to various Manhattan addresses until Harriet is listed as a widow in the New York City Directory of 1924–1925. She was, however, still living with her daughter, Jessica R. Eagleson.[7] Jessica Eagleson gave the textile to the Museum in 1979 when she was 99 years old.

Another Log Cabin quilt from New York City is one of only two quilts in the Museum's collection believed to have been made by a man. According to information supplied to the Museum with the quilt, the "Samuel Steinberger Log Cabin Quilt" (fig. 57) was made by a tailor who reportedly used the remnants of satin and velvet linings for what was probably a parlor throw. The New York City Directory for 1900 does show a "Sam'l Steinberger, tailor," living at 352 E. 3rd

55. LOG CABIN QUILT, COURTHOUSE STEPS VARIATION
Quiltmaker unidentified; United States; 1870–1890; cotton; 81¼" x 79¾". Gift of Mrs. Alice Kaplan; 1977.13.6

Street in Manhattan. New York State census records for that year similarly show a "Sam Steinberger" at that address and indicate that both Sam and his wife, Sarah, were born in Hungary—Sam in April, 1865, and Sarah in January, 1870. Sam immigrated to America in 1884 and he and Sarah were married in 1889. Their two children, Freda (or Frieda) and Simon, were born in New York in 1889 and 1890, respectively. Directory listings through 1925 show "Sam'l" and his family at a number of different addresses in Manhattan and the Bronx, and Sarah is listed as a widow, living in the Bronx with her daughter, in the Directory for 1934.[8]

This quilt is unusual because of the way the design varies from the typical "Courthouse Steps" pattern. Changes in color and fabric give the blocks—and the whole quilt—an asymmetrical look, a distinct difference from the regularity usually found in Log Cabins. Compare, for example, this quilt with the cotton "Log Cabin Quilt, Courthouse Steps Variation" (fig. 55) discussed above. The substitution of a light color in the Steinberger quilt where a dark would be expected make some of the "Courthouse Steps" look uneven,

**56. LOG CABIN THROW, LIGHT AND
DARK VARIATION**

*Harriet Rutter Eagleson (1855–c.1925); New York City;
1874–1880; Silk and cotton; 57³/₄" x 57³/₄". Gift of Miss Jessica R.
Eagleson; 1979.18.1*

**57. SAMUEL STEINBERGER LOG
CABIN QUILT, COURTHOUSE STEPS
VARIATION**

*Samuel Steinberger (1865–c.1934); New York City; 1890–1910;
silk; 69¹/₂" x 58" framed. Gift of a Museum friend in honor of
Robert Bishop, Director of the Museum of American Folk Art;
1990.17.8*

58. LOG CABIN QUILT, BARN RAISING VARIATION

Sara Olmstead King; Connecticut; 1875–1885; silk; 67¹⁄₈" x 67¹⁄₈". Gift of Mrs. E. Regan Kerney; 1980.12.01

58A. DAGUERREOTYPE: PORTRAIT OF SARA OLMSTEAD KING

Gift of Mary Kerney Levenstein in memory of Albert E. McVitty, Jr.; 1981.11.1

59. LOG CABIN QUILT, PINEAPPLE VARIATION

Quiltmaker unidentified; possibly Lancaster County, Pennsylvania; 1880–1900; cotton; 83¼" x 83". Gift of Kinuko Fujii, Osaka, Japan; 1991.8.1

60. LOG CABIN QUILT, WINDMILL BLADES VARIATION

Ada Hapman (Mrs. William) Kingsley (c.1859–1939); South Windsor, New York or Athens, Pennsylvania; 1880–1900; silk; 73" x 65" framed. Gift of Margaret Cavigga; 1985.23.6

61. STRING QUILT

*Quiltmaker unidentified; possibly Kentucky; 1920–1940; wool,
with cotton binding; 75¼" x 65". Gift of Jolie Kelter and Michael
Malcé; 1988.26.1*

although this is simply a visual illusion. Likewise, a "log" might be made up of two small strips of fabric rather than a single long one, again giving the impression that the block is uneven.

Perhaps the most elegant of the "show" Log Cabins in the Museum's collection is the "Log Cabin Quilt, Barn Raising Variation" (fig. 58), made by Sarah Olmstead King (fig. 58a) of Connecticut. The silk fabrics, including velvet and satin, along with the ribbon used to make this quilt are particularly beautiful, and include a mix of woven and printed materials that were popular as dress goods in the second half of the nineteenth century. A note that was pinned to the quilt when it was given to the Museum explains the choice of fabrics: "Quilt made by Mother from pieces of our dresses, among others her own wedding dress, and our first silk dresses. It is in a way a sort of history of our early days." The note was signed "E. M. D.," the initials of Sarah King's daughter Emma Mabel Dwight (Mrs. John Elihu Dwight).[9]

The colors and fabrics used on this and many of the other Log Cabin quilts in the Museum's collection clearly reflect the popular dress and decorating styles of the late-nineteenth century. Quilt historian Virginia Gunn has observed that "Women liked to make log cabin quilts, a pattern particularly suited to an era that loved stripes and a rich oriental rug effect."[10] A careful study of the King quilt reveals fabrics that imitate Eastern paisley designs, a number of Japanese-inspired floral prints, and a variety of delicate stripes and plaids. The colors are rich and deep, reminiscent of exotic Eastern interiors and textiles. A large border of burgundy-and-black-striped velvet finishes the quilt and helps suggest the Oriental rug effect.

At some point in the mid- to late- 1870s, a variation of the basic Log Cabin design known as the "Pineapple" or "Windmill Blades" pattern became popular among American quiltmakers. The Museum owns two quilts in slightly different sets of this pattern: "Log Cabin Quilt, Pineapple Variation" (fig. 59), made of cotton; and "Log Cabin Quilt, Windmill Blades Variation" (fig. 60), made from many tiny pieces of silk. In this version of the Log Cabin design, the darker fabrics are usually arranged to form "pineapples" or "blades" that radiate out from the center squares. The ends of all the strips are clipped at an angle to create the illusion of motion or suggest the spiky leaves of a pineapple. Assembling this pattern is often more complex than for the other Log Cabin designs and requires great precision in the piecing. In the Museum's cotton

example, just two colors, red and yellow, have been used to fool the eye into seeing only the pineapples or blades, not the "cabins" or blocks out of which the quilt is actually sewn. These blocks are much more visible on the silk quilt, which employs a variety of light colored fabrics to contrast with the pineapples.

While the origins of the cotton "Pineapple" are unknown, the silk quilt can be firmly traced to its maker, Ada Hapman (Mrs. William) Kingsley. According to Mrs. Kingsley's granddaughter, Esther J. McCune, her grandmother was living in either South Windsor, New York, or Athens, Pennsylvania, both towns in rural areas near the New York/Pennsylvania border, at the time she made the quilt. And although Ms. McKune recalled that her grandmother made "many quilts of various patterns," this was the only one of silk and, consequently, it was never allowed to be used. Ms. McKune also recalled that her grandmother specifically asked that the quilt be handed down to her.[11]

The final quilt in this chapter, the "String Quilt" (fig. 61) has been included here because, both in terms of design and construction, String quilts generally resemble Log Cabins more than any other type of quilt. String quilts, made of many pieces of narrow fabric sewn together became popular in the last quarter of the nineteenth century. Like the Log Cabins, they were usually foundation pieced,[12] and they continued to be made well into the twentieth century using the foundation method of piecing.[13] Log Cabins made after 1920, however, generally were constructed using the traditional American piecing method. The lack of a foundation on this quilt, therefore, would only help confirm the post-1920 date that other clues have indicated.

The fabric selected for this quilt, a wool doubleknit that was commonly used for stockings, uniforms, and the type of "sack" dresses that were popular in the late 1920s and 1930s, also indicates that the quilt was probably made between 1920 and 1940. This is consistent with the oral history that has been handed down with the bedcover. This information states that the quilt was made in Kentucky by an African-American woman who used remnants of fabrics obtained from her job in a textile factory.[14] String and "Strip" quilts, made of many narrow pieces, are one popular form of African-American quilt, perhaps derived from an African textile tradition (see Chapter 10). Unfortunately, it cannot be determined if the Museum's quilt has acquired an African-American provenance over the years because of its aesthetics or because of factual data that has been lost.

SHOW QUILTS

Although they are called quilts, the textiles presented in this chapter were never meant to be used as functional bedcovers and they were usually not quilted. One might be carefully placed on a bed for decorative effect or draped over the back of a sofa, but never was it slept under, laundered, or treated like its utilitarian cotton cousin. Rather, a show quilt was intended to demonstrate its maker's good taste and knowledge of the popular decorative trends. To keep her family warm at night, a quiltmaker in the second half of the nineteenth century could purchase blankets and woven coverlets from mail-order catalogues or the local store. But to keep her house looking up-to-date, she made a show quilt out of silk or fine wool.

SHOW QUILTS

Quilts made of silk were created in America during the late eighteenth and early nineteenth centuries, but what is generally considered the silk "show quilt" tradition probably began in the second quarter of the nineteenth century. The "Appliquéd and Embroidered Pictorial Bedcover" (fig. 62), made of a fine wool ground with silk floral and animal appliqués, was most likely created at this time. In both materials and technique, the bedcover is similar to "Frances M. Jolly's Quilt Top," signed and dated 1839 and in the collection of the Smithsonian Institution.[1] Neither textile has been quilted and each employs extensive use of embroidery as well as appliqué work. For both these quilts, the use of silk has been limited to the appliqués and embroidery, probably due to the relative scarcity and high price of silk at this time.

By the middle of the nineteenth century, a number of economic, social, and aesthetic factors contributed to the great popularity of the show quilt. First was the basic availability of the materials. At mid-century, silk—once too rare and expensive for the average quiltmaker—was both attainable and affordable due to the expansion of the China trade, and began to replace cotton for dresses and quilts among the most stylish. At this time, a silk show-quilt style developed parallel to the calico-quilt style. By the 1880s, the height of show-quilt popularity, silk fabric was mass-produced domes-

tically, although the yarn still had to be imported from China. Unfortunately, these silks were usually "weighted," or treated with mineral salts for extra body. Such treatment made the silks heavier (and gave the clothing that elegant rustle when a lady walked), but it also created a serious conservation problem—many of the fabrics in the quilts have been eaten away by the added minerals. In the early twentieth century, the price of silk began to rise again (influenced by the Chinese Civil War), but the show-quilt tradition already had waned, due both to a change in fashion and a decline in the availability of the fabrics.

The popularity of the silk show quilt can also be traced to the influence of the periodicals of the day. In 1850, *Godey's Lady's Book* published a pattern for silk patchwork, and for the rest of the nineteenth century, most of the editors of the fashion-conscious publications advocated the silk show-quilt style as opposed to the old-fashioned cotton patchwork. Mrs. Pullan, an English author and needleworker who came to the United States to be the director of the handiwork department of *Frank Leslie's Magazine*, wrote in 1859 that cotton patchwork was "not worth either candle or gas light." However, little bits of expensive silk, velvet, or satin, turned into "handsome articles of decoration," would be acceptable.[2] Another author, Florence Hartley, writing in the *Ladies' Handbook of Fancy and Ornamental Work*, also in 1859, disagreed with Mrs. Pullan. But by saying that "We own to a liking for Patchwork, genuine old fashioned patchwork, such as our grandmothers made, and such as some dear old maiden aunt, with imperfect sight, is making for fairs and charities, and whiling away otherwise tedious hours."[3] she makes it clear that by 1859, the "real old Patchwork of bits of calico"[4] already was considered passé by the cognoscenti.

The "Star of Bethlehem Quilt" (fig. 63) is an example of a show quilt made entirely of silk, but in a pattern that could—and probably thirty years earlier would—have been made of cotton. Although the maker of the quilt remains unidentified, its ownership can be reliably traced to the family of Jeremiah Sullivan Black, Attorney General of the United States in 1857 under President Buchanan and an advisor to President

62. APPLIQUÉD AND EMBROIDERED PICTORIAL BEDCOVER

Maker unidentified; possibly New York; 1825–1845; wool, silk, cotton, and beads, with silk and cotton embroidery; 87" x 86".

Gift of Ralph Esmerian; 1991.27.1

Andrew Johnson. Black's daughter, Mary, was a physician married to another physician, Lemuel R. Hurlburt. Both practiced in Lockport, New York, for many years and the quilt, among their possessions at their deaths, was willed to their friend and office nurse, Marie Smith. At Mrs. Smith's death, the quilt was passed on to her daughter, Mary S. Lehmann. It was brought to the Museum's attention during one of the quilt days sponsored by the Museum's New York State Quilt Project.

Many show quilts have erroneously been catalogued as Crazy quilts in the past, and although they

63. STAR OF BETHLEHEM QUILT

Quiltmaker unidentified; possibly Sullivan County, New York;
1880–1900; silk and cotton; 99" x 94¹/₄". Purchase made possible
with funds from "The Great American Quilt Festival II";
1990.15.1

often share many of the same characteristics as Crazies, such as foundation piecing, luxurious fabrics, and embroidery embellishments, they have not been randomly patched and should not be categorized with the true Crazies. Instead, Crazy quilts should be considered to be a subcategory within the larger show-quilt tradition.

The "Stars and Pentagons Quilt" (fig. 64), for example, previously has been published as the "Contained Crazy Quilt." Although the textile does give an overall "crazy" effect when viewed from a distance, close inspection proves that it is actually made up of a regular pattern of pieced pentagons and five-pointed stars. As was popular in the late-nineteenth century, however, there are a number of irregular and asymmetrical features to this quilt. The sashing, for example, contains wavy rather than straight black lines, and the small pentagons within the sashing point in opposite directions. Within the blocks, the large pentagons also alternate direction, so that the top row points upward, the second downward, and so forth. The piecing within each block also *appears* to be irregular; however, although the colors are different in each block, careful study again reveals that, except for a few very minor differences, the piecing pattern is the same in each one.

It has not been determined whether this quilt is an original design, or a copy or adaptation of one published in a magazine of the period. Research has not revealed a similar quilt or a printed source for the pattern, although this cannot be ruled out since various periodicals were publishing needlework designs in the late nineteenth century.

The maker of the 1886 "Map Quilt" (fig. 65)—the date has been embroidered in Roman numerals (MDC-CCLXXXVI) along the border of Washington and Oregon—previously published as the "Map Crazy Quilt," did use a piecing pattern that was illustrated in a book or magazine to form a background for a textile map of the United States. Instructions for the "Y"-shaped pattern—called "right-angle piecing"—were published in several late-nineteenth-century English and American sources[5] and the design was especially suggested for use in small projects such as throw pillows.[6] Here, however, it has been adapted as the background pattern.

Maps have been recorded on textiles since ancient times. The word itself has its origin in the Latin *mappa*, meaning napkin, and during the Middle Ages, maps painted on cloth were known as *mappae mundi*. Handkerchief maps have been popular both in this country and in England as tourist souvenirs since the nineteenth century, and maps were depicted on samplers in both countries by eighteenth- and nineteenth-century schoolgirls.[7] It is rare, however, to find a pieced quilt in the form of a map. One almost contemporaneous example (dated 1887) was made by H. A. Deuel and is in the collection of the Kansas State Historical Society. This quilt celebrates Kansas achieving statehood in

64. STARS AND PENTAGONS QUILT
Quiltmaker unidentified; United States; 1880–1900; silk; 81" x 44" framed. Gift of Jacqueline L. Fowler; 1981.2.1

1861 with a detailed map of the state depicting all the counties and rivers.[8]

In contrast to the detailing of the Kansas quilt, the "Map Quilt" has an unfinished quality. It lacks the over-embellished quality that is characteristic of this period; there are few decorative motifs. Only two major rivers—the Mississippi and the Missouri—have been delineated. Decorative embroidery stitches have been used to mark the boundaries between a few of the states, and just five states include embroidered designs. Although anecdotal information supplied with the quilt states that it was made in Virginia, that state has not been embellished in any way and this provenance cannot be proved. Most notable is the star in Texas, but there is also a spider web in Colorado, a flower in Wyoming, and floral motifs in Iowa and Illinois. Why these states should have received special attention—or if the maker simply did not complete the quilt—cannot be determined.

CRAZY QUILTS

Crazy quilts were not only the most popular form of show quilts, but possibly the most popular of all American quilts. To call the Crazy quilt a fad item is to underestimate the phenomenon, and to call a "Crazy" a quilt is to misunderstand the purpose of these textiles. Like most show quilts, they were decorative objects, although Crazy patchwork is generally found in a greater range of sizes and had more ornamental uses than the typical silk show quilt. The Museum's collection includes crazy-patched items that were used as table mats, pillow covers, and even a lady's robe, as well as those that actually may have been placed on a bed—albeit for aesthetic purposes only.

The Crazy quilt era is generally dated from 1876, the year of the Philadelphia Centennial Exposition, to the beginning of the twentieth century. The first discussion of Crazy quilts in *Peterson's Magazine* appeared in 1879, and 1884 was the peak year for Crazies in the popular periodicals.[9] The Japanese influence at the Centennial is generally cited as the seminal factor in the origin of the Crazy quilt. However, there are some cotton Crazy quilts that can be positively dated earlier than the Centennial and that can be looked at as prototypes of the more popular and decorative silk-and-velvet style that developed after 1876.

65. MAP QUILT

Quiltmaker unidentified; possibly Virginia; dated 1886 in embroidered Roman numerals; silk and cotton, with silk embroidery; 78³/₄" x 82¹/₄". Gift of Dr. and Mrs. C. David McLaughlin; 1987.1.1

66. CLEVELAND-HENDRICKS CRAZY QUILT

*Quiltmaker unidentified, initialed J.F.R.; United States;
1885–1890; lithographed silk ribbons, silk, and wool, with cotton
fringe and silk and metallic embroidery; 75" x 77" with fringe.
Gift of Margaret Cavigga; 1985.23.3*

The collection of The Metropolitan Museum of Art in New York City includes a cotton "contained Crazy" (meaning that the crazy patches are contained within diamond sashing) that is inscribed "Made by Mrs. Nancy Doughty in the 82nd year of her age for her friend Miss Lizzie Cole A. D. 1872."[10] Similar in appearance, although not in sewing technique, are two quilts in the collection of the Shelburne Museum in Vermont. "The Streets of Boston Appliqué Quilt,"[11] signed "EMK 1873" and also made of cotton, has the look of a Crazy quilt, although the small scraps of fabric have been appliquéd to a ground rather than foundation-pieced as are most Crazies. The cotton "Hexagons and Triangles Pieced Quilt,"[12] also at Shelburne and dated "c. 1850s," bears a strong resemblance to the Metropolitan's "Contained Crazy," although in this example, the diamond sashing contains fabric that has been printed in an irregular pattern rather than pieced.

Finally, there are several other pieced cotton "Contained Crazies" in the available literature[13] that are usually broadly dated to the second half of the nineteenth century.

It is quite possible that these cotton Crazy quilts were the earliest examples, the inspiration for the elaborate textiles that developed later. The cotton style, already in existence in the 1870s, would have combined with other forces—such as the Aesthetic Movement motifs and principles, exhibitions of Japanese artifacts, the influence of the women's magazines, and the art needlework movement—to create the fancy Crazies that became so popular after 1876. The cotton quilts were perhaps one source of the style and were embellished and elaborated on as new fabrics and new design sources became available.

Although the Museum of American Folk Art does not own any pre-1876 cotton Crazy quilts, the collection does include a number of fancy examples that clearly show the effects of the other influences on the development of this style. In general, the overall look of the typical silk and velvet Crazy quilt can at least be partially related to the design principles and motifs popular in the Aesthetic Movement, a style that originated in England and reached its height in America in the 1870s and 1880s. This movement, which emphasized art in the production of household furnishings, including ceramics, furniture, wallpaper, and textiles, sought to elevate the decorative arts to the status of fine arts.

Interiors furnished in the Aesthetic Movement-style could display a variety of design motifs. There was a special enthusiasm for almost anything Japanese, but the designs of the Islamic world, ancient Greece and Egypt were also popular. Design elements from the American past were popular in the American version of the style and there was a wide use of motifs found in nature, although these were usually more abstract than naturalistic. The Aesthetic Movement was also a period marked by an abundance of what was called "surface ornament"—patterns on walls, ceilings, carpets, window draperies, portières, pillows, and upholstery.[14] Artful, usually asymmetrical arrangements were displayed everywhere and bare tabletops were not to be seen. Clearly, a Crazy quilt, combining a variety of fabrics, stitches, and decorative motifs in an elaborate and irregular display of colors and patterns, was the perfect decorative accessory for such an interior.

The 1876 Philadelphia Centennial Exposition is often cited as the catalyst for the American interest in the principles of the Aesthetic Movement, and it is also generally mentioned as the catalyst for the interest in art needlework and Japanese design that are associated with this movement and that are also major features of the Crazy quilt. The Japanese Pavilion at the Centennial was one of the most popular at the fair, and it is widely credited for introducing the American public to Japanese arts and culture. It has been theorized that the Crazy-quilt design can be traced to the design of a Japanese print, or the Japanese "cracked ice" design[15] that is similar to what is called "crazing" in porcelain glazes. A related theory states that the Crazy-quilt design is based on an ancient Japanese textile tradition called *kirihame*, a technique involving complex effects achieved with both appliqué and patchwork that was prized in Japan as early as the sixteenth century.[16]

Whether the irregular, asymmetrical style of the Crazy quilt developed from Japanese kirihame, prints, or porcelain glazing, or from a previously existing style of American quiltmaking, or some merging of the two, it is clear that the motifs and designs of the Orient had a significant effect on the decoration of the Crazies. The 1882 journal *Art Amateur* noted this when it reported that "When the present favorite style of quilt was introduced it was called the Japanese, but the national sense of humor has been too keen, and the Japanese is now generally known as the 'crazy' quilt."[17] Typical Japanese-inspired motifs that were seen not just on Crazy quilts, but on printed textiles, wallpapers, ceramics, silver, and other home furnishings were insects (especially beetles and spiders with webs), butterflies, fish, vases, flowering tree branches, and birds (primarily cranes and other elongated species).

The most popular Japanese-inspired motif, however, was the fan, which could be depicted as either the small, hand-held variety or as large, open corner fans. Both types are seen in the "Cleveland-Hendricks Crazy Quilt" (fig. 66). With its seemingly random combination of motifs, this textile exemplifies the Aesthetic Movement interest in surface ornament and exotic design as it is translated into the Crazy quilt. The maker cannot be identified (the initials "J. F. R." embroidered on the upper left of the quilt may be those of the maker or the recipient of the quilt), but her political sentiments remain clear. The strutting rooster in the center of the quilt was an emblem often used by the Democratic Party in the 1880s and 1890s, and particularly in Grover Cleveland's campaign. This and other large motifs in the quilt were originally parts of campaign banners. Below the rooster are the portraits of two unsuccessful Democratic presidential candidates, Samuel J. Tilden of New York (lower left), who ran in 1876, and Winfield S. Hancock of Pennsylvania (lower right), the candidate in 1880. These fabrics were evidently saved by the maker until after Grover Cleveland's successful 1884 campaign, as Cleveland and his running mate, Thomas A. Hendricks, are shown in the upper right and left respectively. Other memorabilia stitched into the quilt are a ribbon from Cleveland's inauguration in 1885, ribbons from an 1884 barbecue in Ithaca, New York, and a cartoon that depicts a smiling Democrat and a frowning Republican, with a large black appliquéd hand pointing at the latter.

Although the fans and the political motifs are the most obvious decorations on this quilt, the maker also has included an eclectic assortment of designs, includ-

67. S.H. CRAZY QUILT

Quiltmaker unidentified, initialed S. H.; United States; 1885–1895; silk, ink, paint, and cotton
foundation with silk embroidery; 75" x 74". Gift of Margaret Cavigga; 1985.23.4

67 A . *Detail from quilt.*

67 B . *Detail from quilt.*

ing embroidered flowers, stars, boots, crescent moons, butterflies, a pitcher, and an artist's palette. As was common for show quilts in general and Crazies in particular, the top was not quilted to attach it to the backing, but tied on the reverse with fancy pale-blue silk ribbons. To finish the quilt, a commercially woven cotton fringe was added to three sides.

The "S. H. Crazy Quilt" (fig. 67) is a similar combination of motifs drawn from different sources popular in the last decades of the nineteenth century. Here they are reproduced on the quilt top using a number of techniques. Various flowers have been painted directly onto the quilt and a terrier, lithographed onto a piece of silk, stands in the middle of a floral vine. But the majority of pictures have been embroidered using chenille work and several other different stitches. Embroidered motifs include the ubiquitous Japanese fans, butterflies, and a carp; birds, cats, owls, flowers, a lobster, and the head of an Egyptian pharaoh. Most distinctive on this quilt, however, are the Kate Greenaway-style children that have been depicted in outline embroidery on a number of different blocks.

Usually, these embroidered, painted or printed designs were not the original invention of the quiltmaker. Many of the figures were reproduced from designs found in magazines, books on fancywork, and manufacturers' and store brochures. The patterns could be purchased outright or copied from printed sources. Kate Greenaway, for example, published a book of her designs for outline embroidery. Frequently, the pictures that were purchased were perforated, and stamping powder was forced through the holes. When the powdered pattern was lifted up, an outline of powder dots remained to guide the embroiderer. If this was too cumbersome for the quiltmaker, she could trace the design using a soft pencil and tracing paper, and some designs also were printed on iron-on transfer paper. For those who felt that even this was too much effort, there were firms that offered fabric patches already stamped with designs. Finally, if the quiltmaker did not even want to do her own embroidery, there were pre-embroidered appliqués available for purchase that could be sewn directly onto the Crazy quilt.

The popularity of this type of decorative embroidery can also be related to the 1876 Centennial celebration. Another well-visited exhibit at the fair was that of the Royal School of Art Needlework from Kensington, England. The school had been established in 1872 for the two-fold purpose of restoring "ornamental needlework to the high place it once held among decorative arts," while at the same time supplying "suitable employment for poor gentlewomen."[18] Both the principles of the Royal School and its style of needlework were adapted in America following the Centennial. But while the social-reform ambitions of the Kensington school met with limited success here, embroidery became an extremely popular means of decorating textiles, including quilts.

As is seen on the "S. H. Crazy Quilt" (fig. 67), as well as the "Rachel Blair Greene Crazy Quilt" (fig. 68), Kate Greenaway-style children were among the favorite motifs of late-nineteenth-century quiltmakers. Greenaway was an English artist whose illustrations could be seen in (and copied from) either books—her first, *Under the Windows*, was published here in 1878—or periodicals, including *Harper's Bazar*, beginning in 1879, and *Godey's* beginning in 1880. The children, dressed in costumes that are closer to eighteenth- than late-nineteenth-century design, caught the public fancy and made Greenaway a household name by the mid 1880s. Figures based on her drawings and actual scenes from her books were also made into commercially available stamping patterns that could be ordered through advertisements in magazines. The scene on the "S. H. Crazy Quilt" depicting two children sitting on a brick wall closely resembles a picture from Greenaway's book, *Marigold Garden*, published in 1885.

The maker of the "S. H. Crazy Quilt" (fig. 67) was not only employing the popular embroidery designs of the day, but she may also have been using her quilt to experiment with new piecing patterns. While most of the blocks are typically "crazy," featuring random designs, one block (directly above the center) is made of the pattern called "Dresden Plate" in the twentieth century (see detail), but in the nineteenth century it may have been a variation of the "Fans" pattern, published in *Peterson's Magazine* in 1885.[19] This design is also quite similar to the favorite Japanese chrysanthemum, a pattern that was even used to decorate the walls of the Japanese pavilion at the Centennial Exposition. Again, as is typical with Crazies, the blocks have not been quilted, but the whole piece has been finished with a double border of machine-quilted satin that most likely was commercially purchased. The maker was evidently an avid embroiderer, however, and she made sure to cover even the seams of the borders with delicate stitching.

In contrast to the block style of the "S. H. Crazy Quilt" (fig. 67), as well as the other Crazies in this section, the "Rachel Blair Greene Crazy Quilt" (fig. 68) has been constructed in an overall random pattern. This type of quilt was usually made on one large piece of foundation backing (rather than individual squares) and would have been started in the center or at one of the corners. Instead of being preplanned, patches were usually added in a seemingly haphazard manner. Like the other quiltmakers, however, Rachel Blair Greene combined embroidered, painted, and lithographed motifs on her textile. The embroidered owls (see detail), butterflies, and spider webs are similar to those on the other quilts, but Mrs. Greene was especially adept at delicate hand painting. Many of the flowers are both embroidered and painted, and several of the Kate Greenaway-style children are embroidered, and then the same scene is repeated in paint on another section of the quilt. A group of three little girls walking in a row,

68. RACHEL BLAIR GREENE CRAZY QUILT
Rachel Blair Greene (1846–1909); Belvedere, New Jersey; 1885–1895; silk and paint with metallic and silk embroidery; 72" x 71³⁄₄". Gift of James I. Chesterley; 1982.18.1

68A. *Detail from quilt.*
68B. *Detail from quilt.*
68C. *Detail from quilt.*

for example, can be found embroidered in the bottom center of the quilt and painted in the top left (see details).

The scenes of children playing may have been placed on the quilt because, as mentioned above, they were fashionable at the time, or they may have had special meaning to the quiltmaker. Rachel Blair was born in Johnsonburg, New Jersey, in 1846. She married Charles A. Greene in 1869 and they moved to Tallula, Illinois, and then York, Nebraska, before returning to Belvedere, New Jersey, in 1887 or 1888. The couple had four children, including two daughters, Alice Elizabeth (born 1871), and Helen Mary (born 1882). According to Helen Mary, the quilt was sewn from pieces of the dresses made for her and her sister "when we were little girls." Rachel Blair Greene died in Belvedere in 1909.[20]

If the fabrics used for this quilt were indeed pieces of the Greene girls' dresses, then they were certainly fashionable children, for the top includes a mix of plain and pattern-woven silks, including brocades, velvets, and taffetas. Such elaborate fabrics were commonly used in the heyday of the Crazy quilt, and if scraps were not available, they could be easily purchased or purloined. There are numerous stories in the popular literature of the day about women cutting snips from their husband's neckties and cadging bits of fabric from local stores. But by 1884, manufacturers caught on to the profit that could be made from selling bits and pieces of silk, and some even went into the business of pre-packaging fabrics into kits for Crazy blocks. This use of small scraps of material, however, led to the mistaken belief, popular during the quilt revival of the 1920s, that "scrap-bag" Crazies were the earliest type of American quilts and dated to the Colonial period. Ruth Finley's well-known (and still-available) 1929 book, *Old Patchwork Quilts and The Women Who Made Them*, especially helped to popularize the myth of the Crazy as the archetypal

American quilt: "The original shapeless scraps, at first fitted together in 'crazy' fashion, very early were trimmed into uniform patches. . . ."[21] But while the top of a Crazy quilt sometimes may look as if the maker simply threw a handful of fabric pieces into the air and sewed them together where they landed, it should be remembered that, as for most quilts, a great deal of planning went into the making of a Crazy. Furthermore, the foundation method of construction used for piecing a Crazy required a great deal of extra fabric that usually was specially purchased and the backing was also frequently made of a large expanse of material, often a silk or other luxurious fabric, that also had to be carefully selected and bought at considerable expense.

While many Crazy quilts do exhibit a characteristically random quality, a Crazy occasionally can be so ordered and regular that it appears as if the maker were simply using the form as a fashionable background. The "Equestrian Crazy Quilt" (fig. 69), for example, is composed of twenty-four center-medallion style Crazy patchwork blocks arranged around a larger medallion at the center of the quilt. The two matching pillow shams (fig. 70) are similarly composed of center medallions of riders on horseback surrounded by Crazy patchwork. While the piecing in each block is random, there is an order and symmetry to the quilt and shams that seems to stretch the definition of a Crazy. The silk fabrics, including velvet and taffeta, used for the top

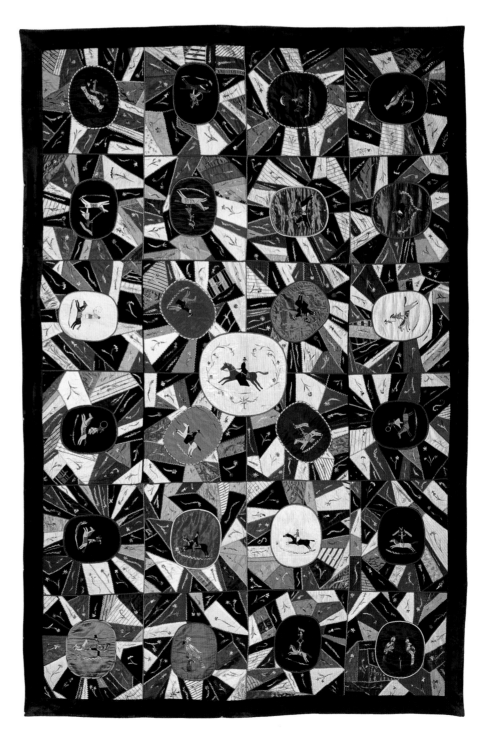

69. THE EQUESTRIAN CRAZY QUILT

Quiltmaker unidentified; possibly New York State; 1880–1900; silk and cotton, with cotton embroidery; 92" x 61½". Gift of Mr. and Mrs. James D. Clokey III; 1986.12.1

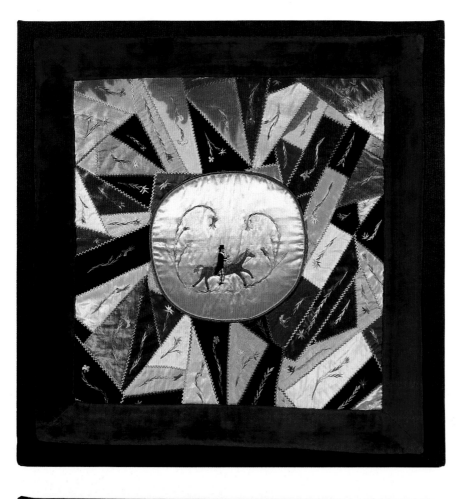

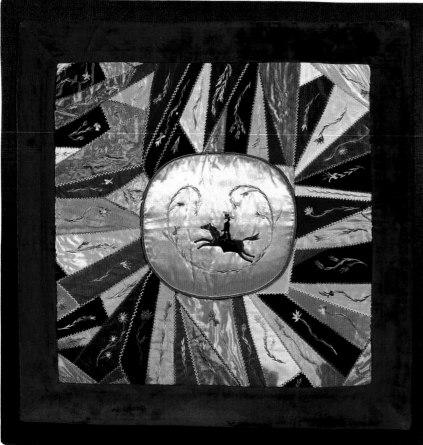

**70. EQUESTRIAN CRAZY
QUILT PILLOW SHAMS**
*Quiltmaker unidentified; possibly New
York State; 1880–1900; silk, with cotton
embroidery; 27" x 27" each. Promised gift
of Mr. and Mrs. James D. Clokey III;
P1.1988.1 a & b*

are almost all solids or unobtrusive stripes, and each patch has been embroidered with a single small flowering stem. Most of the center medallions contain the figure of a rider on horseback, but each rider is engaged in a different activity ranging from sitting sedately on a standing animal to performing acrobatic feats on running steeds. A few of the medallions include birds instead of horses, and the most unusual scene, located at the lower left of the quilt, features a rooster in a top hat and pants handing a bouquet to a hen.

Considered together, the figures on the quilt appear to be performers in some kind of spectacle, although the exact event remains unknown. Anecdotal information supplied to the Museum with the quilt stated that the maker was a member of a traveling circus from the southern tier of upper New York State. However, this information cannot be proved, and the designs may have been derived from either contemporary printed fabrics or other sources or from a type of woven ribbon, known as Stevengraphs—ribbon pictures woven in silk on jacquard looms. These ribbons, which included a set of racing horses with jockeys that do resemble one of the figures on this quilt, were widely available and were sometimes incorporated into Crazy quilts.

Although much smaller and simpler than the "Equestrian Crazy Quilt" (fig. 69), the "Center Star Crazy Throw" (fig. 71) exhibits a similar feeling of restraint on the part of the maker, Mary Ann Crocker Hinman. In this example of the Crazy-quilt genre, the design emphasis is on the piecing—a star for the center and fans throughout—rather than on the embroidery, which for the most part is limited to chains along borders and inside the "folds" of the fans. The small size of the textile indicates that it probably was used as a parlor throw and, according to the donor of the quilt, the maker's granddaughter, the design was her grandmother's own. Mary Ann Crocker Hinman was born in 1817 in Lebanon, New York, and died in 1893 in Lima, New York. She had ten children—the donor's father was her youngest—and as her granddaughter states: "how she had time to make a quilt I cannot imagine."[22]

As mentioned above, the Crazy-patchwork technique could be adapted for a wide variety of objects. Perhaps the most unusual in the Museum's collection is the "Crazy Trousseau Robe" (fig. 72) made by Emma Cummins Snively Crosier Pauling (see fig. 72a). The garment has been foundation pieced as a quilt would be, and it is made of the same types of fabrics—silk, velvet, lace—and embellished with the same kinds of decoration—embroidery, ribbon, and cording—as the Crazy quilts of the period. What is most fascinating about this textile, however, is the history of its maker.

"Emma Cummins Pauling must have been an unusual woman in her time."[23] She was born in Somerset, Pennsylvania, on May 6, 1848. According to family history, she ran away from home at the age of 14 to marry a French-Canadian man who was so cruel to her that

his family gave her money to return to Pennsylvania. She later married a Mr. Snively and followed him to Utah with the couple's daughter. Emma was widowed during a brawl in a bar that started when her husband made uncomplimentary remarks about her. An acquaintance, one Mr. Lawless, defended Emma's honor and a fight followed in which Mr. Snively was killed. Mr. Lawless was deemed to have acted in self defense and judged innocent. Emma wrote to her sister, Lillian, in Pennsylvania to tell her about the man who had protected her honor and to invite her to come West to meet him. Lillian and Nicholas Lawless were married in 1874.

In 1872, Emma had been selected to be one of the first women railroad telegraphers in the West. Her diary, still owned by her family, provides fascinating glimpses of her life in the 1880s and 1890s when she worked for the railroad in a variety of often lonely outposts in Utah, Idaho and Wyoming, as well as her accounts, recipes, and thoughts about the events of the day.

> May 4th, 1886: My Birthday, cloudy, rain and hail at times during day—spent morning in making up some of my reports, and the afternoon sewing . .

> June 8, 1889: A terrible flood washing nearly all of Johnstown and inhabitants away—occurred on Friday 31st of May-at-about 3 pm—many of our old friends and acquaintances lost in the fearful waters—which was 40 feet in depth—covering and sweeping everything as it went . . .
> October 12, 1889: Mr. Ryder (Train Master) came in at ten. Asked me how would like to go to Logan permanently to work nights . . .
> October 23rd, 1889: Cloudy and dreary wind blew hard all night—feel very blue and lonely.

Surviving relatives believe that Emma Cummins Snively Crosier Pauling was married four times, although they only have the names of three of her husbands. She died of pneumonia in March 1924.

While often considered a product of a sophisticated, urban environment, the show-quilt phenomenon reached the most rural parts of the country as well. Emma Pauling may have made her elegant robe while she was working at one of her isolated stations, possibly McCammon, Idaho. Like most of the women of the period, however, she had access to newspapers and magazines that showed her the latest fashions and included patterns for sewing. Sometimes, women in the more rural areas did not have the luxurious fabrics that are most associated with the style, and so they used cotton or wool or whatever was available. An example of a "country Crazy" in the Museum's collection is the "Missouri Bridal Crazy Quilt" (black-and-white fig. 21), made by May Dodge Harper of Poplar Bluff, Missouri, in 1900.

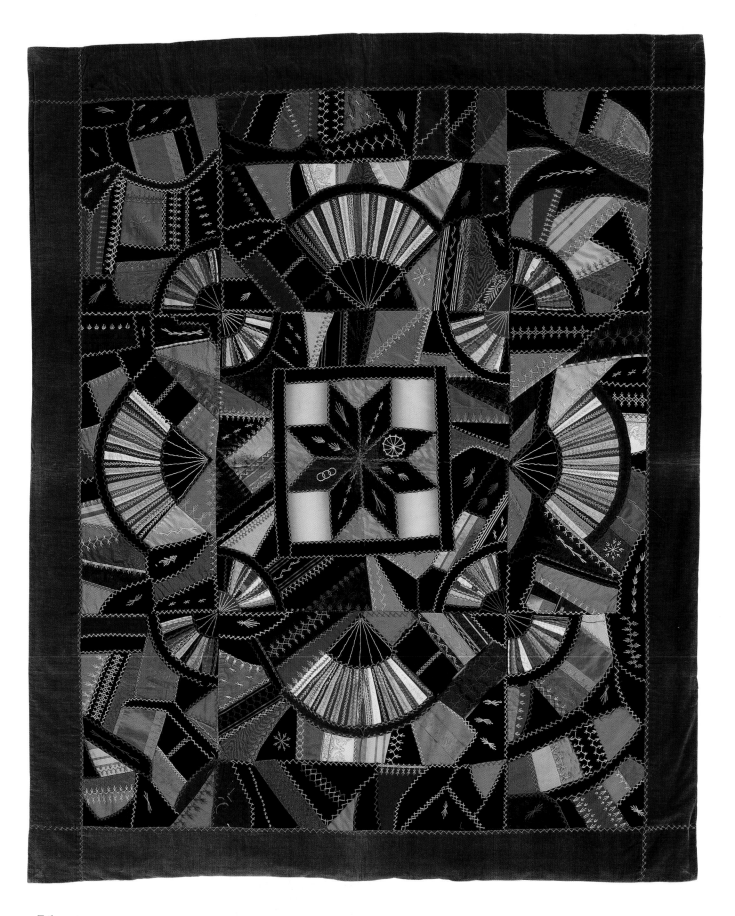

71. CENTER STAR CRAZY THROW

Mary Ann Crocker Hinman (1817–1893); New York State; 1880–1890;
silk, with silk embroidery; 64" x 52³/₄". Gift of Ruth E. Avard; 1993.2.1

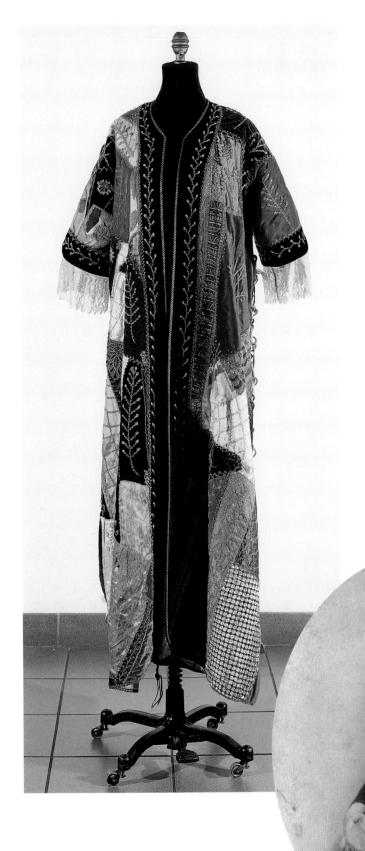

Late in the nineteenth century, as the interest in Crazies began to fade, a deterioration of the form could be seen: pieces became larger, surface ornamentation decreased, less-expensive fabrics began to be used, and the quilts became less decorative and more utilitarian. Sometimes, these late Crazies are confused with what were called "haps" or "comforts" in some areas and that also were made from large, often irregular pieces of fabrics, generally tied rather than quilted. Haps also were made using the foundation method of piecing, but usually are much heavier than Crazy quilts and were meant to be functional bedcovers.[24] By the end of the nineteenth century, the principles and motifs of the Aesthetic Movement were no longer fashionable, and, for the most part, quiltmaking returned to its cotton roots.

72. CRAZY TROUSSEAU ROBE

Emma Cummins Snively Crosier Pauling (1848–1924); possibly McCammon, Idaho; 1882–1900; silk and lace, with silk cording and metallic and silk embroidery; Height: 55 1/4". Gift of the Family of Emma K. Lentz; 1990.8.1

72A. *Emma Cummins Snively Crosier Pauling*

As seen in many of the Crazy quilts discussed above, outline embroidery, popularized by the Royal School of Art Needlework, was a favorite form of textile decoration after the Centennial. Beginning in the 1880s, books and magazines printed drawings that could be copied and used for "embellishing tidies, screens, fans, mats, cushions, and table and other house linen of all description,"[25] as one publication explained. The designs were simple drawings that were to be "generally followed in the Kensington outline stitch, but may also be wrought in short back-stitch or fine chain-stitch."[26] The popularity of this type of embroidery was based on both its artistic quality and, perhaps most important to some, the speed and ease with which it could be worked. As textile historian Margaret Vincent notes, outline work was considered appropriate for women "who have neither time, eyesight nor means to indulge in intricate and elaborate needlework."[27]

The "In Honor Shall Wave Spread" (fig. 73) is typical of this style in its combination of Turkey red cotton thread worked on a white cotton ground. As is also common on these quilts, the embroidered motifs simply have been copied from a variety of sources and placed on the quilt without regard to scale, and some of the same motifs appear repeatedly. Like many Crazy quilts, the surface of this bedcover is densely covered with designs in an asymmetrical arrangement. Probably none of the motifs was original, and future research undoubtedly will reveal sources for most, if not all, of the figures on the quilt. Typical Aesthetic Movement motifs, such as cranes, owls, and butterflies, intermingle with Kate Greenaway-style children, scenes from Currier & Ives prints, and a number of patriotic and political designs.

Perhaps the most historically interesting motifs on this quilt top are two coal scuttles that can be found to the right of the center. One, depicted with a shovel in its arm, is inscribed "Poor man's empty scuttle in December the 25, 1902." The other says "Rich man's full scuttle in December the 25, 1902." These cartoon drawings probably refer to the strike by the United Mine Workers against their employers, members of the anthracite coal monopoly. The work stoppage caused a coal shortage throughout the nation in the winter of 1902–1903. The strike was settled in 1903 when President Roosevelt called for impartial arbitration that granted the miners shorter hours and a wage increase.[28]

Many of the historical figures on this quilt top can also be traced to printed sources.[29] The scene at the top right of the quilt that includes a large figure of a man on a staircase while two smaller men hold rifles is an almost exact outline of the *Death of Col. Ellsworth*, a Currier & Ives print published in 1861 and reproduced here (fig. 73a). The story of Colonel Ellsworth must have been well known to anyone as

interested in American history as the maker of this bedcover. Elmer Ephraim Ellsworth was the commander of the U. S. Zouave Cadets (a volunteer regiment) in Illinois and a young law student in Abraham Lincoln's office when Lincoln was elected President. Ellsworth accompanied Lincoln to Washington, and when the Civil War broke out, he went to New York (his home state), where he recruited a regiment from the New York volunteer firemen and dressed them after the fashion of the French Zouaves. The regiment went to Washington where it was mustered into United States service. On May 24, 1861, during the occupation of Alexandria, Virginia, Ellsworth saw the Confederate flag flying over the Marshall House, a local hotel, and determined to remove it. He tore the flag off the roof, but as he descended the stairs with the flag in his arms, he was shot dead by the proprietor of the hotel, James W. Jackson, who in turn was shot by one of Ellsworth's escort. Ellsworth was young, handsome, and well known, and his death— the first of note to occur in the Civil War—produced a sensation in the country. It inspired many newspaper and magazine articles, as well as the Currier & Ives print.[30]

The figure on horseback between the two coal scuttles on the right side of the quilt also may have been copied from one of a number of Currier & Ives prints, although the prints themselves were based on an 1801 painting by Jacques Louis David entitled *Napoleon Crossing the Saint-Bernard*. The embroiderer simplified the scene, however, and eliminated the troops that are in the background of the painting and the prints.

She also simplified the print entitled *Indian Buffalo Hunt: Close Quarters*[31] for the figures that are found directly above the center medallion of the quilt. The scene on the quilt includes the main figures of the print—the Indians on horseback, the fallen buffalo— but eliminates the background.

A second equestrian figure, immediately recognizable as George Washington and found on the bottom of the quilt, possibly was copied from a photograph of a statue that the maker saw in a magazine. *Harper's Bazar* of May 19, 1900 includes a photograph of the statue by Daniel C. French and Edward C. Potter along with the article, "American Women's Gift to France." According to the article, the statue was presented to France by the Washington Statue Association "as a proof of the reverence in which the great Virginian is held by the women of this country, and of their grateful regard for a sister republic."[32]

The patriotic and military emphasis of this quilt is clear. A number of the military figures on the quilt have been identified by the maker as: "Jackson 1812," "Sheridan 1864," "Custer 1876," and "Roosevelt 1898," and were probably also traced from printed sources. Crossed flags and the motto: "In Honor Shall Wave," along with an image of Washington and the dates 1776 and 1876 are stitched on the top left corner, recalling the

73. IN HONOR SHALL WAVE SPREAD

Maker unidentified; Yonkers, New York; dated December 25, 1902;
cotton with Turkey red cotton embroidery; 86" x 73". Gift of
Elaine Sloan Hart, Quilts of America; 1989.20.1

73A. DEATH OF COL. ELLSWORTH

Published by Currier &Ives; 1861; lithograph. Print Collection:
Miriam and Ira D. Wallach Division of Art, Prints and
Photographs. The New York Public Library; Astor, Lennox and
Tilden Foundations

DEATH OF COL. ELLSWORTH,

Centennial celebration. The Great Seal of the United States, soldiers, cannons, and eagles also abound, and, in an unusual juxtaposition, are placed side by side with peaceful animals, birds, and flowers.

Although the motifs may not have been original, the maker of the "In Honor Shall Wave Spread" (fig. 73) showed some individuality in her combination and perhaps choice of designs and placement of them on the bedcover. Outline embroidered quilts commonly consist of more-pedestrian motifs, usually related by a common theme such as Mother Goose figures or biblical events (see the "Bible History Quilt," black-and-white fig. 25). Often, these were what are known as "Penny-Square" quilts, consisting of blocks of muslin stamped with designs for embroidery. The blocks, along with enough thread to complete the square, could be purchased for one cent at local dry-goods stores or at chain stores like Woolworth's that were becoming popular at the beginning of the twentieth century. When enough blocks had been purchased and embroidered, they would be sewn together into quilts, or table covers, or other textiles. Favorite motifs for penny squares included nursery rhymes, biblical stories, fairy tales and children's stories, historical and political figures, and famous buildings. After 1925, series patterns such as birds and flowers became popular subjects for outline embroidery. An example of this type of work in the Museum's collection is the "Botanical Embroidered Cover" (Catalogue #134), consisting of eighty-one separate squares of flowers surrounded by an embroidered vine.[33]

REVIVAL QUILTS

By the last quarter of the nineteenth century, the power of professional tastemakers to influence quiltmakers already was firmly established. As styles changed and Americans rejected what came to be seen as the excessive ornamentation of the late Victorian period, the makers of quilts again were guided by influential trendsetters who now urged them to look backward for inspiration. They were eagerly led in this search by a profusion of designers, editors, and manufacturers.

An interest in the American past had been sparked by the Philadelphia Centennial Exposition of 1876, where the New England Kitchen, furnished with a potpourri of antiques from various periods, was one of the more popular exhibits at the fair. This growing sense that the artifacts of Early America were worthy of attention coincided with a design style that was gaining in popularity at the turn of the century and that helped pave the way for the comeback of the cotton quilt. While the proponents of the Arts and Crafts Movement may not have set out to revive quilting, as they had embroidery and other handwork, "such a revival was, nevertheless, understandable as handmade crafts, the use of natural unadorned materials and simple, straightforward designs were championed."[1] The cotton quilts that were made before the onset of the popularity of silk and fine-wool show quilts were seen as precursors of Arts and Crafts simplicity and by the first decade of the twentieth century, patchwork quilts were defined as art objects—and collected as such—for the first time.

At the beginning of the twentieth century, the elaborate show quilts of the previous generation—like the portières, table covers, lambrequins and other "dust catchers" that they complemented—were seen as not just out of style, but actually unhealthful, promoting tuberculosis and other infectious diseases. In contrast, cotton patchwork quilts were viewed as the appropriate accessories for the new, "cleaner" decorating styles that drew their inspiration from a romanticized American past. Colonial-style houses, Cape Cod cottages, and rustic bungalows that recalled, however inaccurately, the Early American period, replaced the ornately trimmed Victorian buildings, and they were filled with furnishings that the editors of the popular journals believed our forefathers would have used for their decorating. As one 1912 article stated, "These quaint old Colonial beds are in great demand just now and there is nothing more suitable for a covering than one of these patchwork quilts."[2]

For some quiltmakers, the resurgence of interest in "old-fashioned" cotton quilts meant actually pulling the old textiles out of the trunks and attics where they had been stored and copying the original patterns as closely as possible. The "Star of Bethlehem with Satellite Stars Quilt" (black-and-white fig. 23) in the Museum's collection, for example, approximates a nineteenth-century quilt in its overall design, color, and choice of fabrics. It is only when the fabrics are examined closely that the use of synthetic fibers mixed with cotton is revealed and it is clear that the quilt was made in the twentieth century.

The maker of the "Tree of Life Cut-Out Chintz Quilt" (fig. 74) went even further back in time for inspiration, creating a twentieth-century version of the type of bedcover that had been popular in the late-eighteenth and early-nineteenth centuries (see Chapter 2). This flowering tree design was originally adapted from the palampores that were once imported from India, but by the 1920s or 1930s when this quilt was made, the seamstress was probably copying an antique bedcover that she had either seen or seen illustrated. She may also have been inspired by antique fabrics as some of the motifs in the center of the quilt were cut from chintz that was printed in the first half of the nineteenth century. Other fabrics, interspersed throughout the center field and the border, date from the early twentieth century. The combination of old and new fabrics gives this bedcover a jaunty air, and clearly marks it as a product of the revival period of quiltmaking.

Sometimes, the early-twentieth-century quiltmakers used a nineteenth-century example for inspiration, but changed colors or details either to suit the materials at hand, the maker's skills, or perhaps to make the quilt look more up to date. The "Bull's Eye Quilt" (fig. 75), made between 1900 and 1920 in Berks County, Pennsylvania, bears a strong resemblance to a mid-nineteenth-century quilt called "Compass" that was made in the same area and that is now in the collection

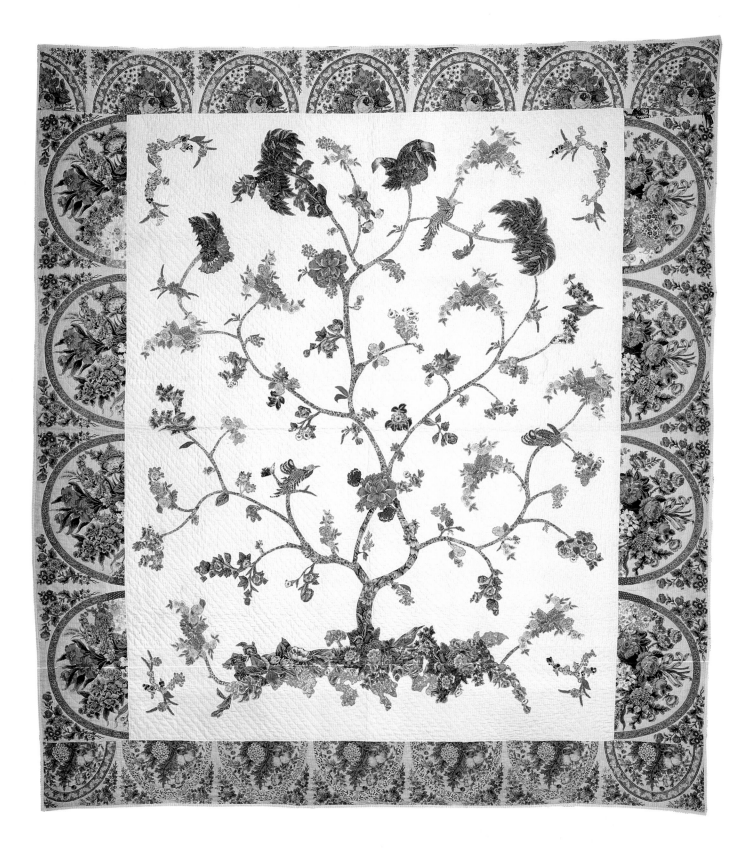

74. TREE OF LIFE CUT-OUT CHINTZ
QUILT

*Quiltmaker unidentified, initialed GMR; probably Wiscasset,
Maine; 1925–1935; cotton; 96" x 90". Promised gift of a Museum
friend; P1.1992.4*

of the Historical Society of Berks County.[3] Colors and some other components of the quilt have been changed (the nineteenth-century quilt has a white background and is more detailed) but the primary design elements—a large compass or "bull's eye" surrounded by tulips—is strikingly similar.

The "Bull's Eye Quilt" (fig. 75) is an example of a pattern that had a distinct regional distribution. Besides the nineteenth-century "Compass" example, four identical twentieth-century quilts made at the same time and in the same place—between Bechtelsville and Boyertown in Berks County—have been identified.[4] One of the quilts can be positively dated before 1916, as the maker died nine days after the birth of her fifth child in 1916. It is likely that the other three were made at about the same time, since all were made from the same fabrics, possibly purchased together.

The Museum's quilt had been attributed to Alverda Herb, the name that appears on a printed label sewn onto the back of the quilt. Local informants in the Bechtelsville-Boyertown area who remember Herb, however, attest to the fact that she "couldn't even sew on a button" and certainly would not have been able to make a quilt. Family members also confirmed that Herb never made any quilts. However, her mother, Sally Herb Heydt, made quilts and inherited others, and Herb's stepfather, Edgar Heydt, also inherited quilts from his family. Herb and her family often attached labels to their textiles to mark ownership or future bequests, and, in fact, two other quilts made of different patterns but in the same fabrics and with Herb's name tag on the back are still owned by relatives. Alverda Herb was known to have disposed of antiques and family belongings privately and at several public auctions. The auction list of Edgar Heydt's estate sale, held on Memorial Day, 1979, in Pottstown, Pennsylvania, includes a quilt described as a "Circle" that may very well be the Museum's "Bull's Eye."[5]

It has not been determined whether one of the makers adapted the "Bull's Eye" pattern herself from an earlier quilt or whether the pattern was published locally. While patterns for patchwork had been published in such magazines as *Godey's* since the first half of the nineteenth century, by the early twentieth century the periodicals of the day were actively catering to a quiltmaking audience. Some of the more upscale publications, such as *The Ladies Home Journal*, commissioned artists and designers to develop original quilt patterns. The most influential of these was Marie Daugherty Webster, who was an Indiana housewife and amateur quiltmaker when she was selected to be the first designer to have her quilt patterns featured in color in the *Journal* in 1911.

Marie Daugherty Webster was a self-educated though sophisticated woman who traveled widely and toured Europe in 1899, a time when the Arts and Crafts Movement was at its height in England and the

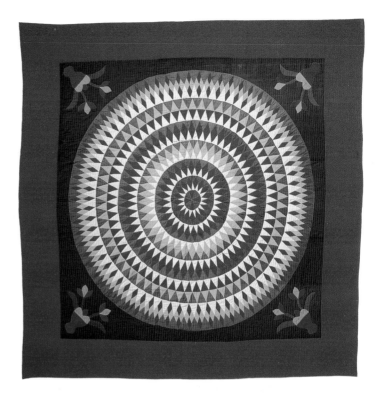

75. BULL'S EYE QUILT

Member of the family of Alverda H. (Hoffman) Herb; Berks County, Pennsylvania; 1900–1920; cotton; 84¹/₂" x 86". Gift of Jackie and Stanley Schneider; 1980.31.2

Continent. When she decided to make quilts, she found the popular designs of the late-nineteenth century not to her taste. She felt that they were cluttered, over-decorated, and often made in intense colors, and so she created her own patterns and used her own color palette. Her quilts featured a pastel color scheme that made use of the new shades that were then possible with improved synthetic dyes, distinct borders, and a medallion center that recalled quilts made a century earlier. Her flower garden was her primary inspiration, and she created appliqué poppies, irises, sunflowers, and other blooms in a new naturalistic style that clearly broke with late-nineteenth-century tradition.

Webster began publishing her designs in 1911, and her book, *Quilts, Their Story and How to Make Them*—the first entirely devoted to the study of quilts—originally was published in 1915 (and is still available). But it was not until the 1920s that her influence became widespread. Until then, twentieth-century quiltmakers were primarily using darker-hued calicoes to sew pseudo-Colonial scrap designs, and few were willing to purchase the relatively expensive, color-coordinated fabrics that Webster advocated. Further, her appliqué designs and those derived from them required more quilting skill and time than the traditional patchwork patterns.[6]

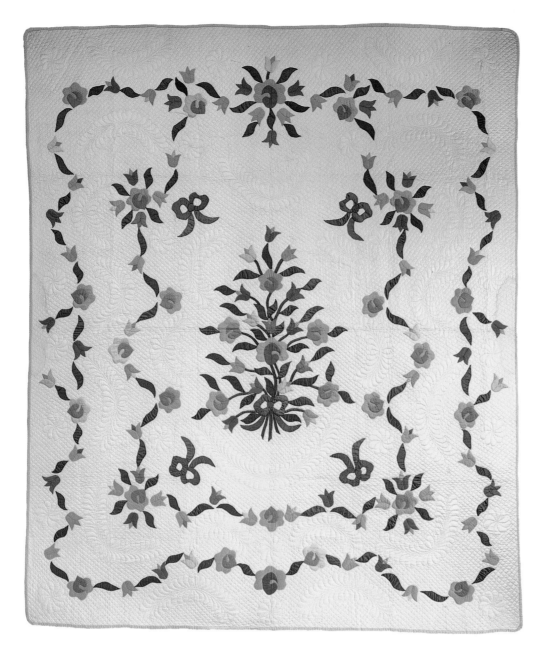

76. TULIP AND ROSE BOUQUET QUILT

Elizabeth Schumacher Leece (1867–1956); Kansas City, Missouri; 1930–1945; cotton; 100¼" x 84½". Gift of Marian Baer; 1984.11.2

76A. *Elizabeth Schumacher Leece*

For those who did follow Webster's innovative style, the results were quilts that exhibited a fresh, new twentieth-century look. The Museum's collection does not include any quilts that were made directly from her published patterns, although there are a number that were clearly influenced by her designs. Three of these—"Tulip and Rose Bouquet Quilt" (fig. 76), "Basket of Flowers Quilt" (fig. 77), and "Daisy Rings Quilt" (fig. 78)—were made by Elizabeth Schumacher Leece (see fig. 76a) of Missouri in the 1930s. All feature appliquéd floral designs on a background of white "Beauty Sheen," a cotton with a satin weave and glossy finish, and, according to the maker's granddaughter, "The quilts of Beauty Sheen were her works of art, used only when company came." Family history also states that they were made for entry in Missouri state fairs, where they all won prizes.[7]

Elizabeth Schumacher Leece clearly took Marie Webster's quiltmaking principles to heart. Webster urged her followers to do the finest work, "taking stitches so tiny that a magnifying glass would be required to discover them!"[8] Leece's granddaughter recalls that "her great pride was that she never used pencil or chalk to mark on the design—only traced a small section with a needle and quilted that before it faded out." And, indeed, the quilting is unusually intricate and elaborate and of the finest quality. Like Webster, Leece was also an avid gardener and was inspired to interpret the flowers she grew in her yard on her quilts. The designs she chose, possibly adapted from published patterns, also display Webster's influence. The "Daisy Rings" recalls the block formats of Webster's earliest quilts, while the "Basket of Flowers" and "Tulip and Rose Bouquet" are in the center-medallion style that Webster advocated beginning with her second group of designs for *Ladies Home Journal* in 1912.

Webster was also one of the first twentieth-century designers to create quilts specifically for children. The August 1912 issue of *Ladies Home Journal* included her last full-color feature for the magazine, entitled "Baby's Patchwork Quilt." Until the end of the nineteenth century, quilts made in crib or small sizes tended to be simply scaled-down versions of traditional designs. By the 1920s, however, magazines and pattern companies were marketing a wide variety of quilts with juvenile themes.

Some of the designs for crib quilts were taken directly from children's literature. The visual source of the figures on the "Gingham Dog and Calico Cat Crib Quilt" (fig. 79) has not been identified, but the words are from a 1911 poem by Eugene Field entitled "The Duel." The poem was very popular during the 1920s and 1930s and a number of toy and quilt patterns were based on the theme of a battling cat and dog.[9] The Museum's collection also includes an unfinished quilt top, "The Elephant's Child" (Catalogue #143), based on Rudyard Kipling's *Just So Stories*, that was sold as a kit for $5 through the *Woman's Home Companion* in February 1934. There is also a crib quilt that features one of the many versions of the ubiquitous appliqué children known as "Sunbonnet Sue" and "Overall Sam" (Catalogue #147), designs that evolved from illustrations originally created by Kate Greenaway in the late nineteenth century.

Three other quilts in this chapter also exhibit the innovations that Marie Webster helped introduce to quiltmaking at the beginning of this century. Both the "Roses and Ribbons Quilt" (fig. 80), by an unidentified quiltmaker and "Dogwood Appliqué Quilt" (fig. 81), made by member of the Ladies' Aid Society of the Hoag's Corner, New York, Methodist Church, are in the center-medallion style Webster promoted, although the dogwood blossoms cross the center in an asymmetrical, Oriental-inspired manner. This quilt's elegant, overall floral design, probably adapted from a published source, recalls the crewel-work spreads and palampores that were used as bedcovers in the eighteenth century and is therefore, perhaps, more authentically "Colonial Revival" than many of the other designs sold for neo-Colonial decorating.

The "Magnolia Blooms Quilt" (fig. 82), also a floral appliqué on a white background, was made from a pattern (and possibly a kit) provided by the Mountain Mist batting company, one of the many sources for quilt designs that proliferated in the first years of the twentieth century.[10] As discussed in Chapter 7, quilting supplies and designs could be ordered by mail by the late nineteenth century. The Ladies Art Company—believed to be the first mail-order quilt pattern company—was founded in St. Louis in 1889. By the early twentieth century, however, providing patterns, kits, and even finished quilts for the quilt revival had become big business.

In keeping with the fad for all things with an Early American pedigree, many of the mail-order companies (as well as newspapers and magazines with syndicated sewing columns) invented fictional grandmas and aunts who assured buyers that their patterns were authentically Colonial. "Grandma Dexter," for example, was the fictitious designer of the Virginia Snow Studios, and "Grandma Clark" advertised the patterns of the W.L.M. Clark Company. "Aunt Martha," who published the pattern for the Museum's "All American Star Quilt" (fig. 83), wrote a syndicated newspaper column for Colonial Patterns, Inc., of Kansas City, Missouri. While some of the designs created by these and other companies were original, many were adaptations of traditional quilt designs, sometimes with a new name.

Both the "Ladies' Dream Quilt" (fig. 84) and the "Rose of Sharon with Flower Pot Border Quilt" (fig. 85), made by Mary Etta Bach, are examples of traditional mid-nineteenth-century floral appliqué designs that were revived and updated by pattern companies for a twentieth-century market. Both even may have been packaged as kits. "Ladies' Dream," sold by mail order by Mrs. Scioto Danner of Kansas, was marketed as a copy of a quilt that had been in the same family for six

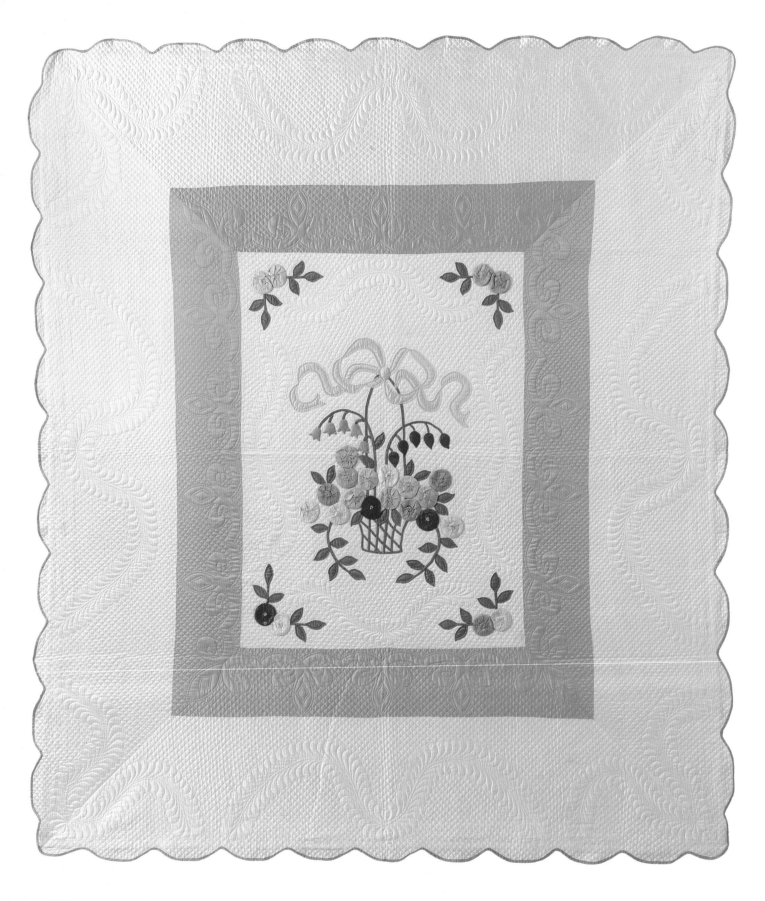

77. BASKET OF FLOWERS QUILT

Elizabeth Schumacher Leece (1867–1956); Kansas City, Missouri;
1930–1940; cotton, with cotton embroidery; 95¹/₂" x 84". Gift of
Marian Baer; 1984.11.4

78. DAISY RINGS QUILT

Elizabeth Schumacher Leece (1867–1956); Kansas City, Missouri; 1930–1945; cotton; 99¾" x 81¾". Gift of Marian Baer; 1984.11.3

79. GINGHAM DOG AND CALICO CAT CRIB QUILT

Quiltmaker unidentified; probably Pennsylvania; 1920–1930; cotton; 33½" x 27½". Gift of Gloria List; 1979.35.1

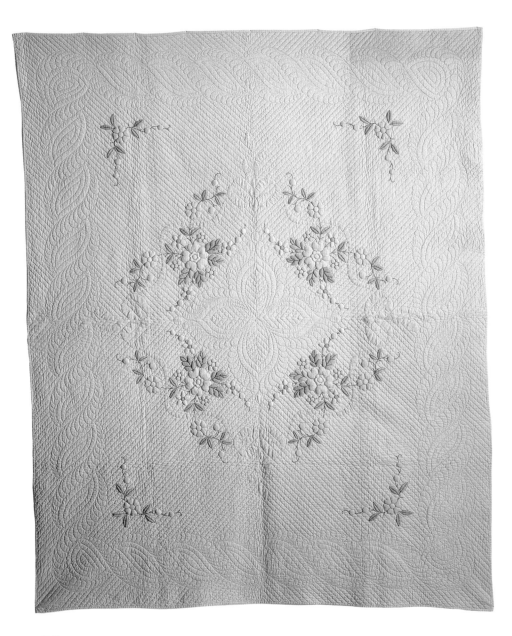

80. ROSES AND RIBBONS QUILT

Quiltmaker unidentified; United States; 1930–1940; cotton; 88" x 74". Gift of a Museum friend; 1995.13.6

81. DOGWOOD APPLIQUÉ QUILT

Ladies Aide [sic] Society of the Methodist Church; Hoag's Corner, New York; 1925–1935; cotton, with cotton embroidery; 92" x 78". Gift of Lorraine Slighter; 1991.16.1

82. MAGNOLIA BLOOMS QUILT

Quiltmaker unidentified; United States; 1930–1940; cotton, with cotton embroidery; 90" x 76". Gift of a Museum friend; 1992.28.3

83. ALL AMERICAN STAR QUILT

Quiltmaker unidentified; New York State; 1940–1945; cotton; 87" x 72". Gift of a Museum friend; 1987.17.2

84. LADIES' DREAM QUILT

Mary Etta (Mrs. Edward Emmet) Bach (1872–1974);
Philadelphia, Pennsylvania; 1930–1940; cotton; 84½" x 84½".
Bequest of the estate of Mildred P. Bach; 1992.27.1

85. ROSE OF SHARON WITH FLOWER POT BORDER QUILT

Mary Etta (Mrs. Edward Emmet) Bach (1872–1974);
Philadelphia, Pennsylvania; 1930–1950; cotton; 93¾" x 77¾".
Bequest of the estate of Mildred P. Bach; 1992.27.2

generations. The pattern's reputed well-documented heritage made it a best seller in the 1930s.[11] Like the many "Grandmas" and "Aunts" of the period, however, such claims often proved to be fictional.

The floral blocks of the "Rose of Sharon with Flower Pot Border Quilt" (fig. 85) also were probably copied from a nineteenth-century textile: The basic design is illustrated in the historic section of *The Romance of the Patchwork Quilt in America*, originally published in 1935 by Carrie Hall and Rose Kretsinger.[12] The design was then updated by combining the traditional blocks, which are smaller than is typically found on nineteenth-century quilts, with potted vine borders.

Mary Etta Bach of Philadelphia, the maker of these quilts, was obviously a skilled seamstress. The "Ladies' Dream Quilt" combines conventional and reverse appliqué work, while the "Rose of Sharon" centers are made in the raised appliqué method. Both these quilts, as well as the examples of her pieced work that are included here, "Pinwheel Sunflower Quilt" (fig. 86) and "Fans Quilt" (fig. 87), exhibit precise, careful stitching and an attention to detail that Marie Webster would have applauded.

According to a local Philadelphia newspaper article published in 1947, Mrs. Bach began her quiltmaking in the early 1930s when she was confined to bed following an operation. Her daughters thought she would enjoy sewing a quilt as "Mother had always admired quilts and been sorry she hadn't inherited any."[13] Her daughters were right, and Mrs. Bach "became so fascinated with quilting that she kept at it almost every minute of her spare time until the war cut off her supply of materials." By that time, she had finished twenty-six bedcovers, even though quilting had to compete with her other hobby—fishing—during the summer.[14]

Both the "Pinwheel Sunflower" and the "Fans" are examples of what are commonly called "scrapbag" quilts, as the makers combined small pieces of fabrics in a variety of different colors and prints. Unlike the dark-hued scrap designs mentioned above that were popular at the beginning of the century, by the middle of the 1920s quiltmakers were opting for light, bright fabrics that they would typically combine on a white or pale background. The wide range in colors and textile designs was made possible by post-World War I improvements in synthetic dyes and new technology for printing them,[15] and the availability of cotton that was inexpensive and produced in a greater variety of prints and weights than ever before. Some scrap patterns, such as the "Fans," or the "Double Wedding Ring," discussed below, were so suited to this great new variety of fabrics that they "became fads that are still with us."[16]

As she did for her appliqué quilts, Mary Etta Bach undoubtedly used commercial patterns—or even kits—for her pieced quilts. The "Pinwheel Sunflower Quilt" (fig. 86) appears to be an adaptation of a pattern produced by Needlecraft Service of New York, a mail-

86. PINWHEEL SUNFLOWER QUILT

Mary Etta (Mrs. Edward Emmet) Bach (1872–1974);
Philadelphia, Pennsylvania; 1930–1950; cotton; 97¹/₂" x 77".
Bequest of the estate of Mildred P. Bach; 1992.27.5

order company that was started in 1933 and is still in business. The pinwheel flowers have been turned so that they form groups of four, rather than the straight rows of flowers in the original design.[17] The "Fans" pattern, however, is so common that it is probably impossible to identify the exact source. Frequently, many companies offered what were basically the same designs, with perhaps just a detail or two changed. Like the "Ladies' Dream," however, a number of the quilts in the Museum's collection can be firmly attributed to specific pattern companies.

The blocks of potted flowers that comprise the "English Flower Garden Quilt" (fig. 88), for example, were designed by Ruby S. McKim and published in

87. FANS QUILT

Mary Etta (Mrs. Edward Emmet) Bach (1872–1974);
Philadelphia, Pennsylvania; 1930–1950; cotton; 96" x 84".
Bequest of the estate of Mildred P. Bach; 1992.27.6

Capper's Weekly Quilt Block Service in 1929 and the *Kansas City Star* in April, 1930.[18] It also was included in McKim's 1931 book, *101 Patchwork Patterns*, where it was described as "A quilt which is as picturesquely English as Anne Hathaway's cottage."[19] McKim, one of the best-known designers of the period, was a graduate of the Parsons School of Design in New York, a syndicated columnist, and the art-needlework editor for *Better Homes and Gardens*. Along with her husband, she also operated the McKim Studios of Independence, Missouri, a mail-order pattern company, and is renowned today for her series of Art Deco-inspired flower patterns.

The "English Flower Garden Quilt" (fig. 88) as it appears here was not, however, totally designed by Ruby McKim. The maker of the quilt, Jennie Pingrey Stotts of Yates Center, Kansas, combined McKim's design for the blocks with a border created by McKim's successor at the *Kansas City Star*, Evaline Foland. Stotts also added her own small touches to the design. She followed McKim's suggestion for green-and-white gingham flower pots, but added an orange stripe across the top of each pot. Her flower centers are orange rather than the yellow or green ones originally called for in the pattern.

The maker of the "Bible History Quilt," (black-and-white fig. 25) also added her individual touch to an embroidered quilt that was made following designs by Ruby S. McKim. McKim's original twenty-block quilt pattern was sold as transfers for outline embroidery.

88. ENGLISH FLOWER GARDEN QUILT

Jennie Pingrey (Mrs. Charles O.) Stotts; Yates Center, Kansas; 1930–1935; cotton; 95" x 77³/₄".

Gift of a Museum friend; 1987.17.1

The unidentified maker of the Museum's quilt added three other scenes from the Old Testament in the bottom row and probably also designed her own setting for the blocks as the McKim pattern did not have the type of "brick work" set seen on this quilt.[20]

The "Calico Cat Quilt" (fig. 89) is another well-documented pattern from the same period. It was published in syndicated newspaper columns under the names Laura Wheeler and Alice Brooks, both pseudonyms used by Needlecraft Service. To obtain the pattern, readers would send money to either the local newspaper that carried the column or directly to the company in New York. In this example, the maker of the quilt used printed muslin feed sacks as the background diamonds for some of the white kittens. This common practice was promoted by the cotton-bag manufacturers, who, in the mid 1930s, were faced with increased competition from the makers of paper bags. To give their bags more consumer appeal, the cotton-bag makers printed them in floral and geometric

89. CALICO CAT QUILT

Quiltmaker unidentified; possibly Kentucky; 1930–1945; cotton, with cotton embroidery; 83" x 67". Gift of Laura Fisher, Antique Quilts and Americana; 1987.8.1

designs and advocated their use for home-sewing projects, including quilts.

The "Embroidered Floral Appliqué Quilt" (fig. 90) is an example of another type of quilt that was made from mail-order designs. The Rainbow Quilt Company, founded in Cleveland in the 1920s and also still in existence, specialized in stamped blocks that could be sewn together to form a quilt, as well as complete kits that included all the fabric for the quilt. (Another example of a Rainbow stamped pattern for embroidery is the "Embroidered Double Wedding Ring Quilt," black-and-white fig. 26.) All of the blocks in the "Embroidered Floral Appliqué Quilt" (fig. 90), such as the "Poppy," "Poinsettia," "Cardinal and Morning Glory," and "Water Lily Circle," were Rainbow stamped patterns that combined appliqué with embroidery.

While many of the quilt designers of the Revival period relied on the past—real or imagined—for their inspiration, some of the designers were drawing on contemporary sources. By the end of the 1920s, the Art Deco style (originally called Art Moderne or simply Moderne) was gaining popularity in America, due to the *Exposition des Arts Décoratifs et Industriels Modernes* that was held in Paris in 1925. In designs for industry, fashion, and home furnishings, geometric and rectilinear shapes were beginning to replace the graceful curvilinear and asymmetrical designs of the Art Nouveau style. In quilts, this translated to both pieced and appliquéd examples with a geometric, abstract, almost Cubist look.

The Art Deco designs adapted for quilts tended to incorporate straight lines, hard edges, and motifs of zigzags, rays of light and checkerboards. This feeling of power, or what has been called "art imitating machines" rather than nature,[21] can be seen in two of the Museum's quilts from this period. The "Star of France Quilt" (fig. 91), believed to have been inspired by a military decoration of the Napoleonic era, is a pieced and appliquéd design that was pattern number 151 from H. Ver Mehren's Home Art Studios of Des Moines, Iowa. The maker employed a typical Art Deco palette of four shades of yellow sateen—the color scheme suggested by the designer—although it was noted in the pattern that four shades of blue, orchid, or pink would also be suitable.[22] At least one example of this pattern in a combination of the suggested colors has also been found.[23]

The "Compass and Wreath Quilt" (fig. 92) is a pieced and appliquéd quilt that combines traditional patterns with Art Deco-inspired motifs and colors. A black-and-red color combination that draws attention to its radiating points gives the "Mariner's Compass" in the center of the quilt a new, twentieth-century look. This center compass is echoed by the red inner border that also contains red and black compass points that project into the field. In between the compass and the border are two traditional nineteenth-century elements: a red-and-green holiday wreath and a garland

90. EMBROIDERED FLORAL APPLIQUÉ QUILT

Quiltmaker unidentified; United States; 1930–1940; cotton, with cotton embroidiery; 81" x 81". Gift of a Museum friend in honor of Thos. K. Woodard and Blanche Greenstein; 1993.6.4

of flowering vines. The maker of this quilt may have used a still unidentified published pattern, or she may have mixed a variety of elements to produce a bedcover that simultaneously recalls the red-and-green floral appliqués of the nineteenth century and the machine-inspired motifs of the twentieth.

The "Century of Progress Quilt" (fig. 93), made for entry in the Sears, Roebuck-sponsored contest at the 1933 Chicago exposition, includes not just the machine-inspired motifs of the Art Deco period, but literal depictions of some of its modern technological advances as well. A representation of the replica of Fort Dearborn, one of the first attractions erected on the fair site, comprises the central panel of the quilt. For several months before the fair opened, Chicagoans were invited to tour the fort, and it is an image frequently found on the Century of Progress commemorative quilts.[24] This reminder of Chicago's first days (the fort

91. STAR OF FRANCE QUILT

Quiltmaker unidentified; United States; 1930–1940; cotton; 81³/₄″
x 81³/₄″ framed. Gift of Cyril Irwin Nelson in honor of Robert
Bishop, Director of the Museum of American Folk Art; 1990.17.4

92. COMPASS AND WREATH QUILT

Quiltmaker unidentified; Pennsylvania; 1930–1935; cotton with
cotton embroidery; 78¹/₂″ x 88³/₄″. Gift of Shelly Zegart; 1994.12.2

was established in 1803) is bordered on two sides by radiating streaks of yellow and white that recall the "Star of France Quilt" (fig. 91). Above these, a covered wagon and an airplane illustrate the "Century of Progress" theme, as do the buildings on the bottom row. The log cabin on the left may represent the home built by Jean Baptiste du Sable, an African-American from Santo Domingo, that was purchased in 1804 by John Kinzie.[25] On the right is the Travel and Transport Building, the first building erected at the fair site; Chicago's skyline stretches between the depictions of the city's past and present.

Quilt competitions had existed, primarily on the local or state level, since the middle of the nineteenth century. But the nearly 25,000 entries received for the "Century of Progress" contest showed just how far the tradition of making quilts had "revived" by the end of the first third of the twentieth century. Part of the incentive for entering the contest was undoubtedly the $1,000 first prize—a substantial sum in Depression times. As advertisements for the contest announced, "Think What Winning the Grand Prize Would Mean."[26] The thrill of competing with fellow quiltmakers on a national level was no doubt also a part of the contest's appeal, and one that continues to this day (see Chapter 11). It is interesting to note, however, that while many of the entries, like the Museum's example, explored the theme of the contest (a bonus prize of $200 was offered if the top quilt was an "original design commemorating the Century of Progress Exposition"[27]), the grand prize winner was a traditional "Eight-Point Combination Feathered Star," and the runner up was "Colonial Rose," a pastel appliquéd design in the manner first advocated by Marie Webster.

As the Art Deco style evolved, quilt designs began to lose some of their hard edges and exchange straight lines for curves. Once again, the impetus for change came from the industrial world, which by the mid-1930s was streamlining everything from automobiles to toasters. Many of the popular quilt patterns of the period also emphasized curves, including "Dresden Plate," "Grandmother's Flower Garden," and "Double Wedding Ring,"[28] the most numerous pattern in the Museum's collection.[29]

There has been great discussion in the quilt literature regarding the origin of the "Double Wedding Ring" design, much of it reviewed in a previous Museum publication, *The Romance of Double Wedding Ring Quilts* (1989). In short, the argument has involved whether the pattern dates from the nineteenth or the twentieth century. The Museum's collection includes a candlewick bedspread dated 1897 in the "Double Wedding Ring" pattern (black-and-white fig. 3) and a number of quilt historians[30] have placed the design in the late nineteenth century. Barbara Brackman has found the earliest dated and published patterns in the late 1920s and states that oral histories place the design in the early 1920s.[31]

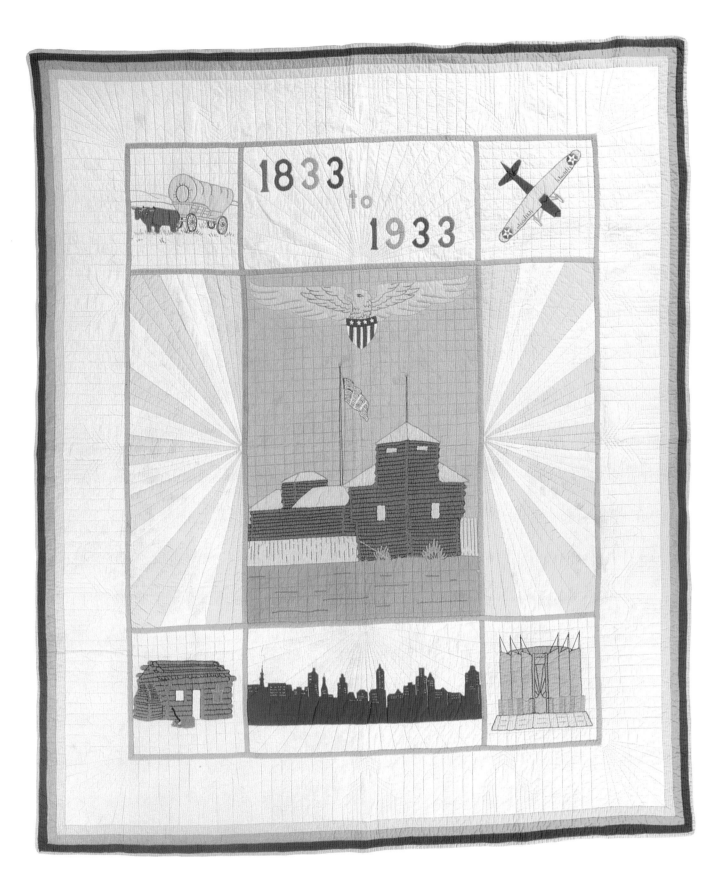

93. CENTURY OF PROGRESS QUILT

Quiltmaker unidentified; Ohio; dated 1933; cotton, with cotton embroidery; 88½" x 74¼". Gift of Shelly Zegart; 1995.26.1

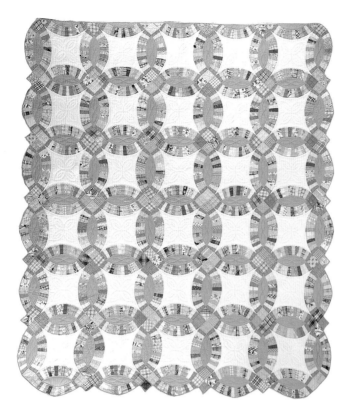

94. DOUBLE WEDDING RING QUILT

Quiltmaker unidentified; United States; 1935–1945; cotton and blends; 96¼" x 83". Gift of Robert Bishop; 1993.4.9

95. DOUBLE WEDDING RING QUILT

Quiltmaker unidentified; United States; 1940–1950; cotton; 84½" x 83" framed. Gift of Robert Bishop; 1993.4.14

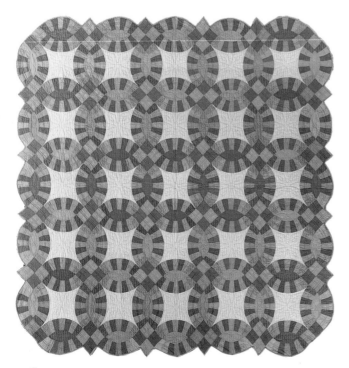

A possible explanation for the divergent theories regarding the origin of this pattern is that the "Double Wedding Ring," as it was marketed in the twentieth century, was an updated version of a design that already existed—although perhaps in slightly different formats—in the nineteenth century. As discussed above, designers, manufacturers, and needlework editors were all looking to the American past for inspiration for their quilt designs. The "Hexagon" or "Honeycomb" pattern of the early nineteenth century became the "Grandmother's Flower Garden" of the twentieth century. "Dresden Plate," essentially a variation of the nineteenth-century "Fans" pattern, also can be found in the quilts made in the 1880s. The Museum's "S. H. Crazy Quilt" (fig. 67), for example, includes a "Dresden Plate" design. The "Fans" pattern itself retained its popularity, although with updated colors and fabrics, well into the twentieth century.

A pieced quilt, made between 1830 and 1850 and in the collection of the Winterthur Museum,[32] bears a striking resemblance to the pattern called "Double Wedding Ring" today, as do some versions of the nineteenth-century pattern known as "Orange Peel," which can be made as either a pieced or appliqué design. A number of other nineteenth-century quilts displaying what is essentially the interlocking rings motif also can be identified in both pieced and appliqué work and under a number of different names.[33] In all probability, the pattern makers of the twentieth century, looking for designs they could market as "authentically Colonial," adapted one or more of the nineteenth-century examples. To make it acceptable to the quiltmaker of the 1920s, the colors were updated, the edges were rounded off—scalloped borders were especially popular during this period—and the suggested backgrounds were white or pastels.

Because the Museum's collection of Double Wedding Ring quilts is so extensive (fifty-nine quilts), there is the opportunity to examine the many variations possible in overall design, materials, and color. Some of the variations show the input of published sources, but many were the results of individual quiltmakers who were adapting the basic pattern to their own quilting skills, fabrics, and taste. And as the Double Wedding Ring quilt gained in popularity and different pattern companies sought to market the design, a variety of names were applied to it and the many variations on the basic theme. Thirty-eight different types of Wedding Ring quilts were identified by Robert Bishop in *The Romance of Double Wedding Ring Quilts,*[34] and this list does not include individual variations that were devised by inventive quiltmakers.

One of the commonest types of Double Wedding Ring quilts in the Museum's collection is figure 94, created by an unidentified quiltmaker probably between 1935 and 1945. The pastel colors and small, subtle prints set against a white background comprise the

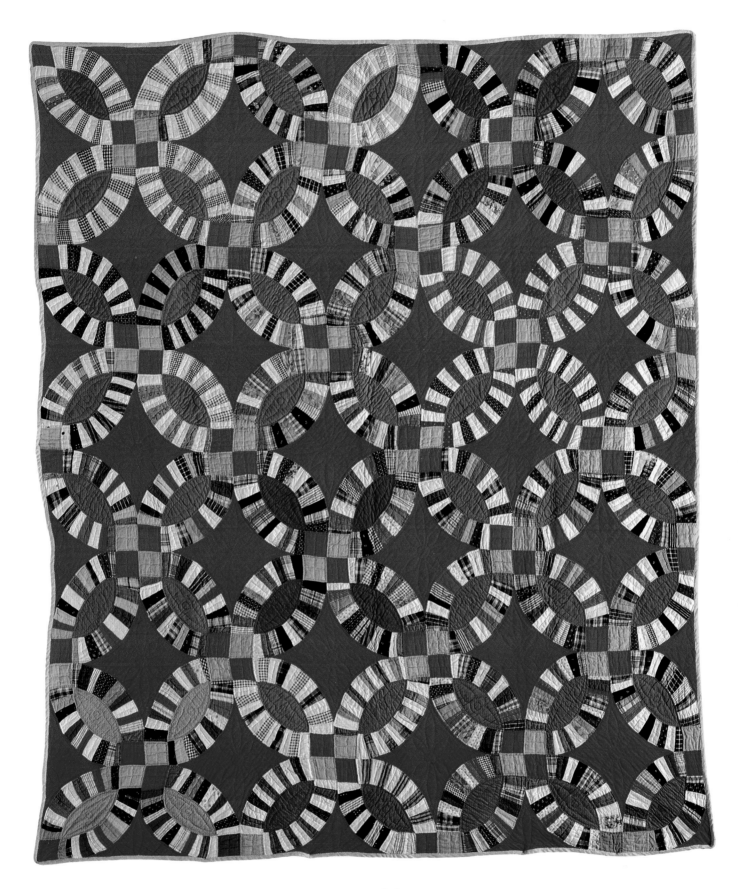

96. DOUBLE WEDDING RING QUILT
Quiltmaker unidentified, possibly African-American; probably Georgia; 1930–1940; cotton; 86¼" x 72" framed. Gift of Robert Bishop; 1993.4.19

97. AMISH DOUBLE WEDDING RING QUILT

Susie (Mrs. Harry) Bontrager (d.1954); Yoder, Kansas; 1935–1945; cotton and synthetics; 95¹/₂" x 78¹/₂" framed. Gift of Robert Bishop; 1990.25.18

98. GOLDEN WEDDING RING QUILT

Quiltmaker unidentified; United States; 1934–1940; cotton; 81¹/₄" x 72¹/₂" framed. Gift of Robert Bishop; 1993.4.3

99. INDIAN WEDDING RING QUILT

Quiltmaker unidentified; United States; 1935–1945; cotton;
82¹/₂" x 70³/₄" framed. Gift of Robert Bishop; 1993.4.38

100. FRIENDSHIP KNOT QUILT

Quiltmaker unidentified; United States; 1945–1960; cotton and cotton blends; 87" x 75½" framed. Gift of Robert Bishop; 1990.25.19

most expected and easily identified color scheme of the period. This quilt obviously was well-planned, but whether by the maker on her own or with the help of a published pattern cannot be determined. A scalloped edge is used on three sides; the straight edge at the top would probably have been covered by the pillows at the head of the bed. The pale green surrounding the intersections visually connects with the border, providing a unified appearance to the quilt.

Figure 95 is also a pastel-toned quilt with scalloped borders, but the use of solid-colored fabrics gives the quilt a stronger, bolder look. This quilt also has been well-planned. The two center rows have been pieced with blue lozenges placed vertically and green lozenges horizontally in the exact middle of the quilt, focusing the eye immediately. All of the rings are pieced with the colors in the exact same order and all of the intersections are a four-patch made up of two blue and two gold diamonds.

An even bolder example of the pattern is figure 96, believed to have been made by an African-American quiltmaker in Georgia between 1930 and 1940. Pale pastels have been almost totally foregone in this quilt, which is composed of rings pieced in alternating dark and light fabrics, solid red and gold intersections, and tan lozenges (except for the lower left corner), all set

against a vibrant red background. In some places, the selection of fabrics for the rings is strong (black and gold; red and white) and in other places muted, creating a feeling of improvisation in the overall design that is often cited as a characteristic of African-American quiltmaking (see Chapter 10).

Susie Bontrager, an Amish quiltmaker from Yoder, Kansas, also used solid-colored fabrics in her unusual Double Wedding Ring quilt (fig. 97), although her choice of materials was determined by the Amish proscription against patterned fabrics (see Chapter 9). Mrs. Bontrager's quilt is a combination of both typical Amish characteristics and elements of quiltmaking in the outside world in the 1935 to 1945 period. While the overall pattern is "Double Wedding Ring," the rings are composed of "Nine Patch" blocks, a common Amish design. As is typical of Amish quilts, the Double Wedding Ring pattern is confined to the central field which is surrounded by multiple borders. The selection of both light colors, including the pastel pink and white used for the borders, and the Double Wedding Ring design itself indicate the influence of the outside world on Amish quiltmaking by the middle of the 1930s.

Many of the Double Wedding Ring quilts in the Museum's collection are variations on the basic theme. To create the "Golden Wedding Ring Quilt" (fig. 98), the maker enhanced the typical design with broken, six-pointed stars in the center of each ring. The pattern was offered for sale in the October 1934 issue of *The Royal Neighbor*. The advertisement stated: "To attain the Happy Golden Wedding Day is one of the most important events in all lives. This new quilt pattern is dedicated to those who can look back over 50 years of happy married life."[35] A gold-and-blue color scheme emphasizes the anniversary theme of the quilt.

An appealing variation of the Double Wedding Ring design is the pattern that has been published as both "Pickle Dish" and "Indian Wedding Ring" (fig. 99). The *Kansas City Star* published Evaline Foland's "Pickle Dish" pattern in October 1931, calling it "A quilt with all the intrigue of the Wedding Ring and a still greater opportunity for effective color display. . . ."[36] The paper warned, however, "If you have made a successful Wedding Ring quilt try this one, but if you are a brand new quilter better stay with the simplier (sic) designs."[37]

The "Friendship Knot Quilt" (fig. 100), published by the *Kansas City Star* in January 1932,[38] is a more unusual variation on the Double Wedding Ring theme. Instead of overlapping, each of the rings is joined by touching half stars. In this example, the half stars are all a solid dark brown that contrasts strongly against the pastels of the rings and the cream of the background fabric. An optical illusion is created, focusing the eye on the diamonds formed between the touching stars rather than on the rings themselves.

The most unusual bedcover in the Museum's collection that includes the Double Wedding Ring motif is the "Sampler Quilt" (fig. 101), a melange of traditional

101. SAMPLER QUILT

Quiltmaker unidentified; United States;
1935–1945; cotton; 84" x 71³/₄" framed.
Gift of Robert Bishop; 1993.4.8

patterns that have been appliquéd onto a solid background. Both the large size and the placement of one of the Double Wedding Rings in the exact center of the quilt are indicative of the importance of this design during the Quilt Revival period.

The Double Wedding Ring pattern may have been (and continues to be) extremely popular, but it was by no means easy to execute. In *The Romance of the Patchwork Quilt in America*, Carrie Hall noted that "Real quilt enthusiasts delight in this all-over pattern, but it is hardly the design for the novice to undertake."[39] Contemporary quilt editor Bonnie Leman has written that "Making it successfully was something of a challenge, also, for women who needed to take their minds off their money troubles."[40]

Quilts of the 1910 to 1950 period often have been disparaged for their lack of originality and degenerated sewing skills.[41] Indeed, many were made using inexpensive fabrics in garishly dyed colors that wore out quick-

ly and that no longer please today's tastes. However, many of the examples in the Museum's collection are as distinguished by inventiveness, attention to detail, and precise workmanship as those made in previous centuries. Quiltmakers traditionally have shared patterns, both individually and through quilting groups or published sources, and just as traditionally they have adapted those designs to suit their skills and the prevailing fashions. Perhaps because there are so many more twentieth-century quilts extant than earlier examples, the repetition of patterns and the existence of substandard workmanship stands out. In general, poorly made eighteenth- and nineteenth-century quilts or those made in pedestrian designs simply were used up, and it is primarily the "best" quilts, the ones that were used for show or company, that have survived. For the period of the Quilt Revival, however, we are fortunate to have a great variety of bedcovers available for study.

AMISH QUILTS

The Amish quilt collection of the Museum of American Folk Art is important not only because it comprises a significant percentage of the total collection (117 out of 398 quilts), but also because it includes examples from most of the major Amish quiltmaking centers: Lancaster and Mifflin Counties in Pennsylvania; Ohio; and Indiana. This varied assemblage provides an opportunity to compare and contrast the quilting traditions of the different areas and, in the process, consider the ways of life in these communities that led to the creation of a distinctive style of American quilt.

All quilts—indeed all art—should be examined in the context of the society that produced the objects. Unfortunately, the particular community or culture that created a work of art (especially folk art) is often unknown or, at best, can only be assumed based on visual or anecdotal information. With Amish quilts, however, there is the opportunity to examine a category of objects with ample knowledge of the history—particularly the religious background—of the society that created those objects.

The history, sociology, and religion of the Amish have been fully discussed in many books.[1] It is, however, beneficial to bear some of this background in mind when looking at the quilts in the Museum's collection and considering why they are distinct from other forms of American quilts.

The Amish in America today are the descendants of the Swiss Brethren, part of the strong Anabaptist movement that followed the Reformation in the sixteenth century. The Amish rejected what they saw as the decadence of the Roman Catholic and Protestant churches of their day. Along with other Anabaptist sects they repudiated the iconography of these religions, including elaborate dress and ornate churches, and instead chose the simplicity of the early Christians as their model.

The Amish were followers of Jacob Amman (c.1644– c.1730), a Swiss Mennonite bishop who was so conservative that he severed his ties with the Mennonite church in the 1690s partly because he believed it was not strict enough in its practice of *Meidung*, or shunning those who deviate from the

Ordnung, or rules of conduct of the church. Amman's followers formed the group, later called Amish after him, that migrated to the Palatinate region along the Rhine, and to the Netherlands.

Harshly persecuted in Europe for their beliefs, the Amish began to migrate to America at the invitation of William Penn. The first group probably arrived with other "Pennsylvania Germans" in 1727 or 1737. During the Colonial period they settled on the rich farmland of Berks, Chester, and Lancaster counties in Pennsylvania, where they could continue the way of life they had left in Europe, and which they essentially lead today. The Amish attempt to keep themselves separate from the outside world, and they generally reject those modern conveniences, such as electricity, cars, telephones, and television, that they feel would bring them into contact with that world. Their style of dress, a fashion closer to eighteenth-century Europe than twentieth-century America, is also meant to distinguish them as a group apart.

The Amish, like other Germanic groups, did not bring a tradition of quiltmaking to America with them. Blankets, featherbeds, and woven coverlets were the more typical style of bedding. At some point in the nineteenth century, the Amish learned to make quilts from their "English" neighbors, which is what they call all people outside their sect. There are a very few Amish documents (mostly estate inventories) that mention quilts between the 1830s and the 1870s, but such quilts had to have been exceedingly rare, and only two known examples exist that can be dated before 1870. The quiltmaking tradition seems to have taken hold among the Amish in the 1870s and 1880s, and the majority of Amish quilts collected today were made between the 1880s and the 1960s.[2]

As befits their conservative lifestyle and their religious prohibition against naturalistic images, the earliest Amish quilts were made of large pieces of a single color fabric (either cotton or wool), much like the whole-cloth wool quilts made in the late eighteenth and early nineteenth centuries by "English" quiltmakers (see Chapter 1). By the end of the nineteenth century, these were followed by quilts with more colors and more design elements, although large, geometric pieces

of solid-colored fabric were still the norm. Until recently, in fact, all Amish quilts were based on geometric patterns, particularly squares, diamonds, and rectangles. The classic Lancaster County designs—"Center Square," "Diamond in the Square," and "Bars"—are examples of patterns that originated in the nineteenth century and continued to be made through the twentieth century, partly due to the conservatism of all aspects of Amish life.

LANCASTER COUNTY QUILTS

According to family history, the "Diamond in the Square Quilt" (fig. 102) in the Museum's collection was made by Rebecca Fisher Stoltzfus in the Groffdale area of Lancaster County in 1903. This pattern, unique to Lancaster County, is actually an Amish adaptation of the center-medallion style of quilt, popular among English quiltmakers in the first half of the nineteenth century (see Chapter 2). The Amish woman's selection of this outmoded style of quilt was not happenstance. According to quilt historian Eve Wheatcroft Granick, the choice of the old fashioned medallion style "seems to have been a deliberate attempt to make their quilts in accordance with Amish standards of nonconformity to 'English' fashion."[3]

This "Diamond in the Square Quilt" is composed of many typical Lancaster County features: The fabrics are fine quality, solid-color wools, since patterned material, although sometimes found on the back, was considered too "worldly" for quilt tops; the dimensions are square; and the center motif is surrounded by a narrow inner border and a particularly wide outer border, finished with proportionately large corner blocks.

This quilt, like a great many other Amish examples, also is characterized by stitching of exquisite quality. Although most Amish quilts were pieced together with a foot-powered treadle sewing machine (acceptable because it does not use electricity), they were typically quilted by hand. This example includes favorite Lancaster County motifs such as Quaker feathers in the outer border, pumpkin seeds in the inner border, and a wreath-star center. Less common are the fruit compotes stitched into the corner blocks. Quite possibly the realistic quilting motifs, such as the fruit compotes, were the maker's way of circumventing her society's prohibition against naturalistic designs. Fruits, flowers, baskets, and other non-geometric forms were often appliquéd onto the quilts of her "gay Dutch" and "English" neighbors. While the Amish generally rejected appliqués because they served no practical purpose, they may have felt it was acceptable to stitch many of the same designs into their quilts, satisfying themselves with the knowledge that their tiny, precise stitches were necessary to hold the backing, filling, and top together.

The "Bars Quilt" (fig. 103) illustrated here was quilted with many of the same motifs, including pump-

102. DIAMOND IN THE SQUARE QUILT

Rebecca Fisher Stoltzfus; Groffdale area of Lancaster County, Pennsylvania; 1903; wool, with rayon binding added later; 77" x 77". Gift of Mr. and Mrs. William B. Wigton; 1984.25.1

kin seeds in the narrow inner border and feathers in the large outer border. Instead of corner blocks in a contrasting color, however, the corners are separate pieces of the same red as the outer border and they are quilted with tulip designs. As is often found in the "Bars" pattern, the quilt is rectangular rather than square.

The two other Lancaster County bedcovers illustrated in this section, "Sunshine and Shadow Quilt" (fig. 104) and "Double Nine Patch Quilt" (fig. 105), are both examples of patterns that probably developed after the "Center Square," "Diamond in the Square," and the "Bars," in the later nineteenth or early twentieth century. The "Sunshine and Shadow" pattern still maintains the central focus of the "Diamond in the Square," but many small pieces of fabric have been used to compose the center element instead of a few large ones. The "Double Nine Patch" is a block-work pattern, popular in the outside world by the middle of the nineteenth century, but not seen among the Amish until much later.

Both the "Sunshine and Shadow" and the "Double Nine Patch" quilts have been quilted in a manner that supports the fact that they were probably made later than the other two quilts, most likely during the 1930s. The "Sunshine and Shadow" (fig. 104) is quilted with a

103. BARS QUILT

Quiltmaker unidentified; Lancaster County, Pennsylvania;
1910–1920; wool with cotton backing; 87¹/₄″ x 72¹/₂″. Gift of Mr.
and Mrs. William B. Wigton; 1984.25.2

104. SUNSHINE AND SHADOW QUILT

Quiltmaker unidentified; Lancaster County, Pennsylvania;
1930–1940; wool, rayon, and cotton; 83³/₄" x 82³/₄".
Gift of Mr. and Mrs. William B. Wigton; 1984.25.4

105. DOUBLE NINE PATCH QUILT

Quiltmaker unidentified; Lancaster County, Pennsylvania;
1930–1940; wool and wool-rayon blend; 79¹/₂" x 75³/₄".
Gift of Mr. and Mrs. William B. Wigton; 1984.25.5

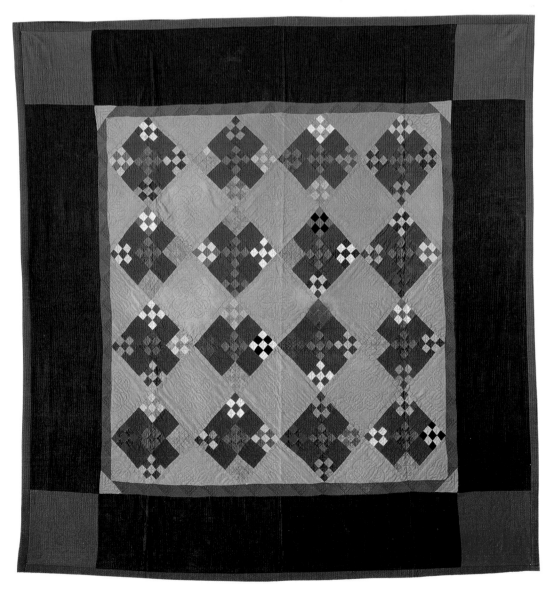

rose wreath around the border, a popular motif during this period.[4] The "Double Nine Patch" (fig. 105) has particularly elaborate quilting, including a floral vine in the outer border, a vase with three flowers in each of the corner blocks, and a snowflake motif in the plain blocks of the field. The traditional pumpkin seeds can be found in the solid brown blocks of the nine-patch design. The motifs are also double-stitched, a practice that was less common after the 1940s. According to Eve Granick, such elaborate and extensive quilting is evidence that a quilt was made in the 1920s or 1930s.[5] Both of these quilts, while primarily sewn of the fine wool that is typical of Lancaster County quilts made before 1940, also contain some rayon blends, pointing to a date closer to 1940.

It is in the beautiful, bold wool examples of Lancaster County that one is made particularly aware of the striking colors chosen by the Amish women for their quilts. While much of the color choice for a quilt was determined by the fabrics and dyes available at any particular time, community values and informal rules regarding the appropriateness of a specific color choice also influenced the maker's selections. It is sometimes confusing, therefore, to compare the bright colors of the quilts against the "plain" face that the Amish present to the outside world. However, since the Amish *Ordnung* does not specifically refer to quilts, the women were not prevented from combining the deep jewel tones and vivid pastels they favored with more expected—and somber—earth shades and other dark colors. And while the brightly colored fabrics often were purchased specially for quiltmaking, some Amish also still use pinks, blues, greens, and other bright colors for their clothing, particularly for children, although the vivid hues are frequently hidden beneath a black cape or jacket.

MIFFLIN COUNTY QUILTS

Mifflin County, Pennsylvania, and specifically the Kishacoquillas Valley ("Kish Valley" or "Big Valley" as it is commonly called), has been home to the Amish since the 1790s, when several families moved there from Lancaster and Chester counties. Currently, five separate and distinct Amish groups, all stemming from an original church that existed until the 1850s, occupy the Valley, and each maintains its own distinguishing rules, including those that encompass clothing colors and styles, buggy styles, housing styles and decoration, and quiltmaking.[6]

The Museum's collection includes quilts made by members of three of these Amish groups. In general, the simplest examples, such as the "Four in Split Nine Patch Quilt" (black-and-white fig. 28), tend to be those made by the Nebraska Amish, the most conservative group, not only in the Valley but in all of North America. As the example illustrated in this book suggests, four- and nine-patch variations were the only kinds of patterns permitted among the Nebraska Amish, and the color choices allowed the quiltmakers were also extremely limited. The fabrics used to make the quilts were usually left over from sewing the family's clothing, and were generally restricted to a palette of subdued natural shades. Quilts of the Nebraska Amish were intended to be functional, and reflect the conservatism inherent in all aspects of their makers' lives.

Two of the bedcovers illustrated here, "Four Patch in Triangles Quilt" (fig. 106), and "Four in Block-Work Quilt" (fig. 107) were made by members of the Byler Group, also called the "Yellow Topper" Amish because of the color of their buggy tops. (The Nebraska Amish are also known as the "White Topper" Amish.) The Byler church is slightly less conservative than the Nebraska Amish, as is evidenced by the use of some bright colors in the quilts included here. However, as is clear from the patterns chosen by the makers of these and other quilts from Mifflin County in the Museum's collection (Catalogue #s 239–250), four- and nine-patch patterns would appear to be the most popular designs among all the groups in the Big Valley.

Because the Mifflin County quilts in the Museum's collection were mostly collected directly from the families of the makers, many are accompanied by genealogical information that help both to date the quilts correctly and to give some overview as to the development of quiltmaking in the Big Valley. The "Four Patch in Triangles Quilt" (fig. 106), for example, was made by Barbara Zook Peachey (1848–1930), who married Abraham Z. Peachey in 1867. After his death in 1900, she lived with her son Abram D. Peachey, and made the quilt for her granddaughter, Katie M. Peachey Kanagy, between 1910 and 1920. Unlike Lancaster County, where wool was the fabric of choice for quilts, Mifflin County Amish quilts are commonly found in a variety of fabrics, and often the fabrics were mixed in a single quilt. This quilt is made of cotton and cotton sateen, and quilted with a simple overall grid pattern.

The "Four in Block-Work Quilt" (fig. 107) was made slightly later, probably between 1925 and 1935, by Annie M. Peachey Swarey, who also used a variety of fabrics in her quilt, including pieces of the newly available cotton/rayon. According to Eve Granick, the American Viscose Corporation opened a factory in Lewiston, Pennsylvania, in 1921, making rayon readily available to the Amish through a local outlet shop. Amish quilts from Mifflin County, therefore, often will show a characteristic use of this fabric much earlier than those made in other communities.[7]

The oldest Mifflin County quilts in the Museum's collection were made by members of a third Amish church in the Big Valley, the Peachey or "Black Topper" Amish. This group has been described as slightly more "liberal" than the other two groups discussed here,[8] and both of these quilts are examples of patterns that were common in the outside world, although their

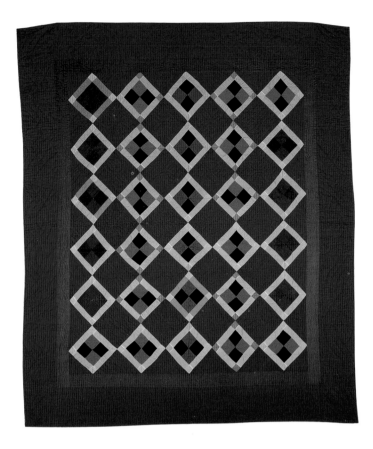

106. FOUR PATCH IN TRIANGLES QUILT

Barbara Zook Peachey (1848–1930); Yellow Topper Amish; Mifflin County, Pennsylvania; 1910–1920; cotton; 85½" x 78¾". Gift of Mr. and Mrs. William B. Wigton; 1984.25.12

107. FOUR IN BLOCK-WORK QUILT

Annie M. Peachey (Mrs. David M.) Swarey (b.1902); Yellow Topper Amish; Mifflin County, Pennsylvania; 1925–1935; Cotton, rayon, and synthetics; 85" x 72½". Gift of Mr. and Mrs. William B. Wigton; 1984.25.10

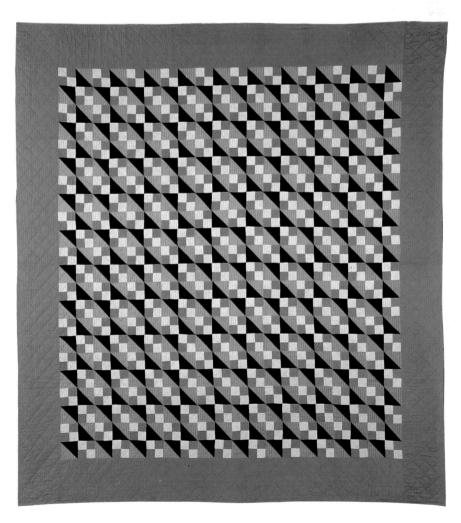

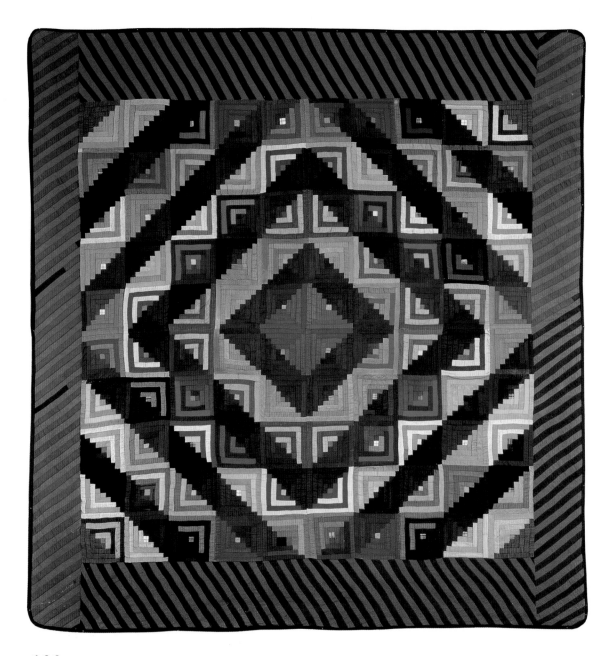

108. LOG CABIN QUILT, BARN RAISING VARIATION

Lydia A. (Kanagy) Peachey (1863–1949); Yellow Topper Amish; Mifflin County, Pennsylvania; 1890–1900; wool and cotton, with cotton backing; 85" x 80½". Gift of Mr. and Mrs. William B. Wigton; 1984.25.14

peak popularity among the "English" probably occurred at least a generation before they were adopted by the Amish. The "Log Cabin Quilt, Barn Raising Variation" (fig. 108) was made by Lydia A. (Kanagy) Peachey, probably between 1890 and 1900. As discussed in Chapter 6, wool and cotton Log Cabin quilts such as this became popular among most quiltmakers in the outside world in the 1860s, and by the end of the nineteenth century, when this example was made, were more likely to be "show" quilts made of luxurious and impractical fabrics such as silk.

The Log Cabin quilt shown here was made of both wool and cotton in rich, saturated colors that were particularly popular among the Peachey quiltmakers. Of special interest is the fact that there has been some minor use of patterned fabrics—checks and inconspic-

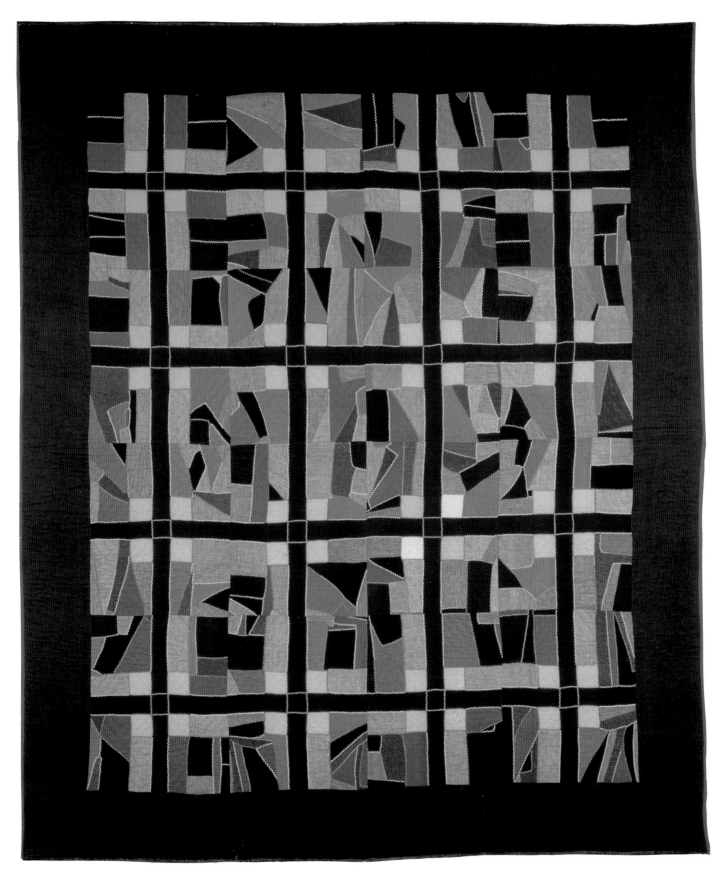

109. CRAZY PATCH QUILT

Leah Zook Hartzler; Black Topper Amish; Mifflin County,
Pennsylvania; 1903; wool and cotton, with cotton embroidery;
88" x 75". Gift of Mr. and Mrs. William B. Wigton; 1984.25.15

uous prints—on this quilt. As mentioned above, patterned fabrics are generally considered too worldly for use by the Amish. Occasionally, however, rather than wasting material, a small check or print that has been acquired in a bundle of fabrics will be used in a subdued way, such as for the tiny chimney of a Log Cabin block.

This quilt is also different from the Log Cabins found in the outside world in the nineteenth century because it was not foundation pieced as was typical for Log Cabins at that time (see Chapter 6). It was also entirely hand pieced, rather than pieced with a treadle sewing machine like the majority of Amish quilts.

The second Peachey Amish quilt in this section, the "Crazy Patch Quilt" (fig. 109), is also an Amish adaptation of a pattern common in the outside world at an earlier time. According to family history, the quilt was made by Leah Zook Hartzler for her sister, Lydia, on the occasion of Lydia's marriage to Daniel J. Yoder in 1903. As discussed in Chapter 7, Crazy quilts reached their peak of popularity in the 1880s. This remarkable example can be considered both an Amish woman's interpretation of a design that was already waning among quilt makers outside her community, and a quilt that is totally in keeping with the relatively narrow aesthetic parameters set by that community.

While obviously influenced by the fanciful silk-and-velvet Crazy quilts popular in the last quarter of the nineteenth century, the Amish maker of this quilt has imposed order and regularity on what is by definition a disordered and asymmetrical design. The Crazy patches are neatly set off by pumpkin-colored squares at the corners, and on close examination it can be seen that even the Crazy patches themselves are ordered by a traditional Mifflin County four-patch pattern. As is common for a Crazy quilt, this example also has been embellished with embroidery, although there is none of the elaborate stitching or fanciful designs found on those in the outside world. The embroidery work is limited to a single stitch, the herringbone, and it is used only to outline the individual patches. Furthermore, unlike typical Crazies among the "English" that are usually tied and often lack a filling, this is a real quilt, composed of three layers that have been joined together by a variety of quilting motifs, including shells, ropes, and chevrons.

MIDWESTERN QUILTS

By far the largest number of Amish quilts in the Museum's collection were made in the Midwest, particularly Indiana and Ohio. This reflects both the large settlements of Amish in these two states and the popularity of quiltmaking in these communities, as well as the fact that the Museum was the beneficiary of a generous gift of Indiana quilts in 1980.[9]

What may be the oldest Midwestern quilt in the Museum's collection, however, was probably made in one of the comparatively smaller communities.

Although there is no genealogical information to prove exactly where the "Center Star with Corner Stars Quilt" (fig. 110) was made, it resembles a group of quilts made in the Arthur, Illinois, community in the late nineteenth century. Previous publications have placed the quilt's origins variously in Ohio and Pennsylvania, but according to Eve Granick, the colors and wool fabric of this quilt are similar to other Arthur, Illinois, quilts made in the 1880s. This stable and prosperous community is known for the use of fine materials, a strong color sense, and unusual borders and piecing arrangements,[10] all of which can be seen on this uncommon quilt.

The oldest positively dated Amish quilt in the Museum's collection is the "Double Irish Chain with Zig-Zag Border Quilt" that was made in 1892 in Plain City, Ohio (black-and-white fig. 37). Although the quiltmaker has not been identified (the initials "J F" have been stitched into the quilt along with the date "M 1 1892"), it is known that the quilt was made as a gift for Nicholas R. Yutzy and Tena Hochstetler who were married on January 14, 1892, in Holmes County, Ohio. The couple had thirteen children, and the quilt remained in the family until it was purchased from one of their daughters, Ada Kaufman.[11]

As is typical of both nineteenth- and twentieth-century Midwestern Amish quilts, this "Double Irish Chain" is made entirely of cotton. The subdued brown and green earth tones of the quilt, however, were more popular during the nineteenth century, as were the rounded corners. The zig-zag border is a feature that is often found on Ohio Amish quilts.

The "Plain" or "Inside Border" pattern is also one that was favored by Ohio Amish quiltmakers, both for full- and crib-size quilts. The "Inside Border Crib Quilt" (fig. 111) shown here is somewhat unusual because the sawtooth border around the edge of the quilt has been appliquéd to the top. The inner border, pieced out of green and yellow triangles, is also particularly striking. As is typical of the "plain" patterns, the quilting on both the crib quilt and the full-size "Double Inside Border Quilt" (fig. 112) shown here is of the finest quality. Each combines a variety of quilting designs with meticulous stitching that is shown to best advantage by the solid-color backgrounds.

The Museum's collection also includes a "Plain" quilt from Ohio (Catalogue #330) that is neither a crib nor a full-size quilt, but rather a long and narrow shape (67" x 31½"). This very simple, somber textile (gray with black borders) was probably a "lounge quilt," made for the small, usually narrow, day beds that were once used in Amish living rooms in place of upholstered sofas.[12] A "Double Nine Patch Quilt" (Catalogue #329) in the collection was made in a similar size and was probably also used as a lounge quilt.

Perhaps the greatest difference between Amish quilts made in the Midwest and those made in Pennsylvania is the increased number of patterns that are found in the Midwest, both those borrowed from

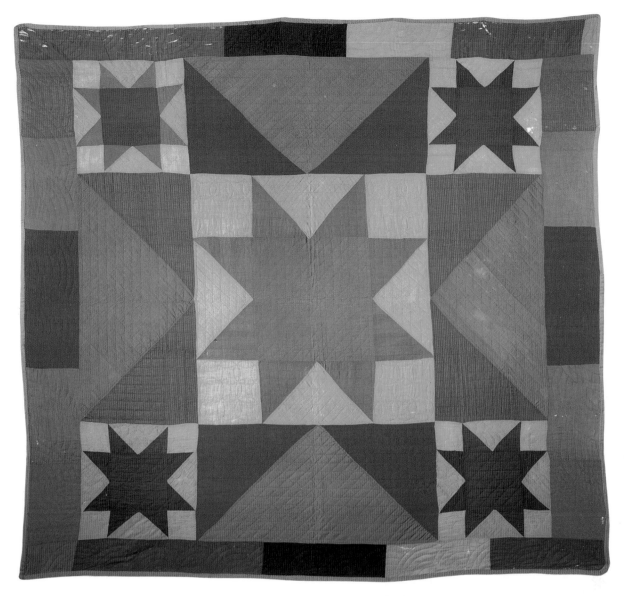

110. CENTER STAR WITH CORNER STARS QUILT

Unidentified member of the Glick family; probably Arthur, Illinois; 1890–1900; wool, with cotton backing; 76³/₄" x 82¹/₂". Gift of Phyllis Haders; 1985.3.1

111. INSIDE BORDER CRIB QUILT

Quiltmaker unidentified; Midwestern United States; 1925–1935; cotton; 56" x 44³/₄". Gift of George and Carol Henry; 1991.12.1

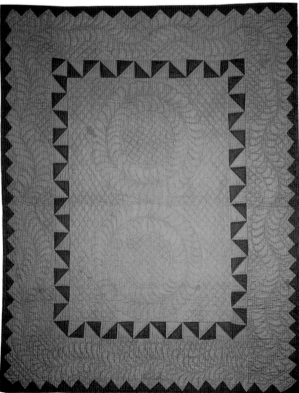

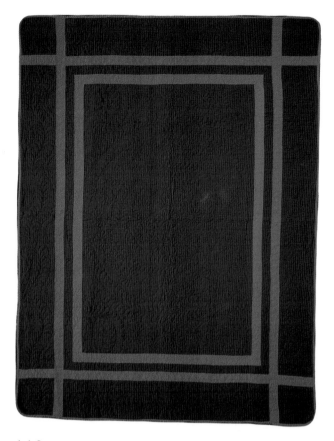

the outside world and those that originated in the Amish communities. The greater variety of patterns may be a byproduct of the fact that the Amish in Ohio, Indiana, Illinois, and elsewhere in the Midwest generally do not live in such concentrated communities as their counterparts in Pennsylvania and consequently have more opportunities to be exposed to the outside world and its influences. Because of the slightly less restrictive nature of life in *some* Midwestern Amish communities,[13] there also may have been greater freedom to experiment with quilt patterns.

This great range of patterns—from the simplest "One Patch Quilt" (fig. 113) to the complex "Carpenter's Wheel Variation Quilt" (fig. 114)—can be seen in the large grouping of Indiana Amish quilts that are part of the Museum's collection. Typically, the quilts are block designs surrounded, like most Amish quilts, by a narrow inner border and a wide outer border. Cotton is the preferred fabric, although a variety of different cotton weaves are used (sometimes in a single quilt), and pieces of other fabrics, such as wool, may be found along with the cotton on some quilts. Although there are exceptions, the quilting on Midwestern

112. DOUBLE INSIDE BORDER QUILT

Quiltmaker unidentified; Probably Ohio; 1910–1925; cotton; 85½" x 66". Gift of David Pottinger; 1980.37.55

113. ONE PATCH QUILT

Quiltmaker unidentified; Midwestern United States; dated 1921 in quilting; cotton and wool; 75½" x 64". Gift of David Pottinger; 1980.37.54

114. CARPENTER'S WHEEL VARIATION QUILT

Quiltmaker unidentified; Midwestern United States; 1945–1955; cotton and synthetics; 91" x 81½". Gift of David Pottinger; 1980.37.41

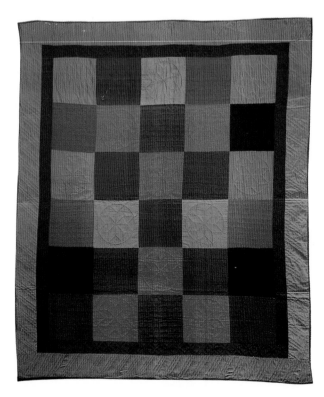

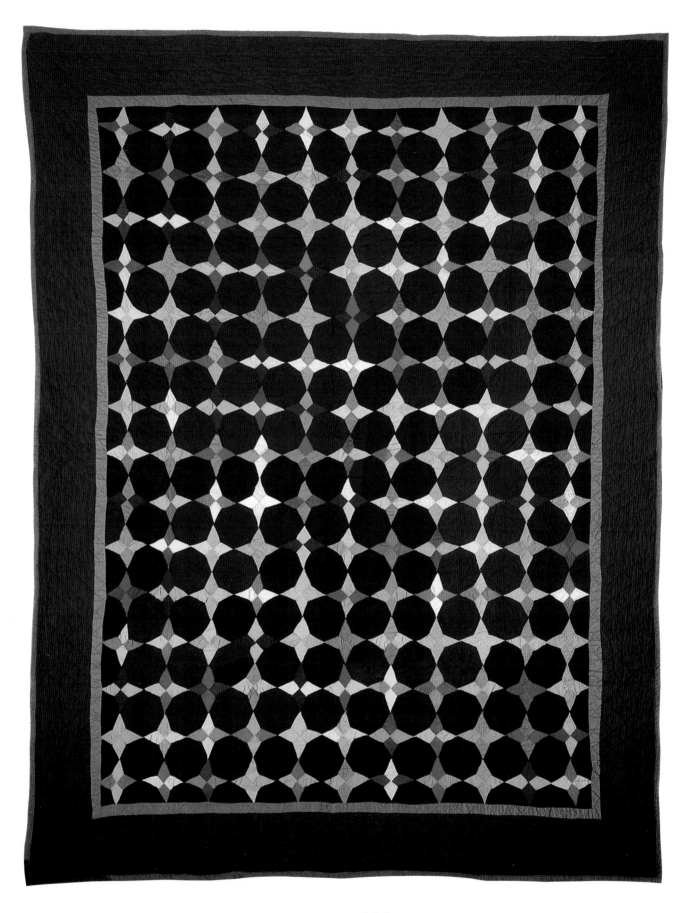

115. HUMMINGBIRDS QUILT
Quiltmaker unidentified; Shipshewana, Indiana; 1920–1930; cotton; 87³/₄" x 68¹/₄" framed. Gift of David Pottinger; 1980.37.69

116. HOLE IN THE BARN DOOR
VARIATION QUILT

*Mrs. Menno Yoder, initialed L M Y; Emma, Indiana; dated March
26, 1942 in quilting; cotton; 82" x 61½". Gift of David Pottinger;
1980.37.89*

117. OCEAN WAVES QUILT

*Anna Yoder Raber; Honeyville, Indiana; 1925–1935; cotton and
synthetics; 85¾" x 79¾". Gift of David Pottinger; 1980.37.82*

Amish quilts is generally not as elaborate as it is on the Lancaster County examples.

The Indiana quilts illustrated here demonstrate color combinations that were particularly preferred by the Amish in the Midwest in the years when most of the quilts in the Museum's collection were made, the 1920s through the 1940s. In the early years of the twentieth century, black became a favorite color for quilts, especially as a background. Sometimes, a dark blue was chosen instead. Both colors provided a strong contrast to the bold reds, yellows, blues, greens, and other hues that the quiltmakers frequently selected for their patterns. Such a dark-and-bright color combination often made even the simplest pattern appear especially exciting. The "Hummingbirds Quilt" (fig. 115), for example, an exceptionally graphic quilt, derives its visual appeal from rows of inexpertly stitched four-pointed stars in vivid colors set against a black field. The "Hole in the Barn Door Variation Quilt" (fig. 116), one of a pair of matching bedcovers, uses only a bright yellow in combination with black to make a common pattern uncommonly bold. A backing of the same yellow fabric turned over the front to form the binding also adds excitement to this quilt. "Ocean Waves Quilt" (fig. 117), "Tumbling Blocks Quilt" (fig. 118), the two versions of the "Lone Star Quilt" (fig. 119, 120), "Double Wedding Ring Quilt" (fig. 121) and "Rolling Stone Quilt" (fig. 122) are other examples of patterns commonly seen in the outside world that have been given a distinctly Amish appearance by the combination of bright fabrics set against dark backgrounds, the exclusive use of solid-colored fabrics, and a setting style that frames the pattern within narrow inner borders and wide outer borders.

118. TUMBLING BLOCKS QUILT
Mrs. Ed Lantz; Elkhart, Indiana; 1910–1920; cotton; 80½" x 66¼". Gift of David Pottinger; 1980.37.62

119. LONE STAR QUILT
Mrs. David Bontraeger, initialed D B; Emma, Indiana; 1920–1930; cotton; 84" x 74" framed. Gift of David Pottinger; 1980.37.50

120. LONE STAR QUILT
Amanda Yoder and her daughter Anna; Honeyville, Indiana;
1925–1940; cotton; 79" x 75½". Gift of David Pottinger;
1980.37.57

121. DOUBLE WEDDING RING QUILT
Mrs. Andy G. Byler; Atlantic, Pennsylvania; 1930–1940; cotton,
wool, linen, and rayon; 84" x 66½". Gift of Cyril Irwin Nelson in
memory of his grandparents Guerdon Stearns and Elinor Irwin
(Chase) Holden, and in honor of his parents, Cyril Arthur and
Elise Macy Nelson, 1982.22.3

122. ROLLING STONE QUILT

Quiltmaker unidentified, initialed L M; Indiana; dated January 28, 1925 in quilting; cotton; 82¼" x 69". Gift of David Pottinger; 1980.37.24

123. FANS QUILT

Quiltmaker unidentified, initialed P M; Indiana; 1925–1935; cotton, wool, and rayon, with cotton embroidery; 82" x 71½". Gift of David Pottinger; 1980.37.86

124. CHINESE COINS QUILT

Sarah Miller; Haven, Kansas; 1935; cotton; 82" x 61½".
Gift of David Pottinger; 1980.37.1

125. SAILBOATS QUILT

Amanda Lehman; Topeka, Indiana; 1955–1965; cotton;
86¼" x 72" framed. Gift of David Pottinger; 1980.37.26

One "English" pattern that appears to have been particularly popular among the Amish in Indiana during the first decades of the twentieth century is "Fans." The Museum's collection includes three Indiana Amish quilts in this pattern, including the example illustrated here (fig. 123). Once again, however, the popularity of this pattern in these colors during this time period is an indication of the conservative nature of Amish quiltmaking. "Fans" made in the outside world during the 1920s and 1930s were typically composed of pastel-colored cottons set against a white or light background (see Chapter 8). Among the Amish, however, the preferred color combinations included the dark backgrounds and richly saturated hues that had been favored by quiltmakers in the outside world in the last quarter of the nineteenth century. As in the example seen here, the Amish "Fans" also were frequently embellished with simple embroidery in a manner reminiscent of Victorian quiltmaking.

Closely related to the Museum's quilts made in Indiana is a group of bedcovers including the "Chinese Coins Quilt" (fig. 124) illustrated here, that were sewn in the community of Haven, Kansas. The women who settled in Haven were usually newly married and they brought with them both their quilts and their quiltmaking traditions from Indiana.[14] A number of the Kansas quilts in the Museum's collection were made by relatives (often daughters) of the women who made the Indiana quilts.

By the middle of the twentieth century, Amish quiltmaking in all of the communities had undergone tremendous changes. A lighter color palette gained acceptance among many of the quilters, and synthetic fabrics—often in harsh hues—began to be widely used. Amish women became aware that there are rules in the outside world about what colors "go" with others, and so their wonderful, uninhibited juxtapositions of colors were replaced by more common combinations. Many quilters also began using synthetic batting which tends to be thicker than cotton. This results in fewer stitches per inch and the selection of less intricate quilting patterns. Finally, as the quilts became valuable collectibles, some Amish started copying the old patterns for the new market, creating quilts that, while often still very effective, lack the inspiration of the originals. The "Carpenter's Wheel Variation Quilt" (fig. 114) is an example of a mid-century Midwestern quilt that, while still retaining the overall aesthetic of an earlier quilt, has been made with less vibrant colors and a variety of fabrics including cotton and synthetics. "Sailboats Quilt" (fig. 125) made by Amanda Lehman in Topeka, Indiana, in the 1950s or 1960s, maintains the colors that were popular earlier in the century, but is a representational pattern that most likely would not have been chosen only a decade or two earlier.

Amish quiltmaking today, although very different from fifty years ago, still retains its conservative aspect. While contemporary quilters in the outside world experiment with hand-dyed fabrics, three-dimensional constructions, and other avant-garde techniques (see Chapter 11), Amish quiltmakers tend to specialize in the traditional patterns that have been popular in the outside world for the past 150 years. Frequently, these quilts are made for sale to tourists, as Amish women have found that quiltmaking is an acceptable way to supplement their income. But while the restrictions of just a few generations ago have disappeared—for example, patterned fabrics and appliqués are now acceptable—they appear to have been replaced by a resistance to experimenting with the contemporary fashion for creating fabric "art." This is consistent with the tradition of Amish quiltmaking, as one of the reasons Amish women may have been allowed to create such masterpieces originally was that the quilts were intrinsically functional and never intended as works of art.

CHAPTER TEN

AFRICAN-AMERICAN QUILTS

In 1990, the Museum of American Folk Art received a matching grant from the National Endowment for the Arts for the purchase of ten quilts made by African-Americans living in the South. The Museum's purpose in seeking this grant was to fill a gap in the collection: quilts created within traditional African-American communities by makers who shared similar backgrounds, artistic motivations, and aesthetics. The Museum selected Dr. Maude Southwell Wahlman, known for her work relating African-American quilts with African textiles, to collect these quilts and present them in an exhibition and publication, Signs and Symbols: African Images in African-American Quilts. Inspired by this grant, eight other contemporary African-American quilts identified by Dr. Wahlman and purchased by private individuals were given to the Museum at the same time.

In the introduction to her book, Dr. Wahlman explains her purpose in examining and collecting African-American quilts: "My thesis is that most African-American quiltmaking derives its aesthetic from various African traditions, both technological and ideological ones. Thus I deliberately study African-American quilts which exhibit similar aesthetic tendencies with African textiles."[1] However, both Dr. Wahlman and others interested in this subject have acknowledged that the kinds of quilts Dr. Wahlman studies and that are included in the Museum's collection represent only one style of African-American quiltmaking. As Dr. Wahlman states, quilt historian Cuesta Benberry "has recently clarified this situation by correctly pointing out the great diversity of quilting made over the last two centuries by African-Americans."[2]

In fact, far from seeing African-American quilts as distinct from the mainstream of American quiltmaking, Ms. Benberry believes that African-Americans, present in America since the seventeenth century, participated in the creation of that mainstream. She maintains that although recent attention has been paid to only one distinct group of quilts—those made by contemporary rural Southerners—this is just part of the story of African-American quilts. As she queries, "How could this small sample of late twentieth century African-American quilts represent in its entirety the contribu-

tion of thousands of black quiltmakers working at the craft over two centuries?"[3]

Unfortunately, it is not possible to identify positively the racial or ethnic heritage of most of the quilts in the Museum's collection. As discussed in other chapters, there are some quilts in the collection that have anecdotal information connecting them to African-American makers—the "Sacret Bibel Quilt" (fig. 43), for example. But those quilts collected using the NEA grant and those that were donated in conjunction with this grant were obtained from known African-American makers, and have been analyzed according to the criteria established by the scholar who gathered them.

Dr. Wahlman has identified seven traits that distinguish the African-American quilts of the type shown here from the Anglo-American tradition: an emphasis on vertical strips; bright colors; large designs; asymmetry; improvisation; multiple-patterning; and symbolic forms.[4]

Vertical strips can be seen on many of the quilts in the collection, but they are especially obvious on the "Strip Quilt" (fig. 126) pieced by Idabell Bester and quilted by Losie Webb. Strip quilts have been related to West African cloth made from narrow strips sewn together, a tradition that would have been remembered by Africans brought to America.[5] According to Dr. Wahlman, this "Strip Quilt" is an "example of a utilitarian quilt made instinctively in the West African tradition of compiling design elements into strips that are then sewn together in a vertical format. The quilter has utilized manufactured materials with vertical black and white strips similar to patterns created with warp threads on West African men's looms."[6]

It should be noted, however, that the strip set has a long tradition in European-American quilts as well, and has been particularly observed in examples made in Pennsylvania.[7] "Strippy" quilts that resemble some of the contemporary African-American plain strip quilts were also popular in the British Isles.[8] It is quilt historian Barbara Brackman's analysis, therefore, that "African-American quilters who strip quilts today may be echoing African aesthetics but they also draw from a strong European-American tradition."[9]

132

126. STRIP QUILT

Idabell Bester (d. c.1992), quilted by Losie Webb; Alabama; pieced in 1980, quilted in 1990; cotton and synthetics; 83" x 71". Gift of Helen and Robert Cargo; 1991.19.4

127. SNAIL TRAIL QUILT

Mary Maxtion (b.1914); Boligee, Alabama; 1990; cotton; 89½" x 77". Museum of American Folk Art purchase made possible in part by a grant from the National Endowment for the Arts, with matching funds from The Great American Quilt Festival 3;

The use of large shapes and strong, contrasting colors has been related to the communicative function of African fabrics. In West Africa, "It can be important to recognize patterns from a distance if one needs to give a proper greeting to someone. Important people wear cloth with complex patterns and a great deal of color."[10] These two characteristics can be found in almost all of the contemporary African-American quilts in the Museum's collection. They are especially emphatic on the "Snail Trail Quilt" (fig. 127) by Mary Maxtion. For this quilt, the maker has taken a small pattern and enlarged it, ensuring that it could be easily seen from a distance. Her color combination of hot pink against black, surrounded by a (mostly) yellow border, is also a bold choice that guarantees the quilt's visibility.

Nora Ezell's "Star Quilt" (fig. 128) is equally bold and colorful, and it is also an example of asymmetry in contemporary African-American quiltmaking, a characteristic that similarly has been related to African textile traditions: "In West Africa, when woven strips with patterns are sewn together to make a larger fabric, the resulting cloth may have asymmetrical and unpredictable designs."[11] The museum's quilt has been called an "asymmetrical tour de force,"[12] combining complete

stars and parts of stars in an unpredictable arrangement that dazzles the eye.

Nora Ezell, an individualist when it comes to her quilts, says that "I have made and sold so many quilts. I do them my way. There is nothing that says you got to do it this way or that. . . . I don't care about color combinations. I do what looks good, but I keep the pattern in mind. I never saw a black flower so I won't put one in a quilt. I don't know which colors blend or fight. As long as it suits me, it's okay."[13]

Lucinda Toomer's "Le Moyne Star Variation Quilt" (fig. 129) appears at first to be a more regular adaptation of a star pattern. However, a close study reveals that the sashes separating the blocks of stars do not line up evenly, and also that some of the stars in this quilt (see the lower right-hand corner) have been "fractured" in much the same way as in Nora Ezell's quilt.

Lucinda Toomer began quilting when she was a child and continued throughout her long life. She made the quilts for her own enjoyment and comfort and kept most of them. She created most of her own patterns, adapting designs from ones she learned from her mother or saw in books and magazines. Like the Museum's "Le Moyne Star Variation," Lucinda Toomer's quilt tops were ordered with strips because "a strip divides so you can see plainer."[14]

The corner of broken stars in Lucinda Toomer's quilt can be seen as an example of improvisation in African-American quiltmaking, an unexpected element in a known pattern that distinguishes it as the maker's own. A similar example of improvisation can be found in Alean Pearson's "Sailboats Quilt" (fig. 130). The pattern appears regular until one looks carefully at the far right row and sees that five of the seven boats have been placed upside down.

The "Rattlesnake Quilt" (fig. 131) by the same maker is also an example of improvisation, although for this quilt it is the variation of color that is more obvious than a change in pattern. While most of the background is pink, green and tan appear in unexpected places. The pattern is also not carried out in the corners of the quilt in any regular manner. Alean Pearson's "Rattlesnake Quilt" appears to be a variation—or improvised version—of the pattern commonly called "Pickle Dish" or "Indian Wedding Ring." (See figure 99 for a more traditional version of this pattern.) However, instead of a circular arrangement as is found in the "Pickle Dish," the "Rattlesnakes" are aligned in rows.

Lureca Outland's quilts have also been noted for their quality of improvisation.[15] The Museum's collection includes her interpretation of the well-known "Double Wedding Ring" pattern (black-and-white fig. 38) which, like the "Rattlesnake Quilt," features straight lines and squared centers instead of the expected circles.

Lureca Outland's "Diamond Four Patch in Cross Quilt" (fig. 132) shows improvisation in her selection of colors and the placement of her sashing, which appears

128. STAR QUILT

Nora Ezell (b.1917); Eutaw, Alabama; dated August 1977 in embroidery; cotton and synthetics; 94" x 79". Museum of American Folk Art purchase made possible in part by a grant from the National Endowment for the Arts, with matching funds from The Great American Quilt Festival 3; 1991.13.1

129. LE MOYNE STAR VARIATION
QUILT
*Lucinda Toomer (1890–1983); Macon, Georgia; 1981; cotton and
synthetics; 71¼" x 62". Gift of Maude and James Wahlman;
1991.32.1*

130. SAILBOATS QUILT
*Alean Pearson (b.1918); Oxford, Mississippi; 1985; cotton and
wool; 88¼" x 80". Museum of American Folk Art purchase made
possible in part by a grant from the National Endowment for the
Arts, with matching funds from The Great American Quilt Festival
3; 1991. 13.8*

131. RATTLESNAKE QUILT

Alean Pearson (b.1918); Oxford, Mississippi; 1985; cotton and synthetics; 85½" x 80½". Museum of American Folk Art purchase made possible in part by a grant from the National Endowment for the Arts, with matching funds from The Great American Quilt Festival 3; 1991.13.7

132. DIAMOND FOUR PATCH IN CROSS QUILT

Lureca Outland (b. c.1904); Boligee, Alabama; 1991; cotton and synthetics; 83" x 78½". Museum of American Folk Art purchase made possible in part by a grant from the National Endowment for the Arts, with matching funds from The Great American Quilt Festival 3; 1991.13.6

133. HENS QUILT

*Pearly Posey (1894–1984); Yazoo City, Mississippi; 1981; cotton
and synthetics; 71" x 69". Gift of Maude and James Wahlman;
1991.32.2*

between some blocks but not others. The diamond motif seen on this quilt is "a common form in African-American culture; one sees it in arts, on graves, on houses, and in paintings."[16] According to Dr. Wahlman, the design may be symbolic as "It is thought to represent the four directions, or the four moments of the Kongo sun: birth, life, death, and rebirth."[17]

The "Four Patch" design of Lureca Outland's quilt disappears in the top row, where it is replaced by a seemingly random pattern. This can be seen as an example of multiple patterning, a concept that is important in African royal and priestly fabrics. Multiple patterning is even more evident in Mary Maxtion's "Everybody Quilt" (black-and-white fig. 39), a sampler-style quilt composed of twenty-five different squares, some of which may have symbolic or historic meaning.

In West Africa, multiple-patterned cloth is believed to communicate the prestige, power, and wealth of the owners who can both name the different patterns and can afford to pay the master weavers to create them.[18] While the African-American quilts may not communicate the owner's status or religion, it is believed by Dr. Wahlman that they show an "African aesthetic preference"[19] for such qualities as improvisation and multiple patterning. It is also believed that these qualities serve a protective function: The complex designs keep evil spirits away because "evil travels in straight lines."[20] Improvisation and multiple patterning are also protective because they ensure that copying is impossible.

Pearlie Posey's "Hens Quilt" (fig. 133) includes most of the characteristics discussed for the quilts above: asymmetry, strips, bold color and patterns, improvisation. But while most of the other contemporary African-American quilts in the Museum's collection were created solely by piecing, the "hens" have

been appliquéd onto the top of this quilt. Appliquéd African-American quilts have often been related to the appliqué tradition found in a number of African cultures, most especially the tapestries made by the Fon of Dahomey.[21] Many African-American appliquéd quilts are made in a narrative style that has been related to African textiles. The best known of these are the two quilts that were made by Harriet Powers: "The Bible Quilt," now in the collection of the Smithsonian Institution, and "The Creation of the Animals Quilt," owned by the Museum of Fine Arts, Boston. Pearlie Posey's "Hens," however, appears to be simply decorative rather than narrative, although the original inspiration for the technique among her community cannot be determined.

It is known that Pearlie Posey learned to make traditional pieced quilts from her grandmother, and that she learned to appliqué from her daughter, Sarah Mary Taylor,[22] when Posey was eighty-six years old. In describing how she planned her appliqué quilts, she expresses the feeling of improvisation that this and the other quilts in the collection demonstrate: "I just like mine mixed up. . . . I'll have a bird sitting over yonder, something else sitting over there, something else sitting over there."[23]

Like all quilts, contemporary African-American examples should be studied and appreciated for both their aesthetic and cultural significance. The quilts in the Museum's collection have been specifically gathered and analyzed for both their aesthetic appeal and their relationship to African textile traditions. However, in studying these quilts, it should be remembered that these are relationships that the quiltmakers themselves have not voiced but have been postulated by quilt scholars from outside the community.

CONTEMPORARY QUILTS

T he most recent resurgence of interest in quilts and quiltmaking can be traced, in part, to the crafts revival that started in America in the mid-1960s. But while many traditional crafts benefited from this renewed interest in the handmade objects of America's past, none has had the continuing, overwhelming popularity of quiltmaking.[1]

Much like the proponents of the late-nineteenth-century Arts and Crafts Movement, some of these quiltmakers and other artisans were reacting against what they viewed as rampant technology and industrialization and the problems these changes brought to modern society. Some were actively seeking a new way of life, and turned to pastimes such as quiltmaking to help support their alternative lifestyles. Others began quilting simply as a way to make their lives more enjoyable.[2]

By the 1970s, the renewed interest in the handmade coincided with a nostalgia craze and a revived appreciation for American arts and antiques, including folk art. "Abstract Design in American Quilts," the landmark exhibition first presented at the Whitney Museum of American Art in New York City in 1971 (and thereafter around the world), helped introduce the concept of "quilts as art" and spurred both quiltmaking and quilt collecting. The 1976 Bicentennial celebration further encouraged an interest in the artistic traditions of America's past, including quilting, and, as the century draws to a close, this interest appears to continue unabated.

As the examples in the Museum's collection demonstrate, quilts made in the late-twentieth century can be very different from those made by prior generations. Although quilts are still made for use on a bed by both professional quiltmakers and enthusiastic hobbyists, there is an increased likelihood today that a quilt—or a work of "fiber art"—will be made for display on a wall. Contemporary artisans also have expanded the boundaries of traditional quiltmaking, experimenting with a wide variety of materials, sewing techniques, sizes and shapes, and exploring the possibilities inherent in such tasks as making their own dyes and transferring photographs directly onto the top of a quilt. In short, it is not unusual for modern quilters to view their quilt tops much as contemporary artists view their canvases. In quiltmaking today, it seems, almost anything goes.

Nancy Crow, the maker of "Bittersweet XII" (fig. 134), was one of the first quilt artists to be recognized as such and is still one of the most renowned. Her "Bittersweet XII" is one of a series of twenty-three quilts made over a three-year period (1980–1983) to document the maker's "idea of the relationship between a woman and a man and of learning to become responsible for one's own happiness."[3]

In some ways, "Bittersweet XII" resembles a conventional pieced quilt. It is composed of nine blocks, each strip pieced, a traditional method of quiltmaking. The geometric pattern, however, while perhaps reminiscent of pieced quilts of the past, is completely original and reveals the artist's primary interest in color and fabric. As Nancy Crow states: "I make quilts because I *need* to use color and because I prefer fabric to paint. I have been influenced by my father even though he died when I was twelve. He was a tailor's apprentice when he was a teenager and eventually, he taught all of his eight children to love quality fabrics and workmanship. So it seems natural to me to make quilts."[4]

"Bittersweet XII" was designed and marked for piecing by Nancy Crow, and then hand quilted by Velma Brill, one of a number of seamstresses who work with the artist on the quilting of her designs.

The "Kimono" hanging (fig. 135) was made by Kumiko Sudo, another professional fiber artist who originally trained in a variety of textile arts in her native Japan. She began making quilts after she first saw antique American quilts during a visit to the United States in 1971.[5]

Like "Bittersweet XII," "Kimono," a small-sized work, is also one in a series by the maker. The quilts in this group, however, bear little resemblance to traditional American quilts other than in the use of patchwork. Instead, Kumiko Sudo draws on Japanese culture and designs for her inspiration and employs silk from kimonos and obis that she has been collecting for many years.

"Kimono" (fig. 135) is the artist's interpretation of an actual kimono of the Genroku Period (1688–1704) in

134. BITTERSWEET XII

Nancy Crow (b.1943); hand-quilted by Velma Brill, Cambridge,
Ohio; Baltimore, Ohio; 1980; cotton-polyester broadcloth; 79½" x
79". Gift of Nancy Crow; 1981.3.1

今の
巧
妙

142

Japan, a time when there was a renaissance in the arts and new and colorful designs were seen in household decorations and clothing. The quilt was inspired by Sudo's memories of the Cherry Blossom Festival in her native land and her family's preparations for the Festival, including the beautiful new kimonos they would receive. According to the maker, "Here I have depicted in an exaggerated manner a then fashionable kimono, with long ribbons on the cuff and scattered layers of appliquéd flowers enhancing its beauty."[6] The calligraphy on the bottom of the quilt is meant to suggest the written prayer that a young girl would offer at a nearby shine during the Festival.

In its inspiration, method of construction, and overall appearance, the "Hudson River Quilt" (fig. 136) bears more relation to nineteenth-century American quilts than either of the other quilts discussed above. Although made between 1969 and 1972, the quilt has roots in the signature quilts sewn a century earlier (see Chapter 3). Unlike the mostly geometric or floral albums of the nineteenth century, however, this contemporary example, like many quilts made since the 1960s, is entirely pictorial.

The "Hudson River Quilt" was conceived by Irene Preston Miller as a means of drawing attention to the beauty of the river and to win support for its protection, endangered at the time by a utility's plan to construct a pump storage plant near a nuclear power plant at Buchanan, New York. The projected construction threatened Storm King Mountain, one of the Hudson's most beautiful landmarks, and also placed in jeopardy the spawning grounds of the striped bass that live in the river.

Mrs. Miller enlisted the aid of thirty women to design the blocks of the quilt. Although the needleworkers originally were selected more for their interest in preserving the Hudson than their sewing skills, the finished blocks, united by a blue sashing that is meant to recall the river, form a coherent story that is well crafted, visually pleasing, and historically important. The blocks relate the journey of the river, from its source at Lake Tear of the Clouds in the Adirondack Mountains (top left) to the New York City harbor (bottom right). Some show historic sites, such as West Point, while others depict sights meaningful to the maker: the "violinist who practices by the river," for example, can be seen in the fourth row, above the fish.

135. KIMONO HANGING

Kumiko Sudo; Berkeley, California; 1988; silk, with silk embroidery; 37³/₄" x 25³/₄". Gift of Kumiko Sudo; 1989.11.1

Fittingly, the "Hudson River Quilt" (fig. 136) began its journey to museums and exhibitions around the world at the Museum of American Folk Art in 1972 as part of an exhibition entitled "The Fabric of the State." Over the years, it raised both funds and awareness of the precarious state of the Hudson. The makers decided to sell the quilt at auction in 1990 to benefit three educational organizations in the Hudson River region. It then was donated to the Museum of American Folk Art, an appropriate home since it was the wish of the makers that the quilt's final destination would be a public institution in the Hudson River Valley.

CONTEST WINNERS

Most of the contemporary quilts in the collection of the Museum of American Folk Art were winning entries in contests sponsored by the Museum between 1986 and 1993. During this time, through its association with the Great American Quilt Festivals 1 through 4, the Museum organized a number of national competitions designed to further its participation in the area of contemporary quiltmaking.

"Glorious Lady Freedom" (fig. 137) by Moneca Calvert of California was the Grand Prize Winning entry in the inaugural contest held by the Museum. Entries, which had to be full-size quilts (72" x 72" with a two-inch variance permitted), were judged on the basis of fine design, expert craftsmanship, and adherence to the contest theme: "Liberty, Freedom and American Heritage in Honor of the Statue of Liberty Centennial Celebration." The winning entries from each state were exhibited at the first Great American Quilt Festival in 1986 and then toured the United States and Japan. The grand prize winner and the second prize winner, "Spacious Skies" by Charlotte Warr-Andersen of Utah (black-and-white fig. 42), were accessioned into the permanent collection of the Museum.

Both these quilts resemble "paintings" in fabric of the Statue of Liberty and are examples of the popular pictorial style of contemporary quiltmaking. Moneca Calvert had been quilting for a number of years when she made "Glorious Lady Freedom," although she had no formal artistic education. After winning the contest, however, she stated; "I guess I have the right to call myself an artist now. This is very exciting for your plain old average American."[7]

A personal visit to the Statue of Liberty in 1982 inspired "Glorious Lady Freedom." "If I had not seen that statue myself I could not have done this quilt. Being from the West, I didn't know what to expect. I was overwhelmed. I learned so much about myself and my country. I am not a flag-waver, but I discovered I am a serious American. When I was thinking about the design I would use, I recalled the words of the song, 'America the Beautiful.' It is all there in my piece. There is something for every American."[8]

136. HUDSON RIVER QUILT

Irene Preston Miller and the Hudson River Quilters; Croton-on-Hudson, New York; 1969–1972; cotton, wool, and blends, with cotton embroidery; 95¼" x 80". Gift of the J.M. Kaplan Fund; 1991.3.1

"Memories of Childhood" was the theme for the Museum's second contest, which invited entrants to sew a crib-size quilt (54" x 45" with a two-inch variance). Winning quilts, selected from each state as well as a number of foreign countries, were exhibited at the Great American Quilt Festival 2 (1989) and then also toured the United States and Japan. The top three prize winners were accessioned into the Museum's collection.

Each quilt was judged on its originality, execution of the theme, overall appearance, craftsmanship, and needlework. The First Place Grand Prize Winner, "Childhood Memory #44—The Cellar: 'Don't worry,' said his sister sweetly, 'I won't turn off the light . . .'", by Elaine Spencer of Colorado (black-and-white fig. 43) is typical of the pictorial, painterly style that again was favored by the majority of the contestants. It illustrates the time in the maker's childhood when she actually did lock her brother in the basement and turn off the light. "But then," she recalls, "he did equally horrible things to me!"[9] Like many quiltmakers of both the past and the present, Elaine Spencer spent a great deal of time collecting appropriate fabrics for her quilt and also experimented with overdying fabrics to achieve the appropriate shadowy effects.[10]

"When Toys and I Were One" (fig. 138) by Jane Blair of Pennsylvania, the Second Place Grand Prize Winner in the "Memories of Childhood" contest, is a *trompe l'oeil* combination of traditional pieced patterns (such as the blocks that form the border of the quilt) and appliquéd pictorial elements, all joined to form the picture of a little girl and her toys. The maker wrote a poem to help her focus on the design for this quilt: "The old horse was gray/I'm sure the boat was blue/My world was pretend/Each day was always fun/When I was a child/And toys and I were one."[11]

The Museum sponsored three separate quiltmaking competitions in conjunction with the Great American Quilt Festival 3 (1991): "Discover America," crib-size quilts made by individuals; "Friends Sharing America," full-size quilts executed by groups; and "America's Flower Garden," full-size quilts done by individuals.

The "Discover America" contest, originally conceived as a celebration of the 500th anniversary of Columbus's arrival in America, was broadened to include quiltmakers' personal discoveries of America, whether through travel, books, film, television, or other experiences. The contest was open to quiltmakers worldwide and entries had to conform to the crib-size format. For this as well as for almost all the other contests sponsored by the Museum, entries had to meet the true definition of a quilt: i.e. they had to be constructed of a top, batting, and backing. The three layers of the quilt had to be quilted by hand, as no machine quilting or tying was permissible. Piecing, appliqué, or embroidery could be used in executing the design of the quilt and these techniques could be used separately or in conjunction with one another. Both appliqué and

embroidery had to be worked by hand, although piecing could be done on a sewing machine as long as no machine stitching would show on the surface of the quilt. As previously, quilts were judged on their adherence to the overall theme of the contest, the originality of the design, general overall appearance, craftsmanship, and needlework.

"The Early Travelers" (fig. 139) by Dawn E. Amos of South Dakota was the First Place Grand Prize Winner of the "Discover America" contest. The artist, who had been a state winner in each of the two previous contests sponsored by the Museum, cautions that the design of this quilt should not be taken as a literal statement about who "discovered" America, but rather as her personal interpretation of the contest theme. "There has been a lot of past misunderstanding between Indians and whites," she states, "but in South Dakota this is a year of reconciliation between the two groups, and I wanted a design that would reflect this new understanding."[12] Amos has based many of her quilt designs on Native American images because her husband is half Sioux and, although she does not want her three sons to grow up dwelling on the past, she does want them to be proud of their heritage.[13]

"The Early Travelers" is an example of a contemporary quilt that literally expands the boundaries of quiltmaking. The design itself goes beyond the borders of the traditional quilt, pointing into space on each side. And much like a painter who mixes her own colors to ensure she achieves the correct palette, most of the colors in this quilt were created through hand-dyeing to obtain the exact earth tones the quiltmaker desired.[14]

In what was both a nostalgic nod to the quilting bees of the past and a recognition of the importance of quilt guilds and other such organizations today, the "Friends Sharing America" contest was the only competition organized by the Museum that was open to groups of quiltmakers—rather than individuals—around the world. "Group" was defined as three or more people, and all participants had to have worked on the quilt. The quilts had to be an original design or an original variation of a traditional pattern; and although the general theme of the contest was "friendship," the idea could be interpreted in many ways. While most of the rules were the same as for the "Discover America" contest, for the first time entrants were permitted to use a sewing machine for their piecing, appliqué work, and embroidery, as well as for quilting. Both the First and Second Place Grand Prize Winners became part of the Museum's permanent collection.

"Quilters' Dwellings" (fig. 140), the Second Place Grand Prize Winner, was made by the Red Apple Quilters—Annamae Kelly, Sharon Falberg, and Sue Nickels—of Michigan. The quilt's design, a combination of traditional pieced patterns and "snapshots" of houses, was inspired by the fabric used to form the quilt's inner border. "As soon as I saw it, I knew the theme should be the homes of the quilters, enclosed

137. GLORIOUS LADY FREEDOM

*Moneca Calvert; Carmichael, California; 1985–1986; cotton,
cotton blends, and linen, with cotton embroidery; 72" x 71½".
The Scotchgard® Collection of Contemporary Quilts, Grand Prize
Winner, The Great American Quilt Contest, in Celebration of the
Statue of Liberty Centennial, 1986; 1986.14.1*

138. WHEN TOYS AND I WERE ONE

Jane Blair; Conshohocken, Pennsylvania; 1988; cotton and polyester; 53³/₄" x 45". Second Place Grand Prize Winner of the "Memories of Childhood" Contest, The Great American Quilt Festival 2, Museum of American Folk Art event sponsored by Fairfield Processing Corporation/Poly-fil®, Springmaid® and Coats & Clark, Inc./Dual Duty Plus® Quilting; 1989.23.2

139. THE EARLY TRAVELERS

Dawn E. Amos; Rapid City, South Dakota; 1990; cotton; 54" x 45". First Place Grand Prize Winner of the "Discover America" Contest at The Great American Quilt Festival 3, a Museum of American Folk Art event sponsored by Fairfield Processing Corporation/Poly-fil® and Springmaid® Fabrics; 1990.19.1

140. QUILTERS' DWELLINGS

Red Apple Quilters: Annamae Kelly, Sharon Falberg, Sue Nickels;
Royal Oak, Michigan; 1990; cotton, cotton blends, silk organza,
plastic and paint; 72" x 72". Second Place Grand Prize Winner of
the "Friends Sharing America" Contest at the Great American
Quilt Festival 3, a Museum of American Folk Art event sponsored
by Fairfield Processing Corporation/Poly-fil® and Springmaid®
Fabrics; 1990.20.2

within the 'picket fence,' which is what the fabric reminded us of," says Kelly, who did the design for the quilt.[15] Hand-dyed, as well as hand-painted, fabrics also were used in this quilt, reflecting the background of Annamae Kelly, who originally trained as a painter but has switched to fabric as her medium.

Entries in the "America's Flower Garden" contest had to conform to the same rules as the previous individual-maker competitions. In keeping with the overall festival theme of "discovery," quiltmakers around the world were asked to let their "creativity blossom" as they rediscovered the long tradition of floral motifs in American quiltmaking. Instead of Grand Prize Winners however, the top twenty-four entries in the contest were selected for exhibition and tour and were purchased for the Museum's permanent collection through a grant provided by the James River Corporation.

"Imagination" (fig. 141), the entry illustrated here, was made by Kazuko Yonekura of Japan, a quiltmaker who has never visited America and used photographs to create her design of cut flowers in a basket against a field of floral-patterned squares. Some of the fabrics in the quilt are antique indigo-dyed cottons, used as an homage to the early years in American quiltmaking when all fabric was too valuable to waste and every scrap was saved.

"Mala Pua Aloha, Garden of Aloha" (black-and-white fig. 44) was created by Mary Alice Kenny Sinton of Oklahoma to acknowledge Hawaii among the many flower gardens found across the United States. The design employs traditional Hawaiian appliqué techniques (derived from the folded, cut-paper designs common in mid-nineteenth century album quilts[16]) to depict typical Hawaiian flowers: hibiscus (the state flower), torch ginger, and kuhuio vine buds, leaves, and blossoms. The four hearts in the center are the quiltmaker's trademark, received from her Hawaiian appliqué teacher.

141. IMAGINATION

Kazuko Yonekura; Kobe, Japan; 1991; cotton. 72" x 72" Winner,
"America's Flower Garden" Contest at The Great American Quilt Festival
3, a Museum of American Folk Art Art event sponsored by Fairfield
Processing Corporation/Poly-fil® and Springmaid® Fabrics; 1991.9.24

GLOSSARY

Album quilts are assemblages of different pieced and appliquéd signed blocks.[1] The most elaborate are from Baltimore, Maryland.

An **all-over set** includes patterns utilizing geometric pieces such as hexagons or diamonds across the entire quilt top.

In **American piecing** a running stitch holds two pieces of fabric, placed face-to-face, and stitched within a seam allowance from the edge.[2]

Appliqué, or laid work, is a nineteenth-century term from the French verb "appliquer," to attach.

Baltimore-style album quilts are very similar to those known to have been made in Baltimore and its environs, but they lack signatures of Baltimoreans or direct associations with that city.

Block set includes those quilts composed of individual units, either pieced, appliquéd, embroidered, or plain, and sewn together with or without sashing.

Calimanco is "a worsted 'stuff with a fine gloss upon it'."[3] To produce the shiny surface, wool fabric was calendered, or passed through metal rollers while heat and pressure were mechanically applied.

Candlewicking can be either a hand-embroidered or machine-made technique. In the former, designs are embroidered on fabric with heavy cotton roving using French knots or whip, cross, satin or bullion stitches. In the latter, loops are raised in the weaving process to create a patterned pile. In both, woven loops or embroidered stitches can be cut to produce tufted effects.

A **center-medallion set** or framed-medallion set has a central focus surrounded by multiple pieced and/or appliquéd borders.[4]

Corded work involves two layers of fabric held together by close, parallel lines of running or back stitches that form a predetermined design. A large-eyed needle threaded with a soft cording is inserted from the back and pulled through the channels that outline the design, creating a raised effect. In the eighteenth century this technique was referred to as Marseilles quilting and in the twentieth century as trapunto, Italian for "quilt."

Cut-out chintz appliqué involves the cutting of printed motifs from fabric and applying them to a ground fabric. As a technique, it dates to the seventeenth century. In the second half of the nineteenth century, the term "broderie perse" was used to describe this technique.

Foundation piecing is a method especially used to construct show quilts made of silks in which the slippery, delicate patches were sewn to a muslin foundation. Log Cabins, Crazies, and String quilts may be foundation-pieced.

Friendship quilts are signature quilts composed of signed blocks, all of the same pattern.

Inlaid appliqué is best described in Caulfield and Saward's *The Dictionary of Needlework: An Encyclopedia of Artistic, Plain and Fancy Needlework* (1882): "carefully design the pattern upon a foundation material, and cut away from that the various flowers or motifs that make up the design. Replace these pieces by others of different colour and textures, accurately cut so as to fit into the places left vacant by the removal of the solid material, and lay these into the foundation without a margin or selvedge overlapping either to the front or back of the work."

Linsey-woolsey refers to a fabric with a linen or cotton warp and a wool weft. It is a term used erroneously in the past to refer to glazed-wool, whole-cloth quilts and in this catalogue is used only if the fabric is of the linen/cotton and wool weave.

Marseilles quilting in the seventeenth century was a hand-sewn technique similar to today's corded and stuffed work. After 1763, spreads and yardgoods woven on a loom in patterns similar to the handmade product were exported from the French port of Marseilles to Europe and then America. By 1830, **Marseilles spread** was the term for the popular all-white bedcovers woven on the Jacquard loom. These spreads are classified as whitework, but since they are not handmade, they are not included in this catalogue.

Mosaic is a term for continuous hexagon piecing. References to "hexagon" or "honeycomb" patchwork are found in *Godey's* 1835 issue. In the 1920s, the pattern composed of hexagon florets became known as Grandmother's Flower Garden.[5]

Onlaid or conventional appliqué refers to decorative patches cut from assorted textiles and sewn onto a contrasting background fabric.

A **Palampore** is a seventeenth-century cotton textile with painted and/or printed designs imported from Palampur, India. In England, a palampore was a costly bedspread, not found in homes of those of "the common ranks of life." Initially the designs were Persian, but as trade developed, the Indian printers catered to English taste. The Tree of Life design was a popular palampore motif.

Patchwork is an eighteenth- and nineteenth-century term describing both pieced and appliquéd quilts. A 1782 Baltimore county probate list includes: "1 counterpin patchwork."[6]

Pieced quilts are made up of seamed straight or curved edge patches, blocks, or other design units to form the quilt top.

Quilt in reference to a bedcover is usually defined as having three layers: a top, a middle filling, and a backing. The quilting stitches, often in elaborate, decorative designs, hold the three layers together. For the purposes of this catalogue, the term "quilt" is also used to denote bedcovers of only two layers that in addition might lack quilting stitches.

A **quilt top** in this catalogue refers to an unfinished quilt of only one layer.

Raised appliqué involves padding the appliquéd patches with fibers such as cotton to create a three-dimensional effect.

Reverse appliqué involves cutting away a top layer of fabric, turning under the raw edges, and blindstitching them to the second layer, revealing a shape in the exposed underlaying fabric.[7]

Sampler album quilts, composed of a variety of pieced and/or appliquéd patterns, are not signed and therefore are usually made by one individual as opposed to a group.[8]

Sashing or strips of fabric can be sewn between quilt blocks to join them together to form the quilt top. Sashing strips can incorporate both pieced and appliquéd designs and often are embellished with decorative quilting motifs.

Set refers to the organizational design of the quilt top.

Signature quilts are composed of signed blocks and include both album and friendship quilts.

Spread refers to bedcovers of one layer, either handsewn or machine-woven.

Strip set includes patchwork organized into strips and then sewn together, often alternating with plain strips.[9]

Stuffed work involves using a blunt instrument such as a bodkin to insert cotton padding to raise design elements in the quilting pattern.

Template, also known as English or paper piecing, employs paper patterns over which the fabric is basted, and then the individual pieces are whipstitched together to form an all-over set. The technique is especially used for hexagon and diamond-shaped patterns.

Whitework includes white whole-cloth quilts embelished with white embroidery, candlewicking, or stuffed and corded work. In the early nineteenth century, it was referred to as embroidery on muslin. Today it is sometimes called muslin work.[10]

Whole-cloth describes quilts made from one fabric, which may be composed of seamed lengths to make up the entire quilt top.

[1]Jessica F. Nicoll, *Quilted for Friends* (Delaware, 1986), Introduction.

[2]Barbara Brackman, *Clues in the Calico* (McLean, Virginia, 1989), p. 97.

[3]Florence M. Montgomery, *Textiles in America 1650-1870* (New York, 1984), p. 185.

[4]Brackman, *Clues in the Calico*, p. 123.

[5]Ibid., p. 169.

[6]Susan Burows Swan, *Plain & Fancy* (New York, 1977), p. 230.

[7]Marie Shirer and Marla G. Stefanelli, *The Quilters' How-to Dictionary* (Colorado, 1991), p. 55.

[8]Brackman, *Clues in the Calico*, p. 150.

[9]Ibid., p. 124.

[10]Margaret Vincent, *The Ladies' Work Table* (Allentown, PA, 1988), p. 14.

NOTES

› CHAPTER ONE ‹

1. Jane C. Nylander, "Flowers from the Needle," in *An American Sampler: Folk Art from the Shelburne Museum* (Washington, D.C., 1987), p. 44.
2. Florence Montgomery, *Textiles in America 1650–1870* (New York, 1984), p. 185.
3. Barbara Brackman, *Clues in the Calico* (McLean, Va., 1989), p. 134.
4. Montgomery, *Textiles in America*, p. 200.
5. Brackman, *Clues in the Calico*, p. 82.
6. Fabrics identified and dated by Gillian Moss, Associate Curator of Textiles, Cooper-Hewitt Museum, New York City.
7. Florence Montgomery, *Printed Textiles: English and American Cottons and Linens 1700–1850* (New York, 1970), p. 162.
8. Ibid., p. 243.
9. Margaret Vincent, *The Ladies' Work Table* (Allentown, Pa., 1988), p. 14.
10. For a full discussion of this topic see: Sally Garoutte, "Marseilles Quilts and Their Woven Offspring," *Uncoverings*, vol. 3 (1982), pp. 115–134.
11. Brackman, *Clues in the Calico*, p. 133.
12. Ibid., p. 112.
13. Patsy and Myron Orlofsky, *Quilts in America* (New York, 1974), pp. 211–212.
14. Genealogical research provided by former Folk Art Institute student Paula Laverty.
15. Amelia Peck, *American Quilts & Coverlets in the Metropolitan Museum of Art* (New York, 1990), p. 249.
16. Robert Bishop, *The Romance of Double Wedding Ring Quilts* (New York, 1989), p. viii.

› CHAPTER TWO ‹

1. See correspondence in Museum of American Folk Art object file.
2. Montgomery, *Printed Textiles*, p. 130.
3. Fabrics dated by Gillian Moss.
4. Brackman, *Clues in the Calico*, p. 128.
5. Gloria Seaman Allen, *Old Line Traditions: Maryland Women and Their Quilts* (Washington, D.C., 1985), p. 7.
6. Brackman, *Clues in the Calico*, p. 136.
7. Montgomery, *Printed Textiles*, p. 126.
8. Ibid., p. 129.

9. Ibid., p. 328.
10. Carrie A. Hall and Rose G. Kretsinger, *The Romance of the Patchwork Quilt in America* (Caldwell, Idaho, 1935), p. 101.
11. Roderick Kiracofe and Mary Elizabeth Johnson, *The American Quilt: A History of Cloth and Comfort 1750–1950* (New York, 1993), p. 100.
12. Brackman, *Clues in the Calico*, p. 97.
13. Ibid.
14. Fabrics dated by Gillian Moss.
15. Mimi Sherman, "A Fabric of One Family: A Saga of Discovery," *The Clarion*, vol. 14, no. 2 (Spring, 1989), pp. 55–62.

› CHAPTER THREE ‹

1. Brackman, *Clues in the Calico*, p. 147.
2. See Sherman, "A Fabric of One Family," pp. 55–62.
3. Jessica Nicoll, "Signature Quilts and the Quaker Community, 1840–1860," *Uncoverings*, vol. 7 (1986), pp. 27–37.
4. Sherman, "A Fabric of One Family," p. 62.
5. Ibid., p. 61.
6. Nicoll, "Signature Quilts," p. 35.
7. Preliminary research on this quilt was done by Museum intern Ayda Manukyan.
8. Doris Bowman, *The Smithsonian Treasury: American Quilts* (Washington, D.C., 1991), p. 45.
9. Research by Lee Kogan in Museum of American Folk Art object file.
10. Bowman, *The Smithsonian Treasury*, p. 45.
11. Nicoll, "Signature Quilts," p. 29.
12. Ibid., p. 35.
13. Barbara Brackman, "Signature Quilts: Nineteenth-Century Trends," *Uncoverings*, vol. 10 (1989), p. 31.
14. Brackman, *Clues in the Calico*, p. 149.
15. Dena Katzenberg, *Baltimore Album Quilts* (Baltimore, Md., 1980).
16. Jennifer F. Goldsborough, "An Album of Baltimore Album Quilt Studies," *Uncoverings*, vol. 15 (1994), pp. 73-110.
17. Katzenberg, *Baltimore Album Quilts*, p. 62.
18. See Eleanor Hamilton Sienkiewicz, "The Marketing of Mary Evans," *Uncoverings*, vol. 10 (1989), for a discussion of the problems with the Mary Evans attribution.
19. Goldsborough, "An Album of Baltimore Album Quilt Studies," p. 97.

20. Jennifer F. Goldsborough, "Baltimore Album Quilts," *The Magazine Antiques*, vol. cxlv, no. 3 (March, 1994), p. 419.
21. Ibid.
22. Katzenberg, *Baltimore Album Quilts*, p. 116.
23. Ibid., p. 99.
24. Ibid., p. 98.
25. Goldsborough, "An Album of Baltimore Album Quilt Studies," p. 102.
26. Amelia Peck, *American Quilts & Coverlets*, p. 50.
27. Katzenberg, *Baltimore Album Quilts*, p. 106.
28. Ibid., pp. 64–65.
29. Goldsborough, "An Album of Baltimore Album Quilt Studies," p. 96.
30. Prior to 1855, Elizabeth, New Jersey, was known as Elizabeth Town township or Elizabeth borough. Elizabethport, also spelled Elizabeth Port, was the name given to a specific part of the city.
31. Lee Kogan, "The Quilt Legacy of Elizabeth, New Jersey," *The Clarion*, vol. 15, no. 1 (Winter, 1990), pp. 58–64.
32. Ibid., p. 61.
33. Ibid., p. 63.
34. Ibid.
35. Ibid.
36. Ibid., p. 60.
37. Ibid.
38. Brackman, "Signature Quilts," p. 35.
39. Ibid.
40. Paula Laverty, "Many Hands: The Story of an Album Quilt," *Folk Art*, vol. 18, no. 1, (Spring, 1993), pp. 52–57.
41. Ibid., p. 56.
42. The Museum's collection includes a crib-sized quilt in this pattern. See fig. 51, Chapter 5.
43. Brackman, *Clues in the Calico*, p. 23.
44. Information provided by Museum researcher and former Folk Art Institute student Deborah Ash.
45. See Barbara Brackman, *Encyclopedia of Pieced Quilt Patterns* (Paducah, Ky., 1993) for examples of "Dewey" patterns.

› CHAPTER FOUR ‹

1. Barbara Brackman, *Encyclopedia of Applique* (McLean, Va., 1993), p. 30, and Ricky Clark, *Quilted Gardens: Floral Quilts of the Nineteenth Century* (Nashville, Tenn., 1994), p. ix.
2. Brackman, *Encyclopedia of Applique*, p. 16.
3. Ibid.
4. Ibid.
5. Ibid., p. 17.
6. Ibid., p. 27.
7. Brackman, *Clues in the Calico*, p. 142.
8. Brackman, *Encyclopedia of Applique*, p. 21.
9. Ibid.
10. Gloria Seaman Allen and Nancy Gibson Tuckhorn, *A Maryland Album: Quiltmaking Traditions—1634–1934* (Nashville, Tenn., 1995), p. 152.
11. Clark, *Quilted Gardens*, p. 71.
12. Dilys Blum and Jack L. Lindsey, *Nineteenth-Century Appliqué Quilts* (Philadelphia, 1989), p. 32.
13. Clark, *Quilted Gardens*, p. 41.
14. Ibid.
15. Brackman, *Encyclopedia of Applique*, p. 74.
16. Anita Schorsch, *Plain & Fancy: Country Quilts of the Pennsylvania-Germans* (New York, 1992), p. 72.
17. Ibid., p. 33.
18. Jeannette Lasansky, "The Typical Versus the Unusual/ Distortions of Time," in *In the Heart of Pennsylvania: Symposium Papers* (Lewisburg, Pa., 1986), p. 61.
19. Brackman, *Encyclopedia of Applique*, p. 22.
20. Ibid., p. 11.
21. Information from *History of Bucks County*, p. 257, supplied by Cory M. Amsler, Assistant Curator for Collections, the Bucks County Historical Society.
22. Information supplied by Cory M. Amsler.
23. Information from *History of Bucks County*, p. 257.
24. Although this object is only one layer, it is called a quilt because the maker labeled it "Sacret Bibel Quilt" in writing.
25. Sandi Fox, *Wrapped in Glory: Figurative Quilts & Bedcovers 1700–1900* (Los Angeles, 1990), p. 153.
26. Ibid.

› CHAPTER FIVE ‹

1. Quilts pieced using the log cabin (foundation) technique are discussed in Chapter 6. Quilts pieced of chintz in the first half of the nineteenth century are discussed in Chapter 2. Pieced "show quilts" are discussed in Chapter 7. Pieced quilts made during the quilt revival period (1910–1950) are discussed in Chapter 8. Pieced Amish quilts are discussed in Chapter 9. Pieced African-American quilts are discussed in Chapter 10.
2. Brackman, *Clues in the Calico*, pp. 170–171.
3. Museum of American Folk Art cataloguing information.
4. Brackman, *Clues in the Calico*, p. 157.
5. Ibid., p. 63.
6. Jacqueline M. Atkins and Phyllis A. Tepper, *New York Beauties: Quilts from the Empire State* (New York, 1992), p. 91.
7. A complete list of these quilts can be found in the Museum of American Folk Art object file.
8. Brackman, *Clues in the Calico*, p. 158.
9. Barbara Brackman, "Blue-and-White Quilts," *Quilters Newsletter Magazine*, vol. 18, no. 3 (March, 1987), p. 23.
10. Marsha McCloskey, *Feathered Star Quilts* (Bothell, Wash., 1987), p. 30.
11. Karoline Patterson Bresenhan and Nancy O'Bryant Puentes, *Lone Stars: A Legacy of Texas Quilts, 1836–1936* (Austin, Texas, 1986), p. 39. This quilt was made in New York State and carried to Texas in 1910.
12. *An American Sampler: Folk Art from the Shelburne Museum* (Washington, D.C., 1987), p. 143.
13. Mary Elizabeth Johnson, *Star Quilts* (New York, 1992), p. 20.
14. Brackman, *Clues in the Calico*, p. 170.
15. Judy Mathieson, "Some Published Sources of Design Inspiration for the Quilt Pattern Mariner's Compass—17th to 20th Century," *Uncoverings*, (1981), p. 11.
16. Brackman, *Clues in the Calico*, p. 61.
17. Roderick Kiracofe and Mary Elizabeth Johnson, *The American Quilt*, p. 132.
18. Brackman, *Encyclopedia of Pieced Quilt Patterns*, p. 414.
19. See the "Cross River Album Quilt," fig. 28, Chapter 3, for a quilt block made in the almost identical design.
20. Research on the history of Kearny, New Jersey, provided

by Museum volunteer and former Folk Art Institute student Phyllis Selnick.

21. Herbert Ridgeway Collins, *Threads of History: Americana Recorded on Cloth, 1775 to the Present* (Washington, D.C., 1979), p. 236.

22. Otto Charles Thieme, " 'Wave High the Red Bandanna': Some Handkerchiefs of the 1888 Presidential Campaign," *Journal of American Culture*, vol. 3, no. 4 (Winter, 1980), p. 687. Research provided by former Museum staff member Hunter Demos.

23. Marilyn Brooks, *World of Quilts at Meadowbrook Hall* (Rochester, Mich., 1983). p. 57.

24. Katy Christopherson, *The Political and Campaign Quilt* (Frankfort, Ky., 1984), p. 43.

25. *The Quilt Digest 3* (San Francisco, 1985), p. 40.

> CHAPTER SIX <

1. British quilt historian Janet Rae disputes the American origin of the Log Cabin pattern and proposes that the design originated in Great Britain hundreds of years ago. See Janet Rae, *Quilts of the British Isles* (New York, 1987), p. 68. The authors of this book, however, believe that Rae has not provided any examples of British Log Cabin quilts that can be positively dated earlier than American examples.

2. Brackman, *Clues in the Calico*, p. 23.

3. Ibid.

4. See, for example, the New York State Quilt Project. Atkins and Tepper, *New York Beauties* (New York, 1992), pp. 106–110.

5. Barbara Brackman, "Fairs and Expositions: Their Influence on American Quilts" in *Bits and Pieces: Textile Traditions* (Lewisburg, Pa., 1991), p. 93.

6. Information on Mary Jane Smith provided by Museum of American Folk Art docent and former Folk Art Institute student Jeanne Riger.

7. Complete census and directory information available in Museum of American Folk Art object file.

8. Complete census and directory information available in Museum of American Folk Art object file.

9. Information from Museum of American Folk Art object file.

10. Virginia Gunn, "Dress Fabrics of the Late 19th Century: Their Relationship to Period Quilts," in *Bits and Pieces*, p. 7.

11. Information from Museum of American Folk Art object file.

12. Because this quilt entered the Museum's collection permanently mounted on a frame, it has not been possible to determine if it was pieced using the foundation method.

13. Brackman, *Clues in the Calico*, p. 146.

14. Information from Museum of American Folk Art object file.

> CHAPTER SEVEN <

1. Bowman, *The Smithsonian Treasury*, p. 31.

2. Quoted in Virginia Gunn, "Victorian Silk Template Patchwork in American Periodicals 1850–1875," *Uncoverings*, vol. 4 (1983), p. 16.

3. Ibid. p. 17.

4. Ibid.

5. For example, S.F.A. Caulfield and Blanche C. Saward, *Encyclopedia of Victorian Needlework [Dictionary of Needlework]* (New York, 1972), p. 384. Unabridged reissue of *The Dictionary of Needlework: An Encyclopedia of Artistic, Plain, and Fancy Needlework* (A.W. Cowan, 1882).

6. *Needle and Brush: Useful and Decorative* (New York, 1889), p. 79.

7. Collins, *Threads of History*, p. 24.

8. Pat Ferrero, Elaine Hedges, and Julie Silber, *Hearts and Hands: The Influence of Women and Quilts on American Society* (San Francisco, 1987), p. 53.

9. Brackman, *Clues in the Calico*, pp. 143–144.

10. Peck, *American Quilts & Coverlets*, p. 93.

11. Dennis Duke and Deborah Harding, eds., *America's Glorious Quilts* (New York, 1987), p. 276.

12. Ibid., p. 270.

13. Penny McMorris, *Crazy Quilts* (New York, 1984), p. 45.

14. Catherine Lynn, "Decorating Surfaces: Aesthetic Delight, Theoretical Dilemma," in *In Pursuit of Beauty: Americans and the Aesthetic Movement* (New York, 1986), p. 53.

15. McMorris, *Crazy Quilts*, p. 12.

16. Catherine Lynn, "Surface Ornament: Wallpapers, Carpets, Textiles, and Embroidery," in *In Pursuit of Beauty*, p. 105.

17. Quoted Ibid.

18. Virginia Gunn, "Crazy Quilts and Outline Quilts: Popular Responses to the Decorative Art/Art Needlework Movement, 1876–1893," *Uncoverings* (1984), vol. 5, p. 134.

19. Brackman, "Fairs and Expositions," p. 91.

20. Information from Museum of American Folk Art object file.

21. Ruth E. Finley, *Old Patchwork Quilts and the Women Who Made Them* (Philadelphia and London, 1929), p. 48.

22. Information from Museum of American Folk Art object file.

23. Letter from family of Emma Pauling to Elizabeth V. Warren, May 12, 1990. All information on Emma Pauling, including excerpts from her diary, provided by surviving descendants.

24. Jeannette Lasansky, "Quilts of Central Pennsylvania," *The Magazine Antiques*, vol. cxxxi, no. 1 (January, 1987), p. 295.

25. *Needle-Craft, Artistic and Practical* (New York, 1889), p. 41.

26. Ibid.

27. Vincent, *The Ladies' Worktable*, p. 73.

28. Historical research provided by Museum of American Folk Art curator Stacy C. Hollander.

29. Research on print sources by former Folk Art Institute student Soo-Kyung Kim.

30. Allen Johnson and Dumas Malone, eds., *Dictionary of American Biography, vol. vi.* (New York, 1931), pp. 109–110.

31. Gale Research Company, *Currier & Ives: A Catalogue Raisonne* (Detroit, 1983), p. 339.

32. "American Women's Gift to France," *Harper's Bazar*, vol. 33, no. 20 (May 19, 1900), p. 151.

33. The small, square size of this textile indicates that it may have been made to cover a table rather than a bed.

› CHAPTER EIGHT ‹

1. Penny McMorris and Michael Kile, *The Art Quilt*, (San Francisco, 1986), pp. 26–27.
2. Quoted in Questa Benberry, "The 20th Century's First Quilt Revival, Part II: The First Quilt Revival," *Quilter's Newsletter Magazine*, September, 1979, p. 25.
3. Schorsch, *Plain & Fancy*, p. 89.
4. Information on Alverda Herb and the "Bull's Eye" quilts provided by Holly Green. See Nancy and Donald Roan, *Lest I Shall Be Forgotten: Anecdotes and Traditions of Quilts* (Green Lane, Pa., 1993), p. 50.
5. Information provided by Holly Green.
6. Brackman, *Clues in the Calico*, p. 29.
7. Information on Elizabeth Schumacher Leece provided by her granddaughter, Marion Baer.
8. Marie D. Webster, "The May Tulip Quilt in Appliqué," *Needlecraft, The Magazine of Home Arts*, May, 1931, p. 6.
9. Letter from Questa Benberry to Stacy Hollander, January 21, 1989.
10. Brackman, *Encyclopedia of Applique*, p. 165.
11. Thos. K. Woodard and Blanche Greenstein, *Twentieth Century Quilts, 1900–1950*, (New York, 1988), p. 12.
12. Hall and Kretsinger, *The Romance of the Patchwork Quilt in America*, p. 112.
13. "The Little Lady of 76 and her 'Holiday' Quilts," article on Mary Etta Bach from unidentified Philadelphia newspaper dated December 27, 1947. Article available in Museum of American Folk Art object file.
14. Ibid.
15. Brackman, *Clues in the Calico*, p. 31.
16. Ibid., p. 160.
17. See Woodard and Greenstein, *Twentieth Century Quilts*, p. 59, for an illustration of the original design.
18. Information on this pattern provided by Cuesta Benberry, Edith M. Leeper, and Louise O. Townsend in letters to Stacy Hollander.
19. Ruby McKim, *101 Patchwork Patterns*, second edition (New York, 1962), p. 44.
20. Letter from Questa Benberry to Stacy Hollander, November 23, 1987.
21. McMorris and Kile, *The Art Quilt*, p. 35.
22. Woodard and Greenstein, *Twentieth Century Quilts*, p. 74.
23. Cyril I. Nelson, *The Quilt Engagement Calendar 1996* (New York, 1995), #42.
24. Merikay Waldvogel and Barbara Brackman, *Patchwork Souvenirs of the 1933 World's Fair* (Nashville, Tenn., 1993), p.84.
25. Ibid.
26. Ibid., p. 34.
27. Ibid., p. 35.
28. McMorris and Kile, *The Art Quilt*, p. 37.
29. Most of the Museum's Double Wedding Ring quilts were the collection of the late Dr. Robert Bishop. The quilts were given to the Museum in a series of gifts both before and after his death.
30. See, for example: Orlofsky, *Quilts in America*, p. 246.
31. Brackman, *Clues in the Calico*, p. 160.
32. See Susan Swan, *Plain & Fancy: American Women and Their Needlework, 1700–1850* (New York, 1977), p. 207.
33. For a complete discussion, see Bishop, *The Romance of Double Wedding Ring Quilts*, p. 3.
34. Ibid., p. 6.
35. Quoted Ibid., p. 28.
36. Harold and Dorothymae Groves, eds., *The Kansas City Star Classic Quilt Patterns: Motifs & Designs* (1988), p. 43.
37. Ibid.
38. Brackman, *Encyclopedia of Pieced Quilt Patterns*, p. 501.
39. Quoted in Bishop, *The Romance of Double Wedding Ring Quilts*, p. 1.
40. Ibid.
41. McMorris and Kile, *The Art Quilt*, p. 30.

› CHAPTER NINE ‹

1. See, especially, the works of John A. Hostetler, including *Amish Society* (Baltimore and London, 1980).
2. Eve Wheatcroft Granick, *The Amish Quilt*, (Intercourse, Pa., 1989), p. 29.
3. Ibid., p. 76.
4. Information provided by Connie Hayes, from Museum of American Folk Art object file.
5. Granick, *The Amish Quilt*, p. 81.
6. See ibid., p. 91, for a chart on the evolution of Amish and Mennonite groups in Mifflin County.
7. Ibid., p. 94.
8. Ibid., p. 91.
9. In 1980, David Pottinger gave the Museum 92 Midwestern Amish quilts. Most were from Indiana, but the gift also included quilts made in Ohio and from the Amish community of Haven, Kansas, which had close ties to the settlements in Indiana.
10. Granick, *The Amish Quilt*, p. 141.
11. Information provide by Barbara S. Janos.
12. Stanley A. Kaufman with Leroy Beachy, *Amish in Eastern Ohio* (Walnut Creek, Ohio, 1990), p. 48.
13. The Schwartzentruber Amish in Ohio and the Old Order Amish in Indiana are among the most conservative of all Amish groups.
14. Granick, *The Amish Quilt*, p. 143.

› CHAPTER TEN ‹

1. Maude Southwell Wahlman, *Signs and Symbols: African Images in African-American Quilts* (New York, 1993), p. vii.
2. Ibid.
3. Cuesta Benberry, *Always There: The African-American Presence in American Quilts* (Louisville, Ky., 1992), p. 15.
4. Wahlman, *Signs and Symbols*, p. vii.
5. Ibid. See also: John Michael Vlach, *The Afro-American Tradition in Decorative Arts* (Cleveland, 1978), p. 55.
6. Wahlman, *Signs and Symbols*, p. 49.
7. Barbara Brackman, "The Strip Tradition in European-American Quilts," *The Clarion*, vol. 14, no. 4 (Fall, 1989), p. 44.
8. Ibid., p. 51.
9. Ibid.
10. Wahlman, *Signs and Symbols*, p. 35.
11. Ibid.
12. Ibid., p. 44.
13. Quoted Ibid., p. 4
14. Quoted Ibid., p. 17.

15. Ibid., p. 48.
16. Ibid., p. 56.
17. Ibid.
18. Ibid., p. 48.
19. Ibid.
20. Ibid.
21. Vlach, *The Afro-American Tradition in Decorative Arts*, pp. 44–54.
22. For a quilt by Sarah Mary Taylor, see Catalogue #360.
23. Wahlman, *Signs and Symbols*, p. 22.

› CHAPTER ELEVEN ‹

1. McMorris and Kile, *The Art Quilt*, p. 43.
2. See Ibid., pp. 40–56 for an essay on this subject.
3. Information from Museum of American Folk Art oject file.
4. Ibid.
5. "The Meetin' Place," *Quilters Newsletter Magazine*, vol. 18, no. 10 (November-December 1987), p. 24.
6. Kumiko Sudo, *Expressive Quilts*, (Berkeley, Calif., 1989), p. 51.
7. Robert Bishop and Carter Houck, *All Flags Flying: American Patriotic Quilts as Expressions of Liberty* (New York, 1986), p. ii.
8. Ibid.
9. Jacqueline M. Atkins, ed., *Memories of Childhood* (New York, 1989), p. ii.
10. Ibid.
11. Ibid., p. v.
12. Jacqueline M. Atkins, ed., *Discover America and Friends Sharing America* (New York, 1991), p. ii.
13. Ibid.
14. Ibid.
15. Ibid., p. 53.
16. Brackman, *Clues in the Calico*, p. 163.

GLORIOUS AMERICAN QUILTS
THE QUILT COLLECTION OF THE
MUSEUM OF AMERICAN FOLK ART

In this catalogue checklist, the quilt entries are grouped under the appropriate chapters. For consistency in labeling those quilts for which a pattern name was not provided by the quiltmakers, either a descriptive name has been used or a published pattern as identified by Barbara Brackman in either her *Encyclopedia of Applique: An Illustrated, Numerical Index to Traditional and Modern Patterns* or her *Encyclopedia of Pieced Quilt Patterns*. Quiltmakers' identities, life dates, and places of residence, if known, are given. The term "probably," when used for a person or a place, denotes more certainty than "possibly." Initials on quilts, either embroidered on the surface or stitched into the quilting patterns, are noted, although they may not represent the quiltmaker but the individual for whom the quilt was made. Unless a quilt is dated or has a firm family history, a range of dates is used instead of the "circa" dating system. "Circa" or "c." is occasionally used with life dates when published records do not state specific years. Basic terms for fibers, such as cotton, wool, or silk are listed instead of the various weaves of cloth. If identifiable, particular synthetic fibers are noted.

WHOLE-CLOTH QUILTS

WOOL QUILTS

1. Indigo Calimanco Quilt
Quiltmaker unidentified
Probably New England; 1800–1820
Wool
86" x 95"
Promised gift of a Museum friend in honor of Joel and Kate Kopp; P1.1995.4
See color fig. 1.

2. Calimanco Quilt With Border
Quiltmaker unidentified
United States; 1810–1820
Wool
96" x 91"
Gift of Cyril Irwin Nelson in devoted memory of his grandmother, Elinor Irwin (Chase) Holden; 1993.6.5
See color fig. 2.

3. Pieced Calimanco Quilt
Quiltmaker unidentified
New England; 1810–1820
Wool
96" x 88"
Promised gift of a Museum friend; P1.1992.6

4. Whole-Cloth Quilt
Quiltmaker unidentified
New England; 1800–1825
Wool
97" x 88$\frac{1}{4}$"
Gift of Robert Bishop; 1985.37.10

5. Center Star Quilt
Quiltmaker unidentified
New England; 1815–1825
Wool
100$\frac{1}{2}$" x 98"
Gift of Cyril Irwin Nelson in honor of Robert Bishop, Director of the Museum of American Folk Art; 1986.13.1
See color fig. 3.

6. Harlequin Medallion Quilt
Quiltmaker unidentified
New England; 1800–1820
Wool
87" x 96"
Gift of Cyril Irwin Nelson in loving memory of his grandparents, John Williams and Sophie Anna Macy; 1984.33.1
See color fig. 4.

7. Linsey-Woolsey Quilt
Quiltmaker unidentified
Possibly New England; 1810–1840
Linen and wool
90$\frac{1}{2}$" x 85"
Gift of Robert Bishop; 1985.37.11

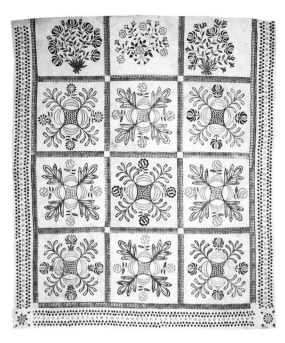

1. BLOCK-WORK STENCILED SPREAD

Possibly Sara Massey; possibly Watertown, New York;
1825–1840; cotton and paint; 88" x 76¼". Gift of Robert Bishop;
1985.37.9

CHINTZ AND COPPERPLATE-PRINTED QUILTS

8. Chintz Whole-Cloth Quilt
Quiltmaker unidentified
United States; 1810–1820
Cotton
91¼" x 87"
Gift of a Museum friend in honor of Joel and Kate Kopp;
1993.6.7
See color fig. 5.

9. Whole-Cloth Quilt with Pieced Border
Quiltmaker unidentified
Probably New England; 1810–1820
Cotton
88" x 76"
Promised gift of a Museum friend; P1.1995.1
See color fig. 6.

10. Copperplate-Printed Whole-Cloth Quilt
Quiltmaker unidentified
New England or England; 1800–1815
Linen and cotton
96" x 93"
Gift of a Museum friend in honor of Laura Fisher; 1995.13.3
See color fig. 7.

11. Chintz Whole-Cloth Quilt with Ball Fringe
Elizabeth Higgs (1795–1872)
Pennsylvania; 1850–1872

Cotton
93¾" x 92⅞"
Gift of Lynn M. Lorwin; 1985.13.1

STENCILED SPREADS

12. Pots of Flowers Stenciled Spread
Maker unidentified
New England; 1825–1835
Cotton and paint with cotton fringe
92" x 85" framed
Gift of George E. Schoellkopf; 1978.12.1
See color fig. 8.

13. Block-Work Stenciled Spread
Possibly Sara Massey
Possibly Watertown, New York; 1825–1840
Cotton and paint
88" x 76¼"
Gift of Robert Bishop; 1985.37.9
See black-and-white fig. 1.

WHITEWORK BEDCOVERS

14. Tree of Life Whitework Quilt
Quiltmaker unidentified
United States; dated 1796
Cotton with cotton fringe
92¼" x 87¾"
Promised gift of a Museum friend; P1.1995.7
See fig. 9.

15. Basket of Flowers Whitework Quilt
Quiltmaker unidentified
Possibly Pennsylvania; 1810–1820
Cotton with cotton fringe
97½" x 90"
Promised gift of a Museum friend; P1.1992.2
See fig. 10.

16. Anna Bromham Whitework Quilt
Anna Page Bromham (c.1770–1844)
New Haven, Connecticut; 1825–1835
Cotton
92" x 81½"
Gift of Mary D. Bromham; 1989.3.1

17. Sarah Stoddard Candlewick Spread
Sarah Elmira Stoddard (1813–1887)
Groton, Connecticut; dated April 5, 1832
Cotton with clipped cotton roving and cotton fringe
96¾" x 92" without fringe
Gift of a Museum friend; 1985.36.2
See fig. 11.

18. Maria Clark Candlewick Spread
Maria Clark
Probably Coventry, Connecticut; 1825–1840
Cotton with cotton roving
102" x 94"
Promised gift of a Museum friend; P1.1995.2
See fig. 12.

19. Susan Tibbets Candlewick Spread
Susan Tibbets
Possibly Connecticut; dated 1847
Cotton with clipped cotton roving
100 1/2" x 91"
Gift of a Museum friend; 1991.18.1
See fig. 13.

20. Flowering Vines Candlewick Spread
Maker unidentified
New England; 1810–1820
Cotton with clipped roving and cotton fringe
96" x 95" including fringe
Gift of a Museum friend in honor of Cora Ginsburg; 1993.6.8
See fig. 14.

21. Eagle Candlewick Spread
Maker unidentified
United States; 1810–1820
Cotton with cotton fringe
96" x 78"
Gift of a Museum friend; 1995.13.2
See fig. 15.

22. Concentric Circles Candlewick Spread
Maker unidentified
Maine; 1830–1840
Cotton with clipped cotton roving
89 1/2" x 86 1/4"
Gift of Jay Johnson; 1991.6.2

23. Candlewick Spread with Eagles
Maker unidentified, initialed N.G.
United States; dated A.D. 1871
Cotton with cotton fringe
89" x 71 1/2"
Gift of a Museum friend in honor of Robert Bishop, Director
of the Museum of American Folk Art; 1990.17.2
See black-and-white fig. 2.

24. Double Wedding Ring Candlewick Spread
Maker unidentified
United States; dated June 1897
Cotton with clipped cotton roving
79 3/4" x 65"
Gift of Robert Bishop; 1990.25.1
See black-and-white fig. 3.

CHINTZ QUILTS

CUT-OUT CHINTZ QUILTS

25. Martha Micou Cut-Out Chintz Quilt
Martha Chatfield Micou
Possibly Virginia or South Carolina; 1835–1840
Cotton
92" x 92 1/2"
Gift of Mary W. Carter; 1988.2.1
See black-and-white fig. 4.

26. Cut-Out Chintz Quilt with Sawtooth Border
Quiltmaker unidentified
Pennsylvania; 1835–1850

2 . CANDLEWICK SPREAD WITH EAGLES
Maker unidentified, initialed N.G.; United States; dated A.D. 1871; cotton, with cotton fringe; 89" x 71 1/2". Gift of a Museum friend in honor of Robert Bishop, Director of the Museum of American Folk Art; 1990.17.2

3 . DOUBLE WEDDING RING CANDLEWICK SPREAD
Maker unidentified; United States; dated June 1897; cotton, with clipped cotton roving; 79 3/4" x 65". Gift of Robert Bishop; 1990.25.1

4. MARTHA MICOU CUT-OUT CHINTZ QUILT

Martha Chatfield Micou; possibly Virginia or South Carolina;
1835–1840; cotton; 92" x 92½". Gift of Mary W. Carter; 1988.2.1

Cotton
100" x 104"
Gift of a Museum friend in honor of Cora Ginsburg;
1992.28.1
See color fig. 16.

27. Cut-Out Chintz Quilt with Chintz Border
Quiltmaker unidentified
Possibly New England; 1835–1850
Cotton
100" x 91"
Promised gift of a Museum friend in honor of Judith and
James Milne; P1.1995.5
See color fig. 17.

PIECED CHINTZ QUILTS

28. Center Medallion and Flying Geese Quilt
Quiltmaker unidentified
New England; 1825–1835
Cotton
80" x 80"
Gift of a Museum friend in honor of Thos. K. Woodard and
Blanche Greenstein; 1995.13.5
See color fig. 18.

29. Variable Stars Quilt
Quiltmaker unidentified
New England; 1825–1840
Cotton and linen
95" x 87"
Museum of American Folk Art purchase made possible by a

grant from the George and Frances Armour Foundation;
1985.33.1
See color fig. 19.

30. Carpenter's Wheel Quilt
Quiltmaker unidentified
Pennsylvania; 1835–1845
Cotton
102¼" x 101¼"
Gift of a Museum friend; 1992.28.2
See color fig. 20.

31. Lady of the Lake Quilt
Quiltmaker unidentified, initialed E.M.
United States; dated 1837
Cotton
92¼" x 91"
Gift of a Museum friend in honor of Joel and Kate Kopp;
1991.18.3
See color fig. 21.

32. Chintz Bars and Pinwheels Quilt
Quiltmaker unidentified
United States; 1830–1850
Cotton
86" x 79"
Gift of a Museum friend; 1991.18.4
See black-and-white fig. 5.

5. CHINTZ BARS AND PINWHEELS QUILT

Quiltmaker unidentified; United States; 1830–1850; cotton;
86" x 79". Gift of a Museum friend; 1991.18.4

33. Honeycomb Quilt Top
Quiltmaker unidentified
United States or England; 1835–1845
Cotton
98³/₄" x 75"
Gift of Mr. and Mrs. Edwin C. Braman; 1978.27.1
See color fig. 22.

34. Sunburst Quilt
Probably Rebecca Scattergood Savery (1770–1855)
Philadelphia, Pennsylvania; 1835–1845
Cotton
118¹/₂" x 125¹/₈"
Gift of Marie D. and Charles A.T. O'Neill; 1979.26.2
See color fig. 23.

SIGNATURE QUILTS

FRIENDSHIP QUILTS

35. Savery Friendship Star Quilt
Elizabeth Hooten (Cresson) Savery and others
Philadelphia, Pennsylvania; 1844
Cotton and linen with inked signatures and drawings
80" x 83¹/₄"
Gift of Marie D. and Charles A.T. O'Neill; 1979.26.1
See color fig. 24.

36. Missouri Friendship Quilt
Avis Day
Warrenton, Missouri; 1850
Cotton and ink with cotton embroidery
86¹/₂" x 67¹/₂"
Gift of Beverly Walker Reitz in memory of Vest Walker; 1984.22.9

ALBUM QUILTS

37. Sarah Morrell Album Quilt
Possibly Sarah Morrell and others
Pennsylvania and New Jersey; 1843
Cotton and ink with cotton embroidery
93¹/₄" x 95¹/₄"
Gift of Jeremy L. Banta; 1986.16.1
See color fig. 25.

38. Baltimore-Style Album Quilt Top
Possibly Mary Heidenroder Simon (b.1810)
Probably Baltimore, Maryland; 1849–1852
Cotton and ink
109" x 105"
Gift of Mr. and Mrs. James O. Keene; 1984.41.1
See color fig. 26.

39. Dunn Album Quilt
Sewing Society of the Fulton Street United Methodist Episcopal Church
Elizabethport, New Jersey; 1852
Cotton and ink with cotton embroidery
99¹/₄" x 100"
Gift of Phyllis Haders; 1980.1.1
See color fig. 27.

40. Cross River Album Quilt
Mrs. Eldad Miller (1805–1874) and others
Cross River, New York; 1861
Cotton and silk with wool embroidery
90" x 75"
Gift of Dr. Stanley and Jacqueline Schneider; 1980.8.1
See color fig. 28.

FUND-RAISING QUILTS

41. Admiral Dewey Commemorative Quilt
Possibly The Mite Society (Ladies' Aid), United Brethren Church
Center Point, Indiana; 1900–1910
Cotton with Turkey red cotton embroidery
88" x 65"
Gift donated by Janet Gilbert for Marie Griffin; 1993.3.1
See color fig. 29.

42. Schoolhouse Quilt Top
The Presbyterian Ladies of Oak Ridge, Missouri
Oak Ridge, Missouri; 1897–1898
Cotton with cotton embroidery
74¹/₂" x 90¹/₂"
Gift of Beverly Walker Reitz in memory of Vest Walker; 1984.22.10
See black-and-white fig. 6.

6 . SCHOOLHOUSE QUILT TOP

The Presbyterian Ladies of Oak Ridge, Missouri; Oak Ridge, Missouri; 1897–1898; cotton, with cotton embroidery; 74¹/₂" x 90¹/₂". Gift of Beverly Walker Reitz in memory of Vest Walker; 1984.22.10

APPLIQUÉ QUILTS

FLORAL QUILTS

43. Tulip Bouquet Quilt
Margaret Walker (1833–1912)
Vicinity of Oak Ridge, Missouri; 1880–1900
Cotton
89¹/₂" x 77¹/₂"
Gift of Beverly Walker Reitz in memory of Vest Walker;
1984.22.3
See black-and-white fig. 7.

44. Whig Rose Quilt
Quiltmaker unidentified
Possibly Pennsylvania; 1860–1880
Cotton
96¹/₄" x 94¹/₄"
Gift of Karen and Warren Gundersheimer; 1980.20.1
See color fig. 30.

45. Abigail Hill Whig Rose Quilt
Abigail Hill
Probably Indiana; dated 1857–1858
Cotton
79³/₄" x 70"
Gift of Irene Reichert in honor of her daughter, Susan
Reichert Sink, and granddaughter, Heather Sink; 1992.13.1
See color fig. 31.

8 . PRINCESS FEATHER QUILT
*Women of the Walker household; vicinity of Oak Ridge, Missouri;
1880–1900; cotton; 83" x 81". Gift of Beverly Walker Reitz in
memory of Vest Walker; 1984.22.2*

7 . TULIP BOUQUET QUILT
*Margaret Walker (1833–1912); vicinity of Oak Ridge, Missouri;
1880–1900; cotton; 89¹/₂" x 77¹/₂".*

46. Whig Rose Quilt with Swag and Tassel Border
Quiltmaker unidentified
United States; 1850–1860
Cotton
100" x 82"
Gift of Irene Reichert in honor of Nathan Druet; 1993.1.2
See color fig. 32.

47. Princess Feather Quilt
Women of the Walker household
Vicinity of Oak Ridge, Missouri; 1880–1900
Cotton
83" x 81"
Gift of Beverly Walker Reitz in memory of Vest Walker;
1984.22.2
See black-and-white fig. 8.

48. Strawberries in Pots Quilt
Quiltmaker unidentified
Possibly Missouri; 1850–1860
Cotton
91" x 89"
Gift of Phyllis Haders; 1981.18.1
See color fig. 33.

49. Turkey Tracks Quilt
Quiltmaker unidentified
Possibly Ohio; 1840–1860
Cotton
90" x 86"
Promised gift of a Museum friend; P1.1995.9
See color fig. 34.

50. Sunflowers and Hearts Quilt
Quiltmaker unidentified
Possibly New England; 1860–1880
Cotton
85" x 91"
Gift of Frances and Paul Martinson; 1994.2.1
See color fig. 35.

51. MTD Quilt Top
Quiltmaker unidentified
United States; dated 1842
Cotton
99" x 94"
Promised gift of a Museum friend; P1.1995.8
See color fig. 36.

52. Floral Medallion Quilt
Quiltmaker unidentified
Possibly Vincennes, Indiana; 1870–1880
Cotton
86" x 70"
Gift of Irene Reichert; 1993.1.3
See color fig. 37.

53. Oak Leaf with Cherries Quilt
Quiltmaker unidentified
United States; 1870–1880
Cotton with wool embroidery
80" x 78"
Gift of Irene Reichert; 1993.1.1
See color fig. 38.

54. Centennial Quilt
Possibly Gertrude Knappenberger
Possibly Emmaus, Pennsylvania; dated 1876
Cotton with cotton embroidery
84" x 74" framed
Gift of Rhea Goodman; 1979.9.1
See color fig. 39.

55. Hearts and Pineapples Quilt Top
Quiltmaker unidentified
Probably Pennsylvania; 1850–1870
Cotton
87" x 69¹/₂"
Gift of Cyril Irwin Nelson in memory of his grandparents,
Guerdon Stearns and Elinor Irwin (Chase) Holden, and in
honor of his parents, Cyril Arthur and Elise Macy Nelson;
1982.22.4
See black-and-white fig. 9.

56. Birds and Oak Leaves Quilt Top
Quiltmaker unidentified
United States; 1870–1890
Cotton with cotton embroidery
89¹/₂" x 80"
Gift in memory of George Arthur Mason Senior by his
daughter; 1990.4.1
See black-and-white fig. 10.

57. Blossom and Cherry Appliqué Quilt
Unidentified member of the Hilton family

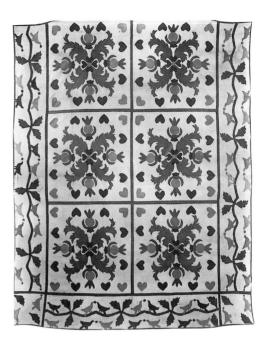

9 . HEARTS AND PINEAPPLES QUILT TOP

Quiltmaker unidentified; probably Pennsylvania; 1850–1870; cotton; 87" x 69¹/₂". Gift of Cyril Irwin Nelson in memory of his grandparents, Guerdon Stearns and Elinor Irwin (Chase) Holden, and in honor of his parents, Cyril Arthur and Elise Macy Nelson; 1982.22.4

10 . BIRDS AND OAK LEAVES QUILT TOP

Quiltmaker unidentified; United States; 1870–1890; cotton, with cotton embroidery; 89¹/₂" x 80". Gift in memory of George Arthur Mason Senior by his daughter; 1990.4.1

United States; 1890–1910
Cotton
86" x 70¹/₂"
Gift of Elisabeth H. Belfer in memory of Marion Hilton;
1993.5.2

SAMPLER QUILTS

58. Bird of Paradise Quilt Top
Quiltmaker unidentified
Vicinity of Albany, New York; 1858–1863
Cotton, wool, silk and ink with silk embroidery
84¹/₂" x 69⁵/₈"
Gift of the Trustees of the Museum of American Folk Art;
1979.7.1
See color fig. 40.

59. Cookie Cutter Quilt
Quiltmaker unidentified
Probably Pennsylvania; 1875-1925
Cotton
71¹/₂" x 79¹/₂"
Gift of Jackie and Stanley Schneider; 1979.21.1
See color fig. 41.

60. Union and Liberty Sampler Quilt Top
Quiltmaker unidentified
New York State; 1860–1870
Cotton, wool, and silk with metallic and silk embroidery
84" x 87¹/₂"
Gift of Jackie and Stanley Schneider; 1980.31.1
See black-and-white fig. 11.

PICTORIAL QUILTS

61. Sarah Ann Garges Appliqué Quilt
Sarah Ann Garges (c.1834-c.1887)
Doylestown, Pennsylvania; dated 1853
Cotton, silk, wool and wool embroidery
96" x 98"
Gift of Warner Communications Inc.; 1988.21.1
See color fig. 42.

62. Sacret Bibel Quilt
Susan Arrowood
Possibly West Chester, Pennsylvania; 1875–1895
Cotton, silk, wool and ink with cotton embroidery
88¹/₂" x 72" framed
Gift of the Amicus Foundation, Inc., and Evelyn and
Leonard Lauder; 1986.20.1
See color fig. 43.

MISCELLANEOUS QUILTS

63. Appliqué Crib Quilt
Quiltmaker unidentified
Probably Pennsylvania; 1840–1860
Cotton
33¹/₄" x 33³/₄" framed
Gift of Joel and Kate Kopp; 1980.5.1
See black-and-white fig. 12.

**11. UNION AND LIBERTY SAMPLER
QUILT TOP**
*Quiltmaker unidentified; New York State; 1860–1870; cotton,
wool, and silk, with metallic thread and silk embroidery; 84" x
87¹/₂". Gift of Jackie and Stanley Schneider; 1980.31.1*

12. APPLIQUÉ CRIB QUILT
*Quiltmaker unidentified; probably Pennsylvania; 1840–1860; cot-
ton; 33¹/₄" x 33³/₄" framed. Gift of Joel and Kate Kopp; 1980.5.1*

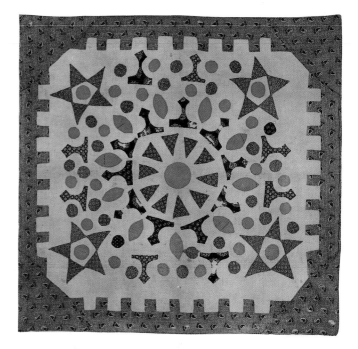

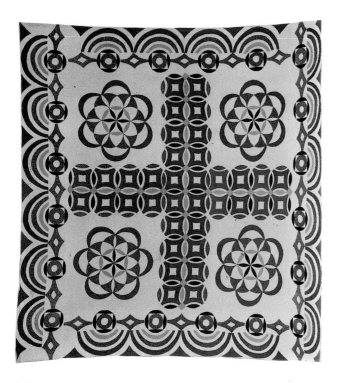

13. ORANGE PEEL VARIATION QUILT

Quiltmaker unidentified; Pennsylvania; 1860–1880; cotton; 116″
x 118″. Gift of Dr. and Mrs. W. J. Robbins; 1982.12.1

64. Orange Peel Variation Quilt
Quiltmaker unidentified
Pennsylvania; 1860–1880
Cotton
116" x 118"
Gift of Dr. and Mrs. W. J. Robbins; 1982.12.1
See black-and-white fig. 13.

65. Cactus Rose Quilt Block
Quiltmaker unidentified
Pennsylvania; 1855–1865
Cotton
29" x 28" framed
Gift of a Museum friend in honor of Robert Bishop, Director
of the Museum of American Folk Art; 1990.17.5

PIECED QUILTS

GEOMETRIC QUILTS

66. Nine Patch Quilt
Quiltmaker unidentified
Probably New England; 1820–1830
Linen and cotton
86³/₄" x 79¹/₂"
Gift of Mrs. Alice Kaplan; 1979.17.1
See black-and-white fig. 14.

67. Feathered Touching Stars Quilt
Quiltmaker unidentified

Ohio; dated 1846
Cotton
85¹/₂" x 84³/₄"
Gift of a Museum friend; 1989.17.6
See color fig. 44.

68. Pieties Quilt
Maria Cadman Hubbard (b.1769)
Probably Austerlitz, Columbia County, New York; dated 1848
Cotton
88¹/₂" x 81"
Gift of Cyril Irwin Nelson in loving memory of his parents,
Cyril Arthur and Elise Macy Nelson; 1984.27.1
See color fig. 45.

69. ECB Feathered Stars Quilt
Quiltmaker unidentified, pieced initials ECB
Possibly New York State; 1850–1860
Cotton
95¹/₂" x 76¹/₂"
Gift of a Museum friend; 1985.36.1
See color fig. 46.

70. Star of Bethlehem with Star Border Quilt
Quiltmaker unidentified
United States; 1840–1860
Cotton
90³/₄" x 90¹/₂" framed
Gift of Cyril Irwin Nelson in honor of Robert Bishop,
Director of the Museum of American Folk Art; 1990.17.3
See color fig. 47.

14. NINE PATCH QUILT

Quiltmaker unidentified; probably New England; 1820–1830;
linen and cotton; 86³/₄" x 79¹/₂". Gift of Mrs. Alice Kaplan;
1979.17.1

15. MARINER'S COMPASS QUILT

Quiltmaker unidentified; United States; 1840–1860; cotton;
75¼" x 70". Gift of Kinuko Fujii, Osaka, Japan; 1991.8.2

71. Mariner's Compass Quilt
Quiltmaker unidentified
Region unknown; 1840–1860
Cotton
75¼" x 70"
Gift of Kinuko Fujii, Osaka, Japan; 1991.8.2
See black-and-white fig. 15.

72. Mariner's Compass Variation Quilt
Quiltmaker unidentified, embroidered initials BB
Maine; 1880–1890
Cotton with cotton embroidery
86" x 82"
Gift of Cyril Irwin Nelson in memory of his grandparents,
Guerdon Stearns and Elinor Irwin (Chase) Holden, and in
honor of his parents, Cyril Arthur and Elise Macy Nelson;
1982.22.1
See color fig. 48.

73. Pieced Block-Work Quilt with Printed Border
Quiltmaker unidentified
Pennsylvania; 1840–1860
Cotton
91¼" x 85¾"
Gift of a Museum friend; 1995.13.4
See color fig. 49.

74. Diamond in a Square Variation Quilt Top
Quiltmaker unidentified
Massachusetts; 1870–1880
Cotton
88" x 84"
Gift of a Museum friend in honor of Jolie Kelter and
Michael Malcé; 1982.22.2
See color fig. 50.

75. Nine Patch Quilt
Quiltmaker unidentified
Possibly Maryland or Virginia; 1840–1860
Wool
76" x 67¾"
Gift of Margo Ernst; 1989.16.27

76. Miniature Double Nine Patch Quilt
Quiltmaker unidentified
United States; 1850–1875
Cotton
73¾" x 68¼" framed
Gift of a Museum friend in honor of Robert Bishop, Director
of the Museum of American Folk Art; 1990.17.7

77. Blazing Star Crib Quilt
Quiltmaker unidentified
Maine; 1880–1890
Cotton
44" x 32¾"
Gift of David L. Davies; 1991.29.2
See black-and-white fig. 16.

78. Mosaic Crib Quilt
Possibly Blanche Miller Wiley
United States; 1880–1900
Cotton
36¼" x 32½"
Gift of Margaret Cavigga; 1989.13.1

16. BLAZING STAR CRIB QUILT

Quiltmaker unidentified; Maine; 1880–1890; cotton; 44" x 32¾".
Gift of David L. Davies; 1991.29.2

79. Mosaic Geese in Flight Quilt
Quiltmaker unidentified
United States; 1890–1910
Cotton
83$^{1}/_{2}$" x 82$^{1}/_{4}$" framed
Gift of a Museum friend in honor of Robert Bishop, Director
of the Museum of American Folk Art; 1990.17.6

80. Geese in Flight Variation Crib Quilt
Quiltmaker unidentified
United States; 1880–1900
Cotton and wool
58$^{1}/_{2}$" x 52$^{3}/_{4}$"
Gift of Dorothy and Leo Rabkin; 1991.17.1

81. Basketweave Quilt
Quiltmaker unidentified
United States; 1890–1910
Cotton
78$^{3}/_{4}$" x 78$^{1}/_{4}$"
Gift of Dorothy and Leo Rabkin; 1991.17.2

82. Touching Stars Quilt
Quiltmaker unidentified
United States; 1875–1890
Cotton
77" x 68"
Gift of Robert Bishop; 1990.25.27

83. Feathered Star with Sawtooth Border Quilt
Quiltmaker unidentified
New York State; 1890–1900
Cotton
86" x 71$^{1}/_{2}$"
Gift of Elisabeth H. Belfer in memory of Marion Hilton;
1993.5.1

84. Ocean Waves Quilt
Quiltmaker unidentified
Ohio; 1875–1920
Cotton
92" x 79"
Gift of Bill Weaver in memory of Mr. Quincy Weaver and
Mrs. Anna Mahaffey Weaver; 1982.16.1

85. Centennial Quilt Top
Quiltmaker unidentified
United States; 1876
Cotton
61" x 60$^{1}/_{2}$"
Gift of Howard and Shirley Lanser; 1988.11.1

86. Baskets Quilt
Avis Day (Mrs. John Harvey) Walker (b.1844)
Vicinity of Oak Ridge, Missouri; 1890–1900
Cotton
84" x 82"
Gift of Beverly Walker Reitz in memory of Vest Walker;
1984.22.1

87. Postage Stamp Quilt
Avis Day (Mrs. John Harvey) Walker (b.1844)
Vicinity of Oak Ridge, Missouri; 1890–1900

Cotton
89$^{1}/_{2}$" x 71"
Gift of Beverly Walker Reitz in memory of Vest Walker;
1984.22.5

88. Red and White Lattice with Sawtooth Border Quilt
Women of the Walker household
Vicinity of Oak Ridge, Missouri; 1890–1900
Cotton
79" x 63$^{1}/_{2}$"
Gift of Beverly Walker Reitz in memory of Vest Walker;
1984.22.6

89. Seven Stars Quilt
Women of the Walker household
Vicinity of Oak Ridge, Missouri; 1890–1900
Cotton
81$^{1}/_{2}$" x 69$^{1}/_{2}$"
Gift of Beverly Walker Reitz in memory of Vest Walker;
1984.22.7
See black-and-white fig. 17.

90. Georgetown Circle Quilt
Quiltmaker unidentified
Kentucky; 1900–1920
Cotton
82$^{1}/_{2}$" x 67"
Gift of Shelly Zegart; 1994.12.3

17. SEVEN STARS QUILT
*Women of the Walker household; vicinity of Oak Ridge, Missouri;
1890–1900; cotton; 81$^{1}/_{2}$" x 69$^{1}/_{2}$". Gift of Beverly Walker Reitz in
memory of Vest Walker; 1984.22.7*

18. SADDLEBRED HORSE QUILT
Quiltmaker unidentified; possibly Kentucky; 1910–1930; cotton; 77³/₄" x 81³/₄". Gift of Shelly Zegart; 1994.12.1

COMMEMORATIVE AND PICTORIAL QUILTS

91. Baby Crib Quilt
Quiltmaker unidentified
Possibly Kansas; 1861–1875
Cotton with cotton embroidery
36³/₄" x 36"
Gift of Phyllis Haders; 1978.42.1
See color fig. 51.

92. Flag Quilt
Mary C. Baxter
Kearny, New Jersey; 1898–1910
Cotton with cotton embroidery
77¹/₄" x 78³/₄" framed
Gift of the Amicus Foundation, Inc., Anne Baxter Klee, and Museum Trustees; 1985.15.1
See color fig. 52.

93. Grover Cleveland Quilt
Quiltmaker unidentified
New York State; 1884–1890
Cotton
85¹/₂" x 85¹/₂"
Gift of Made in America-Margy Dyer; 1982.17.1
See color fig. 53.

94. Saddlebred Horse Quilt
Quiltmaker unidentified
Possibly Kentucky; 1910–1930
Cotton
77³/₄" x 81³/₄"

Gift of Shelly Zegart; 1994.12.1
See black-and-white fig. 18.

LOG CABIN QUILTS

95. Mary Jane Smith Log Cabin Quilt, Barn Raising Variation
Mary Jane Smith (1833–1869) and her mother, Mary Morrell Smith (1798–1869)
Whitestone, Queens County, New York; 1861–1865
Cotton, wool and silk
81" x 74"
Gift of Mary D. Bromham, grandniece of Mary Jane Smith; 1987.9.1
See color fig. 54.

96. Log Cabin Quilt, Courthouse Steps Variation
Quiltmaker unidentified
United States; 1870–1890
Cotton
81¹/₄" x 79³/₄"
Gift of Mrs. Alice Kaplan; 1977.13.6
See color fig. 55.

97. Log Cabin Throw, Light and Dark Variation
Harriet Rutter Eagleson (1855–c.1925)
New York City; 1874–1880
Silk and cotton
57³/₄" x 57³/₄"
Gift of Miss Jessica R. Eagleson; 1979.18.1
See color fig. 56.

98. Samuel Steinberger Log Cabin Quilt, Courthouse Steps Variation
Samuel Steinberger (1865–c.1934)
New York City; 1890–1910
Silk
69¹/₂" x 58" framed
Gift of a Museum friend in honor of Robert Bishop, Director of the Museum of American Folk Art; 1990.17.8
See color fig. 57.

99. Log Cabin Quilt, Barn Raising Variation
Sara Olmstead King
Connecticut; 1875–1885
Silk
67¹/₈" x 67¹/₈"
Gift of Mrs. E. Regan Kerney; 1980.12.1
See color fig. 58.

100. Log Cabin Quilt, Pineapple Variation
Quiltmaker unidentified
Possibly Lancaster County, Pennsylvania; 1880–1900
Cotton
83¹/₄" x 83"
Gift of Kinuko Fujii, Osaka, Japan; 1991.8.1
See color fig. 59.

101. Log Cabin Quilt, Windmill Blades Variation
Ada Hapman (Mrs. William) Kingsley (c.1859–1939)
South Windsor, New York, or Athens, Pennsylvania; 1880–1900
Silk
73" x 65" framed

Gift of Margaret Cavigga; 1985.23.6
See color fig. 60.

102. Log Cabin Quilt Top
Lutitia Hope (1860–1934)
Oak Ridge, Missouri; 1930–1934
Cotton
76¹/₂" x 76"
Gift of Beverly Walker Reitz in memory of Lutitia Hope; 1984.22.20

FOUNDATION-PIECED QUILTS

103. String Quilt
Quiltmaker unidentified
Possibly Kentucky; 1920–1940
Wool with cotton binding
75¹/₄" x 65"
Gift of Jolie Kelter and Michael Malcé; 1988.26.1
See color fig. 61.

104. String Star Doll Quilt
Quiltmaker unidentified
United States; 1930–1940
Cotton
21" x 21"
Gift of Constance Schrader; 1976.4.1

105. Premium Quilt Top
Bertha Ward Metcalfe
Tyrone, Pennsylvania; 1912–1917
Cotton with cotton embroidery
69" x 56¹/₂"
Gift of James D. Metcalfe; 1980.7.1

SHOW QUILTS

106. Appliquéd and Embroidered Pictorial Bedcover
Maker unidentified
Possibly New York; 1825–1845
Wool, silk, cotton and beads with silk and cotton embroidery
87" x 86"
Gift of Ralph Esmerian; 1991.27.1
See color fig. 62.

107. Star of Bethlehem Quilt
Quiltmaker unidentified
Possibly Sullivan County, New York; 1880–1900
Silk and cotton
99" x 94¹/₄"
Purchase made possible with funds from "The Great American Quilt Festival II"; 1990.15.1
See color fig. 63.

108. Stars and Pentagons Quilt
Quiltmaker unidentified
United States; 1880–1900
Silk
81" x 44" framed
Gift of Jacqueline L. Fowler; 1981.2.1
See color fig. 64.

109. Map Quilt
Quiltmaker unidentified

Possibly Virginia; dated 1886 in embroidered Roman numerals
Silk and cotton with silk embroidery
78³/₄" x 82¹/₄"
Gift of Dr. and Mrs. C. David McLaughlin; 1987.1.1
See color fig. 65.

110. Oregon Political Ribbon Quilt
Probably E.A. Kelley
Oregon; 1923
Silk with silk embroidery
73" x 67³/₄", framed
Gift of Margaret Cavigga; 1985.23.9
See black-and-white fig. 19.

111. Tumbling Blocks Quilt
Winifred Cummings O'Hara
Hastings-on-Hudson, New York; 1890–1900
Silk
73" x 65"
Gift of Donald McKinney in memory of Cherrie Gould McKinney; 1988.3.1

112. Fans Quilt
Quiltmaker unidentified
Possibly Minnesota; dated 1922–1923
Rayon, wool and cotton with cotton embroidery
69¹/₂" x 68¹/₂"
Gift of Margaret Cavigga; 1985.23.7
See black-and-white fig. 20.

19. OREGON POLITICAL RIBBON QUILT

Probably E.A. Kelley; Oregon; 1923; silk, with silk embroidery; 73" x 67³/₄" framed. Gift of Margaret Cavigga; 1985.23.9

20. FANS QUILT

Quiltmaker unidentified; possibly Minnesota; dated 1922–1923; rayon, wool, and cotton, with cotton embroidery; 69¹/₂" x 68¹/₂".
Gift of Margaret Cavigga; 1985.23.7

113. Square Within a Square Quilt
Quiltmaker unidentified
England or United States; 1870–1900
Wool with wool embroidery
85¹/₂" x 66" framed
Gift of General Foods; 1986.7.1

114. Make Way for the Man of the Quilt
Quiltmaker unidentified
Possibly Newburgh or Woodstock, New York; 1885–1900
Silk, cotton and metallic buttons with silk embroidery
90" x 81¹/₄" framed
Promised gift of Carol Burtin Fripp; P2.1991.1

CRAZY QUILTS

115. Cleveland-Hendricks Crazy Quilt
Quiltmaker unidentified, initialed J.F.R.
United States; 1885–1890
Lithographed silk ribbons, silk, and wool with cotton fringe and metallic and silk embroidery
75" x 77" with fringe
Gift of Margaret Cavigga; 1985.23.3
See color fig. 66.

116. S.H. Crazy Quilt
Quiltmaker unidentified, initialed S. H.
United States; 1885–1895
Silk, ink, paint and cotton with silk embroidery
75" x 74"
Gift of Margaret Cavigga; 1985.23.4
See color fig. 67.

117. Rachel Blair Greene Crazy Quilt
Rachel Blair Greene (1846–1909)
Belvedere, New Jersey; 1885–1895
Silk and paint with metallic and silk embroidery
72" x 71³/₄"
Gift of James I. Chesterley; 1982.18.1
See color fig. 68.

118. The Equestrian Crazy Quilt
Quiltmaker unidentified
Possibly New York State; 1880–1900
Silk and cotton with cotton embroidery
92" x 61¹/₂"
Gift of Mr. and Mrs. James D. Clokey III; 1986.12.1
See color fig. 69.

119. Equestrian Crazy Quilt Pillow Shams
Quiltmaker unidentified
Possibly New York State; 1880–1900
Silk with cotton embroidery
27" x 27" each
Promised gift of Mr. and Mrs. James D. Clokey III; P1.1988.1 a & b
See color fig. 70.

120. Center Star Crazy Throw
Mary Ann Crocker Hinman (1817–1893)
New York State; 1880–1890
Silk with silk embroidery
64" x 52³/₄"
Gift of Ruth E. Avard; 1993.2.1
See color fig. 71.

121. Missouri Bridal Crazy Quilt
May Dodge Harper
Poplar Bluff, Missouri; dated 1900
Wool and cotton with wool embroidery
91¹/₂" x 66¹/₄"
Gift of Margaret Cavigga; 1985.23.1
See black-and-white fig. 21.

122. Crazy Quilt
Quiltmaker unidentified
United States; 1902
Wool, cotton and rayon with cotton embroidery
61¹/₄" x 46¹/₂"
Gift of Betty Gubert; 1980.18.1

123. W.H.G. Red Rose Crazy Quilt
Unidentified member of the Morton-and-Whiting Family, initialed W.H.G.
United States; 1893–1915
Silk, cotton, wool, paint with mica flecks and with metallic and silk embroidery
66¹/₂" x 67¹/₂"
Gift of Margaret Cavigga; 1985.23.2

124. MV Crazy Throw
Maker unidentified, initaled MV
United States; 1880–1890
Silk and spangles with metallic and silk embroidery
50" x 51¹/₄"
Gift of Margaret Cavigga; 1985.23.8

125. LMH Crazy Star Quilt
Quiltmaker unidentified, initialed LMH
Possibly Vermont; 1890–1900
Silk, cotton and paint with silk embroidery
68¼" x 57"
Gift of Eve Winer, New York City; 1991.2.1

126. Crazy Quilt with Corner Fans
Quiltmaker unidentified
Colerain, Ohio; dated 1895
Wool, silk, cotton and paint with Berlin wool embroidery
83½" x 74½"
Gift of Anne Baxter Klee; 1985.41.1

127. Noah's Ark Cover
Maker unidentified
Nova Scotia or Quebec, Canada; 1890–1910
Cotton and silk
50" x 70"
Gift of the Potter Family; 1988.7.1

128. Campbell Family Star Crazy Throw
Agnes Campbell Throop (1856–c.1937) and her sister Clara
Campbell Howard (1858–1938)
New York City; 1880–1900
Silk, spangles, paint with wool, metallic and silk embroidery
58¼" 57½"
Gift of Agnes Lester Wade in memory of Elizabeth Belle
Campbell Lester; 1995.6.1

129. Vortex Quilt
Quiltmaker unidentified
Possibly Pennsylvania; 1940–1950
Silk and rayon
64" x 79½"
Gift of Laura Fisher, Antique Quilts and Americana, New
York City; 1992.14.1

130. Crazy Trousseau Robe
Emma Cummins Pauling (1848–1924)
Possibly McCammon, Idaho; 1882–1900
Silk and lace with silk cording and metallic and silk embroidery
Height: 55¼"
Gift of the Family of Emma K. Lentz; 1990.8.1
See color fig. 72.

131. Boxer Dog Crazy Mat
Probably Mrs. Triece, initialed JJJ
Pennsylvania; 1885–1895
Silk with lace edging and silk and wool embroidery
37" x 30" with trimming
Gift of Margaret Cavigga; 1985.23.5
See black-and-white fig. 22.

132. Crazy Patchwork Mat
Maker unidentified
Green Bay, Wisconsin; 1885–1900
Silk with metallic and silk embroidery
36¼" x 36¼"
Gift of Margaret and Al Cavigga; 1987.16.1

21. MISSOURI BRIDAL CRAZY QUILT
May Dodge Harper; Poplar Bluff, Missouri; dated 1900; wool and cotton, with wool embroidery; 91½" x 66¼". Gift of Margaret Cavigga; 1985.23.1

22. BOXER DOG CRAZY MAT
Probably Mrs. Triece, initialed JJJ; Pennsylvania; 1885–1895; silk, with lace edging, and silk and wool embroidery; 37" x 30", with trimming. Gift of Margaret Cavigga; 1985.23.5

23. STAR OF BETHLEHEM WITH
SATELLITE STARS QUILT

Quiltmaker unidentified; possibly Pennsylvania; 1930–1950; cotton and blends; 81" x 81¼". Gift of Mr. and Mrs. Frederick M. Danzinger; 1985.4.1

OUTLINE EMBROIDERED QUILTS

133. In Honor Shall Wave Spread
Maker unidentified
Yonkers, New York; dated December 25, 1902
Cotton with Turkey red cotton embroidery
86" x 73"
Gift of Elaine Sloan Hart, Quilts of America; 1989.20.1
See color fig. 73.

134. Botanical Embroidered Cover
Maker unidentified
United States; 1920–1940
Cotton with cotton embroidery
60½" x 60¾"
Gift of Robert Bishop; 1986.9.1

135. Outline Embroidered Crib Quilt
Quiltmaker unidentified, embroidered "Frank Scanland Houck"
United States; dated 1933
Cotton with cotton embroidery
53½" x 36"
Gift of a Museum friend; 1993.6.3

REVIVAL QUILTS

136. Star of Bethlehem with Satellite Stars Quilt
Quiltmaker unidentified
Possibly Pennsylvania; 1930–1950
Cotton and blends

81" x 81¼"
Gift of Mr. and Mrs. Frederick M. Danziger; 1985.4.1
See black-and-white fig. 23.

137. Tree of Life Cut-Out Chintz Quilt
Quiltmaker unidentified, initialed GMR
Probably Wiscasset, Maine; 1925–1935
Cotton
96" x 90"
Promised gift of a Museum friend; P1.1992.4
See color fig. 74.

138. Bull's Eye Quilt
Member of the family of Alverda H. (Hoffman) Herb
Berks County, Pennsylvania; 1900–1920
Cotton
84½" x 86"
Gift of Jackie and Stanley Schneider; 1980.31.2
See color fig. 75.

139. Tulip and Rose Bouquet Quilt
Elizabeth Schumacher Leece (1867–1956)
Kansas City, Missouri; 1930–1945
Cotton
100¼" x 84½"
Gift of Marian Baer; 1984.11.2
See color fig. 76.

140. Basket of Flowers Quilt
Elizabeth Schumacher Leece (1867–1956)
Kansas City, Missouri; 1930–1940
Cotton with cotton embroidery
95½" x 84"
Gift of Marian Baer; 1984.11.4
See color fig. 77.

141. Daisy Rings Quilt
Elizabeth Schumacher Leece (1867–1956)
Kansas City, Missouri; 1930–1945
Cotton
99¾" x 81¾"
Gift of Marian Baer; 1984.11.3
See color fig. 78.

142. Gingham Dog and Calico Cat Crib Quilt
Quiltmaker unidentified
Probably Pennsylvania; 1920–1930
Cotton
33½" x 27½"
Gift of Gloria List; 1979.35.1
See color fig. 79.

143. The Elephant's Child Quilt Top
E. Buckner Kirk
United States; 1934
Cotton with cotton embroidery
80" x 56½"
Gift of Kirk Hollingsworth; 1992.2.1

144. Roses and Ribbons Quilt
Quiltmaker unidentified
United States; 1930–1940
Cotton

88" x 74"
Gift of a Museum friend; 1995.13.6
See color fig. 80.

145. Dolly Crib Quilt
Quiltmaker unidentified
United States; 1930–1950
Cotton with cotton embroidery
48¹/₄" x 31³/₄"
Gift of Margaret Cavigga; 1988.28.1

146. Hollyhock Cottage Quilt
Quiltmaker unidentified
United States; 1930–1940
Cotton with cotton embroidery
88¹/₄" x 72¹/₂"
Gift of Margaret Cavigga; 1988.28.2
See black-and-white fig. 24.

147. Sunbonnet Children Crib Quilt
Quiltmaker unidentified
United States; 1930–1940
Cotton
63³/₄" x 44¹/₄"
Gift of Margaret Cavigga; 1988.28.3

148. Dogwood Appliqué Quilt
Ladies Aide [*sic*] Society of the Methodist Church
Hoag's Corner, New York; 1925–1935
Cotton with cotton embroidery
92" x 78"
Gift of Lorraine Slighter; 1991.16.1
See color fig. 81.

149. Magnolia Blooms Quilt
Quiltmaker unidentified
United States; 1930–1940
Cotton with cotton embroidery
90" x 76"
Gift of a Museum friend; 1992.28.3
See color fig. 82.

150. All American Star Quilt
Quiltmaker unidentified
New York State; 1940–1945
Cotton
87" x 72"
Gift of a Museum friend; 1987.17.2
See color fig. 83.

151. Ladies' Dream Quilt
Mary Etta (Mrs. Edward Emmet) Bach (1872–1974)
Philadelphia, Pennsylvania; 1930–1940
Cotton
84¹/₂" x 84¹/₂"
Bequest of the estate of Mildred P. Bach; 1992.27.1
See color fig. 84.

152. Rose of Sharon with Flower Pot Border Quilt
Mary Etta (Mrs. Edward Emmet) Bach (1872–1974)
Philadelphia, Pennsylvania; 1930–1950
Cotton

24. HOLLYHOCK COTTAGE QUILT
Quiltmaker unidentified; United States; 1930–1940; cotton, with cotton embroidery; 88¹/₄" x 72¹/₂". Gift of Margaret Cavigga; 1988.28.2

93³/₄" x 77³/₄"
Bequest of the estate of Mildred P. Bach; 1992.27.2
See color fig. 85.

153. Rose of Sharon Quilt
Mary Etta (Mrs. Edward Emmet) Bach (1872–1974)
Philadelphia, Pennsylvania; 1950–1960
Cotton
101" x 84¹/₂" with ruffle
Bequest of the estate of Mildred P. Bach; 1992.27.3

154. Flower Basket Quilt
Mary Etta (Mrs. Edward Emmet) Bach (1872–1974)
Philadelphia, Pennsylvania; 1930–1940
Cotton
88¹/₂" x 79¹/₄"
Bequest of the estate of Mildred P. Bach; 1992.27.4

155. Pinwheel Sunflower Quilt
Mary Etta (Mrs. Edward Emmet) Bach (1872–1974)
Philadelphia, Pennsylvania; 1930–1950
Cotton
97¹/₂" x 77"
Bequest of the estate of Mildred P. Bach; 1992.27.5
See color fig. 86.

25. BIBLE HISTORY QUILT

Quiltmaker unidentified; Ohio; 1930–1940; cotton, with cotton embroidery; 91" x 57¼". Gift of Tom Cuff; 1984.7.1

156. Fans Quilt
Mary Etta (Mrs. Edward Emmet) Bach (1872–1974)
Philadelphia, Pennsylvania; 1930–1950
Cotton
96" x 84"
Bequest of the estate of Mildred P. Bach; 1992.27.6
See color fig. 87.

157. English Flower Garden Quilt
Jennie Pingrey (Mrs. Charles O.) Stotts
Yates Center, Kansas; 1930–1935
Cotton
95" x 77¾"
Gift of a Museum friend; 1987.17.1
See color fig. 88.

158. Bible History Quilt
Quiltmaker unidentified
Ohio; 1930–1940
Cotton with cotton embroidery
91" x 57¼"
Gift of Tom Cuff; 1984.7.1
See black-and-white fig. 25.

159. Calico Cat Quilt
Quiltmaker unidentified
Possibly Kentucky; 1930–1945
Cotton with cotton embroidery
83" x 67"
Gift of Laura Fisher, Antique Quilts and Americana; 1987.8.1
See color fig. 89.

160. Embroidered Floral Appliqué Quilt
Quiltmaker unidentified
United States; 1930–1940
Cotton with cotton embroidery
81" x 81"
Gift of a Museum friend in honor of Thos. K. Woodard and Blanche Greenstein; 1993.6.4
See color fig. 90.

161. Martha Washington's Wreath Quilt
Quiltmaker unidentified
United States; 1930–1940
Cotton, linen and synthetics with cotton embroidery
80½" x 64"
Gift of a Museum friend; 1993.6.6

162. Star of France Quilt
Quiltmaker unidentified
United States; 1930–1940
Cotton
81¾" x 81¾" framed
Gift of Cyril Irwin Nelson in honor of Robert Bishop, Director of the Museum of American Folk Art; 1990.17.4
See color fig. 91.

163. Compass and Wreath Quilt
Quiltmaker unidentified
Pennsylvania; 1930–1935
Cotton with cotton embroidery
78½" x 88¾"
Gift of Shelly Zegart; 1994.12.2
See color fig. 92.

164. Century of Progress Quilt
Quiltmaker unidentified
Ohio; dated 1933
Cotton with cotton embroidery
88½" x 74¼"
Gift of Shelly Zegart; 1995.26.1
See color fig. 93.

165. Bricks with Streaks of Lightning Quilt Top
Lutitia Hope (1860–1934)
Oak Ridge, Missouri; 1930–1934
Cotton
92" x 81½"
Gift of Beverly Walker Reitz in memory of Lutitia Hope; 1984.22.11

166. Nine Patch Variation Quilt Top
Lutitia Hope (1860–1934)
Oak Ridge, Missouri; 1930–1934
Cotton
78½" x 66"
Gift of Beverly Walker Reitz in memory of Lutitia Hope; 1984.22.12

167. Butterfly Quilt Top
Lutitia Hope (1860–1934)
Oak Ridge, Missouri; 1930–1934
Cotton
87" x 73¾"
Gift of Beverly Walker Reitz in memory of Lutitia Hope; 1984.22.13

168. Mosaic Stars Quilt Top
Lutitia Hope (1860–1934)
Oak Ridge, Missouri; 1930–1934
Cotton
84" x 72"
Gift of Beverly Walker Reitz in memory of Lutitia Hope;
1984.22.16

169. Star of Bethlehem Quilt Top
Lutitia Hope (1860–1934)
Oak Ridge, Missouri; 1930–1934
Cotton
84" x 77^1/$_2$"
Gift of Beverly Walker Reitz in memory of Lutitia Hope;
1984.22.18

170. Diagonal Four Patch Variation Quilt Top
Lutitia Hope (1860–1934)
Oak Ridge, Missouri; 1930–1934
Cotton
88" x 66"
Gift of Beverly Walker Reitz in memory of Lutitia Hope;
1984.22.19

171. Seven Stars Within Stars Quilt Top
Lutitia Hope (1860–1934)
Oak Ridge, Missouri; 1930–1934
Cotton
85" x 75"
Gift of Beverly Walker Reitz in memory of Lutitia Hope;
1984.22.21

172. Prairie Point Quilt
Quiltmaker unidentified
Middletown, New York; 1930–1940
Rayon
90" x 78"
Gift of General Foods Corporation; 1984.37.1

173. Double Wedding Ring Quilt
Quiltmaker unidentified
United States; 1935–1945
Cotton and cotton blends
96^1/$_4$" x 83"
Gift of Robert Bishop; 1993.4.9
See color fig. 94.

174. Double Wedding Ring Quilt
Quiltmaker unidentified
United States; 1940–1950
Cotton
84^1/$_2$" x 83" framed
Gift of Robert Bishop; 1993.4.14
See color fig. 95.

175. Double Wedding Ring Quilt
Quiltmaker unidentified, possibly African-American
Probably Georgia; 1930–1940
Cotton
86^1/$_4$" x 72" framed
Gift of Robert Bishop; 1993.4.19
See color fig. 96.

176. Amish Double Wedding Ring Quilt
Susie (Mrs. Harry) Bontrager (d.1954)
Yoder, Kansas; 1935–1945
Cotton and synthetics
95^1/$_2$" x 78^1/$_2$" framed
Gift of Robert Bishop; 1990.25.18
See color fig. 97.

177. Golden Wedding Ring Quilt
Quiltmaker unidentified
United States; 1934–1940
Cotton
81^1/$_4$" x 72^1/$_2$" framed
Gift of Robert Bishop; 1993.4.3
See color fig. 98.

178. Indian Wedding Ring Quilt
Quiltmaker unidentified
United States; 1935–1945
Cotton
82^1/$_2$" x 70^3/$_4$" framed
Gift of Robert Bishop; 1993.4.38
See color fig. 99.

179. Friendship Knot Quilt
Quiltmaker unidentified
United States; 1945–1960
Cotton and cotton blends
87" x 75^1/$_2$" framed
Gift of Robert Bishop; 1990.25.19
See color fig. 100.

180. Sampler Quilt
Quiltmaker unidentified
United States; 1935–1945
Cotton
84" x 71^3/$_4$" framed
Gift of Robert Bishop; 1993.4.8
See color fig. 101.

181. Embroidered Double Wedding Ring Quilt
Quiltmaker unidentified
Possibly New England; 1930–1940
Cotton with cotton embroidery
76^1/$_4$" x 76^1/$_2$" framed
Gift of Robert Bishop; 1993.4.25
See black-and-white fig. 26.

182. Double Wedding Ring Quilt
Quiltmaker unidentified
United States; 1935–1945
Cotton
82" x 76"
Gift of Robert Bishop; 1990.25.4

183. Double Wedding Ring Quilt
Emily Hasbrouck
Possibly Albany, New York; 1930–1940
Cotton
90^1/$_2$" x 75"
Gift of Robert Bishop; 1990.25.5

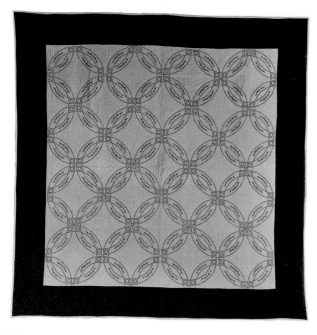

26. EMBROIDERED DOUBLE WEDDING RING QUILT

Quiltmaker unidentified; possibly New England; 1930–1940; cotton, with cotton embroidery; 76¼" x 76½" framed. Gift of Robert Bishop; 1993.4.25

184. Double Wedding Ring Quilt
Quiltmaker unidentified
Monterey, California; 1935–1945
Cotton
82½" x 65½"
Gift of Robert Bishop; 1990.25.6

185. Double Wedding Ring Quilt
Quiltmaker unidentified
United States; 1935–1945
Cotton
80¾" x 71" framed
Gift of Robert Bishop; 1990.25.7

186. Double Wedding Ring Quilt
Quiltmaker unidentified
Pennsylvania; 1935–1945
Cotton
88" x 74"
Gift of Robert Bishop; 1990.25.8

187. Double Wedding Ring Quilt
Quiltmaker unidentified
Texas; 1940–1950
Cotton
78" x 59¾"
Gift of Robert Bishop; 1990.25.9

188. Double Wedding Ring Crib Quilt
Quiltmaker unidentified
United States; 1935–1945

Cotton
43 x 32"
Gift of Robert Bishop; 1990.25.10

189. Double Wedding Ring Crib Quilt
Quiltmaker unidentified
Houston, Texas; 1935–1945
Cotton
57½" x 36¾"
Gift of Robert Bishop; 1990.25.11

190. Double Wedding Ring Quilt
Quiltmaker unidentified
United States; 1935–1945
Cotton
81½" x 68"
Gift of Robert Bishop; 1990.25.12

191. Double Wedding Ring Quilt
Quiltmaker unidentified
Possibly Pennsylvania; 1930–1950
Cotton
77¾" x 71½"
Gift of Robert Bishop; 1990.25.13

192. Double Wedding Ring Quilt
Mary K. Borkowski (b.1916)
Dayton, Ohio; dated 1988
Cotton and cotton-polyester blends with cotton embroidery
55¼" x 55"
Gift of Robert Bishop; 1990.25.14

193. Double Wedding Ring Quilt
Quiltmaker unidentified
United States; 1930–1940
Cotton
83¾" x 83"
Gift of Robert Bishop; 1990.25.15

194. Double Wedding Ring Quilt
Quiltmaker unidentified
United States; 1935–1945
Cotton
81¾" x 70¾"
Gift of Robert Bishop; 1990.25.16

195. Double Wedding Ring Quilt
Quiltmaker unidentified
Possibly Maine; 1930–1945
Cotton
70" x 68"
Gift of Robert Bishop; 1990.25.17

196. Double Wedding Ring Quilt
Quiltmaker unidentified
United States; 1935–1945
Cotton
75" x 67½"
Gift of Robert Bishop; 1990.25.20

197. Double Wedding Ring Quilt
Quiltmaker unidentified
Possibly Texas; 1935–1945

Cotton
90" x 73¹/₄"
Gift of Robert Bishop; 1993.4.1

198. Double Wedding Ring Quilt
Quiltmaker unidentified
Possibly New England; 1935–1945
Cotton
88¹/₂" x 71¹/₂"
Gift of Robert Bishop; 1993.4.2

199. Indian Wedding Ring Quilt
Quiltmaker unidentified
United States; 1935–1945
Cotton and synthetics
82³/₄" x 73¹/₂" framed
Gift of Robert Bishop; 1993.4.4

200. Double Wedding Ring Quilt
Jessie Reynolds
Delray Beach, Florida; 1935–1945
Cotton
68¹/₂" x 56¹/₄"
Gift of Robert Bishop; 1993.4.5

201. Double Wedding Ring Quilt
Quiltmaker unidentified
Possibly Texas; 1935–1945
Cotton
85" x 62" framed
Gift of Robert Bishop; 1993.4.6

202. Pickle Dish Quilt
Quiltmaker unidentified
Possibly Ohio; 1935–1945
Cotton
86³/₄" x 62¹/₂"
Gift of Robert Bishop; 1993.4.7

203. Patriotic Double Wedding Ring Quilt with Prairie Points
Quiltmaker unidentified
United States; 1935–1950
Cotton
79" x 71³/₄" framed
Gift of Robert Bishop; 1993.4.10

204. Amish Double Wedding Ring Quilt
Esther Enger
Holmes County, Ohio; dated March 15, 1950
Cotton, wool and synthetics
91" x 72"
Gift of Robert Bishop; 1993.4.11

205. Double Wedding Ring Quilt
Quiltmaker unidentified
United States; 1945–1955
Cotton
86¹/₄" x 68³/₄" framed
Gift of Robert Bishop; 1993.4.12

206. Double Wedding Ring Quilt
Quiltmaker unidentified

United States; 1940–1950
Cotton, silk, and wool
69" x 48"
Gift of Robert Bishop; 1993.4.13

207. Double Wedding Ring Quilt
Quiltmaker unidentified
Possibly Michigan; 1945–1955
Cotton and cotton blends
78" x 63¹/₄" framed
Gift of Robert Bishop; 1993.4.15

208. Amish Double Wedding Ring Quilt
Anna Weaver
Holmes County, Ohio; 1950
Cotton and synthetics
89¹/₂" x 75³/₄" framed
Gift of Robert Bishop; 1993.4.16

209. Double Wedding Ring Quilt
Quiltmaker unidentified
United States; 1940–1950
Cotton
77¹/₄" x 66³/₄"
Gift of Robert Bishop; 1993.4.17

210. Amish Double Wedding Ring Quilt
Quiltmaker unidentified
Possibly Indiana; 1945–1955
Cotton
82" x 82"
Gift of Robert Bishop; 1993.4.18

211. Double Wedding Ring Quiltt
Quiltmaker unidentified
Possibly Missouri; 1930–1940
Cotton
83" x 75"
Gift of Robert Bishop; 1993.4.20

212. Double Wedding Ring Quilt
Quiltmaker unidentified
United States; 1930–1940
Cotton
93" x 87¹/₄" framed
Gift of Robert Bishop; 1993.4.21

213. Double Wedding Ring Quilt with Le Moyne Stars
"Grandmother Wyatt"
Indiana; 1928
Cotton, wool, silk, and synthetics
87³/₄" x 72"
Gift of Robert Bishop; 1993.4.22

214. Double Wedding Ring Quilt
Quiltmaker unidentified
United States; 1930–1950
Cotton
95" x 77"
Gift of Robert Bishop; 1993.4.23

215. Double Wedding Ring Quilt
Quiltmaker unidentified

Possibly Southern United States; 1930–1940
Cotton
83³/₄" x 67¹/₂"
Gift of Robert Bishop; 1993.4.24

216. Double Wedding Ring Quilt
Quiltmaker unidentified
United States; 1930–1950
Cotton
89" x 72³/₄"
Gift of Robert Bishop; 1993.4.26

217. Double Wedding Ring Quilt
Quiltmaker unidentified, possibly Mennonite
United States; 1930–1940
Cotton
83¹/₂" x 67³/₄" framed
Gift of Robert Bishop; 1993.4.27

218. Double Wedding Ring Quilt
Quiltmaker unidentified
Possibly Michigan; 1925–1945
Cotton
81" x 81³/₄" framed
Gift of Robert Bishop; 1993.4.28

219. Friendship Knot Quilt
Quiltmaker unidentified
United States; 1930–1945
Cotton
81" x 71"
Gift of Robert Bishop; 1993.4.29

220. Amish Double Wedding Ring Quilt
Anna (Mrs. John A.) Raber
Honeyville, Indiana; 1935
Cotton
54" x 49¹/₄" framed
Gift of Robert Bishop; 1993.4.30

221. Amish Double Wedding Ring Quilt
Quiltmaker unidentified
Holmes County, Ohio; 1935–1945
Cotton
82¹/₄" x 66¹/₄"
Gift of Robert Bishop; 1993.4.31

222. Double Wedding Ring Quilt
Quiltmaker unidentified, possibly African-American
Southern United States; 1935–1945
Cotton
81¹/₄" x 65"
Gift of Robert Bishop; 1993.4.32

223. Amish Double Wedding Ring Quilt
Quiltmaker unidentified
Ohio or Indiana; 1935–1945
Cotton
89" x 75¹/₄" framed
Gift of Robert Bishop; 1993.4.33

224. Double Wedding Ring Quilt
Quiltmaker unidentified
United States; 1935–1945

Cotton
80³/₄" x 65"
Gift of Robert Bishop; 1993.4.34

225. Double Wedding Ring Quilt
Quiltmaker unidentified
Ohio; 1935–1945
Cotton
91¹/₄" x 76"
Gift of Robert Bishop; 1993.4.35

226. Indian Wedding Ring Quilt
Quiltmaker unidentified
United States; 1935–1945
Cotton
90¹/₂" x 70¹/₂" framed
Gift of Robert Bishop; 1993.4.36

227. Double Wedding Ring Quilt
Quiltmaker unidentified
Possibly Midwestern United States; 1935
Cotton
95¹/₂" x 73"
Gift of Robert Bishop; 1993.4.37

228. Double Wedding Ring Quilt
Elizabeth Schumacher Leece (1867–1956)
Kansas City, Missouri; 1930–1945
Cotton
90" x 79"
Gift of Marian Baer; 1984.11.1

229. Double Wedding Ring Quilt Top
Lutitia Hope (1860–1934)
Oak Ridge, Missouri; 1930–1934
Cotton
88¹/₂" x 73"
Gift of Beverly Walker Reitz in memory of Lutitia Hope;
1984.22.15

230. Pickle Dish with Leaf Border Quilt Top
Lutitia Hope (1860–1934)
Oak Ridge, Missouri; 1930–1934
Cotton
82¹/₂" x 69"
Gift of Beverly Walker Reitz in memory of Lutitia Hope;
1984.22.17

AMISH QUILTS
LANCASTER COUNTY, PENNSYLVANIA

231. Diamond in the Square Quilt
Rebecca Fisher Stoltzfus
Groffdale area of Lancaster County, Pennsylvania; 1903
Wool with rayon binding added later
77" x 77"
Gift of Mr. and Mrs. William B. Wigton; 1984.25.1
See color fig. 102.

232. Bars Quilt
Quiltmaker unidentified
Lancaster County, Pennsylvania; 1910–1920
Wool with cotton backing

87$^1/_4$" x 72$^1/_2$"
Gift of Mr. and Mrs. William B. Wigton; 1984.25.2
See color fig. 103.

233. Sunshine and Shadow Quilt
Quiltmaker unidentified
Lancaster County, Pennsylvania; 1930–1940
Wool, rayon, and cotton
83$^3/_4$" x 82$^3/_4$"
Gift of Mr. and Mrs. William B. Wigton; 1984.25.4
See color fig. 104.

234. Double Nine Patch Quilt
Quiltmaker unidentified
Lancaster County, Pennsylvania; 1930–1940
Wool and wool-and-rayon blend
79$^1/_2$" x 75$^3/_4$"
Gift of Mr. and Mrs. William B. Wigton; 1984.25.5
See color fig. 105.

235. Sawtooth Diamond in the Square Quilt
Quiltmaker unidentified
Lancaster County, Pennsylvania; 1921–1935
Wool and rayon with cotton backing
87" x 85$^3/_4$"
Gift of Mr. and Mrs. William B. Wigton; 1984.25.3
See black-and-white fig. 27.

236. Diamond in the Square Quilt
Quiltmaker unidentified
Lancaster County, Pennsylvania; 1920–1940
Wool with cotton backing
81$^1/_2$" x 79$^1/_2$"
Gift of Paige Rense; 1981.4.1

237. Diamond in the Square Quilt
Quiltmaker unidentified
Lancaster County, Pennsylvania; 1920–1940
Wool
72" x 74"
Gift of Elizabeth Wachs; 1992.9.1

238. Bars Quilt
Quiltmaker unidentified; initialed S S
Lancaster County, Pennsylvania; 1890–1920
Wool
81$^1/_4$" x 72$^3/_4$"
Gift of Mr. and Mrs. Robert L. Williams; 1985.31.2

MIFFLIN AND ATLANTIC COUNTIES, PENNSYLVANIA

239. Four in Split Nine Patch Quilt
Lydia A. (Yoder) Hostetler; White Topper Amish; embroidered LAY
Mifflin County, Pennsylvania; 1920–1930
Cotton with cotton embroidery
77" x 67"
Gift of Mr. and Mrs. William B. Wigton; 1984.25.7
See black-and-white fig. 28.

240. Double Four Patch Quilt
Sara Hostetler; White Topper Amish; embroidered SH
Mifflin County, Pennsylvania; 1920–1930
Cotton with cotton embroidery

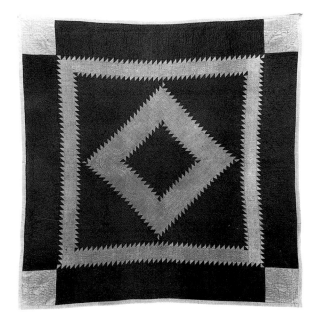

27. SAWTOOTH DIAMOND IN THE SQUARE QUILT

Quiltmaker unidentified; Lancaster County, Pennsylvania; 1921–1935; wool and rayon, with cotton backing; 87" x 85$^3/_4$". Gift of Mr. and Mrs. William B. Wigton; 1984.25.3

28. FOUR IN SPLIT NINE PATCH QUILT

Lydia A. (Yoder) Hostetler, embroidered LAY; White Topper Amish; Mifflin County, Pennsylvania; 1920–1930; cotton, with cotton embroidery; 77" x 67". Gift of Mr. and Mrs. William B. Wigton; 1984.25.7

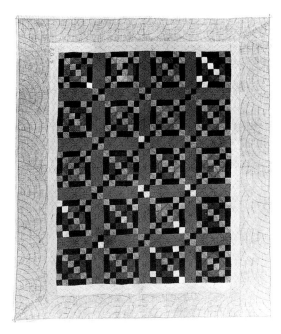

$77^1/_2$" x $68^1/_2$"
Gift of Mr. and Mrs. William B. Wigton; 1984.25.6

241. Block-Work Quilt, Nine Patch Variation
Frannie Hostetler; White Topper Amish
Mifflin County, Pennsylvania; 1880–1890
Wool with cotton backing
69" x 64"
Gift of Mr. and Mrs. William B. Wigton; 1984.25.8

242. Ratchet Quilt
Arie Yoder; White Topper Amish
Mifflin County, Pennsylvania; 1920–1930
Wool and cotton
$72^1/_4$" x 68"
Gift of Mr. and Mrs. William B. Wigton; 1984.25.9

243. Four Patch in Triangles Quilt
Barbara Zook Peachey (1848–1930); Yellow Topper Amish
Mifflin County, Pennsylvania; 1910–1920
Cotton
$85^1/_2$" x $78^3/_4$"
Gift of Mr. and Mrs. William B. Wigton; 1984.25.12
See color fig. 106.

244. Four in Block-Work Quilt
Annie M. Peachey (Mrs. David M.) Swarey (b.1902); Yellow Topper Amish
Mifflin County, Pennsylvania; 1925–1935
Cotton, rayon, and synthetics
85" x $72^1/_2$"
Gift of Mr. and Mrs. William B. Wigton; 1984.25.10
See color fig. 107.

245. Log Cabin Quilt, Barn Raising Variation
Lydia A. (Kanagy) Peachey (1863–1949); Yellow Topper Amish
Mifflin County, Pennsylvania; 1890–1900
Wool and cotton with cotton backing
85" x $80^1/_2$"
Gift of Mr. and Mrs. William B. Wigton; 1984.25.14
See color fig. 108.

246. Triple Irish Chain Quilt
Quiltmaker unidentified; Yellow Topper Amish
Mifflin County, Pennsylvania; 1920–1930
Wool and cotton
98" x 86"
Gift of Mr. and Mrs. William B. Wigton; 1984.25.11

247. Nine Patch in Block-Work Quilt
Quiltmaker unidentified; Yellow Topper Amish
Mifflin County, Pennsylvania; 1910–1920
Cotton
$79^1/_2$" x $68^1/_2$"
Gift of Mr. and Mrs. William B. Wigton; 1984.25.13

248. Crazy Patch Quilt
Leah Zook Hartzler; Black Topper Amish
Mifflin County, Pennsylvania; 1903
Wool and cotton with cotton embroidery
88" x 75"
Gift of Mr. and Mrs. William B. Wigton; 1984.25.15

See color fig. 109.

249. Bars Quilt
Elizabeth Yoder (b.1857); Black Topper Amish
Mifflin County, Pennsylvania, 1870–1880
Wool and cotton
84" x 65"
Gift of Mr. and Mrs. William B. Wigton; 1984.25.16

250. Wild Goose Chase in Bars Quilt
Anne Beachey (Mrs. John K.) Yoder (b.1860); Black Topper Amish
Mifflin County, Pennsylvania; 1880–1900
Cotton
80" x 68"
Gift of Mr. and Mrs. William B. Wigton; 1984.25.17

251. Double Wedding Ring Quilt
Mrs. Andy G. Byler
Atlantic, Pennsylvania; 1930–1940
Cotton, wool, linen, and rayon
84" x $66^1/_2$"
Gift of Cyril Irwin Nelson in memory of his grandparents Guerdon Stearns and Elinor Irwin (Chase) Holden, and in honor of his parents, Cyril Arthur and Elise Macy Nelson, 1982.22.3
See color fig. 121.

MIDWEST

252. One Patch Quilt
Quiltmaker unidentified
Midwestern United States; dated 1921 in quilting
Cotton and wool
$75^1/_2$" x 64"
Gift of David Pottinger; 1980.37.54
See color fig. 113.

253. Carpenter's Wheel Variation Quilt
Quiltmaker unidentified
Midwestern United States; 1945–1955
Cotton and synthetics
91" x $81^1/_2$"
Gift of David Pottinger; 1980.37.41
See color fig. 114.

254. Inside Border Crib Quilt
Quiltmaker unidentified
Midwestern United States; 1925–1935
Cotton
56" x $44^3/_4$"
Gift of George and Carol Henry; 1991.12.1
See color fig. 111.

255. Log Cabin Crib Quilt, Light and Dark Variation
Quiltmaker unidentified
Midwestern United States; 1910–1920
Cotton
$38^1/_4$" x 31"
Gift of David Pottinger; 1980.37.2

256. One Patch on Point Crib Quilt
Quiltmaker unidentified

Midwestern United States; 1900–1915
Cotton and wool
57" x 36"
Gift of David Pottinger; 1980.37.10

257. Ohio Star Crib Quilt
Quiltmaker unidentified
Midwestern United States; 1910–1930
Cotton
43" x 36¹/₂"
Gift of David Pottinger; 1980.37.13

258. Star Crib Quilt
Quiltmaker unidentified
Midwestern United States; 1930–1940
Cotton
37¹/₄" x 35"
Gift of David Pottinger; 1980.37.18

259. Log Cabin Crib Quilt, Windmill Blades Variation
Quiltmaker unidentified
Midwestern United States; 1920–1940
Wool and cotton with buttons
34" x 32¹/₂"
Gift of David Pottinger; 1980.37.19
See black-and-white fig. 29.

260. Double Nine Patch Quilt
Quiltmaker unidentified
Midwestern United States; 1915–1930
Cotton
84" x 71"
Gift of David Pottinger; 1980.37.22

261. Ohio Star Quilt
Quiltmaker unidentified
Midwestern United States; 1910–1920
Wool with cotton backing
72" x 60"
Gift of David Pottinger;1980.37.25

262. Double Irish Chain Variation Quilt
Quiltmaker unidentified
Midwestern United States; 1925–1935
Cotton
82¹/₂" x 68"
Gift of David Pottinger; 1980.37.30

263. Window Panes Quilt
Quiltmaker unidentified
Midwestern United States; 1930–1940
Cotton
82³/₄" x 67¹/₂"
Gift of David Pottinger; 1980.37.34

264. Nine Patch Quilt
Quiltmaker unidentified
Midwestern United States; 1925–1935
Cotton
84³/₄" x 54"
Gift of David Pottinger; 1980.37.38

265. Evening Star Quilt
Quilmaker unidentified

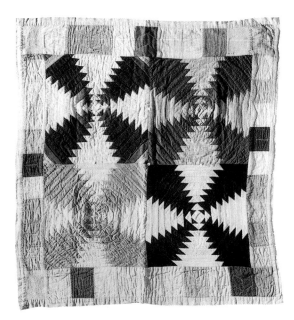

**29. LOG CABIN CRIB QUILT, WIND-
MILL BLADES VARIATION**
*Quiltmaker unidentified; Midwestern United States; 1920–1940;
wool and cotton, with buttons; 34" x 32¹/₂". Gift of David
Pottinger; 1980.37.19*

Midwestern United States; 1910–1925
Cotton and wool
88" x 64"
Gift of David Pottinger; 1980.37.44

266. Triple Irish Chain Quilt
Quiltmaker unidentified
Midwestern United States; 1915–1930
Cotton
81¹/₂" x 71"
Gift of David Pottinger; 1980.37.48

267. Star Block Quilt
Quiltmaker unidentified
Midwestern United States; 1910–1925
Cotton, synthetics, and wool
88" x 66"
Gift of David Pottinger; 1980.37.51

268. Ocean Waves Variation Quilt
Quiltmaker unidentified
Midwestern United States; 1915–1925
Cotton
84³/₄" x 72¹/₄" framed
Gift of David Pottinger; 1980.37.65

269. School House Quilt
Quiltmaker unidentified
Midwestern United States; 1910–1920
Cotton
75" x 63"
Gift of David Pottinger; 1980.37.60
See black-and-white fig. 30.

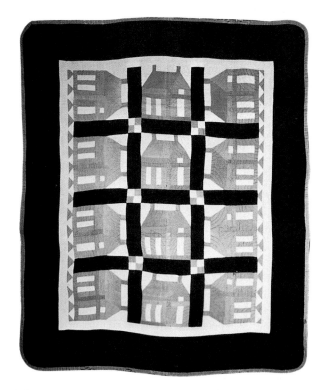

30. SCHOOL HOUSE QUILT

Quiltmaker unidentified; Midwestern United States; 1910–1920; cotton; 75" x 63". Gift of David Pottinger; 1980.37.60

31. WILD GOOSE CHASE QUILT

Quiltmaker unidentified, initialed M; Midwestern United States; 1910–1925; cotton; 72½" x 62½". Gift of David Pottinger; 1980.37.87

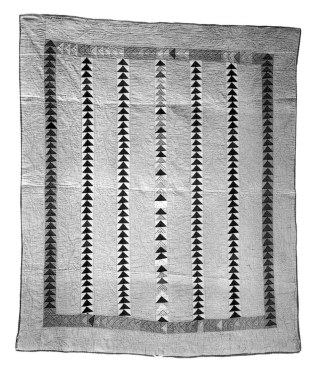

270. Ocean Waves Variation Quilt
Quiltmaker unidentified
Midwestern United States; 1930–1940
Cotton
84" x 70½"
Gift of David Pottinger; 1980.37.73

271. Wild Goose Chase Quilt
Quiltmaker unidentified, initialed M
Midwestern United States; 1910–1925
Cotton
72½" x 62½"
Gift of David Pottinger; 1980.37.87
See black-and-white white fig. 31.

272. Center Star with Corner Stars Quilt
Unidentified member of the Glick family
Probably Arthur, Illinois; 1890–1900
Wool with cotton backing
76¾" x 82½"
Gift of Phyllis Haders; 1985.3.1
See color fig. 110.

273. Chimney Sweep Quilt
Sarah Miller
Clinton Township, Indiana; 1920–1930
Cotton
84½" x 70"
Gift of David Pottinger; 1980.37.45

274. Tumbling Blocks Quilt
Mrs. Ed Lantz
Elkhart, Indiana; 1910–1920
Cotton
80½" x 66¼"
Gift of David Pottinger; 1980.37.62
See color fig. 118.

275. Evening Star Quilt
Quiltmaker unidentified
Elkhart, Indiana; 1925–1935
Cotton
83½" x 71½"
Gift of David Pottinger; 1980.37.68

276. Lone Star Quilt
Mrs. David Bontraeger, initialed D B
Emma, Indiana; 1920–1930
Cotton
84" x 74" framed
Gift of David Pottinger; 1980.37.50
See color fig. 119.

277. Inside Border Crib Quilt
Quiltmaker unidentified
Emma, Indiana; dated 1913 in quilting
Cotton
47½" x 34¼"
Gift of David Pottinger 1980.37.20

278. Single Irish Chain Quilt
Pieced by Mrs. Susan Lambright, quilted by Mrs. David
Weaver; initialed NDH for Nina D. Hostetler, daughter of

Mrs. Lambright
Emma, Indiana; dated Feb. 1931 in quilting
Cotton
85$\frac{1}{2}$" x 75$\frac{1}{2}$"
Gift of David Pottinger; 1980.37.29

279. Ocean Waves Variation Quilt
Quiltmaker unidentified; initialed NDH, probably for Nina
D. Hostetler
Emma, Indiana; 1920–1930
Cotton
82$\frac{1}{2}$" x 71$\frac{3}{4}$"
Gift of David Pottinger; 1980.37.43

280. Hole in the Barn Door Variation Quilt
Mrs. Menno Yoder; initialed L M Y
Emma, Indiana; dated March 26, 1942 in quilting
Cotton
86$\frac{1}{4}$" x 72"
Gift of David Pottinger; 1980.37.89
See color fig. 116.

281. Hole in the Barn Door Variation Quilt
Mrs. Menno Yoder; initialed CMY for her 6th child,
Cornelius M. Yoder
Emma, Indiana; dated February 18, 1943 in quilting
Cotton
87$\frac{1}{2}$" x 71$\frac{1}{4}$"
Gift of David Pottinger; 1980.37.90

282. Ocean Waves Quilt
Anna Yoder Raber
Honeyville, Indiana; 1925–1935
Cotton and synthetics
85$\frac{3}{4}$" x 79$\frac{3}{4}$"
Gift of David Pottinger; 1980.37.82
See color fig. 117.

283. Lone Star Quilt
Amanda Yoder and her daughter Anna
Honeyville, Indiana; 1925–1940
Cotton
79" x 75$\frac{1}{2}$"
Gift of David Pottinger; 1980.37.57
See color fig. 120.

284. Bow Tie Crib Quilt
Quiltmaker unidentified
Honeyville, Indiana; 1920–1940
Cotton
57$\frac{3}{4}$" x 44$\frac{1}{2}$"
Gift of David Pottinger; 1980.37.15

285. Bow Tie Crib Quilt
Quiltmaker unidentified
Honeyville, Indiana; 1920–1940
Cotton with wool backing
55$\frac{3}{4}$" x 45$\frac{1}{2}$"
Gift of David Pottinger; 1980.37.16

286. Log Cabin Quilt, Light and Dark Variation
Quiltmaker unidentified
Honeyville, Indiana; 1900–1920

Wool and cotton
70" x 63"
Gift of David Pottinger; 1980.37.39

287. Hole in the Barn Door Quilt
Quiltmaker unidentified; initialed LB, Age 20
Honeyville, Indiana; dated January 1, 1935 in quilting
Cotton
81$\frac{1}{2}$" x 67"
Gift of David Pottinger; 1980.37.58

288. Fans Quilt
Quiltmaker unidentified
Honeyville, Indiana; 1915–1930
Cotton and wool
81" x 70$\frac{1}{4}$".
Gift of David Pottinger; 1980.37.71

289. Log Cabin Quilt, Barn Raising Variation
Quiltmaker unidentified
Honeyville, Indiana; 1920–1935
Cotton
75$\frac{1}{2}$" x 70"
Gift of David Pottinger; 1980.37.88

290. Sunshine and Shadow Quilt
Amelia Yoder and daughter Leana Yoder
Vicinity of Honeyville, Indiana; 1930–1940
Cotton
74$\frac{3}{4}$" x 67"
Gift of David Pottinger; 1980.37.79

291. Ohio Star Crib Quilt
Polly Bontrager
Yoder Corner, near Honeyville, Indiana; 1910–1920
Cotton
48$\frac{1}{4}$" x 40$\frac{1}{4}$" framed
Gift of David Pottinger; 1980.37.14
See black-and-white fig. 32.

292. Lady of the Lake Variation Quilt
Amanda Sunthimer Yoder
Middlebury, Indiana; 1925–1935
Cotton
86$\frac{1}{2}$" x 71$\frac{1}{4}$" framed
Gift of David Pottinger; 1980.37.31

293. Star Variation Quilt
Quiltmaker unidentified; initialed CM for Cornelius Miller
Middlebury, Indiana; dated Feb. 19, 1929 in quilting
Cotton
89$\frac{1}{2}$" x 70"
Gift of David Pottinger; 1980.37.49

294. Star of Bethlehem with Corner Stars Quilt
Quiltmaker unidentified; initialed M_M
Middlebury, Indiana; dated December 1921 in quilting
Cotton
81" x 71"
Gift of David Pottinger; 1980.37.67

295. Ocean Waves Quilt
Lydia Eash

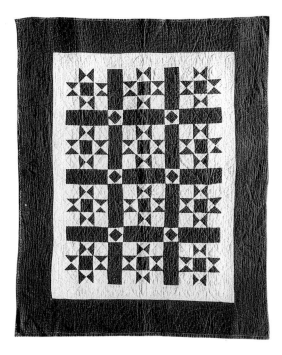

32. OHIO STAR CRIB QUILT

Polly Bontrager; Yoder Corner, near Honeyville, Indiana; 1910–1920; cotton; 48¼" x 40¼" framed. Gift of David Pottinger; 1980.37.14

Middlebury, Indiana; dated Oct. 2, 1930 in quilting
Cotton
78¾" x 68"
Gift of David Pottinger; 1980.37.75

296. Log Cabin Quilt, Barn Raising Variation
Anna Mass
Middlebury, Indiana; 1930–1940
Cotton and rayon
87½" x 79½"
Gift of David Pottinger; 1980.37.76

297. Fans Quilt
Lydia Bontrager
Middlebury, Indiana; 1925–1935
Wool and cotton with cotton embroidery
83¼" x 72¼" framed
Gift of David Pottinger; 1980.37.77

298. Twenty-five Patch Variation Quilt
Lydia Bontrager
Middlebury, Indiana; dated 1930 in quilting
Cotton
77½" x 64½"
Gift of David Pottinger; 1980.37.81

299. Hole in the Barn Door Variation Quilt
Lydia Burkholder with help of daughters, Mary Ann and Barbara
Napanee, Indiana; 1930
Cotton

80¼" x 70"
Gift of David Pottinger; 1980.37.83

300. Hole in the Barn Door Variation Quilt
Lydia Burkholder with help of daughters, Mary Ann and Barbara
Napanee, Indiana; 1930
Cotton
78" x 70¼"
Gift of David Pottinger; 1980.37.84

301. Hummingbirds Quilt
Quiltmaker unidentified
Shipshewana, Indiana; 1920–1930
Cotton
87¾" x 68¼" framed
Gift of David Pottinger; 1980.37.69
See color fig. 115.

302. Split Block Crib Quilt
Mrs. Jacob Miller
Shipshewana, Indiana; 1920–1940
Cotton
40 x 30½"
Gift of David Pottinger; 1980.37.9

303. Sailboats Quilt
Amanda Lehman
Topeka, Indiana; 1955–1965
Cotton
86¼" x 72" framed
Gift of David Pottinger; 1980.37.26
See color fig. 125.

304. Rabbit Paw Variation Crib Quilt
Mrs. Nathaniel Miller, for her first son Amos
Topeka, Indiana; 1930
Cotton
42" x 36"
Gift of David Pottinger; 1980.37.7

305. Variable Star Crib Quilt
Mrs. Henry Miller
Topeka, Indiana; 1925–1930
Cotton
48" x 40"
Gift of David Pottinger; 1980.37.8

306. Sunshine and Shadow Quilt
Susan Beechy
Topeka, Indiana; 1935–1940
Cotton
88¼" x 73¾" framed
Gift of David Pottinger; 1980.37.27

307. Hour Glass Variation Quilt
Mrs. Daniel J. Yoder
Topeka, Indiana; 1915
Cotton
74" x 63¾"
Gift of David Pottinger; 1980.37.32

308. Twenty-five Patch Quilt
Mrs. Daniel J. Yoder
Topeka, Indiana; 1940
Cotton and rayon
74" x 60"
Gift of David Pottinger; 1980.37.33

309. Sawtooth Star Quilt
Quiltmaker unidentified
Topeka, Indiana; dated 1916 in quilting
Cotton
77" x 44¹/₂"
Gift of David Pottinger; 1980.37.36

310. Tree of Life Quilt
Quiltmaker unidentified; embroidered J
Topeka, Indiana; dated March the 1 year 1911 in quilting
Cotton
80³/₄" x 68¹/₂"
Gift of David Pottinger; 1980.37.70

311. Bow Tie Variation Crib Quilt
Susan Shrock
Vicinity of Topeka, Indiana; 1930
Cotton
57" x 40"
Gift of David Pottinger; 1980.37.5

312. Double Nine Patch with Four Patch Corner Blocks Quilt
Quiltmaker unidentified
Vicinity of Topeka, Indiana; 1920–1930
Cotton
76" x 67¹/₄"
Gift of David Pottinger; 1980.37.53

313. Rolling Stone Quilt
Quiltmaker unidentified; initialed L M
Indiana; dated January 28, 1925 in quilting
Cotton
82¹/₄" x 69"
Gift of David Pottinger; 1980.37.24
See color fig. 122.

314. Fans Quilt
Quiltmaker unidentified, initialed P M
Indiana; 1925–1935
Cotton, wool, and rayon with cotton embroidery
82" x 71¹/₂"
Gift of David Pottinger; 1980.37.86
See color fig. 123.

315. Shoo Fly Lounge Quilt
Quiltmaker unidentified
Indiana; dated March 21, 1900 in quilting
Cotton
67" x 43³/₄"
Gift of David Pottinger; 1980.37.17

316. Bear Paw Quilt
Quiltmaker unidentified

Indiana; 1910–1930
Cotton
83" x 68"
Gift of David Pottinger; 1980.37.66

317. Rolling Star Quilt
Quiltmaker unidentified
Indiana; 1935–1945
Cotton
90¹/₂" x 73¹/₂"
Gift of David Pottinger; 1980.37.72

318. Rolling Stone Variation Quilt
Quiltmaker unidentified
Indiana; dated July 19, 1934 in quilting
Cotton
83³/₄" x 69¹/₄"
Gift of David Pottinger; 1980.37.80

319. Le Moyne Star Crib Quilt
Quiltmaker unidentified
Possibly Indiana; 1920–1940
Cotton
51¹/₂" x 37³/₄"
Gift of David Pottinger; 1980.37.6
See black-and-white fig. 33.

33. LE MOYNE STAR CRIB QUILT
Quiltmaker unidentified; possibly Indiana; 1920–1940; cotton;
51¹/₂" x 37³/₄". Gift of David Pottinger; 1980.37.6

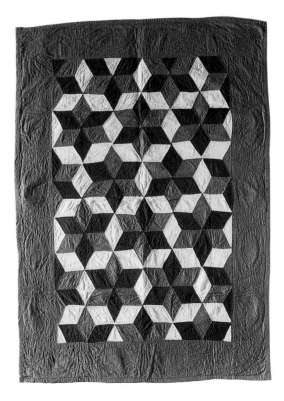

34. BOW TIE IN BLOCK-WORK QUILT

Mrs. Jacob Petershiem; Haven, Kansas; 1916; cotton; 83" x 69¹/₄".
Gift of David Pottinger; 1980.37.28

35. BROKEN STAR QUILT

Clara Bontrager; Haven, Kansas; 1925–1935; cotton; 73¹/₂" x 67¹/₄" framed. Gift of David Pottinger; 1980.37.47

320. Bow Tie Variation Quilt
Quiltmaker unidentified
Probably Kalona, Iowa; 1890–1900
Wool and cotton
76" x 66"
Gift of David Pottinger; 1990.16.1

321. Chinese Coins Quilt
Sarah Miller
Haven, Kansas; 1935
Cotton
82" x 61¹/₂"
Gift of David Pottinger; 1980.37.1
See color fig. 124.

322. Bow Tie in Block-Work Quilt
Mrs. Jacob Petershiem
Haven, Kansas; 1916
Cotton
83" x 69¹/₄"
Gift of David Pottinger; 1980.37.28
See black-and-white fig. 34.

323. Broken Star Quilt
Clara Bontrager
Haven, Kansas; 1925–1935
Cotton
73¹/₂" x 67¹/₄" framed
Gift of David Pottinger; 1980.37.47
See black-and-white fig. 35.

324. Bow Tie Quilt
Clara Bontrager
Haven, Kansas; 1926
Cotton
83³/₄" x 73¹/₂" framed
Gift of David Pottinger; 1980.37.56

325. Ohio Star Quilt
Sarah T. Bontrager
Haven, Kansas; 1926
Cotton
76³/₄" x 67¹/₄"
Gift of David Pottinger; 1980.37.74

326. Pinwheel and Cross in Block Work Quilt
Sarah Miller
Haven, Kansas; 1920
Cotton and wool
76¹/₂" x 69¹/₂"
Gift of David Pottinger; 1980.37.92

327. Wild Goose Chase Variation Quilt
Clara Coon
Kansas; 1920
Cotton
80" x 70¹/₂"
Gift of David Pottinger; 1980.37.46
See black-and-white fig. 36.

328. Bear Paw Quilt
Pieced by Mrs. Joe S. Hostetler; quilted by Mary Frye; initialed LM for Mrs. Abner Miller of Topeka, Indiana

Haven, Kansas; embroidered Mar 1, 1935
Cotton
83^1/$_4$" x 75" framed
Gift of David Pottinger; 1980.37.61

329. Double Nine Patch Lounge Quilt
Mrs. Dan Troyer
Holmes County, Ohio; 1915–1925
Cotton
75^3/$_4$" x 43^1/$_4$"
Gift of Mr. and Mrs. William B. Wigton; 1984.25.19

330. Plain Lounge Quilt
Quiltmaker unidentified
Holmes County, Ohio; 1900–1910
Wool and cotton
67" x 31^1/$_2$"
Gift of Mr. and Mrs. William B. Wigton; 1984.25.21

331. Double Irish Chain Quilt with Zig-Zag Border
Quiltmaker unidentified; initialed J F
Plain City, Ohio; dated 1892
Cotton
89" x 66"
Gift of Barbara S. Janos and Barbara Ross; 1984.1.1
See black-and-white fig. 37.

332. Single Irish Chain Quilt
Unidentified Swartzentruber Amish quiltmaker
Wayne County, Ohio; 1920–1930
Cotton
71^1/$_2$" x 65"
Gift of Mr. and Mrs. William B. Wigton; 1984.25.22

333. Crosses and Losses Quilt
Quiltmaker unidentified
Ohio; 1925–1930
Cotton and cotton/rayon blends
81^3/$_4$" x 64"
Gift of Mr. and Mrs. William B. Wigton; 1984.25.18

334. Nine Patch Crib Quilt
Quiltmaker unidentified
Ohio; 1910–1920
Cotton
39^1/$_2$" x 34^1/$_2$"
Gift of David Pottinger; 1980.37.12

335. Lone Star Quilt
Quiltmaker unidentified
Ohio; 1925–1935
Cotton
75^3/$_4$" x 73^3/$_4$"
Gift of Mr. and Mrs. William B. Wigton; 1984.25.20

336. Plain Quilt
Quiltmaker unidentified
Ohio; 1920–1930
Cotton
87" x 70^3/$_4$"
Gift of Mr. and Mrs. Irwin Warren; 1985.27.1

36. WILD GOOSE CHASE VARIATION QUILT
Clara Coon; Kansas; 1920; cotton; 80" x 70^1/$_2$". Gift of David Pottinger; 1980.37.46

37. DOUBLE IRISH CHAIN QUILT WITH ZIG-ZAG BORDER
Quiltmaker unidentified, initialed J F; Plain City, Ohio; dated 1892; cotton; 89" x 66". Gift of Barbara S. Janos and Barbara Ross; 1984.1.1

38. EVERYBODY QUILT

Mary Maxtion (b.1914); Boligee, Alabama; 1989; cotton and synthetics; 91½" x 85". Gift of Helen and Robert Cargo; 1991.19.2

39. WEDDING RING INTERPRETATION QUILT

Lureca Outland (b. c.1904); Boligee, Alabama; 1991; cotton, wool, and synthetics; 82" x 75". Museum of American Folk Art purchase made possible in part by a grant from the National Endowment for the Arts, with matching funds from The Great American Quilt Festival 3; 1991.13.5

337. Double Inside Border Quilt
Quiltmaker unidentified
Probably Ohio; 1910–1925
Cotton
85½" x 66"
Gift of David Pottinger; 1980.37.55
See color fig. 112.

338. Inside Border Crib Quilt
Quiltmaker unidentified
Probably Ohio; 1910–1920.
Cotton
36½" x 30"
Gift of David Pottinger; 1980.37.3

339. Garden Maze Quilt
Quiltmaker unidentified
Probably Ohio; 1930–1940
Cotton
87" x 68"
Gift of David Pottinger; 1980.37.35

340. Inside Border Quilt
Quiltmaker unidentified
Probably Ohio; 1920–1930
Cotton
83¾" x 75"
Gift of David Pottinger; 1980.37.40

AFRICAN-AMERICAN QUILTS

341. Strip Quilt
Idabell Bester (d. c.1992), quilted by Losie Webb
Alabama; pieced in 1980, quilted in 1990
Cotton and synthetics
83" x 71"
Gift of Helen and Robert Cargo; 1991.19.4
See color fig. 126.

342. Snail Trail Quilt
Mary Maxtion (b.1914)
Boligee, Alabama; 1990
Cotton
89½" x 77"
Museum of American Folk Art purchase made possible in part by a grant from the National Endowment for the Arts, with matching funds from The Great American Quilt Festival 3; 1991.13.2
See color fig. 127.

343. Everybody Quilt
Mary Maxtion (b.1914)
Boligee, Alabama; 1989
Cotton and synthetics
91½" x 85"
Gift of Helen and Robert Cargo; 1991.19.2
See black-and-white fig. 38.

344. Star Quilt
Nora Ezell (b.1917)
Eutaw, Alabama; dated August 1977 in embroidery
Cotton and synthetics
94" x 79"

Museum of American Folk Art purchase made possible in part by a grant from the National Endowment for the Arts, with matching funds from The Great American Quilt Festival 3; 1991.13.1
See color fig. 128.

345. Le Moyne Star Variation Quilt
Lucinda Toomer (1890–1983)
Macon, Georgia; 1981
Cotton and synthetics
71^1/$_4$" x 62"
Gift of Maude and James Wahlman; 1991.32.1
See color fig. 129.

346. Diamond Strip Quilt
Lucinda Toomer (1890–1983)
Macon, Georgia; 1975
Cotton and wool
79^1/$_2$" x 66^1/$_4$"
Gift of William A. Arnett; 1990.7.1

347. Sailboats Quilt
Alean Pearson (b.1918)
Oxford, Mississippi; 1985
Cotton and wool
88^1/$_4$" x 80"
Museum of American Folk Art purchase made possible in part by a grant from the National Endowment for the Arts, with matching funds from The Great American Quilt Festival 3; 1991.13.8
See color fig. 130.

348. Rattlesnake Quilt
Alean Pearson (b.1918)
Oxford, Mississippi; 1985
Cotton and synthetics
85^1/$_2$" x 80^1/$_2$"
Museum of American Folk Art purchase made possible in part by a grant from the National Endowment for the Arts, with matching funds from The Great American Quilt Festival 3; 1991.13.7
See color fig. 131.

349. Wedding Ring Interpretation Quilt
Lureca Outland (b. c.1904)
Boligee, Alabama; 1991
Cotton, wool and synthetics
82" x 75"
Museum of American Folk Art purchase made possible in part by a grant from the National Endowment for the Arts, with matching funds from The Great American Quilt Festival 3; 1991.13.5
See black-and-white white fig. 39.

350. Diamond Four Patch in Cross
Lureca Outland (b. c.1904)
Boligee, Alabama; 1991
Cotton and synthetics
83" x 78^1/$_2$"
Museum of American Folk Art purchase made possible in part by a grant from the National Endowment for the Arts, with matching funds from The Great American Quilt Festival 3; 1991.13.6
See color fig. 132.

351. Hens Quilt
Pearly Posey (1894–1984)
Yazoo City, Mississippi; 1981
Cotton and synthetics
71" x 69"
Gift of Maude and James Wahlman; 1991.32.2
See color fig. 133.

352. Pig Pen Quilt
Pecolia Warner (1901–1983)
Yazoo City, Mississippi; 1982
Cotton, linen, and synthetics
79^1/$_2$" x 76^1/$_2$"
Gift of Maude and James Wahlman; 1991.32.3
See black-and-white fig. 40.

353. Star Variation Quilt
Leola Pettway (b.1929)
Boykin, Alabama; 1991
Cotton and synthetics
80^1/$_2$" x 78^1/$_2$"
Museum of American Folk Art purchase made possible in part by a grant from the National Endowment for the Arts, with matching funds from The Great American Quilt Festival 3; 1991.13.3

354. Star of Bethlehem with Satellite Stars Quilt
Leola Pettway (b.1929)
Boykin, Alabama; 1991
Cotton and synthetics
102" x 93^1/$_2$"
Museum of American Folk Art purchase made possible in part by a grant from the National Endowment for the Arts, with matching funds from The Great American Quilt Festival 3; 1991.13.4

40. PIG PEN QUILT
Pecolia Warner (1901–1983); Yazoo City, Mississippi; 1982; cotton, linen, and synthetics; 79^1/$_2$" x 76^1/$_2$". Gift of Maude and James Wahlman; 1991.32.3

355. Log Cabin Quilt, Courthouse Steps Variation
Plummer T. Pettway (b.1918)
Boykin, Alabama; 1991
Cotton and synthetics
71¹/₂" x 72³/₄"
Gift of Helen and Robert Cargo; 1991.33.1

356. Strip and Bow Tie Variation Quilt
Dennis Jones (1898–1988)
Vienna, Alabama; 1975
Cotton and synthetics
77¹/₂" x 59¹/₂"
Gift of Helen and Robert Cargo; 1991.19.1

357. Strip Variation Quilt
Mozell Benson (b.1934)
Waverly, Alabama; 1991
Cotton, wool and synthetic yarn
89" x 70¹/₂"
Museum of American Folk Art purchase made possible in
part by a grant from the National Endowment for the Arts,
with matching funds from The Great American Quilt
Festival 3; 1991.13.9

358. Sampler Variation Quilt
Mozell Benson (b. 1934)
Waverly, Alabama; 1985
Cotton and synthetic yarn
88" x 67"
Museum of American Folk Art purchase made possible in
part by a grant from the National Endowment for the Arts,
with matching funds from The Great American Quilt
Festival 3; 1991.13.10

359. Strip Quilt
Eva Burrell (b. 1918)
United States; 1989
Cotton and synthetics
84" x 71"
Gift of Helen and Robert Cargo; 1991.19.3

360. Mr. Fletcher Quilt
Sarah Mary Taylor (b. 1916)
Yazoo City, Mississippi; 1990
Cotton and cotton blends
77¹/₂" x 62"
Gift of Marion Harris and Dr. Jerry Rosenfeld; 1995.10.1

CONTEMPORARY QUILTS

361. Bittersweet XII
Nancy Crow (b. 1943); hand-quilted by Velma Brill,
Cambridge, Ohio
Baltimore, Ohio; 1980
Cotton-polyester broadcloth
79¹/₂" x 79"
Gift of Nancy Crow; 1981.3.1
See color fig. 134.

362. Kimono Hanging
Kumiko Sudo
Berkeley, California; 1988

Silk with silk embroidery
37³/₄" x 25³/₄"
Gift of Kumiko Sudo; 1989.11.1
See color fig. 135.

363. Hudson River Quilt
Irene Preston Miller and the Hudson River Quilters
Croton-on-Hudson, New York; 1969–1972
Cotton, wool, and blends with cotton embroidery
95¹/₄" x 80"
Gift of the J.M. Kaplan Fund; 1991.3.1
See color fig. 136.

364. Stars Over Hawaii Quilt
Mary K. Borkowski (b. 1916)
Dayton, Ohio; 1979
Cotton polyester with cotton embroidery
97" x 97"
Gift of Mary K. Borkowski; 1981.5.1
See black-and-white fig. 41.

365. Field of Stars Crib Quilt
Judith Tasker Mount
Flintridge, California; 1978–1979
Cotton and polyester
37" x 37"
Gift of Judith Tasker Mount; 1979.24.1

41. STARS OVER HAWAII QUILT
*Mary K. Borkowski (b. 1916); Dayton, Ohio; 1979; Cotton poly-
ester, with cotton embroidery; 97" x 97". Gift of Mary K.
Borkowski; 1981.5.1*

366. Glorious Lady Freedom
Moneca Calvert
Carmichael, California; 1985–1986
Cotton, cotton blends, and linen with cotton embroidery
72" x 71¹/₂"
The Scotchgard® Collection of Contemporary Quilts, Grand Prize Winner, The Great American Quilt Contest, in celebration of the Statue of Liberty Centennial, 1986; 1986.14.1
See color fig. 137.

367. Spacious Skies
Charlotte Warr-Andersen
Kearns, Utah; 1985–1986
Cotton and polyester blends
72" x 71¹/₂"
The Scotchgard® Collection of Contemporary Quilts, Second Prize Winner, The Great American Quilt Contest, in celebration of the Statue of Liberty Centennial, 1986; 1986.14.2
See black-and-white fig. 42.

368. Childhood Memory #44 The Cellar: "Don't worry," said his sister sweetly, "I won't turn off the light . . ."
Elaine H. Spencer
Fort Collins, Colorado; 1988
Cotton
51³/₄" x 43"
First Place Grand Prize Winner "Memories of Childhood" Contest, The Great American Quilt Festival 2, Museum of American Folk Art event sponsored by Fairfield Processing Corporation/Poly-fil®, Springmaid® and Coats & Clark, Inc./Dual Duty Plus® Quilting; 1989.23.1
See black-and-white fig. 43.

369. When Toys and I Were One
Jane Blair
Conshohocken, Pennsylvania; 1988
Cotton and polyester
53³/₄" x 45"
Second Place Grand Prize Winner "Memories of Childhood" Contest, The Great American Quilt Festival 2, Museum of American Folk Art event sponsored by Fairfield Processing Corporation/Poly-fil®, Springmaid® and Coats & Clark, Inc./Dual Duty Plus® Quilting; 1989.23.2
See color fig. 138.

370. My Dolls
Hanne Wellendorph
Vemmelev, Denmark; 1988
Cotton, silk, and linen with glass beads and cotton embroidery 52¹/₂" x 44"
Third Place Grand Prize Winner "Memories of Childhood" Contest, The Great American Quilt Festival 2, Museum of American Folk Art event sponsored by Fairfield Processing Corporation/Poly-fil®, Springmaid® and Coats & Clark, Inc./Dual Duty Plus® Quilting; 1989.23.3

371. The Early Travelers
Dawn E. Amos
Rapid City, South Dakota; 1990
Cotton
54" x 45"
First Place Grand Prize Winner of the "Discover America"

42. SPACIOUS SKIES

Charlotte Warr-Andersen; Kearns, Utah; 1985–1986; Cotton and polyester blends; 72" x 71¹/₂". The Scotchgard® Collection of Contemporary Quilts, Second Prize Winner, The Great American Quilt Contest, in Celebration of the Statue of Liberty Centennial, 1986; 1986.14.2

43. CHILDHOOD MEMORY #44 THE CELLAR: "DON'T WORRY," SAID HIS SISTER SWEETLY, "I WON'T TURN OFF THE LIGHT..."

Elaine H. Spencer; Fort Collins, Colorado; 1988; cotton; 51³/₄" x 43". First Place Grand Prize Winner "Memories of Childhood" Contest, The Great American Quilt Festival 2, Museum of American Folk Art event sponsored by Fairfield Processing Corporation/Poly-fil®, Springmaid® and Coats & Clark, Inc./Dual Duty Plus® Quilting; 1989.23.1

44. MALA PUA ALOHA, GARDEN OF ALOHA

Mary Alice Kenny-Sinton; Ponca City, Oklahoma; 1991; cotton; 72" x 72". Winner, "America's Flower Garden" Contest at The Great American Quilt Festival 3, a Museum of American Folk Art event sponsored by Fairfield Processing Corporation/Poly-fil® and Springmaid® Fabrics; 1991.9.19

Contest at The Great American Quilt Festival 3, a Musem of American Folk Art event sponsored by Fairfield Processing Corporation/Poly-fil® and Springmaid® Fabrics; 1990.19.1
See color fig. 139.

372. Dare to Dream
Jaime L. Morton
Casa Grande, Arizona; 1990
Cotton with gold lamé and metallic thread
54" x 45"
Second Place Grand Prize Winner of the "Discover America" Contest at The Great American Quilt Festival 3, a Museum of American Folk Art event sponsored by Fairfield Processing Corporation/Poly-fil® and Springmaid® Fabrics; 1990.19.2

373. Edith and Polly
Variable Star Quilters
Souderton, Pennsylvania; 1990
Cotton
72" x 72"
First Place Grand Prize Winner of the "Friends Sharing America" Contest at The Great American Quilt Festival 3, a Museum of American Folk Art event sponsored by Fairfield Processing Corporation/Poly-fil® and Springmaid® Fabrics; 1990.20.1

374. Quilters' Dwellings
Red Apple Quilters: Annamae Kelly, Sharon Falberg, Sue Nickels
Royal Oak, Michigan; 1990
Cotton, cotton blends, silk, plastic and paint
72" x 72"
Second Place Grand Prize Winner of the "Friends Sharing America" Contest at The Great American Quilt Festival 3, a Museum of American Folk Art event sponsored by Fairfield

Processing Corporation/Poly-fil® and Springmaid® Fabrics; 1990.20.2
See color fig. 140.

375. Imagination
Kazuko Yonekura
Kobe, Japan; 1991
Cotton
72" x 72"
Winner, "America's Flower Garden" Contest at The Great American Quilt Festival 3, a Museum of American Folk Art event sponsored by Fairfield Processing Corporation/Poly-fil® and Springmaid® Fabrics; 1991.9.24
See color fig. 141.

376. Mala Pua Aloha, Garden of Aloha
Mary Alice Kenny-Sinton
Ponca City, Oklahoma; 1991
Cotton
72" x 72"
Winner, "America's Flower Garden" Contest at The Great American Quilt Festival 3, a Museum of American Folk Art event sponsored by Fairfield Processing Corporation/Poly-fil® and Springmaid® Fabrics; 1991.9.19
See black-and-white fig. 44.

377. Samplers in My Garden
Mitsuyo Aiba
New York, New York; 1991
Cotton
72" x 72"
Winner, "America's Flower Garden" Contest at The Great American Quilt Festival 3, a Museum of American Folk Art event sponsored by Fairfield Processing Corporation/Poly-fil® and Springmaid® Fabrics; 1991.9.1

378. Who Can Doubt There Is A God?
Donna Albert
Lancaster, Pennsylvania; 1991
Cotton
72" x 72"
Winner, "America's Flower Garden" Contest at the Great American Quilt Festival 3, a Museum of American Folk Art event sponsored by Fairfield Processing Corporation/Poly-fil® and Springmaid® Fabrics; 1991.9.2

379. Garden Lights: A Study in Blue and Green
Jane Aruns
Santa Fe, New Mexico; 1991
Cotton
72" x 72"
Winner, "America's Flower Garden" Contest at The Great American Quilt Festival 3, a Museum of American Folk Art event sponsored by Fairfield Processing Corporation/Poly-fil® and Springmaid® Fabrics; 1991.9.3

380. Family Garden
Susan Bartels
Karlsruhe, Germany; 1991
Cotton painted with fiber reactive dyes
72" x 72"
Winner, "America's Flower Garden" Contest at The Great American Quilt Festival 3, a Museum of American Folk Art event sponsored by Fairfield Processing Corporation/Poly-fil® and Springmaid® Fabrics; 1991.9.4

381. Susan's Saskatchewan Garden
Susan M. Clark
Saskatoon, Saskatchewan, Canada; 1991
Silk with beads, sequins, metallic paints, and embroidery
72" x 72"
Winner, "America's Flower Garden" Contest at The Great American Quilt Festival 3, a Museum of American Folk Art event sponsored by Fairfield Processing Corporation/Poly-fil® and Springmaid® Fabrics; 1991.9.5

382. Simply Sunflowers
Julie Cullen
Cliffside Park, New Jersey; 1991
Cotton
72" x 72"
Winner, "America's Flower Garden" Contest at The Great American Quilt Festival 3, a Museum of American Folk Art event sponsored by Fairfield Processing Corporation/Poly-fil® and Springmaid® Fabrics; 1991.9.6

383. Pavimento
Deborah Ellen Davies
Osterville, Massachusetts; 1991
Cotton, cotton-and-rayon and linen
72" x 72"
Winner, "America's Flower Garden" Contest at The Great American Quilt Festival 3, a Museum of American Folk Art event sponsored by Fairfield Processing Corporation/Poly-fil® and Springmaid® Fabrics; 1991.9.7

384. The Iris Bed
Linda Digiosaffatte
Landing, New Jersey; 1991
Cotton
72" x 72"
Winner, "America's Flower Garden" Contest at The Great American Quilt Festival 3, a Museum of American Folk Art event sponsored by Fairfield Processing Corporation/Poly-fil® and Springmaid® Fabrics; 1991.9.8

385. The Flower Garden
Polly Gladding
Montrose, Pennsylvania; 1991
Cotton and cotton blends
72" x 72"
Winner, "America's Flower Garden" Contest at The Great American Quilt Festival 3, a Museum of American Folk Art event sponsored by Fairfield Processing Corporation/Poly-fil® and Springmaid® Fabrics; 1991.9.9

386. Flowers: In the Sunset Glow
Keiko Gouke
Sendai, Miyagi, Japan; 1991
Cotton
72" x 72"
Winner, "America's Flower Garden" Contest at The Great American Quilt Festival 3, a Museum of American Folk Art event sponsored by Fairfield Processing Corporation/Poly-fil® and Springmaid® Fabrics; 1991.9.10

387. Garden of Hope
Virginia Leigh Jones
Taunton, Massachusetts; 1991
Cotton
72" x 72"
Winner, "America's Flower Garden" Contest at The Great American Quilt Festival 3, a Museum of American Folk Art event sponsored by Fairfield Processing Corporation/Poly-fil® and Springmaid® Fabrics; 1991.9.11

388. Garden Jewels
Pauline G. McCall
Tampa, Florida; 1991
Silk and cotton with cotton embroidery and braid
72" x 72"
Winner, "America's Flower Garden" Contest at The Great American Quilt Festival 3, a Museum of American Folk Art event sponsored by Fairfield Processing Corporation/Poly-fil® and Springmaid® Fabrics; 1991.9.12

389. Fragments of a Summer Garden
Bobbi Finley
San José, California; 1991
Cotton
72" x 72"
Winner, "America's Flower Garden" Contest at The Great American Quilt Festival 3, a Museum of American Folk Art event sponsored by Fairfield Processing Corporation/Poly-fil® and Springmaid® Fabrics; 1991.9.13

390. Frank and Miss Molly in the Poppyfield
Helena K. Neesemann
Brooklyn, New York; 1991
Cotton and synthetics
72" x 72"
Winner, "America's Flower Garden" Contest at The Great American Quilt Festival 3, a Museum of American Folk Art event sponsored by Fairfield Processing Corporation/Poly-fil® and Springmaid® Fabrics; 1991.9.14

391. The Daffodil Garden
Masuyo Otsuji
Otsu City, Japan; 1991
Cotton
72" x 72"
Winner, "America's Flower Garden" Contest at The Great American Quilt Festival 3, a Museum of American Folk Art event sponsored by Fairfield Processing Corporation/Poly-fil® and Springmaid® Fabrics; 1991.9.15

392. Impressions of My Garden
Yvonne Pask
West Hartford, Connecticut; 1991
Cotton
72" x 72"
Winner, "America's Flower Garden" Contest at The Great American Quilt Festival 3, a Museum of American Folk Art event sponsored by Fairfield Processing Corporation/Poly-fil® and Springmaid® Fabrics; 1991.9.16

393. Stella's Song
Oleeta Patterson
Waco, Texas; 1991
Cotton
72" x 72"
Winner, "America's Flower Garden" Contest at The Great American Quilt Festival 3, a Museum of American Folk Art event sponsored by Fairfield Processing Corporation/Poly-fil® and Springmaid® Fabrics; 1991.9.17

394. Hoffman Garden
Wendy C. Reed
Bath, Maine; 1991
Cotton
72" x 72"
Winner, "America's Flower Garden" Contest at The Great
American Quilt Festival 3, a Museum of American Folk Art
event sponsored by Fairfield Processing Corporation/Poly-
fil® and Springmaid® Fabrics; 1991.9.18

395. Michegamee's Wild Rose
Marie Sturmer
Traverse City, Michigan; 1991
Cotton stenciled with acrylic fabric paint and with cotton
embroidery
72" x 72"
Winner, "America's Flower Garden" Contest at The Great
American Quilt Festival 3, a Museum of American Folk Art
event sponsored by Fairfield Processing Corporation/Poly-
fil® and Springmaid® Fabrics; 1991.9.20

396. Shadows in a Summer Garden
Bonnie Jean Thornton
Redmond, Washington; 1991
Cotton and cotton blends

72" x 72"
Winner, "America's Flower Garden" Contest at The Great
American Quilt Festival 3, a Museum of American Folk Art
event sponsored by Fairfield Processing Corporation/Poly-
fil® and Springmaid® Fabrics; 1991.9.21

397. A"maze"ing Flower Garden
Betty Trumpy
Blue Mounds, Wisconsin; 1991
Cotton
72" x 72"
Winner, "America's Flower Garden" Contest at The Great
American Quilt Festival 3, a Museum of American Folk Art
event sponsored by Fairfield Processing Corporation/Poly-
fil® and Springmaid® Fabrics; 1991.9.22

398. Flowers From the Prairies
Ghislaine Verschoren
Versailles, France; 1991
Cotton
72" x 72"
Winner, "America's Flower Garden" Contest at The Great
American Quilt Festival 3, a Museum of American Folk Art
event sponsored by Fairfield Processing Corporation/Poly-
fil® and Springmaid® Fabrics; 1991.9.23

Allen, Gloria Seaman. *Old Line Traditions: Maryland Women and Their Quilts*. Washington, D.C.: D.A.R. Museum, 1985.

Allen, Gloria Seaman and Nancy Gibson Tuckhorn. *A Maryland Album: Quiltmaking Traditions 1634-1934*. Nashville, Tennessee: Rutledge Hill Press, 1995.

"American Women's Gift to France." *Harper's Bazar*. Vol. 53, No. 20 (May 19, 1900): 151.

An American Sampler: Folk Art from the Shelburne Museum. Washington, D.C.: National Gallery of Art, 1987.

Atkins, Jacqueline M., ed. *Discover America and Friends Sharing America*. New York: Dutton Studio Books in association with the Museum of American Folk Art, 1991.

Atkins, Jacqueline M., ed. *Memories of Childhood*. New York: E.P. Dutton in association with the Museum of American Folk Art, 1989.

Atkins, Jacqueline M. and Phyllis A. Tepper. *New York Beauties: Quilts from the Empire State*. New York: Dutton Studio Books in association with the Museum of American Folk Art, 1992.

Atkins, Jacqueline M. *Shared Threads.: Quilting Together-Past and Present*. New York: Viking Studio Books in association with the Museum of American Folk Art, 1994.

Benberry, Cuesta. *Always There: The African-American Presence in American Quilts*. Louisville, Kentucky: The Kentucky Quilt Project, Inc., 1992.

Benberry, Cuesta. "The 20th Century's First Quilt Revival, Part I: The Interim Period." *Quilter's Newsletter Magazine*. Vol. 10, No. 7 (July-August 1979): 20-22.

Benberry, Cuesta. "The 20th Century's First Quilt Revival, Part II: The First Quilt Revival." *Quilter's Newsletter Magazine*. Vol. 10, No. 8 (September 1979): 25-26; 29.

Benberry, Cuesta. "The 20th Century's First Quilt Revival, Part III: The World War I Era." *Quilter's Newsletter Magazine*. Vol. 10, No. 9 (October 1979): 10-11, 37.

Bishop, Robert and Carter Houck. *All Flags Flying: American Patriotic Quilts as Expressions of Liberty*. New York: E.P. Dutton in association with The Museum of American Folk Art, 1986.

Bishop, Robert. *The Romance of Double Wedding Ring Quilts*. New York: E.P. Dutton in association with The Museum of American Folk Art, 1989.

Blum, Dilys and Jack L. Lindsey. "Nineteenth-Century Appliqué Quilts." *Bulletin, Philadelphia Museum of Art*. Vol. 85, Nos. 363-364 (Fall 1989).

Bowman, Doris M. *The Smithsonian Treasury: American Quilts*. Washington, D.C.: Smithsonian Press, 1991.

Brackman, Barbara. "Blue-and-White Quilts." *Quilter's Newsletter Magazine*. Vol. 18, No. 3 (March, 1987): 22-26.

Brackman, Barbara. *Clues in the Calico: A Guide to Identifying and Dating Antique Quilts*. Mclean, Virginia: EPM Publications, Inc., 1989.

Brackman, Barbara. *Encyclopedia of Applique: An Illustrated, Numerical Index to Traditional and Modern Patterns*. McLean, Virginia: EPM Publications, Inc., 1993.

Brackman, Barbara. *Encyclopedia of Pieced Quilt Patterns*. Paducah, Kentucky: American Quilter's Society, 1993.

Brackman, Barbara. "Fairs and Expositions: Their Influence on American Quilts." *Bits and Pieces: Textile Traditions*. Lewisburg, Pennsylvania: Oral Traditions Project of the Union County Historical Society, 1991: 90–99.

Brackman, Barbara. "The Strip Tradition in European-American Quilts." *The Clarion*. Vol. 14, No. 4 (Fall 1989): 44-51.

Brackman, Barbara. "Signature Quilts: Nineteenth Century Trends." *Uncoverings*. Vol. 10 (1989): 25-37.

Bresenhan, Karoline Patterson and Nancy O'Bryant Puentes. *Lone Stars: A Legacy of Texas Quilts, 1836-1936*. Austin, Texas: University of Texas Press, 1986.

Brooks, Marilyn, ed. *The World of Quilts At Meadowbrook Hall*. Rochester, Michigan: Oakland University, 1983.

Bullard, Lacy Folmar and Betty Joe Shiell. *Chintz Quilts: Unfading Glory*. Tallahassee, Florida: Serendipity Press, 1983.

Caulfield, Sophia Frances Anne and Blanche C. Saward. *The Dictionary of Needlework: An Encyclopedia of Artistic, Plain, and Fancy Needlework*. London: A.W. Cowan, 1882. Reprint, *Encyclopedia of Victorian Needlework*. New York: Dover Publications, Inc., 1972.

Christopherson, Katy. *The Political and Campaign Quilt*. Frankfort, Kentucky: The Kentucky Heritage Quilt Society, 1984.

Clark, Ricky. *Quilted Gardens: Floral Quilts of the Nineteenth Century*. Nashville, Tennessee: Rutledge Hill Press, 1994.

Collins, Herbert Ridgeway. *Threads of History: Americana Recorded on Cloth, 1775 to the Present*. Washington, D.C.: Smithsonian Institution, 1979.

Duke, Dennis and Deborah Harding, eds. *America's Glorious Quilts*. New York: Hugh Lauter Levin Associates, Inc., 1987.

Ferrero, Pat, Elaine Hedges, and Julie Silber. *Hearts and Hands: The Influence of Women and Quilts on American Society*. San Francisco: The Quilt Digest Press, 1987.

Finley, Ruth E. *Old Patchwork Quilts and The Women Who Made Them*. Philadelphia and London: J.B. Lippincott, 1929. Reprint, Newton Centre, Massachusetts: Charles T. Branford, 1957.

Fox, Sandi. *Wrapped in Glory: Figurative Quilts and Bedcovers 1700–1900*. New York: Thames and Hudson, Inc. and The Los Angeles County Museum of Art, 1990.

Gale Research Company. *Currier & Ives: A Catalogue Raisonne*. Detroit: Gale Research, 1983.

Garoutte, Sally. "Marseilles Quilts and Their Woven Offspring." *Uncoverings*. Vol. 3 (1982): 115–134.

Godey's Lady's Book. Philadelphia: Louis A. Godey, January 1835.

Goldsborough, Jennifer Faulds. *Lavish Legacies: Baltimore Album and Related Quilts in the Collection of the Maryland Historical Society*. Baltimore, Maryland: Maryland Historical Society, 1994.

Goldsborough, Jennifer F. "An Album of Baltimore Album Quilt Studies." *Uncoverings*. Vol. 15 (1994): 73-110.

Goldsborough, Jennifer F. "Baltimore Album Quilts." *The Magazine Antiques*. Vol. CXLV, No. 3 (March 1994): 412-421.

Granick, Eve Wheatcroft. *The Amish Quilt*. Intercourse, Pennsylvania: Good Books, 1989.

Groves, Harold and Dorothymae Groves, eds. *Kansas City Star Classic Quilt Patterns: Motifs and Design*. Kansas City, Missouri: Groves Publishing Company, 1988.

Gunn, Virginia. "Crazy Quilts and Outline Quilts: Popular Responses to the Decorative Art/Art Needlework Movement, 1876–1893." *Uncoverings*. Vol. 5 (1984): 131–152.

Gunn, Virginia. "Dress Fabrics of the Late 19th Century: Their Relationships to Period Quilts." *Bits and Pieces: Textiles Traditions*. Lewisburg, Pennsylvania: Oral Traditions Project of the Union County Historical Society, 1991: 4–15.

Gunn, Virginia. "Victorian Silk Template Patchwork in American Periodicals 1850–1875." *Uncoverings*. Vol. 4 (1983): 9-25.

Hall, Carrie A. and Rose G. Kretsinger. *The Romance of the Patchwork Quilt in America*. Caldwell, Idaho: Caxton Printers Ltd., 1935. Reprint, New York: Dover, 1988.

Hollander, Stacy C. "African-American Quilts: Two Perspectives." *Folk Art: Magazine of the Museum of American Folk Art*. Vol. 18, No. 1 (Spring 1993): 44-51.

Holstein, Jonathan. *The Pieced Quilt: An American Design Tradition*. Boston, Massachusetts: New York Graphic Society, 1973.

Hostetler, John A. *Amish Society*, Third Edition. Baltimore and London: The Johns Hopkins University Press, 1980.

Houck, Carter. *The Quilt Encyclopedia Illustrated*. New York: Harry N. Abrams Inc., Publishers in association with the Museum of American Folk Art, 1991.

Johnson, Allen and Dumas Malone, eds. *Dictionary of American Biography*. Vol VI. New York: Charles Scribner's Sons, 1931.

Johnson, Mary Elizabeth. *Star Quilts*. New York: Clarkson N. Potter, 1992.

Katzenberg, Dena S. *Baltimore Album Quilts*. Baltimore: The Baltimore Museum of Art, 1981.

Kaufman, Stanley A. with Leroy Beachy. *Amish in Eastern Ohio*. Walnut Creek, Ohio: Ohio Arts Council, 1990.

Kiracofe, Roderick and Mary Elizabeth Johnson. *The American Quilt: A History of Cloth and Comfort 1750–1950*. New York: Clarkson N. Potter, 1993.

Kogan, Lee. "The Quilt Legacy of Elizabeth, New Jersey." *The Clarion*. Vol. 15, No. 1 (Winter 1990): 58-64.

Lasansky, Jeannette, ed. *Pieced by Mother: Over 100 Years of Quiltmaking Traditions*. Lewisburg, Pennsylvania: Union County Historical Society, 1987.

Lasansky, Jeannette. "Quilts of Central Pennsylvania." *The Magazine Antiques*. Vol. CXXXI, No. 1 (January 1987): 288-299.

Lasansky, Jeannette "The Typical Versus the Unusual/Distortions of Time." *In the Heart of Pennsylvania: Symposium Papers*. Lewisburg, Pennsylvania: Oral Traditions Project of the Union County Historical Society, 1986: 56–63.

Laverty, Paula. "Many Hands: The Story of an Album Quilt." *Folk Art: Magazine of the Museum of American Folk Art*. Vol. 18, No. 1 (Spring 1993): 52-57.

Lynn, Catherine. "Decorating Surfaces: Aesthetic Delight, Theoretical Dilemma." *In Pursuit of Beauty*. New York: The Metropolitan Museum of Art and Rizzoli, 1986.

Lynn, Catherine. "Surface Ornament: Wallpapers, Carpets, Textiles and Embroidery." *In Pursuit of Beauty*. New York: The Metropolitan Museum of Art and Rizzoli, 1986.

Mathieson, Judy. "Some Published Sources of Design Inspiration for the Quilt Pattern Mariner's Compass—17th to 20th Century." *Uncoverings*. (1981): 11-18.

McCloskey, Marsha. *Feathered Star Quilts*. Bothell, Washington: That Patchwork Place, 1987.

McKim, Ruby. *101 Patchwork Patterns*. 2nd ed. New York: Dover Publications, Inc. 1962.

McMorris, Penny. *Crazy Quilts*. New York: E.P. Dutton, Inc., 1984.

McMorris, Penny and Michael Kile. *The Art Quilt*. San Francisco: The Quilt Digest Press, 1986.

Montgomery, Florence M. *Printed Textiles: English and American Cottons and Linens 1700–1850*. New York: Viking Press, 1970.

Montgomery, Florence M. *Textiles in America, 1650–1870*. New York: W.W. Norton, 1984.

Needle-Craft: Artistic and Practical. New York: The Butterick Publishing Co., 1889.

Needle and Brush: Useful and Decorative. New York: The Butterick Publishing Co., 1889.

Nicoll, Jessica F. "Signature Quilts and the Quaker Community 1840–1860." *Uncoverings*. Vol. 7 (1986): 27-37.

Nicoll, Jessica F. *Quilted for Friends: Delaware Valley Signature Quilts*. Winterthur, Delaware: The Henry Francis DuPont Winterthur Museum, 1986.

Orlofsky, Patsy and Myron. *Quilts in America*. New York: McGraw-Hill, 1974. Reprint, New York: Abbeville Press, 1992.

Peck, Amelia. *American Quilts & Coverlets in the Metropolitan Museum of Art*. New York: The Metropolitan Museum of Art and Dutton Studio Books, 1990.

Pottinger, David. *Quilts from the Indiana Amish: A Regional Collection*. New York: E.P. Dutton, Inc. in association with the Museum of American Folk Art, 1983.

The Quilt Digest 1, 2. San Francisco: Kiracofe and Kile, 1983–84.

The Quilt Digest 3-5. San Francisco: Quilt Digest Press, 1985–87.

Rae, Janet. *Quilts of the British Isles*. New York: E.P. Dutton, 1987.

Roan, Nancy and Donald Roan. *Lest I Shall Be Forgotten: Anecdotes and Traditions of Quilts*. Green Lane, Pennsylvania, Goschenhoppen Historians, Inc., 1993.

Schorsch, Anita. *Plain & Fancy: Country Quilts of the Pennsylvania-Germans*. New York: Sterling Publishing Co., Inc., 1992.

Sherman, Mimi. "A Fabric of One Family: A Saga of Discovery." *The Clarion*. Vol. 14, No. 2 (Spring 1989): 55-62.

Shirer, Marie. *The Quilters' How-To Dictionary*. Wheat Ridge, Colorado: Leman Publications, Inc., 1991.

Sienkiewicz, Eleanor Hamilton. "The Marketing of Mary Evans." *Uncoverings*. Vol. 10 (1989): 7-24.

Sudo, Kumiko. *Expressive Quilts*. Berkeley, California: Pegasus Publishing, 1989.

"The Meetin' Place" (about Kumiko Sudo). *Quilter's Newsletter Magazine*. vol. 18, No. 6 (November-December 1897): 24.

Swan, Susan Burrows, *Plain & Fancy: American Women and Their Needlework, 1700–1850*. New York: Holt, Rinehart, and Winston, 1977.

Thieme, Otto Charles. "'Wave High the Red Bandanna': Some Handkerchiefs of the 1888 Presidential Campaign." *Journal of American Culture*. Vol. 3, No. 4 (Winter 1980): 686-705.

Vincent, Margaret. *The Ladies' Work Table: Domestic Needlework in Nineteenth-Century America*. Allentown, Pennsylvania, Allentown Art Museum, 1988.

Vlach John Michael. *The Afro-American Tradition in Decorative Arts*. Cleveland: Cleveland Museum of Art, 1978.

Wahlman, Maude Southwell, Ph.D. "African-American Quilts: Tracing the Aesthetic Principles." *The Clarion*. Vol. 14, No. 2 (Spring 1989): 44-54.

Wahlman, Maude Southwell, Ph.D. "Religious Symbolism in African-American Quilts." *The Clarion*. Vol. 14, No. 3 (Summer 1989): 36-44.

Wahlman, Maude Southwell, Ph.D. *Signs and Symbols: African Images in African-American Quilts*. New York: Studio Books in association with the Museum of American Folk Art, 1993.

Waldvogel, Merikay. *Soft Covers for Hard Times: Quiltmaking and the Great Depression*. Nashville, Tennessee: Rutledge Hill Press, 1990.

Waldvogel, Merikay and Barbara Brackman. *Patchwork Souvenirs of the 1993 World's Fair*. Nashville, Tennessee: Rutledge Hill Press, 1993.

Webster, Marie D. "The May Tulip Quilt in Appliqué." *Needlecraft, The Magazine of the Home Arts*. (May 1931): 6.

Webster, Marie D. *Quilts, Their Story and How to Make Them*. Garden City, New York: Tudor Publishing, 1948.

Woodard, Thos. K. and Blanche Greenstein. *Twentieth Century Quilts 1900–1950*. New York: E.P. Dutton, Inc., 1988.

GAVIN ASHWORTH

Color: #8; 39; 39a, b, & c; 40; 40a, b, & c; 59; 61; 61a & b; 70;
95a; 98; 100; 103; 107; 130; 162; 231; 347

GEOFFREY CARR

Color: #163; 164

SCOTT BOWRON

Color: #1; 2; 9; 10; 18; 21; 27; 45; 49; 50; 144; 251; 341; 342;
344; 345; 348; 350; 351; 361; 369; 371; 374; 375
Black & white: #368

HELGA STUDIOS

Color: #15; 17; 19; 20; 23; 142
Black & white: #23; 55

HOEBERMANN STUDIO

Color: #6; 18; 19; 21; 26; 30; 31; 33; 35; 35a & b; 41; 41a; 46; 52;
53; 67; 68; 69; 96; 97; 116; 116a & b; 117; 117a, b, & c; 120; 138;
139; 148; 149; 151; 152; 155; 156; 157; 160; 363; 363
Black & white: #25; 32; 42; 43; 47; 56; 71; 77; 89; 146; 158; 331

SCHECTER LEE

Color: #3; 5; 14; 28; 32; 51; 62; 95; 109; 137; 140; 159; 173; 232;
233; 234; 283; 366

JOHN PARNELL

Color: #119